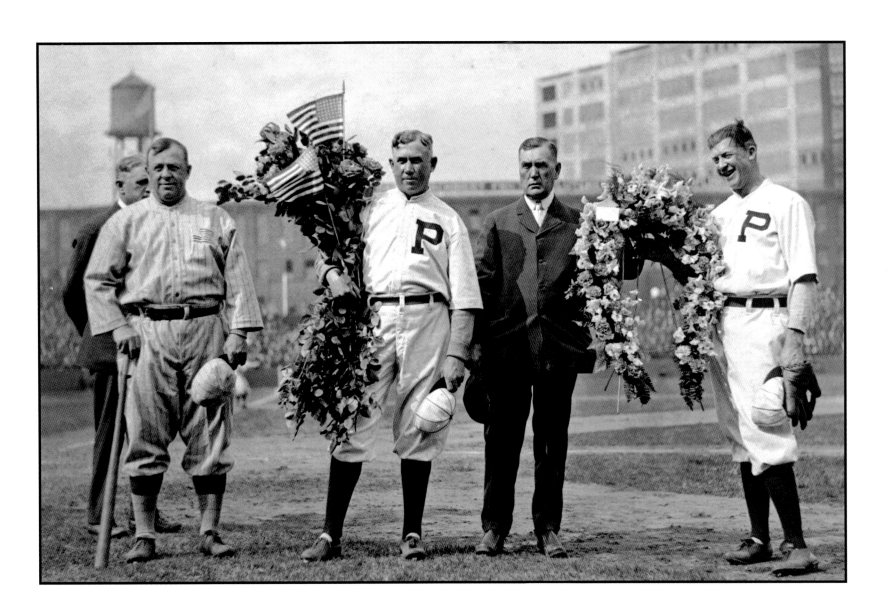

(preceeding page)
Baker Bowl
1917

 Prior to the Phillies' 1917 home opener versus the defending champion
Brooklyn Robins, local dignitaries were on hand to present floral bouquets to
manager Pat Moran(center) and staff ace Grover Cleveland Alexander(far right.)
Brooklyn manager Wilbert Robinson is shown at left leaning on bat.

PHILLIES *Photos*

100 Years of Philadelphia Phillies Images

by

Mark Stang

ORANGE FRAZER PRESS
Wilmington, Ohio

ISBN: 978-1-933197-58-6

Copyright © 2008 by Mark M. Stang

Orange Frazer Press, Inc.
Box 214
37½ West Main Street
Wilmington, Ohio 45177

Telephone 1.800.852.9332 for price and shipping information
Web Site: www.orangefrazer.com
E-mail address: editor@orangefrazer.com

Printed in Canada
Second Printing: April 2009

In memory of Allen Lewis, who covered the Phillies as a sportswriter for the *Philadelphia Inquirer* for thirty years.

-MS

Introduction

In the faces on these pages lie the stories, the legends and the lore of the Philadelphia Phillies. Some of the photographs have brief tales to tell; other pictures, as the old saying suggests, are worth a thousand words.

A few of the images are familiar, but I have included dozens of previously unpublished photos and many others that were published only once, long ago. The 245 images in this book, culled from 14 public and private collections, are what I believe to be the best available photographs of Phillies players from the last century-plus.

This collection of photos includes the famous, the not so famous and the long forgotten personalties in Phillies history. I chose photos for a variety of reasons. Some players were obvious choices. A book of Philadelphia Phillies images couldn't overlook stars like Chuck Klein, Richie Ashburn, Robin Roberts or Mike Schmidt.

But beyond the Hall of Fame caliber players, there are dozens of forgotten personalities whose stories are just as compelling.

When I discovered the exploits of players like Erskine Mayer, or the accomplishments of Tom Seaton, I knew they had to be included. People behind the scenes, the owners, managers and broadcasters also offered fascinating stories. Woven together, I sought to paint a picture that did justice to the rich tapestry that is the tradition of Phillies baseball.

I came to see myself as a baseball archeologist, uncovering photographic treasures hidden for decades in dusty old files. The opportunity to bring a long forgotten photo back to life made my search for the finest available images a rewarding one. I hope you will agree.

So I now present to you the obvious and the obscure, the famous and the forgotten personalities that shaped the Phillies' rich baseball history.

Mark Stang
2008

Acknowledgments

This project would not have been possible without the assistance of many individuals. Many thanks to Tim Wiles and Pat Kelly (and their staffs) at the National Baseball Library in Cooperstown for their assistance. Archivist Steve Gietschier at *The Sporting News* in St. Louis located several key images.

Thanks also to Bryan McDaniel at the Chicago Historical Society for his assistance with *The Daily News* negatives collection. My thanks to John Pettit and Brenda Galloway-Wright at The Urban Archives at Temple University for their assistance with the defunct *Philadelphia Bulletin* photo files.

Vintage photo collectors Dennis Goldstein and Mike Mumby graciously shared their troves of treasured images with Phillies fans everywhere. Many thanks to professional photographers Doug McWilliams, Jack Wallin, the late George Brace (and his daughter Mary) and Skip Trombetti for sharing their work.

Thanks also to Elaine Olund at Lamson Design for the original cover concept. Many thanks to Max Silberman for his proof reading of the text and to long-time Phillies collector Tony Bacon for his friendship and support.

The format used in *Phillies Photos* owes its inspiration to a 1999 publication I co-authored with Greg Rhodes entitled: *Reds in Black and White, 100 Years of Cincinnati Reds Images.* That book, in turn, owes a debt of gratitude to the classic work by Neal and Constance McCabe, *Baseball's Golden Age: The Photographs of Charles M.Conlon* (published in 1993).

I also want to thank Rick Vaughn and the media relations department of the Tampa Bay Rays for their support and assistance in making this project a reality.

Finally, the behind-the-scenes star, as always, is Ryan Asher. His technical wizardry and tireless dedication to providing the best possible image is evident on every page. Ryan also executed the page layout and the cover design.

To all these folks, I offer my sincere appreciation for their hard work and cooperation in making this project possible.

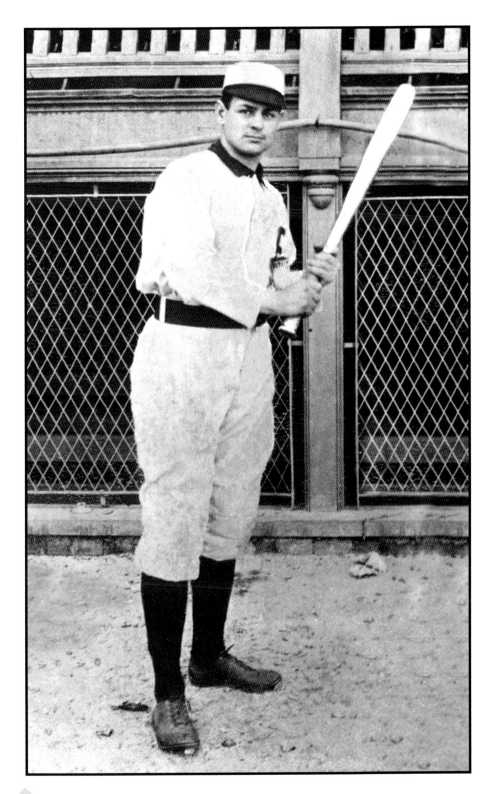

Elmer Flick
Outfielder, 1898 - 1901

At the beginning of the 20th Century, the city of Philadelphia's only professional baseball franchise was a study in mediocrity. For, despite joining the National League in 1883, the Phillies' first 17 seasons had failed to produce a championship banner of any kind. In fact, there had only been one season with better than a third-place finish.

In 1898, the Phillies signed a twenty two year-old rookie named Elmer Flick, who had played just two seasons of minor league ball back in his native Ohio. Flick showed up in training camp with a homemade bat he had turned on a lathe by himself. Just one week into the season, an injury to the team's regular rightfielder got Flick into the starting line-up. He belted out two singles in his debut and never looked back, ending the season with a .302 average. He also knocked in 81 runs, the third highest total on the team and stole 23 bases.

Over the next three seasons, Flick used his speed to steal a total of 96 bases. His quickness also allowed him to cover a lot of ground in the outfield and Flick once made such a spectacluar catch during a game in Pittsburgh that the local fans showered the field with coins in appreciation of what they had just witnessed. Local sportswriters concurred by immediately proclaiming Flick's one-handed catch the greatest ever witnessed in that ballpark.

In 1900, Flick had his greatest season as he knocked in 110 runs to lead the National League and his .378 batting average was second only to Honus Wagner's .381. In addition, Flick led the league in total bases, and was second in both hits and home runs.

However, in 1901, the newly-formed American League put a franchise in Philadelphia to challenge the National League and began luring veteran players with much larger contracts. Following the 1901 season, Flick accepted an offer from Connie Mack's Athletics and jumped to the rival league. The Phillies went to court. The judge ruled in the Phillies' favor, limiting Flick to playing only road games for the Athletics. Faced with the prospect of only getting a half-season's work out of their new acquisition, the Athletics promptly traded Flick to Cleveland in mid-May.

While with Cleveland, Flick won an American League batting crown in 1905 and also led the A. L. in triples for three straight seasons beginning that same year. But in 1908, a mysterious stomach ailment caused Flick to miss almost the entire season. His batting average and playing time slipped dramatically and by 1910 he was out of the major leagues at age 34. Flick played two final seasons back in the minor leagues before retiring.

He later spent time as a scout and his career was all but forgotten when Flick was suddenly elected to the Hall of Fame in 1963.

Charles "Chick" Fraser
Pitcher, 1899 - 1900; 1902 - 1904

Chick Fraser threw the first no-hitter of the 20th Century for the Phillies despite a well-deserved reputation for wildness and a career losing record.

Fraser's first three seasons in the National League had been a disaster. As a rookie with Louisville in 1896, he was 13-25 and led the league in walks. After two more losing seasons, Fraser was purchsed by the Phillies for the bargain-basement price of $1,000. It turned out to be a steal as Fraser suddenly located home plate and began winning games. His 21 wins in 1899 were the second highest total on the Phillies starting staff and his four shutouts were second best in the National League. In 1900, Fraser won 16 games and lowered his ERA to 3.14 to lead the Phillies staff in both categories.

But the lure of a fatter paycheck proved too much for Fraser as he left the Phillies to join the Athletics for the 1901 season. Despite leading the American League in walks, Fraser promptly won 22 games and completed 35 of his 37 starts. He thus became the only pitcher to ever win 20 games for both the Phillies and the Athletics. However, the successful legal challenge brought by the Phillies forced Fraser to return to the National League for the 1902 season.

Fraser never produced another winning record in any of the next three seasons with the Phillies. The lone bright spot came late in the 1903 season in Chicago. Facing the Cubs in the second game of a doubleheader, Fraser blanked them 10-0 on September 18. Although he walked five batters and had four errors comitted behind him, Fraser didn't allow a single hit. It was the only no-hitter thrown in the National League that season.

In 1904, Fraser's 14-24 record finally marked the end of his time with the Phillies, who released him. Fraser signed with Boston for 1905 and promptly lost 21 games and again led the N.L in walks. Another 20 losses for Cincinnati in 1906 got him traded to the Cubs. At age 36, Fraser managed to hang on for another two-plus seasons before returning to the minors for parts of another two years.

In retirement, Fraser spent several decades as a scout for the Pirates, Dodgers and Yankees.

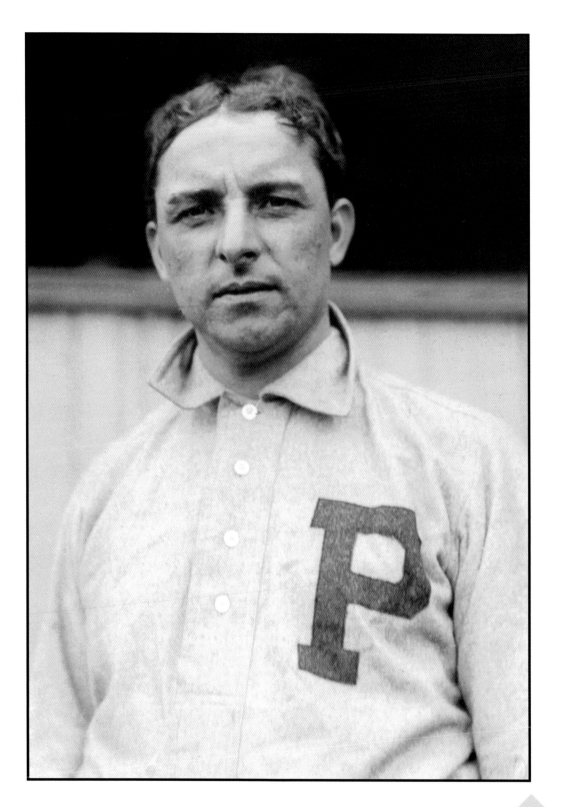

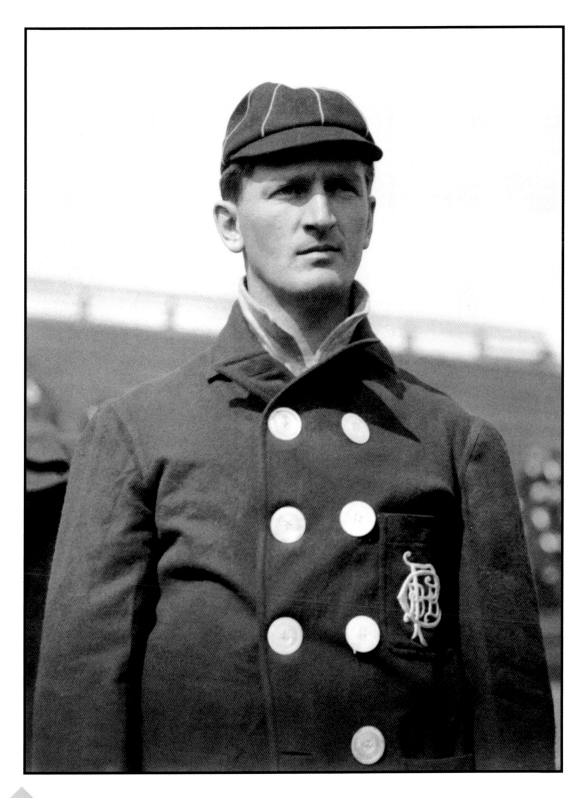

Harry Wolverton
Third Baseman, 1900 - 1904

Harry Wolverton was a steady, if unspectacular, fielder whose greatest fame came as a manager in both the major and minor leagues. Wolverton joined the Phillies early in the 1900 season after two years as a part-time player with the Chicago Cubs. His strong, accurate throwing arm and consistent glove work earned Wolverton the everyday assignment as the Phillies' third-sacker.

His best season in Philadelphia came in 1903 when he battted .308 and swatted 13 doubles and 12 triples. But when the Phillies lost 100 games in 1904, the team's owners overhauled the roster and Wolverton was traded to the Boston Braves. It would be his final season in the majors as a player.

In 1906, Wolverton began managing in the minor leagues, winning league titles in two of his first three seasons. Promoted to manage Newark of the Eastern League in 1909, he led his club to a second-place finish before moving on to Oakland in the Pacific Coast League. By 1912, the New York Highlanders(later renamed the Yankees) of the American League were looking for a new manager and Wolverton got the assignment. He took over a ballclub that had gone 76-76 and finished sixth in 1911.

But when the team lost its first 10 games of the season and finished with a record of 50-102, good for last place in the A.L., Wolverton's regin proved a short one. He was fired at season's end. The 102 losses remain to this day the most in franchise history.

Wolverton returned to the P.C.L. and spent the next four-plus seasons piloting Sacramento and San Francisco. In 1937, Wolverton was killed by a hit and run driver as he stepped off a curb in downtown Oakland.

John Titus
Outfielder, 1903 - 1912

Speedy John Titus spent nine full seasons patrolling the outfield for the Phillies, but it was his durability and quirky mannerisms for which he is best remembered. Titus was already 27 by the time he made it to the majors, but once he joined the Phillies lineup, he didn't miss a single start for nearly eight years.

Titus' fellow players tagged him "Silent John" for his almost monastic silence. On a Phillies team full of loud and profane personalities, Titus let his play on the field speak for itself. Teammate Kid Gleason exclaimed, "He doesn't even make any noise when he spits." But it was his constant habit of taking the field with a toothpick wedged firmly between his teeth that earned Titius the moniker "toothpick Titus". Opposing pitchers tried, without success, to seperate Titus from his toothpick while he was in the batter's box. No one ever recalled it happening. For his part, Titus claimed he needed the sliver to remove the chewing tobacco which became lodged between his teeth.

Beginning in 1908, Titus stole 20 or more bases for three straight seasons. But early in 1911, he broke his leg sliding home against the Cardinals in a game at the Baker Bowl and missed the next six weeks. When Titus returned, his speed was gone and he was no longer an everyday player.

Now 36, he was traded to the Boston Braves midway through the 1912 season. A second broken leg the following year got him shipped to the minor leagues where he spent parts of two seasons with Kansas City before retiring.

In 1915, he returned home to his native Pennsylvania and married his 17 year-old neighbor.

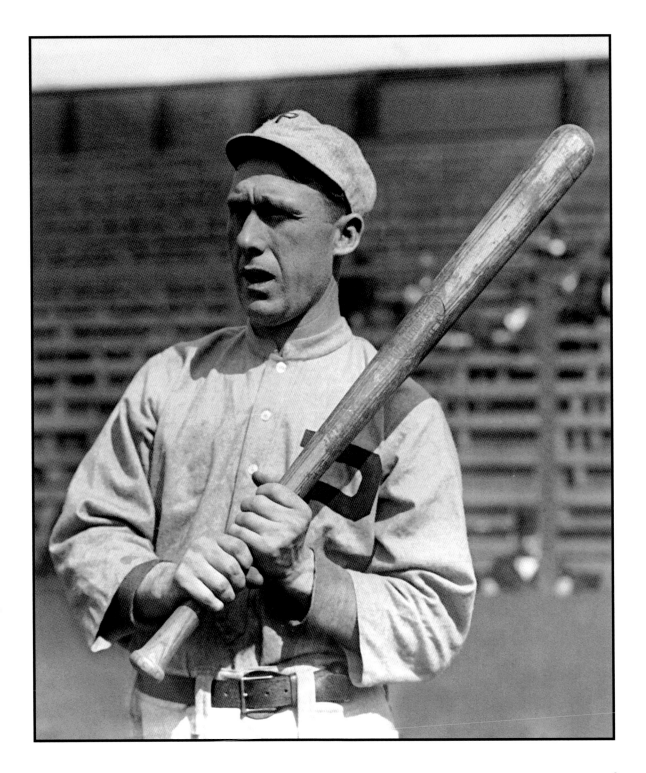

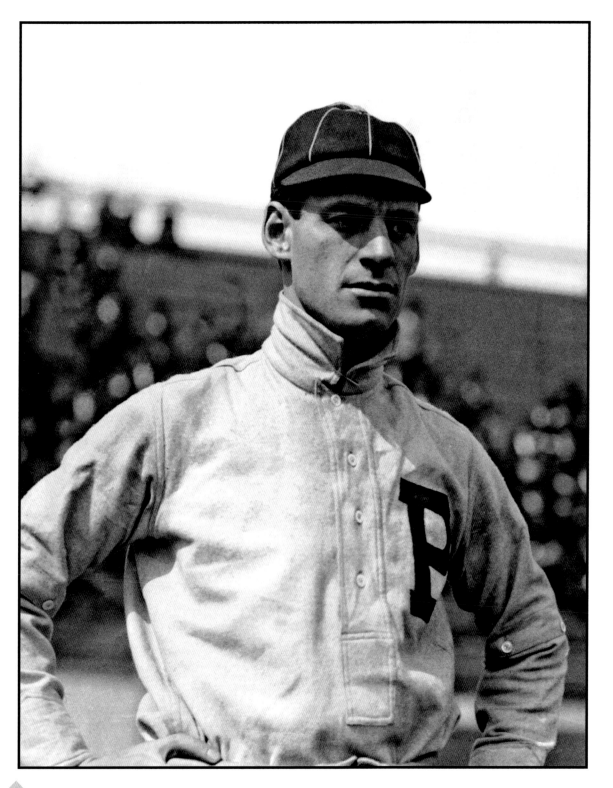

Roy Thomas
Outfielder, 1899 - 1908, 1910 - 1911

Roy Thomas was an exceptionally gifted contact hitter who mastered the art of getting on base. As a rookie in 1899, Thomas batted .325, stole 42 bases and drew a staggering 115 base on balls. In his second season, he hit .316 and led the National League in runs scored with 134. No other player had more than 115.

Thomas quickly perfected the ability to foul off pitch after pitch in an effort to draw a walk. One period news account claimed Thomas once fouled off 27 consecutive offerings. In 1901, N.L. President William Hulbert, tired of watching Thomas frustrate opposing pitchers, convinced the rules committee to institute the two-strike rule regarding foul balls. Prior to that time, foul balls didn't count as strikes unless caught. The new rule did little to keep Thomas off base. He continued leading the National League in walks in six of the next seven seasons.

Thomas also excelled in the field. Stationed between John Titus in right and Sherry Magee in left, Thomas led all N.L. centerfielders in fielding percentage five times and twice led the league in putouts.

Released by the Phillies early in the 1908 season, Thomas signed with the Pirates, where he finished out the remainder of the season before spending the following year with the Boston Braves. In 1910, Thomas returned to the Phillies as a part-time player for another two years.

In retirement, Thomas spent a decade as the baseball coach at the University of Pennsylvania, his alma mater. He also managed briefly in the minor leagues before becoming a sales rep for a local coal company in Philadelphia.

Thomas "Tully" Sparks
Pitcher, 1903 - 1910

Tully Sparks won 22 games for the Phillies in 1907 and was consistently among the league leaders in ERA.

Sparks began his career in the majors by making a single start for the Phillies in 1897 before bouncing among four other clubs over the next four seasons. When he rejoined the Phillies in 1903, he was an unimpressive 11-15. But by 1905, Sparks had managed to win 14 games and his ERA of 2.18 was the lowest among the Phillies starters.

In 1906, Sparks started out strong, winning six of his first eight starts before tailing off to finish 19-16. He did however, notch six shutouts including a 2-0 victory over New York Giants ace Christy Mathewson in late August.

Spark's best season was 1907. Beginning in late July, he reeled off 10 consecutive victories and finished the season by winning 14 of his last 16 starts to finish up 22-8. More importantly, Sparks was at his best when facing the best. In his four starts against the mighty Chicago Cubs, winner of 107 games and the eventual World Champions that season, Sparks was 3-1. His only loss was 1-0 defeat and he limited Chicago hitters to a total of five runs in 36 innings of work. His 22 wins ranked third-best in the National League that year.

Unable to duplicate the success of 1907, Sparks record was 16-15 the following season and in 1909 he won just six games to go with 11 losses. The Phillies had seen enough and Sparks was released early in the 1910 season after failing to win any of his first three starts. At age 35, his career in the majors was over.

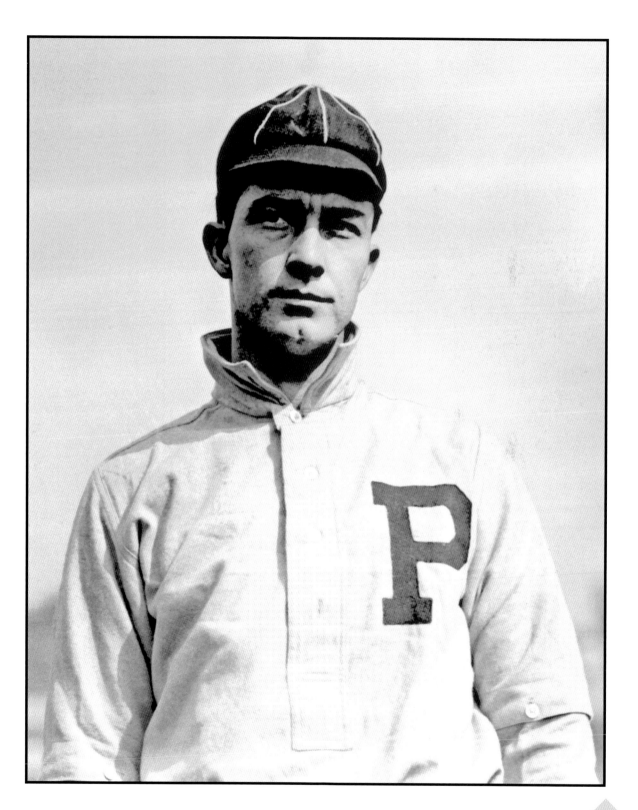

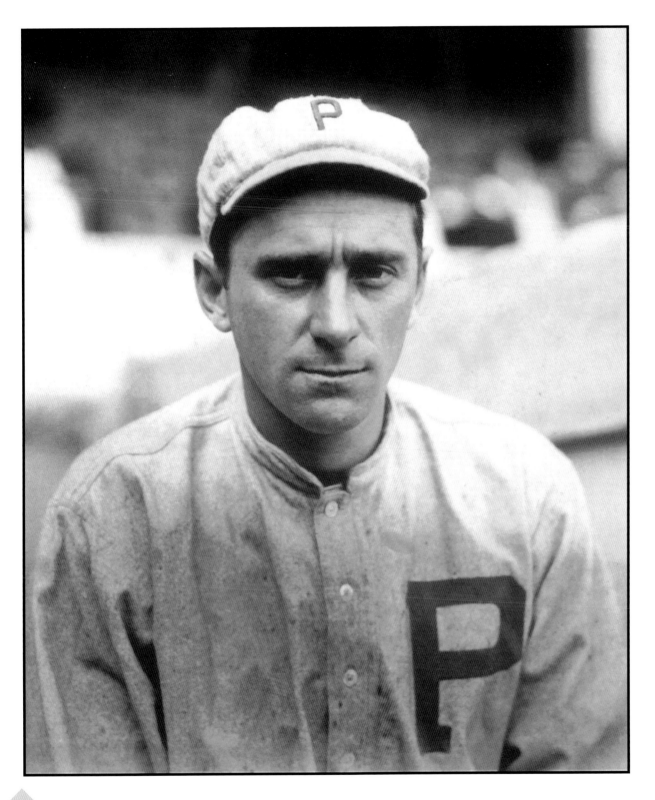

Sherry Magee
Outfielder, 1904 - 1914

Sherwood Robert Magee could do it all from the moment he arrived in the big leagues at the age of 19. He possessed uncommon speed, a strong, accurate throwing arm and was able to hit for both power and average. During his 11 seasons with the Phillies, Magee led the National League in RBI three times, won a batting title and stole a total of 387 bases. He was also the Phillies most consistent run producer for a decade.

Magee was also regarded by the press and fans alike as one of the game's most volatile personalities. His temper was legendary. Magee berated teammates, argued about everything and even knocked out an umpire with a single punch when a called third strike went against him. In an article he penned himself in *The Philadelphia Public Ledger* in 1914, he wrote "They say I'd rather argue than eat my dinner, so let 'em come."

But it was his play on the field that endeared him to Phillies fans. In his first full year in the majors, Magee hit .299, drove in 98 runs, scored 100 runs and his 17 triples were the second most in the N.L. In 1906, Magee swiped 55 bases, which stood as the Phillies single season mark until broken by Juan Samuel in 1984. That same year Magee twice stole four bases in a single game. By 1907, his average had risen to .328 and his 85 RBI were tops in the league.

Remarkably, Magee's best years were still ahead of him.

William "Kitty" Bransfield
First Baseman, 1905 - 1911

Kitty Bransfield was a slick-fielding first baseman who helped anchor the Phillies infield for six seasons. Bransfield had earned his reputation for glovework during his four previous years with the Pittsburgh Pirates. There, he was part of the Pirates' three straight pennant-winning clubs from 1901-03. Bransfield's best season with Pittsburgh was his first. He hit .295 and drove in 91 runs to go along with 17 triples and 23 stolen bases. But when his average dropped to .223 in 1904, Pittsburgh traded him to the Phillies.

The Pirates would immediately regret the deal as they spent the next 15 years searching for a suitable replacement, leading the press and fans to dub the deal "the Bransfield Curse".

Bransfield played an unusually deep first base, postitioning himself on the edge of the outfield grass. He believed it gave him more time to corral ground balls headed for the outfield. It also meant when the ball was hit to one of the other infielders, Bransfield had to drop his head and charge to the first base bag in hopes of arriving at roughly the same time as the anticipated throw. As a result, he later told reporters that during his four seasons in Pittsburgh he never saw shortstop Honus Wagner field a ground ball.

Bransfield's best offensive season with the Phillies came in 1908 when he hit .304 and stole 30 bases. In 1910, he knocked in eight runs in a single game against the Pirates, still the franchise record. But by 1911, he was 36 and a knee injury left him unable to cover much ground. As a result, the Phillies shipped Bransfield to the Cubs, where he played three games before returning to the minor leagues as a player/manager.

Beginning in 1915 he spent six seasons as an umpire, all but one in the minors. Bransfield later returned to his native Worcester, Massachusetts and oversaw construction of the city's playgrounds and recreation areas.

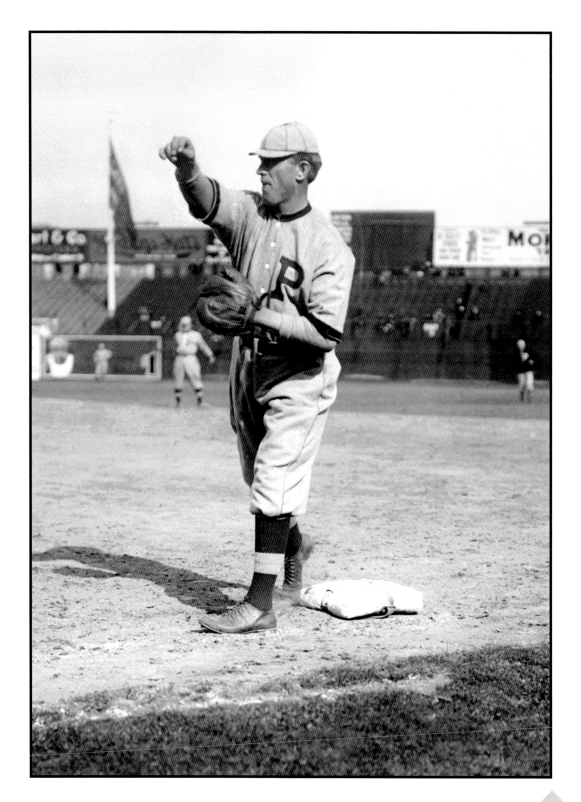

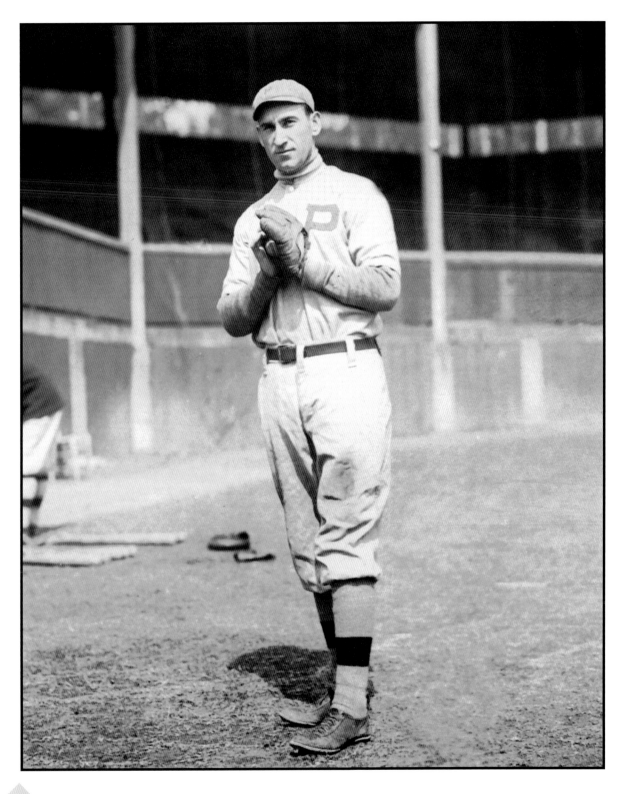

Mickey Doolan
Shortstop, 1905 - 1913

Mickey Doolan's exceptional glovework kept him in the major leagues for more than a dozen years despite his weak showing at the plate. Doolan joined the Phils in 1905 after playing two seasons of college ball at Villanova, where he studied dentistry.

As a youngster, Doolan had once broken his throwing arm. When it finally healed, Doolan was unable to throw overhand and was forced to develop a sidearm "whipping" motion which relied on flicking his wrist to get the ball to the bag. The end result was Doolan's ability to make throws from almost any position. Sportswriter Fred Lieb of *The Sporting News* considered Doolan one of the greatest defensive shortstops of the era.

However, at the plate, it was another story. Doolan had three seasons with the Phillies where he hit below .220. Only once in nine years did his average top .250. It is a mark of the high esteem his teammates held him in that, in 1909, Doolan was named team captain, a postion he held for the next five seasons.

In 1914, Doolan jumped to Baltimore of the newly formed Federal League when they offered him a contract for $6,000. It was a big increase over the $3,500 the Phillies were paying him. When the league folded after the 1915 season, Doolan signed with the Cubs, but at age 36, his career was all but over.

By 1917, he was back in the minors, where he took up managing before returning to the major leagues in 1926 as a coach for the Cubs and later the Reds. Doolan returned to practising dentistry for the next 15 years before retiring to Orlando, where he died in 1951.

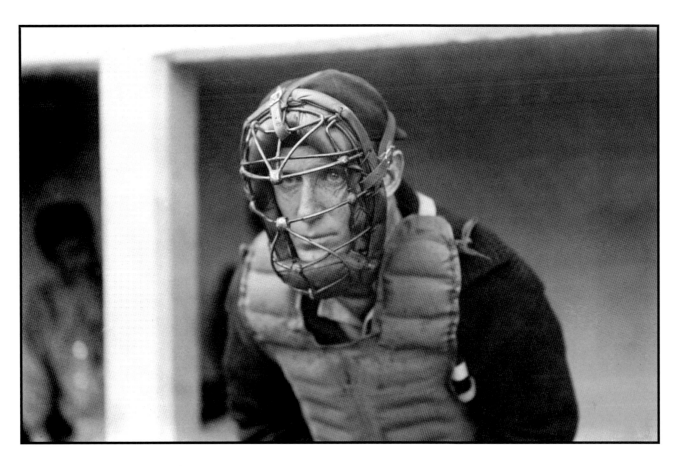

Charles "Red" Dooin
Catcher, 1902 - 1914
Manager, 1910 - 1914

Red Dooin was a fearless catcher who excelled at blocking the plate despite his small size. He caught 1,124 games for the Phillies, second most in team history behind Mike Lieberthal.

Dooin is also believed to be responsible for the innovation of catchers wearing shinguards. Although Hall of Famer Roger Bresnahan is generally credited with the being the first catcher to don the new form of protection, Dooin actually began wearing them first in 1906, albeit under his uniform, where they went unnoticed. That is until he met up with Bresnahan.

During a game in 1907 Bresnahan collided with Dooin at home plate. Impressed by the added protection, Bresnahan approached Dooin in the clubhouse after the game and asked where he could get such an item. Dooin sent Bresnahan to the same sporting goods supplier that had fashioned his pair and Bresnahan was soon seen modeling his new equipment over the top of his uniform. Fans and the press took notice of Bresnahan's appearance and the legend developed mistakenly giving him credit.

Never more than an average performer at the plate, Dooin got a momentary burst of power in 1904, hitting six home runs that season. He would only hit a total of 10 in his entire career. Dooin did, however, possess above average speed, stealing 15 or more bases for the Phillies three times. His talent wasn't confined to the ballpark though. For many years, both during and after his playing days, Dooin traveled the vaudeville circuit as singer and actor, performing his Irish comedy act, "His Last Night Out."

In 1910, Dooin was named manager of the Phillies, although he continued crouching behind the plate, eventually sharing the everyday catching duties with newcomer Bill Killefer. In 1911, Dooin suffered a broken leg in a violent collsion at home plate against the Cardinals, forcing him to miss a large portion of the season. Over the next three seasons, his playing time gradually decreased.

Following the 1914 season, the Phillies traded Dooin, now 35, to the Cincinnati Reds. Beginning in 1917, he spent two seasons playing and managing in the minors before retiring.

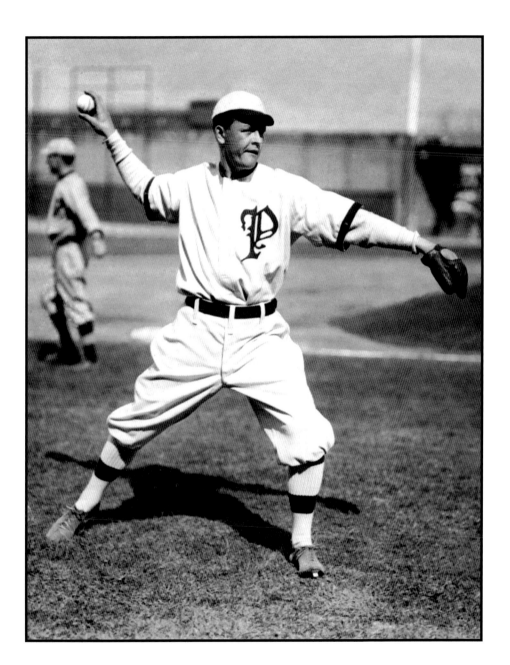

George McQuillan
Pitcher, 1907 - 1910; 1915 - 1916

In 1907, rookie pitcher George McQuillan set a major league pitching record that stood for just over 100 years. McQuillan joined the Phillies for the final month of the season after winning 13 games for Providence. He promptly won four of his five starts including back-to-back shutouts of the Cubs and Reds. In all, he pitched a total of 25 consecutive scoreless innings to begin his major league career, a streak that stood until 2008, when Oakland A's reliever Brad Ziegler eclipsed it.

The following year, McQuillan got off to another torrid start. He won 11 of his first 14 starts and notched four shutouts in the process. But McQuillan's best efforts were often hampered by the Phillies' lackluster offense. In his first six losses, the Phillies scored a total of one run. In mid-June he lost three straight games by identical scores of 1-0.

Whether it was his sudden success, or just pitching in tough luck, McQuillan began drinking heavily and the newspaper accounts of the day contain numerous references to his "breaking training". That August, his wife also filed for divorce. Whatever the reason, McQuillan was basically a .500 pitcher during the second half of the season, finishing with a record of 23-17. McQuillan spent that off-season pitching winter ball in Cuba. But when his club folded in mid-season, McQuillan had to borrow $25 to book passage back to the States. He returned broke and in poor health.

In 1909, McQuillan, obviously out of shape, made only one start in the first six weeks of the season. He never found his rhythm, and struggled to finish with an overall record of 13-16. He did manage to toss four shutouts, including consecutive blankings of Brooklyn and St. Louis in September. The following season, McQuillan made only 17 starts and finished up 9-6, although his ERA of 1.60 was the lowest in the National League. The Phillies, clearly frustrated with his reliability, traded McQuillan to the Reds following the 1910 season.

After spending three years with Cincinnati and Pittsburgh, where he was a combined 31-39, McQuillan rejoined the Phillies midway through the 1915 season. A 5-10 record got him shipped to the minors where he spent parts of another eight years before retiring in 1924.

Otto Knabe
Second Baseman, 1907 - 1913

Franz Otto Knabe teamed with shortstop Mickey Doolan for seven seasons as the Phillies' double-play combination. In an era when the entire National League's ERA was routinely below 2.75 and runs were at a premium, infielders like Knabe perfected the art of keeping opposing baserunners from advancing.

In recalling his playing days, Knabe told a reporter, "Doolan and I didn't specialize in mayhem, but anything went if the umpire wasn't watching. The Cardinals and Phillies used to have some grand battles." During one game, Cardinals Manager Roger Bresnahan had been spiked by Phillies third baseman Hans Lobert and instructed his players to get Lobert. Knabe continued, "Ennis Oakes, a Cardinal outfielder took it upon himself to avenge his manager. Oakes got to first base this day and shouted to Doolan and me, "I'm coming down". We told him to come ahead and he did. As Mickey took the throw from the catcher, I jumped up and landed on my knees on Oakes as he was sliding in. The only place Doolan could find to tag Oakes was on the jaw and he must have knocked him unconsious because they had to carry Oakes off the field. He never did get around to third."

For his part, Knabe was never a great hitter, only once batting over .265. Rather, his job was to get on base in front of the team's sluggers. For instance, despite hitting a modest .237 in 1911, Knabe drew 94 free passes and scored 99 runs. In addition, he twice stole more than 20 bases in a single season.

In 1914, Knabe jumped to Baltimore of the newly formed Federal League and took Mickey Doolan with him. Although only 29, Knabe was named player/manager of his new club. When the League folded two years later, Knabe returned to the National League for one last season split between Pittsburgh and Chicago.

He later managed in the minors before returning to Philadelphia and operating a tavern for many years.

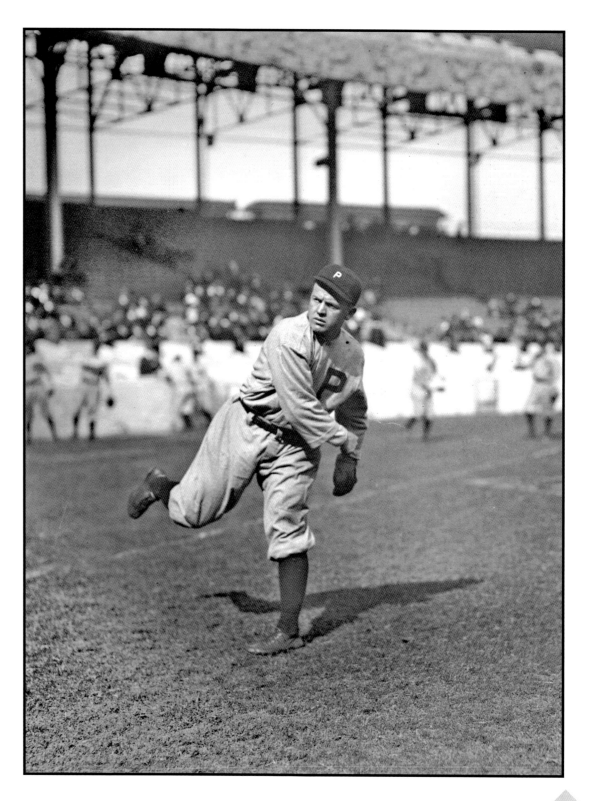

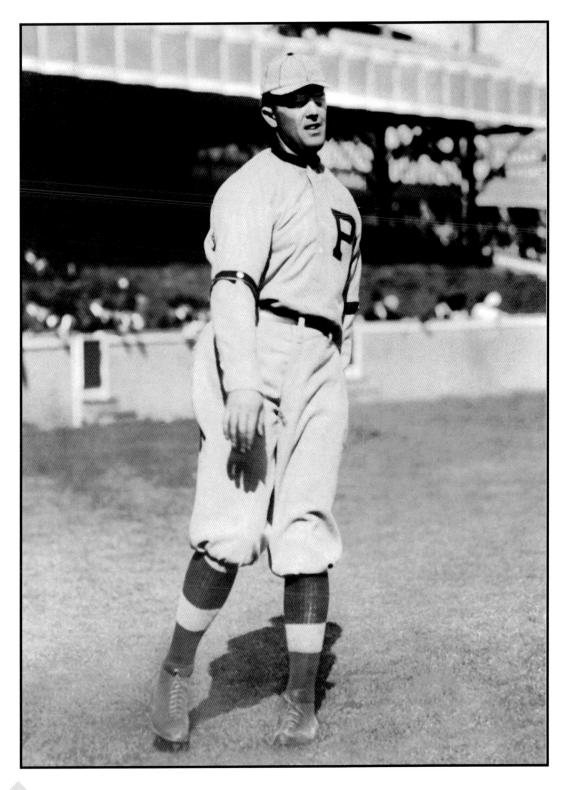

Earl Moore
Pitcher, 1908 - 1913

Righty Earl Moore won 22 games and led the National League in strikeouts for the 1910 Phillies. Moore spent his first five seasons in the majors with Cleveland, where he was a consistent winner. In 1903, he won 19 games and had the lowest ERA(1.77) among American League hurlers. Nicknamed "Crossfire" because of his side-arm delivery, Moore threw a total of 15 shutouts during his first five years with the Indians. But an injury to his left foot caused him to miss almost the entire 1906 season. Shipped to the minors, Moore was thought washed up by many when the Phillies signed him late in 1908.

In Philadelphia, Moore immediately paid dividends by blanking the Reds 5-0 and throwing three consecutive complete games, winning two. More impressively, he didn't allow an earned run in 26 innings of work. In 1909, Moore quickly became the ace of the Phillies starting staff by throwing 300 innings and leading the team with 18 wins and a 2.10 ERA. He struck out 13 batters in a win over the Dodgers and for good measure, also threw four shutouts.

Although 1910 was the best year of Earl Moore's time with the Phillies, it started out poorly. After winning his first two starts, Moore lost six of his next seven and by mid-June, his record stood at 3-7. But just as quickly, he shut out the Braves and Giants in consecutive outings and then reeled off 11 victories in his next 12 starts. His total of 22 wins was equaled by his leading all National League pitchers in strikeouts.

In 1911, Moore worked another 300-plus innings and threw five shutouts, but his record slipped to 15-19. The following year, Moore broke a bone in his pitching hand in late May trying to field a come-backer against the Braves. The injury sidelined Moore for a large portion of the 1912 season and he was never able to regain his old form, ending up a disappointing 9-14.

By 1913, Moore was 34, and when his record stood at 1-3 in July he was sold to the Cubs. He pitched a single season in the Federal League with Buffalo in 1914 before retiring to his home state of Ohio.

Sherry Magee
Brooklyn's Washington Park, 1911

If the Most Valuable Player award had existed in 1910, Phillies outfielder Sherry Magee would have been the unanimous choice. Magee led all National League hitters with a .331 average and 123 RBI. By comparison, no other N.L. batter produced more than 88. Magee also ranked first in slugging percentage, runs scored and total bases while placing second in both doubles and triples. The only reason Magee didn't win the Triple Crown was because his six home runs fell short of the Cubs' Fred Schulte, who finished with 10.

But it was Magee's famous temper which made headlines in 1911. During a home game against the Cardinals on July 10, Magee was called out on strikes by home plate umpire Bill Finneran. Magee exploded in a rage, threw his bat into the air and headed for the dugout. When Magee heard umpire Finneran tell him he was out of the game, Magee charged back towards Finneran and decked him with a single punch, drawing blood. Magee was originally suspended for the remainder of the season, then sat out 36 days when his sentence was reduced.

The loss of Magee could not have come at a worse time for the Phillies, who were just one game out of first place in early July. With their best hitter sidelined, the Phillies went 13-16 over the next month to fall out of the race. They never got back in it, finishing the season in fourth place nearly 20 games behind the eventual champions, the New York Giants.

Magee continued to excel at the plate for another three seasons. In 1914, he again led the National League in both RBI and doubles. But it also marked his final season with the Phillies. That off-season, Magee was dealt to the Boston Braves, who had just won the World Series in 1914. In an ironic twist of fate, after spending over a decade toiling for the lowly Phillies, Magee left the team just before they would capture their first National League pennant in 1915. Magee's Braves finished 1915 in second place.

At age 35, in his final season in the majors, Magee would finally make it to the World Series in 1919 with the Cincinnati Reds. He got one hit in two pinch-hit at bats. Magee continued playing and coaching in the minors for another six years. In 1927, he began umpiring in the New York/Penn League and was hired the following year to umpire in the National League. He worked a single season before dying of pneumonia in 1929 at the age of 44.

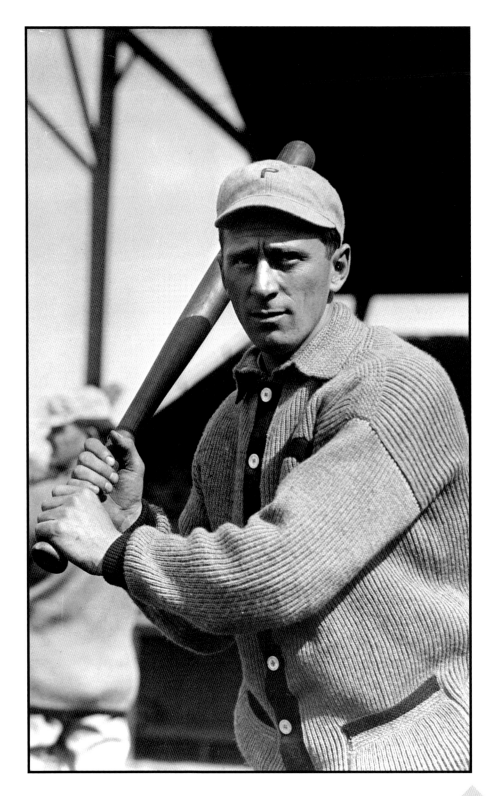

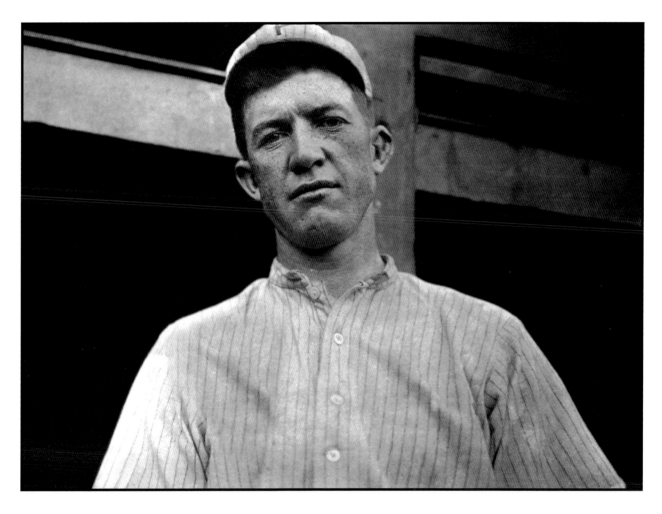

Grover Cleveland Alexander
1911

Grover Cleveland Alexander's rookie season with the Phillies in 1911 ranks among the greatest debuts by a pitcher in baseball history. Almost 100 years after Alexander first joined the Phillies as a 24 year-old, with only two seasons of professional experience, no other major league pitcher has matched his feats.

The Phillies signed Alexander for the bargain basement price of $750. after he won 29 games for Syracuse in 1910. Little was know about him and even less was expected from him by his new teammates. In fact, during training camp, Alexander's habit of avoiding any type of pre-game workout annoyed some of the team's veteran players.

But when Alexander held the Philadelphia Athletics hitless for five innings during the two teams' annual pre-season rivalry, dubbed the City Series, Phillies manager Red Dooin was finally connvinced of the young rookie's potential. After all, the Athletics were the defending World Series champions and boasted a powerful lineup. "The Nebraskan", as the press had begun calling Alexander, joined the Phillies starting rotation.

Alexander lost his debut to the Boston Braves 5-4, but then won 10 of his next 11 starts. By mid-July, his record stood an an eye-popping 17-4. Alexander proved so durable that Dooin routinely started the lanky right-hander on only three days rest. He was also used in relief to ensure Phillies victories and four of his wins came out of the bullpen.

In September, Alexander threw four consecutive shutouts and by season's end, his 28 wins were the most in the National League. Equally impressive was Alexander's workload. He threw a staggering total of 367 innings, tops among all N.L. hurlers and he also ranked first in complete games(36) and shutouts(7).

In Alexander, the Phillies had found their new ace and he was just getting warmed up.

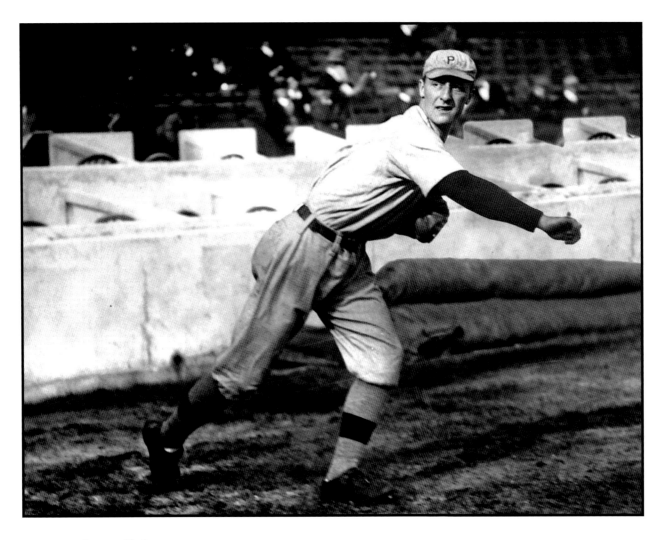

George Chalmers
Pitcher, 1910 - 1916

George Chalmers spent seven years pitching for the Phillies but had a winning record only once. Chalmers, who was born in Scotland, joined the Phillies late in 1910 after winning 25 games for Scranton. He made three starts in the final month of the season. After getting knocked out early in two Phillies losses, Chalmers beat the New York Giants 6-1 to get his first major league win.

In 1911, Chalmers shut out Brooklyn 6-0 in his first start. In late July he blanked the Cardinals 2-0 and three weeks later he beat the New York Giants 2-0 to run his record to 8-4. But Chalmers won only two more of his starts and finished with a record of 13-10. He did manage to throw over 200 innings, but that season, he walked as many batters as he struck out. All those free passes would continue to plague him for the remainder of his career.

After making 22 starts in 1911, Chalmers made only 23 during the next three seasons combined. As his innings dropped dramatically, his losses and ERA mushroomed. Chalmers was a combined 6-17 during the 1912-1914 seasons for the Phillies. In 1914, he spent most of the year back in the minors, throwing a total of just 18 innings for Philadelphia.

In 1915, Chalmers suddenly mastered his control and saw his ERA drop to a career-low 2.48. He started 20 games for the Phillies and pitched much better than his 8-9 record would indicate. In the World Series against the Red Sox, Chalmers started Game 4 and lost 2-1, despite striking out six. But 1916 would be his final season in the majors as his 1-4 record with the Phillies got him released.

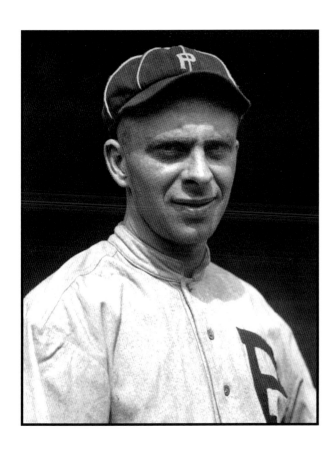

Bill Killefer
Catcher, 1911 - 1917

Bill Killefer was a superb defensive catcher whose skills behind the plate kept him in the major leagues for over a decade. Killefer joined the Phillies in 1911 and took over as the team's everyday catcher the following year. He quickly developed a reputation for throwing out opposing baserunners. In 1913, Killefer played in 120 games and threw out 130 runners, tops among all National League backstops. In addition, four times he led the league in fielding percentage.

At the plate, Killefer provided almost no offensive punch. During six-plus seasons with Philadelphia, he hit bettter than .240 only once. In parts of 13 seasons, totalling over 3,100 at-bats, he hit a total of just four home runs and only once did he ever knock in more than 30 runs in single season. His teammates nicknamed him "Reindeer Bill" for his lack of speed on the bases.

Rather it was Killefer's deft handling of the Phillies pitching staff that made him so valuable. He was generally credited with tutoring Grover Cleveland Alexander's development and the duo stayed linked when they were traded together to the Cubs following the 1917 season.

With Chicago, Killefer won a second N.L pennant in 1918. In 1921, he was named manager of the Cubs, a postion he held for nearly four seasons. In 1930, he took over as manager of the hapless St. Louis Browns, but was fired in 1933 with his team in last place. He later coached in the majors and managed in the minors for many years.

George "Dode" Paskert
Outfielder, 1911 - 1917

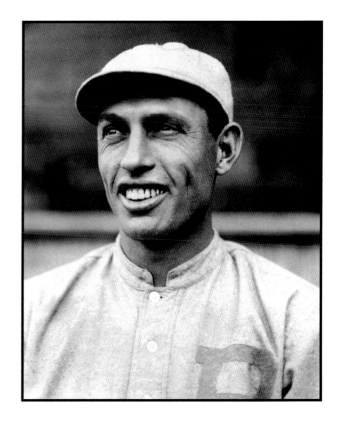

Speedy Dode Paskert was a flashy outfielder noted for his spectacular plays in field. Paskert began his career in the majors with Cincinnati in 1907. But after hitting .300 and stealing 51 bases for the Reds in 1910, he was traded to the Phillies as part of an eight-player deal.

In only his second game with the Phillies, Paskert served notice of what could be expected from him in the field. Facing the New York Giants at the Polo Grounds, Paskert chased down a long fly ball in the outfield gap off the bat of the Giants' Fred Snodgrass. It looked like a sure extra-base hit until Paskert, closing quickly, flung himself parallel to the ground and speared the ball with his bare hand. Teammate Sherry Magee, playing left for the Phillies, later called it the greatest catch he had ever seen.

Paskert's development at the plate took only slightly longer. Hitting at or near the top of the Phillies' batting order, Paskert learned to perfect the art of getting on base, drawing 91 walks in 1912. That same year, he hit .315, stole 36 bases and scored 102 runs. The Phillies' front office was so impressed that they rewarded Paskert with a three-year contract.

But a series of injuries soon hampered his performance. Following the 1917 season, the Phillies traded Paskert to the Cubs for a slugging outfielder named Cy Williams. He played parts of another four seasons with the Cubs and Reds before returning to the minors.

In 1921, Paskert made headlines by rescuing five young children from a burning apartment in Cleveland by making three separate trips into the building.

John "Hans" Lobert
Third Baseman, 1911 - 1914

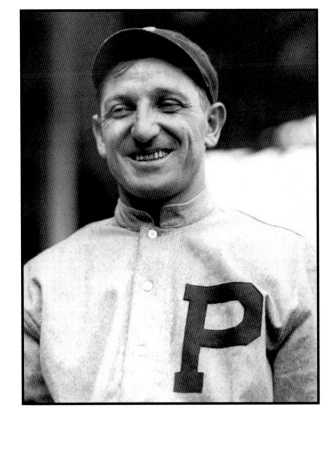

For a guy with bow legs and a stocky physique, Hans Lobert sure could fly around the bases. Lobert stole 30 or more bases seven times during his career, despite being an everyday player for only eight seasons. Nicknamed Hans because of his physical resemblance to the Pirates' Honus Wagner, with whom he played very briefly in 1903, Lobert became a regular with the Cincinnati Reds beginnning in 1906.

Lobert joined the Phillies in 1911 via the same trade that brought outfielder Dode Paskert from the Cubs. In his first season with the Phillies, he produced a career-high 72 RBI. In 1913, Lobert demonstrated his speed by beating New York Giants rookie, and former Olympian, Jim Thorpe in the 100-yard dash at the Polo Grounds. That off-season, Lobert was invited to join the barnstorming tour of Europe and Asia put together by Giants manager John McGraw.

Following the 1914 season, Lobert was all set to accept more money from the Federal League before Giants manager John McGraw convinced him to stay with the Phillies long enough for a trade to be worked out. McGraw was convinced that Lobert was the missing piece to recapturing another pennant. Lobert joined McGraw in New York, but knee injuries slowed him considerably and he retired after the 1917 season.

In 1918, Lobert became the varsity baseball coach at West Point, where he stayed until 1925 when he began scouting, and later coaching, for McGraw and the Giants. In 1934, he returned to the Phillies as a coach and, in 1942, managed the team for a single season.

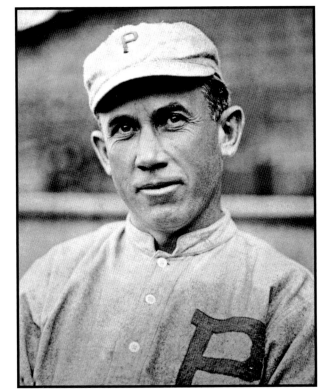

Pat Moran
Catcher, 1910 - 1914
Manager, 1915 - 1918

Pat Moran's career as a back-up catcher was eclipsed by his winning two National League pennants with two different teams. Moran split his first nine years in the big leagues between the Boston Braves and Chicago Cubs, all but two as a reserve.

By the time he joined the Phillies in 1910, Moran was already 34 and he wasn't going to displace a proven veteran like Red Dooin behind the plate. As his playing time dropped off, he soon became the defacto pitching coach for the Phillies, patiently working with the team's veterans and schooling the youngsters.

When Dooin was fired as Phillies manager after a sixth-place finish in 1914, the players approached the team's owner and insisted Moran be given the job. No one was expecting much from an untested former catcher who'd never managed at any level.

But Moran quickly asserted his authority by overhauling the Phillies roster, making deals and trading veterans like Sherry Magee to fill holes in the lineup. During spring training, he drilled his players on the fundamentals and stressed discipline. The results were dramatic as the Phillies began the season with eight straight victories.

The pitching staff, which had ranked last in ERA in 1914, suddenly was the best in either league. In addition, the Phillies allowed the fewest runs of any team in the majors while leading the N.L. in home runs. They were never lower than second place all season and won the N.L. pennant by seven games. In his first season at the helm, Moran had produced the first championship in franchise history.

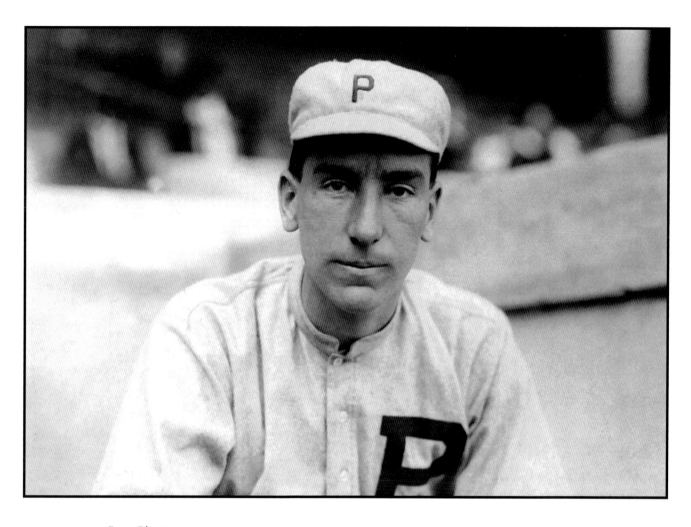

Eppa Rixey
Pitcher, 1912 - 1920

Eppa Rixey won 266 games en route to a place in the Hall of Fame, but his greatest success came after he left Philadelphia. Rixey joined the Phillies midway through the 1912 season, after finishing up his studies at the University of Virginia. He never spent a single day in the minor leagues, highly unusual for a player of his era. Rixey immediately won five of his first six starts, including shutouts of the Braves and Cubs. By season's end he'd won 10 games for the Phillies and was touted in the press as one of the game's most promising newcomers.

But the next two seasons proved a struggle for the lanky left-hander, as his ERA steadily increased and his win total dropped off dramatically. Rixey's habit of missing the first half of each season to continue working on his college degree annoyed Phillies manager Red Dooin. And when Rixey posted a 2-11 record in 1914, his future with the club was clearly in doubt. Luckily for Rixey, the Phillies' sixth-place finish that season meant a change in managers as Dooin was fired and replaced with veteran catcher Pat Moran.

Moran immediately took Rixey under his wing and worked to harness his potential. Rixey later recalled, "It was Pat who made a pitcher out of me. Few men that I've ever known in baseball knew the fine arts of pitching as did Moran."

For his part, Rixey steadily re-gained his confidence. His record of 11-12 in 1915 was deceptive as he got little run support. In nine of his 12 losses, the Phillies scored two or fewer runs. More importantly, Rixey won three of his five starts against the defending champion Boston Braves, who would finish the season in second place behind Philadelphia.

In 1916, the transformation would be complete and Rixey would blossom into a 22-game winner for the Phillies.

Fred Luderus
First Baseman, 1910 - 1920

Fred Luderus swung a potent bat and was considered one of the premier sluggers of his era. Luderus joined the Phillies late in 1910 after playing briefly as a backup for the Chicago Cubs. In Philadelphia, veteran first baseman Kitty Bransfield was 36 and Luderus' early performance at the plate quickly pushed the veteran aside. In his first 21 games with the Phillies, Luderus knocked in 14 runs and hit .294. By the following spring, he was penciled in as the team's everyday first baseman.

In 1911, Luderus had the best year of his major league career. He hit 16 home runs, the second highest total in either league and his 99 RBI were the most by any Phillie that season. Oddly, his round-trippers seemed to come in bunches. In May he hit five in 12 games, all at the Baker Bowl. In July, he twice hit two in a single day. As a left-handed batter, Luderus clearly benefitted from the Baker Bowl's ridiculously short rightfield fence, which stood just 280 feet away.

In the field, however, Luderus was something of a liability. He struggled to corral routine ground balls and thus, was prone to errors. As a result, Luderus led all National League first baseman in fielding miscues four times. But his dependability at the plate endeared him to his teammates and in 1915, he was named team captain. His 36 doubles and .315 average were both second best in the N.L. that year. In the World Series against the Boston Red Sox, Luderus hit .438 and drove in six of the 10 runs the Phillies scored.

Luderus also proved remarkably durable. Beginning in 1916, he played in 533 straight games, then the longest consecutive games streak in the majors. When the streak ended on the final day of the 1919 season, Luderus' time in the majors was all but over. He played another 16 games for the Phillies in 1920, mainly as a pinch hitter, before returning to the minor leagues. There, he played and managed for another nine years.

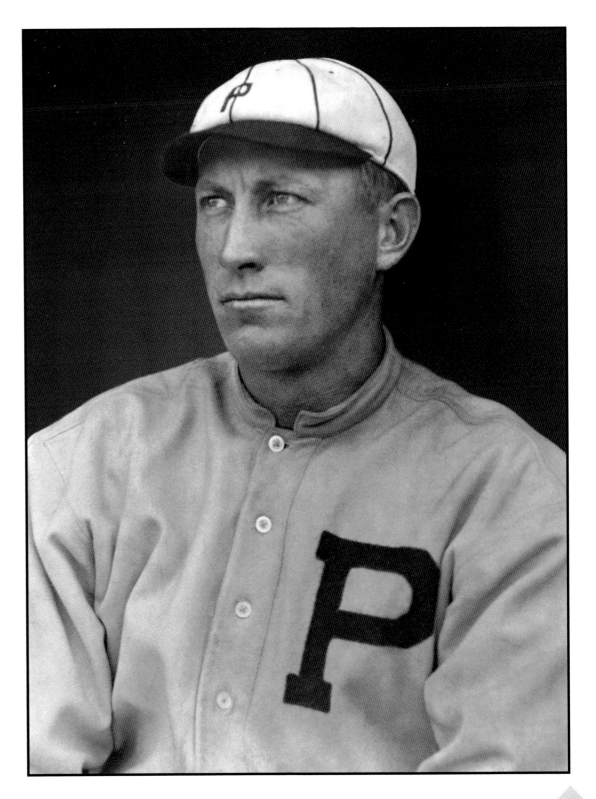

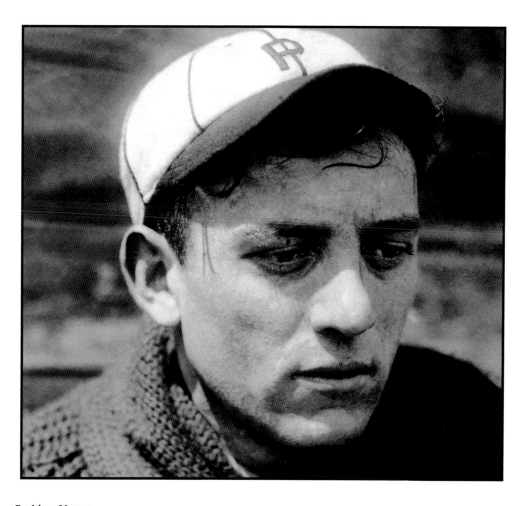

Erskine Mayer
Pitcher, 1912 - 1918

Erskine Mayer was a two-time 20-game winner for the Phillies. Mayer was born James Erskine to a Jewish father who worked as a concert pianist. Mayer played varsity baseball at Georgia Tech, where he studied engineering. He left college before his senior year to pitch professionally and when Mayer went 26-9 for Portsmouth of the Virginia League in 1912, his contract was purchased by the Phillies.

As a rookie in 1913, Mayer alternated between starting assignments and working out of the bullpen to go 9-9 for Philadelphia. Despite his thin frame, Mayer soon developed a reputation as a workhorse. In 1914, he appeared in 48 games, the second highest total in the National League and threw 321 innings. He also won 21 games and threw four shutouts. The highlight was a one-hitter against the Cardinals in July.

Mayer won another 21 games for the Phillies in 1915. He used a side-arm delivery to keep hitters off balance and had the second-lowest ERA on the Phillies staff behind his roommate, Alexander. In the World Series, he started Game 2 and held the Red Sox to a single run through eight innings before losing 2-1. He also started Game 5, but was knocked out in the third inning trailing 2-0 as the Red Sox took the Series in five games.

Apparently all those innings began to take a toll on Mayer. In 1916, he made just 16 starts, his innings dropped in half, and his record was 7-7. Mayer's 11-6 record in 1917 got him dealt to Pittsburgh the following July.

With the Pirates, Mayer engaged in one of the great pitching duels of any era. Mayer threw 15 scoreless innings to begin a game against pitcher Art Nehf and the Boston Braves in August. More improbably, Nehf threw 20 scoreless innings only to lose the game when the Pirates eventually scored twice to win the game in 21 innings. Mayer's time with both the Phillies and the Pirates that season resulted in an overall record of 16-7. He pitched one final season in the majors and another in the minors before retiring after the 1920 season.

Tom Seaton
Pitcher, 1912 - 1913

Tom Seaton won 27 games for the Phillies in 1913, but a pay dispute kept his time in Philadelphia to a minimum. Seaton joined the Phillies in 1912 after winning 26 games for Portland in the Pacific Coast League. As a rookie he used his overpowering fastball to win 16 games and throw 255 innings.

In 1913, Seaton got off to a torrid start. He shut out Brooklyn 1-0 in his first outing and by mid-June, he was undefeated in his first 12 starts. He threw five shutouts and by season's end, Seaton led the National League in wins, strikeouts and innings pitched. Best of all, he was undefeated in four starts against the powerhouse New York Giants, who'd win 101 games and their third straight N.L. crown that season.

All that success had Seaton convinced he was in line for a fatter paycheck. When the Phillies front office offered him a modest increase to $3,500 anually, he went looking elsewhere. The newly formed Federal League was dangling big contracts to the league's best players. Seaton used his leverage to obtain a three-year deal for $8,000 a season from the Brooklyn franchise, making him one of the highest paid players in the new league. He also extracted some additional perks, including the team paying all road expenses for his wife to travel with him during the season, a private suite of rooms on the road and a seperate sitting area on the team's Pullman car for overnight train trips.

Seaton delivered another superb season in 1914, winning 25 games and throwing seven shutouts for a Brooklyn team that was barely a .500 club. But in 1915, he was just 12-11 by August and Brooklyn traded him to Newark. The next year, when the Federal League disbanded, Seaton found himself back in the National League, this time with the Cubs. But his arm could no longer handle the workload and Seaton was a modest 11-10 over the next two years for Chicago. By 1918, he was back in the Pacific Coast League, but was permanently barred from the league in 1920 for suspicion of gambling.

Seaton retired to El Paso and worked in a smelting plant until his death in 1940.

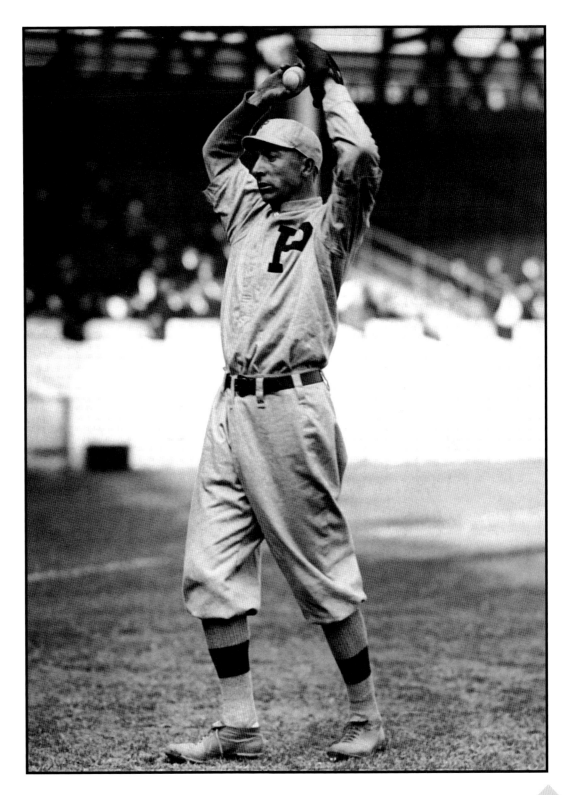

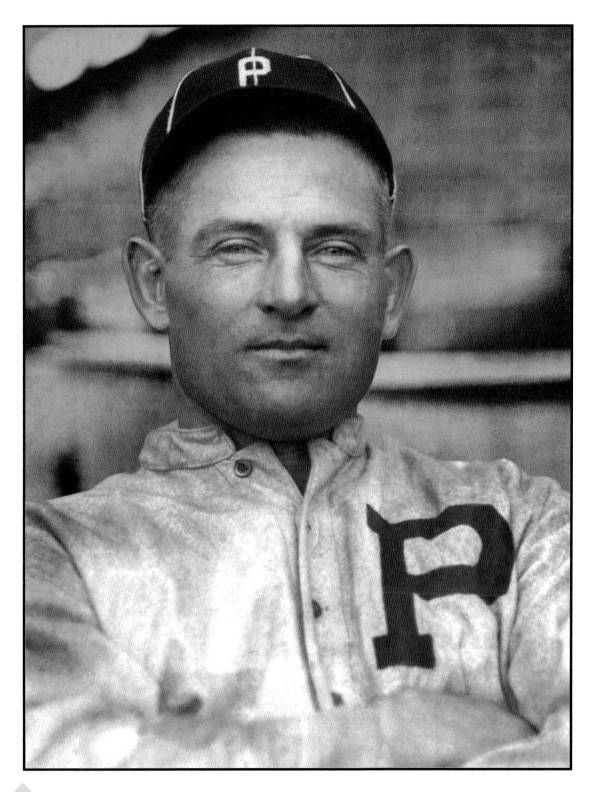

Clifford "Gavvy" Cravath
Outfielder, 1912 - 1920
Manager, 1919 - 1920

Gavvy Cravath led the National League in home runs six times and was the game's premier slugger during the "Deadball Era". At a time when pitchers routinely threw an assortment of trick pitches, including the spitball, and the game was often played with a single mis-shapen ball for all nine innings, hitting the ball for distance was a real challenge. Cravath excelled at it like no other player of his era.

Cravath was already 31 when he joined the Phillies in 1912. He soon replaced veteran John Titus as the team's everyday right-fielder. In 1913, Cravath batted .341 and led the National league in hits, home runs and RBI. His 19 round-trippers led both leagues and were more than the total of five other teams. His 128 RBI were a career-best as no other player in the N.L. had more than 95 that season.

In 1915, Cravath helped power the Phillies to their first pennant by hitting 24 homers and driving in a league-best 115 runs. At the time it was the most home runs in a single season by any player in the 20th Century until broken by Babe Ruth in 1919. But in the 1915 World Series against the Boston Red Sox, Cravath was held to a double and a triple in 16 at-bats.

Beginning in 1917, Cravath again led the National League in home runs for three straight seasons. In 1919, he took over as the Phillies' manager in mid-season but the team's depleted roster led to two straight last-place finishes and Cravath was let go after the 1920 season. After two more seasons as a player/manager back in the minors, Cravath retired to his native California where he invested in real estate and later served as a city judge in Laguna Beach for over 35 years.

William F. Baker
Owner, 1913 - 1930

William F. Baker's ownership of the Phillies was marked by the club's first championship and a steep, steady decline into mediocrity. Baker was a former New York city police commissioner who joined a group of other investors in buying the Phillies franchise in 1913. When Baker's cousin, the club's largest stockholder, died suddenly, Baker assumed control as team President.

Initially, the team's on-field performance, led by pitching ace Grover Cleveland Alexander, produced a second-place finish in 1913. It was the Phillies' best showing in over a decade. But when the ball club fell all the way to sixth place the next year, Baker quickly fired manager Red Dooin and went along with the players' demand to promote coach Pat Moran to take his place. Moran re-tooled the Phillies roster and produced a championship team that won 90 games for the first time in the 20th Century. The club's winning ways also provided a huge increase in attendance, with the Phillies drawing more than 500,000 fans to the Baker Bowl in 1916 for the first time in their history.

But the Phillies new found success was quickly squandered by Baker. Following the 1917 season, when the Phillies again finished in second place, Baker suddenly dealt his 30-game winner Alexander to the Chicago Cubs for two players and $55,000. With World War I raging in Europe, Baker was convinced that Alexander would be called into military service and be lost to the Phillies for the duration of the conflict. In fact, Alexander pitched just three games for the Cubs in 1918 before leaving for Europe. Meanwhile, the Phillies promptly dropped to sixth place as attendance plummeted.

As fans stayed away, Baker was ridiculed in the press for making a series of one-sided trades. In 1920, he sold shortstop Dave Bancroft to the Giants for $100,000 and in 1921, he sent pitcher Eppa Rixey to the Reds, where he quickly developed into a consistent winner. The Baker Bowl, the Phillies' home field for over 35 years by the early 1920's, was a decrepit relic of a bygone era and constantly in need of repairs. Money was so tight, that during the early 1920's the club's groundskeeper kept two goats under the centerfield bleachers to help keep the field manicured. In 1927, two sections of the first base grandstand collapsed, injuring 50 fans.

By 1930, rumors of the club's impending sale filled the local sports pages. Baker denied the club was for sale, but that December, he died suddenly at age 64 while in Montreal to attend the league's annual meetings. William Baker's tenure as Phillies owner set the stage for another 15 years of disappointment.

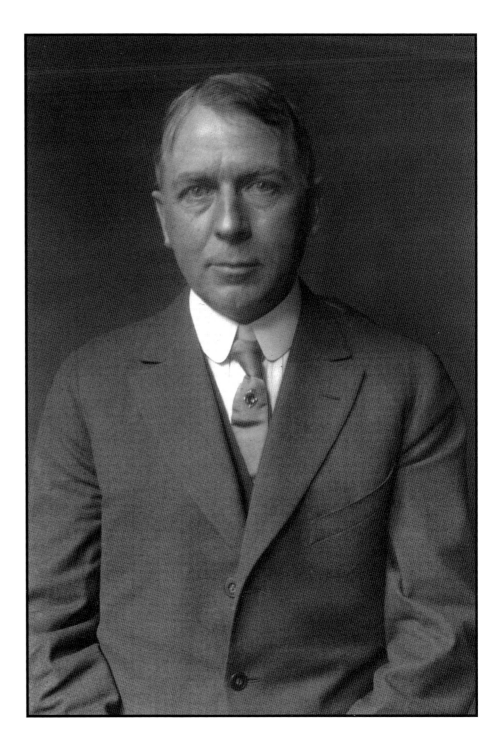

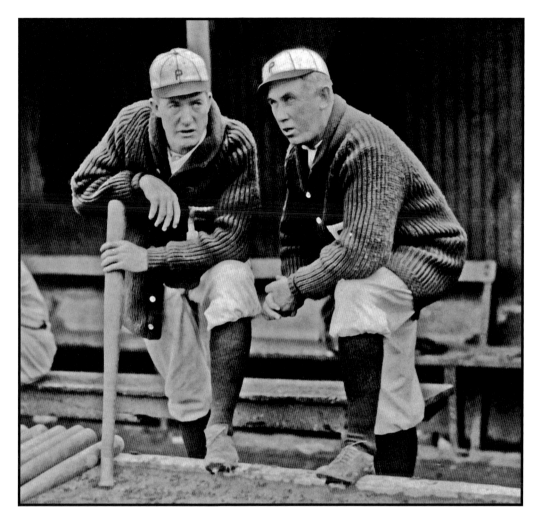

Grover Cleveland Alexander and Pat Moran
Baker Bowl, 1915

Phillies fans had little reason to be optimistic going into the 1915 season. The ball club had finished a disappointing sixth in 1914 and fan favorite Sherry Magee had been traded to the Boston Braves after leading the National League in hits, doubles and RBI. To make matters worse, the Phillie pitching staff's ERA in 1914 was the second worst in the major leagues. And finally, the team's new manager had never run a ball club at any professional level.

But the Phillies surprised everyone by opening the season with eight straight wins. More impressively, they did it against the Boston Braves and New York Giants, the teams that had finished 1-2 in the standings the season before. The Phillies' pitching staff sent the other seven teams a clear message by allowing a total of 10 runs in the first eight games.

But the team's eventual success was a shared effort. Staff ace Alexander had a phenomenal season winning 31 games and leading the N.L. in ERA, strikeouts and shutouts. Erskine Mayer won 21 games for the second straight season and newcomer Al Demaree posted 14 victories. The Phillies pitchers captured the league ERA crown and threw more shutouts and complete games than any other staff in the National League. For good measure, the Phillies also led the league in home runs and were second in slugging percentage.

With this kind of balanced attack, it was no surprise that the Phillies led the standings for most of the season, falling into second place only briefly behind the Cubs in June. By mid-July, the Phillies were back atop the standings and were never seriously challenged over the remainder of the season. They won 90 games and finished in front of the Boston Braves by seven games.

The Boston Red Sox, winners of 101 games in the American League that year, were up next.

Al Demaree
Pitcher, 1915 - 1916

Righty Al Demaree's time with the Phillies was short, but his arrival coincided with the Phillies' first N.L. pennant. Demaree had already spent three seasons with the New York Giants prior to joining Philadelphia. New manager Pat Moran was determined to overhaul the Phillies roster and Demaree was one of several key players he brought in. The Phillies traded veteran third baseman Hans Lobert to the Giants for Demaree and two other players.

In his first action of the 1915 season, Demaree shut out the Giants 3-0. But Phillies fans were quickly questioning the deal when Demaree lost his next six starts, several by lopsided scores. Phillies manager Pat Moran pulled Demaree from the rotation and put him in the bullpen in an effort to get him turned around. In early July, Demaree got another chance. Facing the Giants, he again held them scoreless, this time 1-0. He won five of his next six and in mid-August, threw his third shutout of the season, beating Boston 9-0. Demaree finished up 14-11 but spent the World Series on the bench.

1916 would be the best year of Demaree's major league career. He began by beating his old team, the Giants, in his first two starts. Demaree clearly relished facing his former mates as he beat them six times in eights starts that year. In September, Demaree pitched both games of a doubleheader against the Pirates, winning 7-0 and 3-2. He wound up with a record of 19-14 as the Phillies finished second, 2 1/2 games behind the Brooklyn Dodgers.

Despite his contributions to consecutive winning seasons, the Phillies traded Demaree to the Chicago Cubs that off-season. The Phillies must have sensed his best days were behind him as Demaree was a combined 23-26 for three different teams over the next three seasons.

Demaree retired after the 1919 season and began work as a syndicated sports cartoonist. His work appeared regularly in *The Sporting News* and over 200 daily papers for the next 30 years.

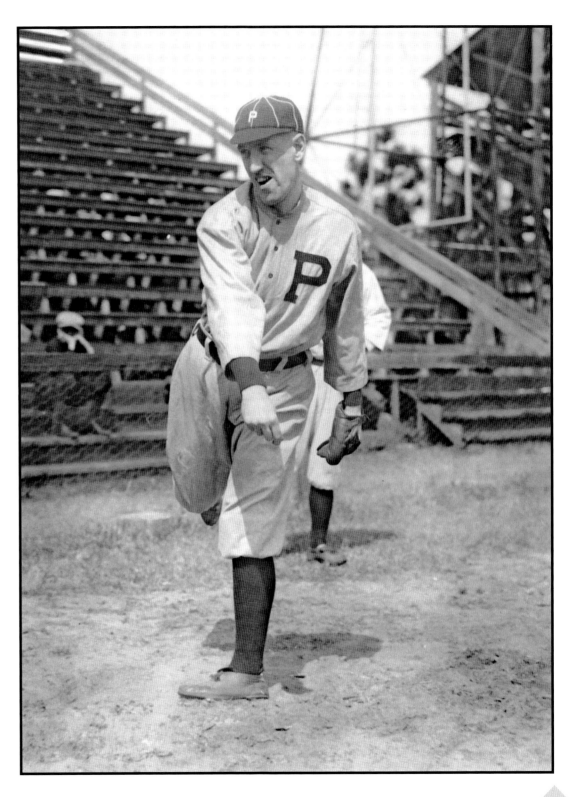

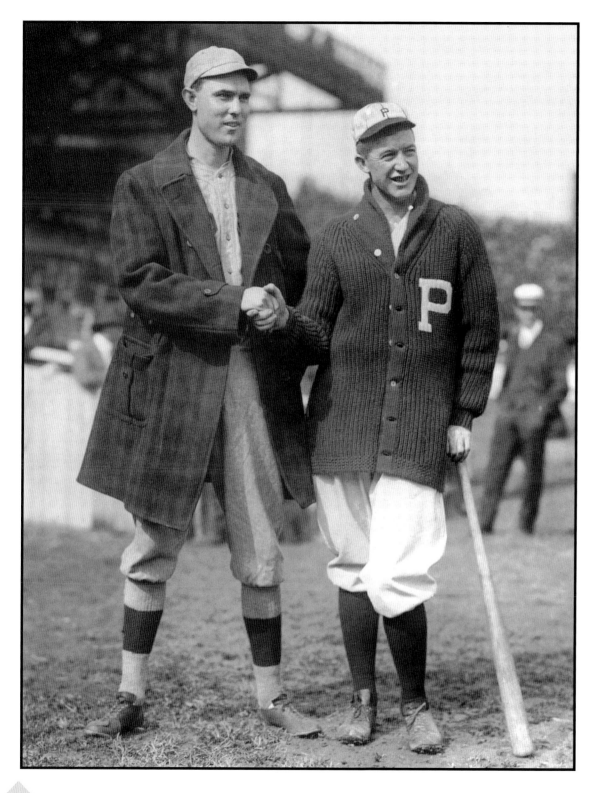

Ernie Shore and Grover C. Alexander
World Series, 1915

Prior to Game 1 of the 1915 World Series at the Baker Bowl, the starting pitchers for both ball clubs posed for the photographers. Boston's Ernie Shore had won 19 games and posted the third-lowest ERA in the American League that season. Alexander had just finished the best season of his young career, winning 31 games and throwing 12 shutouts.

The pitching match up more than lived up to its billing. Shore held the Phillies to just five hits and Alexander didn't allow the Red Sox a run until the top of the eighth. But the Phillies scored twice in the bottom of the eighth to win 3-1.

In a series dominated by superb starting pitching, the next three games would all be decided by the identical score of 2-1.

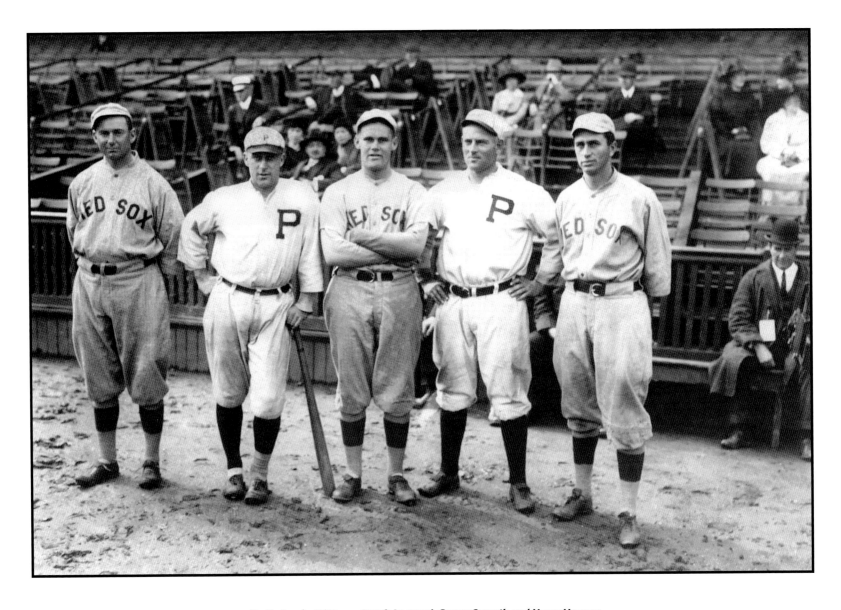

Duffy Lewis, Ed Burns, Dutch Leonard, Gavvy Cravath and Harry Hooper
World Series, 1915

Prior to Game 2 of the 1915 World Series at the Baker Bowl, a wire service photographer gathered together five of the participants who all hailed from California for a portrait.

Red Sox outfielder Duffy Lewis would be the hitting star for Boston, going eight for 18 with a home run and five RBI. Pitcher Dutch Leonard would win Game 3 back in Boston by out-dueling Alexander 2-1. Leonard held the Phillies to three hits and retired the final 20 batters he faced. Outfielder Harry Hooper hit .350 and banged out two home runs in Game 5, the second coming in the ninth to win the game and give Boston the championship.

For their part, the Phillies and Gavvy Cravath couldn't solve the Red Sox pitchers, who limited Philadelphia hitters to a .182 average. The Red Sox also out-hit the Phillies 42-27 and got the key hits when it mattered. Phillies fans had no way of knowing it would be another 35 years before they hosted their second World Series.

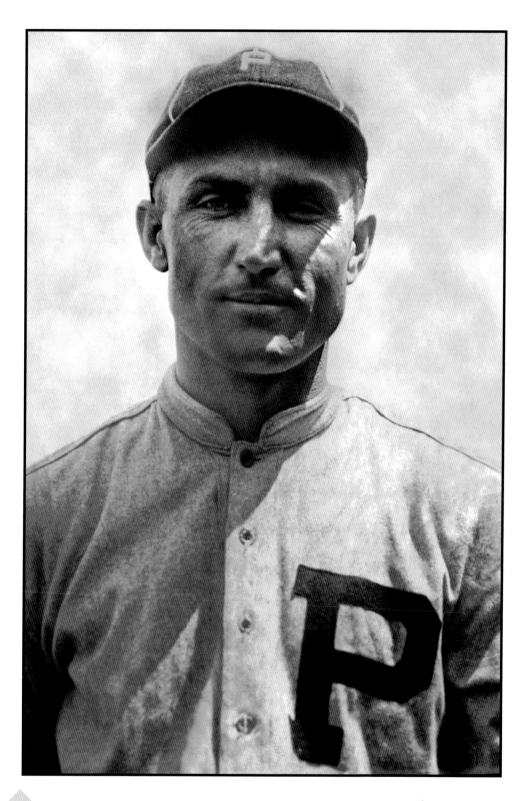

Dave Bancroft
Shortstop, 1915 - 1920

Dave Bancroft was a shortstop with great range and soft hands whose time in Philadelphia was cut short. Bancroft was playing with Portand in the Pacific Coast League when the Phillies purchased his contract. Veteran shortstop Mickey Doolan's departure for the Federal League in 1914 had left the Phillies without a suitable replacement. Critics said that the young Bancroft's bat was weak and he'd never handle major league pitching. But the Phillies new manager, Pat Moran, knew he needed a solid defender for the middle of his infield to help out his pitching staff.

While with the Phillies, the switch-hitting Bancroft was never a big offensive threat, but his glove work in the field drew rave reviews from fans and foes alike. Beginning in 1916, Bancroft led all National League shortstops in total chances for three straight years.

In 1919, after four solid seasons anchoring the middle of the Phillies infield, Bacnroft was sent a contract calling for a pay cut. His response was to ask for a trade to another club. One year later, he got his wish, as Bancroft was sent to the New York Giants for aging shortstop Art Fletcher, a young pitcher named Bill Hubbell and a reported $100,000. The cash may have helped the Phillies pay their bills, but it proved an awful deal.

For his part, Bancroft set about quickly reminding distraught Phillies fans of his worth. Just three weeks after the trade, Bancroft returned to Philadelphia with the Giants and went six for six at the plate. Worse yet, Fletcher was already 35 and would play only one more season in the majors before turning to managing. Hubbell lost constantly and was 27-55 in five-plus seasons with the Phillies.

In New York, Bancroft joined a veteran ball club that won three straight National League flags beginning in 1921. Playing on a winning team certainly agreed with Bancroft as he had the three finest offensive seasons of his career. In 1922, he hit .321 with 209 hits and scored 117 runs.

However, by 1924, Bancroft was on the move again, this time to the Boston Braves as player/manager. But unlike the Giants, the Braves were a terrible team and there was little Bancroft could do. Four straight losing seasons got him fired following the 1927 season. At age 37, Bancroft could still play and he put in two more years with Brooklyn before returning to the Giants as a coach for the next three years. Bancroft managed in the minors briefly and was elected to the Hall of Fame in 1971.

Grover Cleveland Alexander
The Polo Grounds

By 1916, Grover Cleveland Alexander had already won 127 games in his first five seasons with the Phillies. His 1915 season had been his best yet, as he won 31 games, threw 12 shutouts and had four one-hitters. It was hard for anyone to believe that he could improve on any of those numbers. Yet, in 1916, Alexander would set a record that will almost certainly never be equaled.

In 1916, as he did the year before, Alexander led all National League pitchers in almost every statistical category. He ranked first in wins(33), ERA(1.55), complete games(38), strikeouts(167) and innings pitched(388). But the one achievement that stood above all the others was his 16 shutouts.

Alexander proved an equal opportunity offender, blanking every team in the N.L. at least once. More impressively, he was at his best against the best, shutting out the eventual champions, Brooklyn, twice and third-place Boston three times. Down the stretch, in the heat of a tight pennant race, he was masterful. On September 23, with the Phillies only two games behind first-place Brooklyn, Alexander pitched both games of a doubleheader against Cincinnati. He won the first 7-3 and the second 4-0. Five days later, he beat Brooklyn and in his final start of the season, he shut out Boston 2-0. But Alexander's efforts alone could not will the Phillies to a second consecutive pennant as they came up just short.

It is important to note that Alexander also had to contend with pitching in one of the most hitter-friendly ballparks in either league. The right field wall at the Baker Bowl in 1916 was a miniscule 272 feet from home plate. Despite a 40-foot high tin wall above, the dimensions meant that the batters were 38 feet closer than today's hitters are to Fenway Park's fabled "Green Monster", considered close in at 310 feet. Additionally, league rules then allowed that balls which bounced into the stands were counted as home runs. The left field wall at the Baker Bowl, although 335 feet from home plate, was only three feet high. In spite of all this, Alexander threw nine of his 16 shutouts at the Baker Bowl.

When you recall the greatest single seasons by a pitcher in recent memory, you realize how far beyond them Alexander's 16 shutouts puts him. Even Bob Gibson's 13 in 1968, Sandy Koufax's 11 in 1963 or Jim Palmer's 10 in 1975 fall short of Alexander's mark. With relief pitchers making complete games almost extinct and modern day starting pitchers averaging around 35 starts a season, Alexander's mark seems destined to live forever.

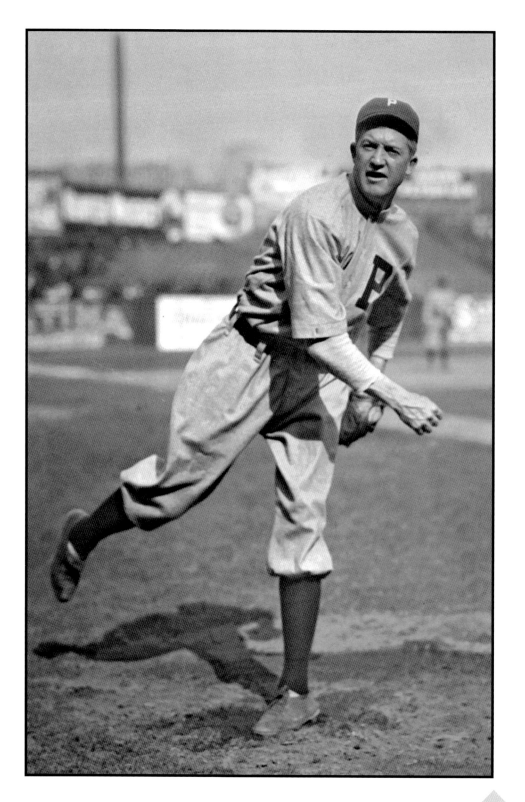

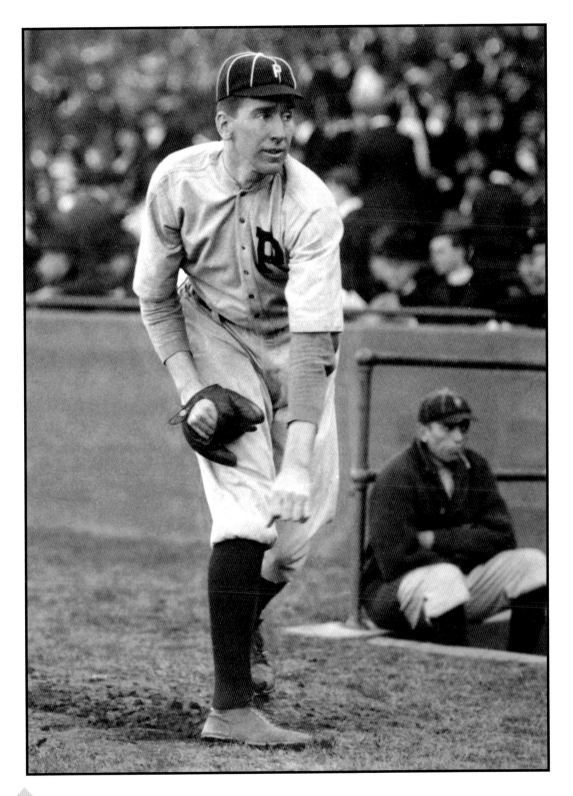

Eppa Rixey

In 1916, Eppa Rixey finally put together a break-out season, winning 22 games for the Phillies. Rixey struck out a career-high 134 batters and his ERA of 1.85 was the third lowest in the National League.

However, 1917 would see a complete reversal of Rixey's pitching fortunes. His 16-21 record, including four shutouts, was due primarily to poor run support. For example, in 12 of his 21 losses, the Phillies scored one run or less. It got so bad during one stretch that Rixey lost five straight starts during which the Phillies offense scored a total of three runs.

Like hundreds of other major leaguers, Rixey spent the 1918 season in Europe, where he served in the Army's Chemical Warfare unit. Some reports say he was gassed. What is certain is that Rixey was late returning to the Phillies and didn't make his first start until mid-June. He promptly lost his first four starts and struggled to a 6-12 record.

In 1920, Rixey's 22 losses led the National League for the second time in four seasons. Despite completing 25 of his 33 starts, Rixey again had little support. The Phillies scored one run or less in 11 of his 22 defeats. That off-season, the Phillies front office decided they had seen enough and traded Rixey to Cincinnati, where former Phillies manager Pat Moran was now the manager of the Reds. Moran was sure he could get Rixey turned around. The trade proved to be a terrible miscalculation for the Phillies.

Being reunited with his former mentor in Cincinnati revitalized Rixey's career. He quickly developed into the workhorse of the Reds pitching staff, throwing more than 300 innings for three straight years, a feat he had never accomplished even once with the Phillies. Better yet, his 25 victories in 1922 were tops in the National League. Rixey then proceeded to win 20 or more games in two of the next three seasons.

Rixey continued pitching for the Reds until 1933. When he finally retired at age 42, Rixey's 266 career wins stood as the record for a left-hander until Warren Spahn eclipsed the mark in 1959.

Rixey was elected to the Hall of Fame in 1963 and died one month later before he could attend the ceremonies in Cooperstown.

Grover Cleveland Alexander
1917

When the 1917 season began, there was no way for Phillies fans to imagine that it would soon mark the end of an era. With a National League pennant in 1915 and a second-place finish the following season, the ballclub was finally among the N.L.'s elite teams.

In 1917, the Phillies would again finish in second place, largely due to the efforts of their ace, Grover Cleveland Alexander. He was a 30-game winner for the third straight year and won his fourth consecutive strikeout crown. Alexander also led the league in ERA and innings pitched and showed his durability by, once again, winning both games of a doubleheader against Brooklyn in September.

That off-season, Phillies owner, William F. Baker, always short of cash, decided to ship Alexander and catcher Bill Killefer to the Chicago Cubs for $55,000 rather than risk losing him to the uncertainty of military service in World War I. It was a gamble the Cubs were obviously willing to take to acquire the National League's best pitcher.

During his eight-plus seasons with the Cubs, Alexander twice won more than 20 games. His 27 wins and 1.91 ERA in 1920 were both the best among National League pitchers and he once again led the league in innings pitched, complete games and strikeouts.

In 1926, Alexander, now 39, was traded to the St. Louis Cardinals. In that Fall's World Series against the New York Yankees, Alexander helped propel St. Louis to its' first championship. He posted complete-game victories in Games 2 and 6. But Alexander's lasting fame came the next day in Game 7 where he helped preserve a 3-2 win by throwing two-plus innings of relief to close out the Series for St. Louis. His strikeout of Yankees hitter Tony Lazzeri with the bases loaded in the seventh inning became the stuff of legend. The next season, Alexander showed doubters that he was still a force on the mound by winning 21 games for the Cardinals.

In 1930, Alexander returned to the Phillies briefly, but he was unable to finish any of his three starts and at age 43, he retired.

He soon began drifting around the country picking up a paycheck wherever he could, mostly by pitching for barnstorming and semi-pro teams. However, in 1939, he was discovered by a sportswriter working for a side-show near Times Square in New York. Later that same year, Alexander was among the first group of inductees into the newly-opened Hall of Fame in Cooperstown. His final years were spent in poverty, living off a monthly $100 check that came from the National League offices. Alexander died back in his native Nebraska in 1950.

Alexander's 373 career wins leave him third on the all-time list and his 90 career shutouts rank second behind only Walter Johnson.

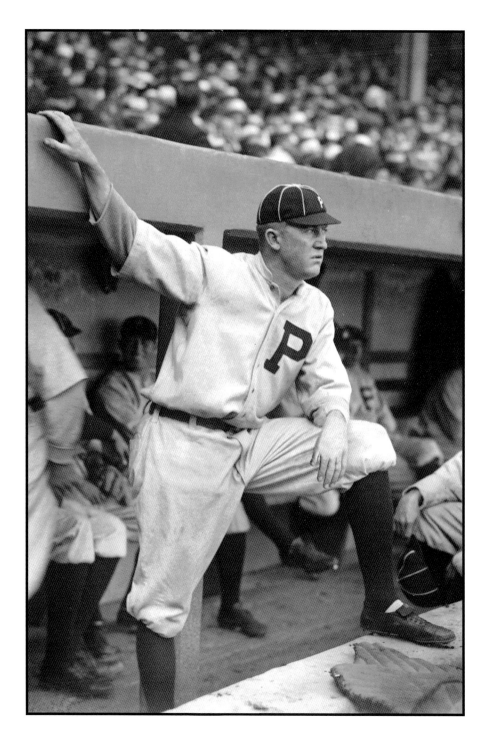

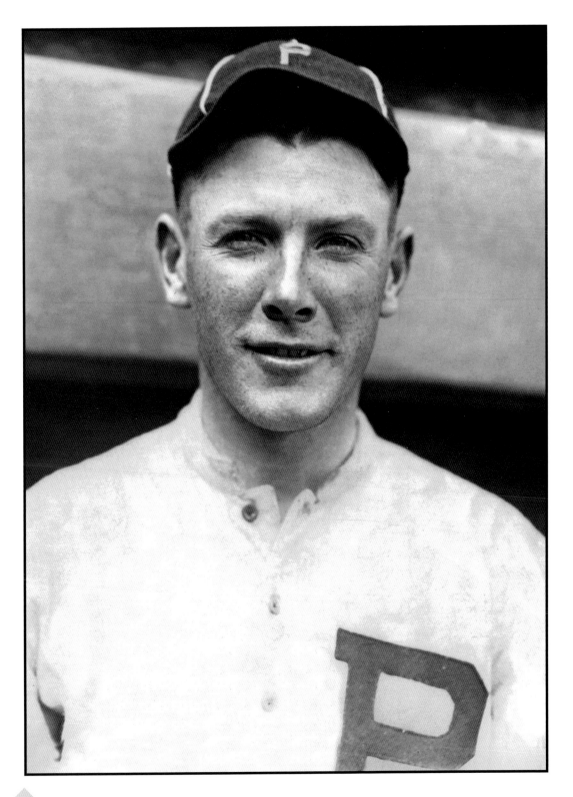

Emil "Irish" Meusel
Outfielder, 1918 - 1921

Irish Meusel was a hard-hitting outfielder who enjoyed his most productive seasons in the majors after he left Philadelphia. Meusel, whose younger brother Bob spent over a decade patrolling the outfield for the Yankees, joined the Phillies in 1918 after hitting .311 for Los Angeles in the Pacific Coast League.

As a rookie, he hit .279 and stole 18 bases. From there it only got better as Meusel raised his batting average each of the next three seasons. In 1920, he hit .309 and his 14 home runs and 69 RBI were the second most on the Phillies, who finished last that year in the National League.

In 1921, Meusel got off to a terrific start and by late July he was hitting .353. But owner William Baker stunned Phillies fans and the local press by suddenly dealing Meusel to the New York Giants for three players and $30,000. In a pattern that became all too common, it was another example of the Phillies front office selling off its' best players to help pay the bills.

In New York, Meusel joined one of the National League's most talented clubs and he quickly became its' chief run producer. In 1922, Meusel knocked in 132 runs which was the second-highest total in the National League. When the Giants defeated the New York Yankees in consecutive World Series in both 1921 and 1922, Meusel knocked in seven runs in each series, the most by any player on either team. In 1923, he led the National League with 125 RBI. It's probably no coincidence that Meusel's first four seasons with the Giants resulted in four straight N.L. pennants from 1921 to 1924.

In 1925, he hit .328 and was the only Giants player with more than 20 home runs and more than 100 RBI. But the following year would be Meusel's last in the big leagues as an everyday player. He was released by the Giants and played 42 games for Brooklyn in 1926 before retiring to the minor leagues.

Meusel returned to his native California and later worked as a gate guard at several horse racing tracks prior to his death in 1963.

Fred "Cy" Williams
Outfielder, 1918 - 1930

Cy Williams was dubbed "the Babe Ruth of the National League" by sportswriters because of his penchant for hitting home runs. During the decade of the 1920's, Williams hit 202 home runs. Among National League batters, only Rogers Hornsby hit more during that same time period.

Williams didn't join the Phillies until he was already 30 years old. He was originally signed by the Chicago Cubs while still a student at Notre Dame and in 1912, he bypassed the minor leagues and went straight to the Cubs. There, he spent most of his first three seasons riding the bench. As Williams' playing time gradually increased, so did his hitting. In 1916, his 12 home runs led the National League, but when his numbers fell off dramatically the next season, he was dealt to the Phillies.

The move jump-started Williams' career as his left-handed swing was perfectly tailored to the Baker Bowl's short right field fence. Hall of Fame manager Bill McKechnie recalled Williams as "the most consistent dead right-field hitter I ever saw. I can't remember ever seeing him hit to left unless it was by accident." Williams himself echoed those sentiments recalling, "I couldn't hit a ball to left if my life depended on it."

As a result, opposing mangers began shifting their defenders to the right side of the diamond in an effort to cut down on Williams' effectiveness. The strategy became known as the "Williams shift" and would be replicated 3 decades later for another hitter named Williams when he played for the Boston Red Sox.

Back in Philadelphia, the shift had little effect as Williams, beginning in 1920, hit at least .320 in four of the next six seasons. On a Phillies team that regularly ranked near the bottom of the National League in scoring runs, Williams was, for many years, the team's lone offensive weapon.

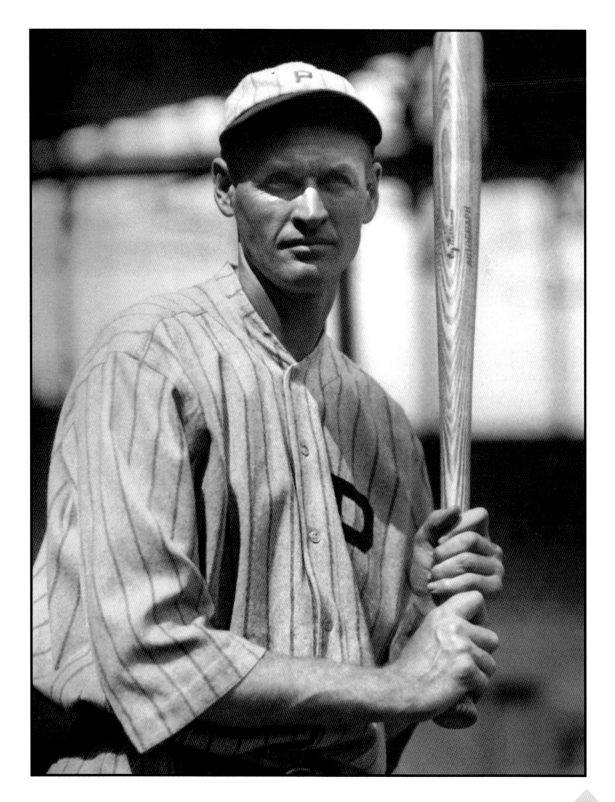

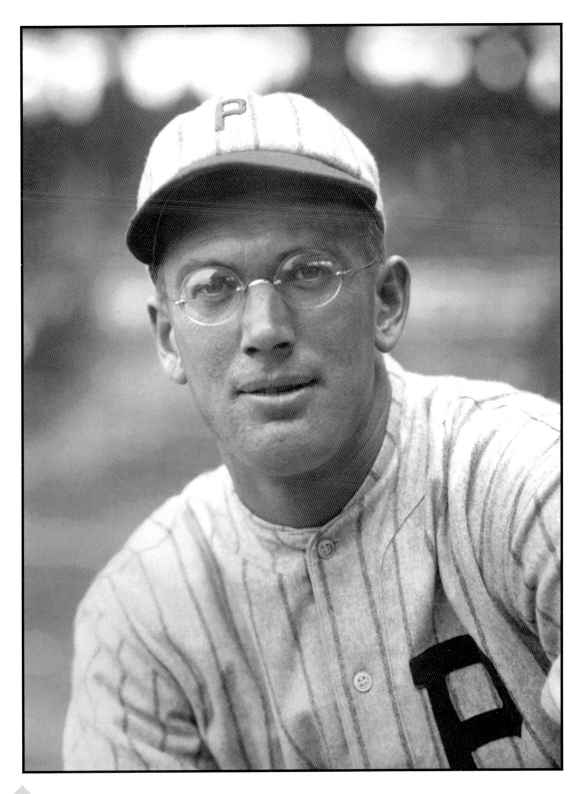

Lee "Specs" Meadows
Pitcher, 1919 - 1923

Lee Meadows was the first ballplayer in the 20th Century to take the field wearing eyeglasses. At the time, this was considered a real novelty. Opposing hitters feared for their safety and sportswriters of the day wondered how Meadows could even locate home plate.

Meadows joined the St. Louis Cardinals in 1915 following two winning seasons in the minors. Originally a spitball pitcher, Meadows was traded to the Phillies midway through the 1919 season.

In 1920, Meadows won eight of his first 10 starts, before struggling to end up at 16-14 for Philadelphia, He did manage to throw three shutouts, including blanking Grover Cleveland Alexander and the Cubs 3-0 in August. However, when the Cleveland Indians' Ray Chapman was struck and killed by an errant pitch that season, the major leagues outlawed the spitball. Although the rule was later amended to allow pitchers like Meadows who had previously thrown the pitch to continue, Meadows never went back to it. Instead, he developed an off-speed pitch which soon became his primary weapon.

But Meadows posted two consecutive losing seasons for the Phillies and early in 1923, he was sent to the Pirates for two players and $50,000. In Pittsburgh, backed by a much stronger team, Meadows flourished, enjoying the three best years of his career. In 1925, he won 19 games as the Pirates won the National League pennant. The next season, he was 20-9 to lead the league in wins. And when Pittsburgh returned to the World Series in 1927, Meadows posted another 19 victories.

By 1929, he was 34 and back in the minor leagues. After pitching for another three seasons, Meadows retired and began working for the Internal Revenue Service, where he remained for nearly 20 years.

Jimmy Ring
Pitcher, 1921 - 1925; 1928

Jimmy Ring was a fire-balling right-hander who often had trouble finding home plate. While with the Phillies, he led the National League in walks four straight years.

Ring began his time in the big leagues with the Cincinnati Reds in 1917, where his manager was pitching great Christy Mathewson. Ring told reporters, "Scouts and others told me I had plenty of stuff, but that was all I had. What handicapped me more than anything else was that I did not have a curveball. When the fast one failed, I was gone. Matty diagnosed my case in about five minutes and began to teach me how to throw a curve. He showed me the proper grip and made me practice until I was blue in the face." Initially, all that instruction paid off.

In 1918, Ring was 9-5 for the Reds and threw four shutouts. The next season, Ring won 10 games for Cincinnati as they won the National League pennant. In the World Series against the White Sox, Ring won Game 4, 2-0 but gave up the winning run in the tenth inning of Game 6. In 1920, Ring threw almost 300 innings and won 17 games for the Reds.

Following the 1920 season, Ring was traded to the Phillies in the deal for pitcher Eppa Rixey. Unfortunately, Rings' five years in Philadelphia would include only one winning season. He proved maddeningly inconsistent. His manager, Art Fletcher summed it up best by saying "One day he is good and another day he is not." The only thing he did with regularity was walk opposing hitters. Beginning in 1922, Ring led all National League hurlers in free passes for four straight seasons.

In 1921, Ring was 10-19 on a Phillies staff where no pitcher won more than 11 games. The following year, he posted a 12-18 record. In 1923, Ring was 18-16 for the Phillies, but even during his only winning season in Philadelphia, he was far from overpowering. In eight of his victories, Ring allowed at least four runs. He also weakened noticeably down the stretch, losing nine of his last 11 starts. However, on a Phillies team that was 50-104 and finished last, Ring was the only starter with a winning record.

Ring was traded to the New York Giants following the 1925 season. There, he was 11-10 for the fifth-place Giants before getting dealt again, this time to the St. Louis Cardinals. He was winless in three starts for St. Louis before returning to the Phillies for his final season in the majors in 1928. A dismal 4-17 record got him released at age 33. Ring never pitched in the majors again.

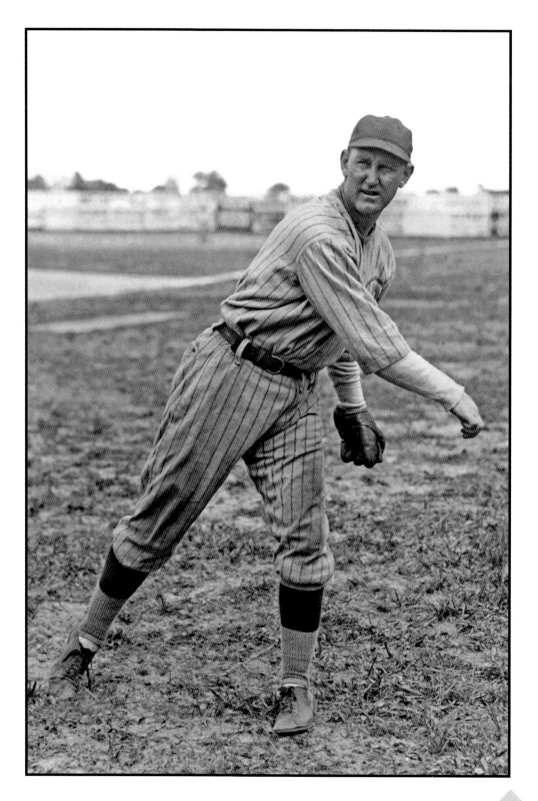

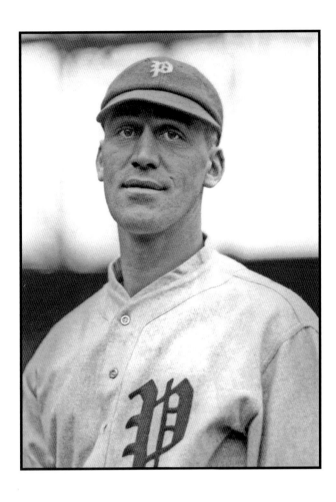

Russ Wrightstone
Infielder, 1920 - 1928

Russ Wrightstone's bat, and not his glove, kept him on the Phillies roster for eight-plus seasons. The Phillies teams of the 1920's were dreadful and talent of any kind was in short supply. A player like Wrightstone, who could routinely hit over .300 and play several positions, was a valuable asset.

However, Wrightstone was a mediocre fielder and, as a result, never played in more than 120 games during any of his eight full seasons with the Phillies. Various managers kept shifting him around the infield in an effort to keep his bat in the lineup. Wrightstone's best season was 1925, when he hit .346 and belted 14 home runs. In 1926, in a game against Pittsburgh, he drove in six runs with two doubles, a triple and a home run.

Early in 1928, the Phillies shipped Wrightstone to the New York Giants, where he finished out the season as the team's primary pinch-hitter. It was also his final season in the major leagues.

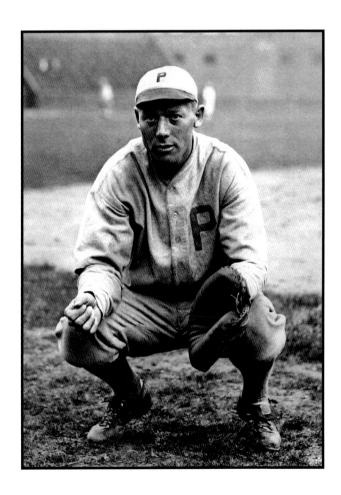

Walter "Butch" Henline
Catcher, 1921 - 1926

Butch Henline was a good-hitting catcher who later became a National League umpire. Henline was one of three players the Phillies got in the deal that sent outfielder Irish Meusel to the Giants. When Henline hit .306 for the Phillies over the second half of the 1921 season, he was given the everyday catcher's job.

His first full season with Philadelphia was his best. Henline hit .316 and added 14 home runs and 64 RBI. During a game against the Cardinals, Henline became the first Phillie in the 20th Century to hit three home runs in one game. In addition, he led all National League catchers in fielding percentage. In 1923, Henline hit .324, the second-highest batting average among N.L. catchers.

But the arrival of rookie catcher Jimmie Wilson soon cut into Henline's playing time. Just before the start of the 1927 season, the Phillies traded Henline to the Brooklyn Dodgers and made Wilson their regular catcher. With Brooklyn, Henline was strictly a back-up.

In 1930, Henline was traded to the Chicago White Sox, where he played sparingly for two seasons before being released. In 1936, he began umpiring in the minor leagues and in 1944 Henline was promoted to the National League. His four seasons in the N.L. were followed by another six umpiring back in the minors.

Freddy Leach
Outfielder, 1923 - 1928

Freddy Leach was a strong-armed outfielder who hit over .300 for four straight years with the Phillies. Despite joining the Phillies in 1923, Leach was quickly sent back to the minor leagues for more seasoning and didn't become an everyday player until 1926, when he hit .329. Stationed in left field at the Baker Bowl, Leach's reputation for throwing out advancing base runners spread quickly. In 1927, he led all National League outfielders with 27 assists. The next year, Leach gunned down 29.

Beginning in 1927, Leach had his two most productive seasons at the plate for the Phillies. He hit 12 home runs and knocked in 83 runs in 1927 and followed that up with 96 RBI in 1928. All that offense earned him a ticket out of town.

Following the 1928 season, Leach was traded to the New York Giants for outfielder Lefty O'Doul and $20,000. Leach missed the first two months of the 1929 season with injuries but recovered to hit .327 for the Giants the following season. In 1932, when Leach returned his Giants contract unsigned, the Giants sold him to the Boston Braves.

In Boston, Leach cracked his kneecap midway through the 1932 season and promptly retired to his Idaho farm.

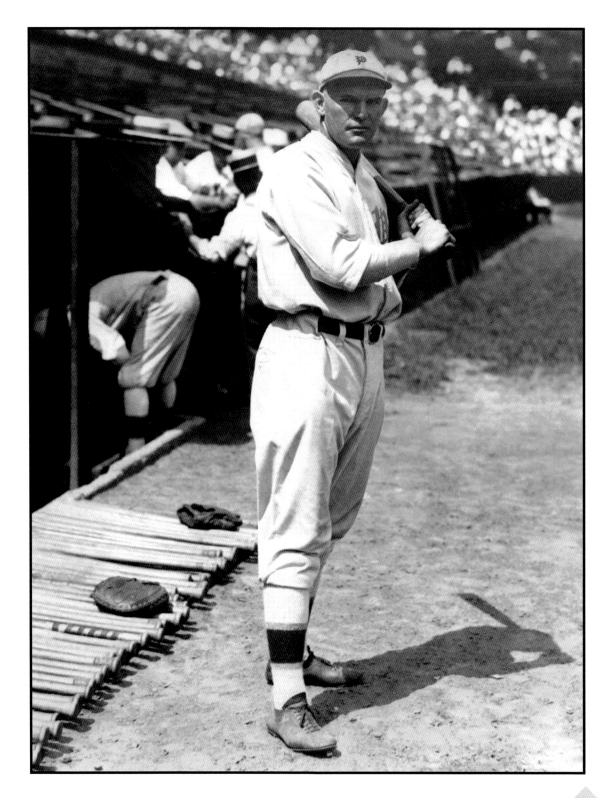

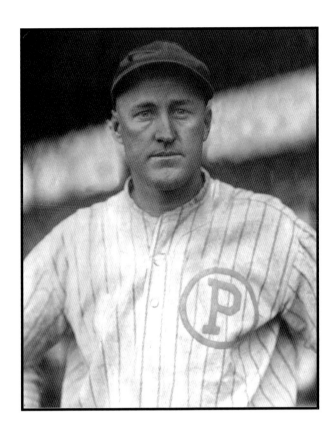

Art Fletcher
Manager, 1923 - 1926

Fiery Art Fletcher spent over a decade as a shortstop in the major leagues with the New York Giants, but his four seasons managing the Phillies were far less rewarding. In 1920, he was traded to Philadelphia and in 1922, at age 37, Fletcher decided to give up playing when he was induced to become manager of the Phillies.

Fletcher inherited a club that had posted five straight losing seasons. Worse yet, it suffered from a distinct lack of talent and even less money. With the Giants, Fletcher was used to playing for a winner and a team that spent money to acquire proven talent. The Phillies, under the direction of owner William F. Baker, did neither of those things. Baker's constant selling off of players to pay the bills really hampered Fletcher's efforts and the duo clashed constantly.

Stuck with mediocre talent, Fletcher tried to get an advantage for the Phillies any way he could. In 1923, he had home plate moved 10 feet closer to the grandstand to lengthen the distance to the Baker Bowl's short right-field wall. That same season, in an effort to boost the confidence of his battered pitching staff, Fletcher had the team's groundskeeper begin storing the baseballs on ice overnight to make them less susceptible to home runs. Neither move had much effect.

In 1925, Fletcher coaxed the Phillies to 68 wins and a sixth-place finish, their best showing since 1918. But the following year, they returned to the bottom of the National League standings and Fletcher was relieved of his duties.

The next season, Fletcher began coaching third base for the New York Yankees, a position he would hold for nearly 20 years.

John "Heinie" Sand
Shortstop, 1923 - 1928

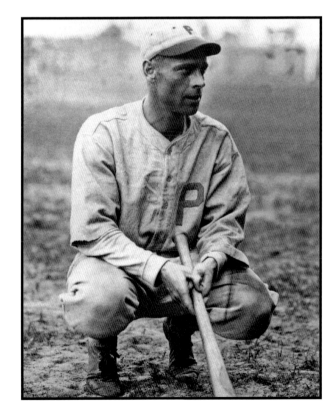

Heinie Sand spent six years as the Phillies' everyday shortstop but is best remembered for his role in exposing a betting scandal.

In 1924, Sand was approached prior to a game by Giants reserve outfielder Jimmy O'Connell and offered $500 if he(Sand) "didn't bear down too hard." The Giants were locked in a tight pennant race with Brooklyn with only three days left in the season, making every game crucial. Sand refused O'Connell's offer and notified his manager, Art Fletcher, that evening back at the team's hotel. In the investigation that followed, O'Connell admitted his guilt and implicated other Giants in the bribe attempt. As a result, O'Connell and Giants coach Cozy Dolan were both permanently banned by Commissioner Landis.

For his part, Sand put in another four seasons as the Phillies' everyday shortstop. Unfortunately, he led all National League shortstops in errors three times. Sand's best year at the plate came in 1927, when he hit .299. But a .211 average the next year got him shipped back to the minor leagues, where he played for another six seasons.

In retirement, Sand worked for a plumbing company in his native San Francisco.

Jimmie Wilson
Catcher, 1923 - 1928
Manager, 1934 - 1938

Jimmie Wilson spent 10 years with his hometown team, as both a catcher and, later, the Phillies' manager. Wilson grew up in the Kensington section of the city, where he excelled at soccer. Convinced to give baseball a try, Wilson was signed by the Phillies after three seasons with New Haven in the Eastern League.

Initially, Wilson shared catching duties with veteran Butch Henline. But Wilson's superior performance at the plate gradually pushed Henline aside. In 1925, Wilson hit .328. In 1926 it was .305. But Wilson's real value was his work behind the plate. Wilson excelled at knowing the weaknesses of opposing hitters and was considered one his era's best signal callers.

Early in 1928, the Phillies suddenly dealt Wilson to the St. Louis Cardinals for another young catcher, Spud Davis. In St. Louis, Wilson had six solid seasons, helping the Cardinals capture three N.L. pennants in four years. In 1929, he hit .325 and drove in a career-high 71 runs. Wilson also proved his worth by helping develop a young Cardinals pitcher named Dizzy Dean.

Following the 1933 season, the Phillies and Cardinals reversed the earlier deal, again swapping Wilson for Spud Davis. Wilson was immediately named player/manager of the Phillies for the 1934 season.

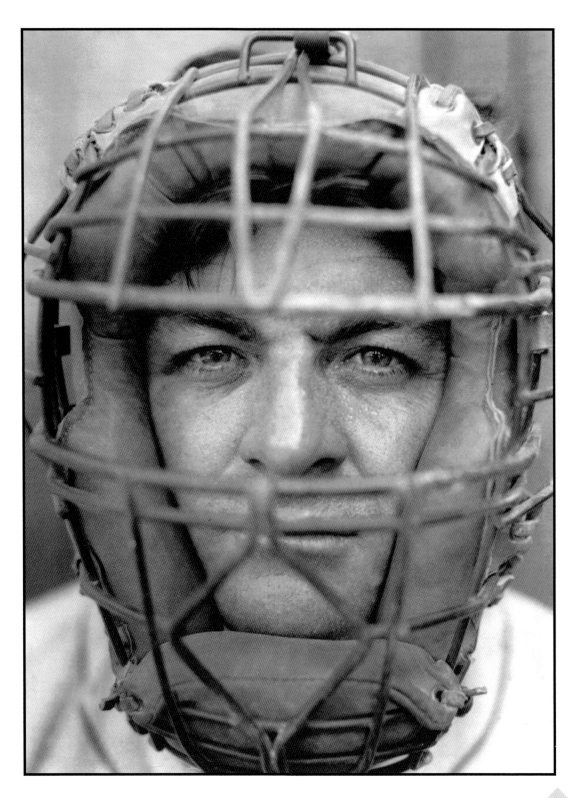

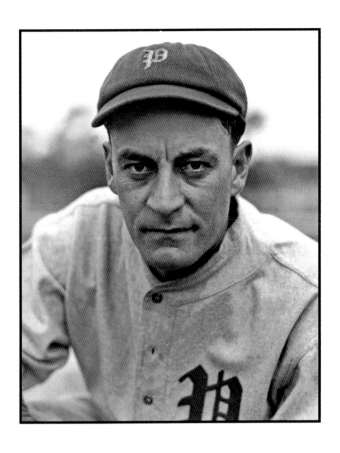

Clarence Mitchell
Pitcher, 1923 - 1928

Lefty Clarence Mitchell spent five-plus seasons pitching for the Phillies and had a winning record only once. In fact, for a guy with his track record of futility it's hard to understand how Mitchell ever managed to last through parts of 18 seasons in the major leagues. Mitchell had only one year where he ever won more than 12 games and then he was a mediocre 13-11 for the 1931 Giants. Perhaps it was his being allowed to continue throwing a spitball long after the pitch had been outlawed by both leagues in 1921.

Ironically, his luck as a hitter wasn't any better. While with Brooklyn in 1920, it was Mitchell who hit into Bill Wambsganss' famous unassisted triple play in the World Series against Cleveland.

During his five full seasons with the Phillies, Mitchell was a combined 40-57. He had only one season where his ERA was under 4.50. It is a mark of how desperate the Phillies were for pitching during the mid-1920's that Mitchell continued to be given a regular starting assignment.

Finally in 1928, the Phillies traded Mitchell to the Cardinals. Despite pitching for a championship team like St. Louis, Mitchell still couldn't manage a winning record in either of his two seasons there. He continued pitching in the majors until the age of 41, then put in one final season in the Pacific Coast League.

In retirement, Mitchell operated a tavern in his native Nebraska.

Claude Willoughby
Pitcher, 1925 -1930

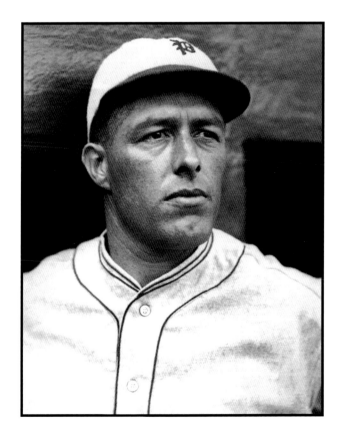

Righty Claude Willoughby's six seasons with the Phillies produced a 38-56 record and mirrored the team's pitching woes. For nine straight seasons, between 1922 and 1930, the Phillies pitching staff had the worst ERA in the major leagues. The Phillies' constant money problems had them depending on untested youngsters like Willoughby and the results were all too predictable.

Willoughby joined the Phillies late in the 1925 season after winning 21 games the season before for a Class D team in Iowa. He made three starts and won two of them. But in 1926, Willoughby demonstrated the folly of handing the ball to such an inexperienced pitcher. Willoughby made 18 starts, won only four of them and often lost by lopsided scores. As a result, he spent most of the next two seasons in the bullpen.

In 1929, Willoughby won the road opener against the Giants 3-1 at the Polo Grounds. He allowed seven hits and loaded the bases four times, but got out of trouble by stranding a total of 20 Giants base runners. That game would prove symptomatic of the entire season as he won 15 games, but still managed to lead the National League in walks. It also proved the highpoint of Willoughby's time in the major leagues.

In 1930, Willoughby won just four of his 24 starts. Worse yet, his ERA ballooned to 7.59 and a 4-17 record got him traded to the Pirates, where he threw just 25 innings before being released. Willoughby never pitched in the majors again.

Fred "Cy" Williams
Baker Bowl, 1926

During the decade of the 1920's, the long-ball theatrics of Phillies slugger Cy Williams was often the only reason to go to the ballpark.

In 1923, during a May game against the Cardinals in St. Louis, Williams hit three home runs. That same month he drove in 44 runs, still the franchise record for a single month. That same season, he became the first Phillie to ever have 40 home runs and 100 RBI in the same year. All this for a last-place team that won a total of 50 games.

In 1926, Williams became the first Phillie to hit a homer in four straight games, a record that stood until Dick Allen hit five straight in 1969. In 1927, he hit for the cycle against the Pirates at Forbes Field. In addition, his 30 home runs that year gave Williams his fourth National League home run crown. Not bad for a player who would turn 40 later that same year.

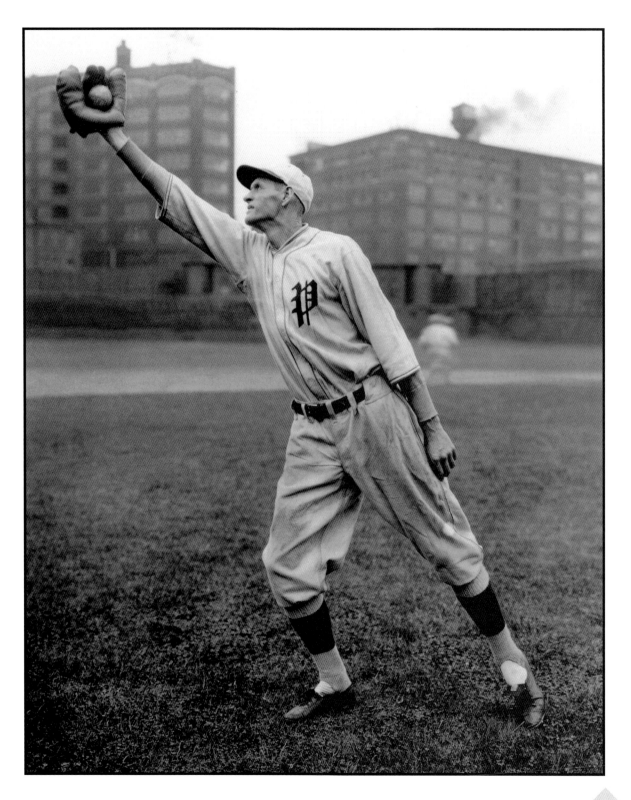

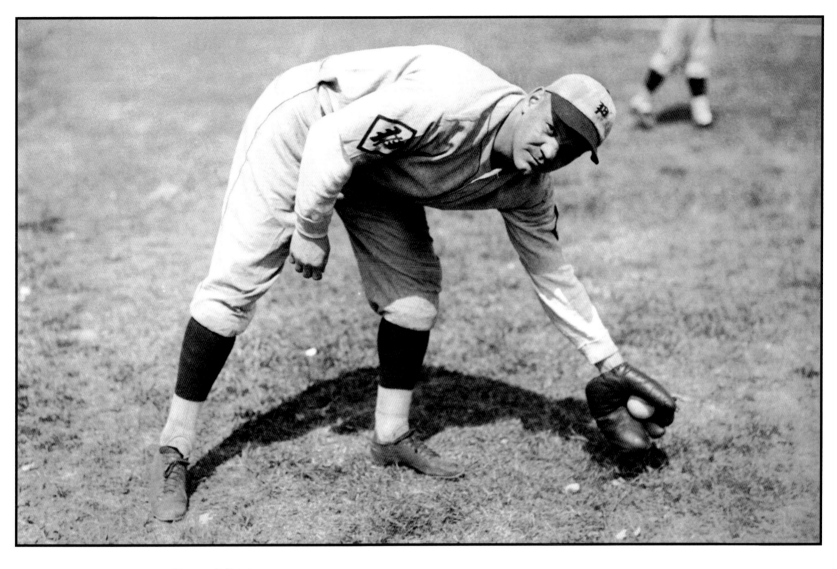

Barney Friberg
Infielder, 1925 - 1932

Versatile Barney Friberg could play almost anywhere on the diamond and once pitched four innings for the Phillies in relief. Friberg had already spent parts of five seasons with the Chicago Cubs, for whom he knocked in more than 80 runs for two straight seasons, prior to being sold to the Phillies halfway through the 1925 season.

With the Phillies, Friberg almost certainly had to check the lineup every day upon arriving at the ballpark to see where he was playing. In 1925, Friberg played all four infield positions, the outfield, caught one game and even pitched. His four innings of relief work included four hits and three walks. In 1926, Friberg spent the entire season playing one position, second base. But

soon he was on the move again, filling in around the Phillies infield wherever he was needed. Phillies manager Burt Shotton called Friberg, "the most valuable man on our team."

At the plate, Friberg was never a big run producer for the Phillies. His best season was 1929 when he hit seven home runs, drove in 55 and hit .301. By 1932, the Phillies had completely overhauled their infield and Friberg's playing time diminished. He was released by Philadelphia and signed by the Boston Red Sox for 1933, but played only 17 games before being let go.

Friberg played one final season in the minors before retiring and working for the General Electric Company in Massachusetts.

Hack Wilson and Cy Williams
Baker Bowl, 1927

The two greatest home run hitters in the National League posed together for the cameras prior to a Cubs-Phillies game in 1927. At age 39, Cy Williams had already led the National League in home runs three times and he would hit another 30 that season.

27 year-old Hack Wilson had led the league in home runs in 1926 and, like Williams, would also hit 30 in 1927 to give the duo the crown in the N.L.

But Wilson would go on to hit 31 in 1928 and 56 in 1930 to capture the long-ball title twice more. The torch had been passed.

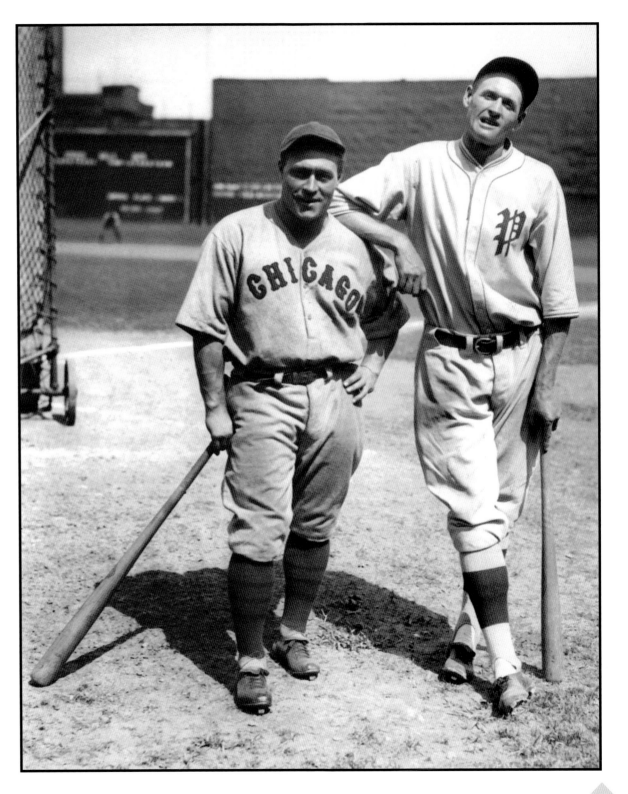

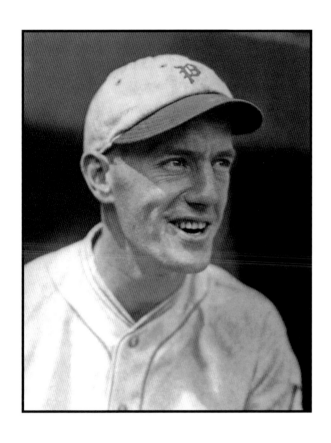

Fresco Thompson
Second Baseman, 1927 - 1930

Fresco Thompson was a lifelong baseball man whose best years as a major league player all occurred with the Phillies. Thompson, whose given first name was Lafayette, joined the Phillies in 1927 after two brief trials with the Pirates and the Giants.

In his first season with Philadelphia, Thompson batted .303 and drove in 70 runs. His speed also allowed him to steal 19 bases and notch 14 triples. During his four seasons as a regular, Thompson hit more than 30 doubles four straight times. Thompson recalled his days with the Phillies thusly, "It was some club. I hit .324 one year and was sixth or seventh in the club batting averages. They wouldn't even let me take batting practice and I wasn't allowed to speak to Lefty O'Doul and Chuck Klein, who were really murdering the ball. Our main trouble was we had no pitchers. We lost games by football scores."

Thompson's time in Philadelphia ended following the 1930 season, when he was traded to the Brooklyn Dodgers. Used sparingly, he was out of the majors by the following year. Thompson soon began managing in the minors and in 1945, he joined Branch Rickey in the Dodgers front office. Over the next 20 years, he ran the team's farm system until he was named General Manager of the Dodgers in 1968. Thompson died less than six months later.

Burt Shotton
Manager, 1928 - 1933

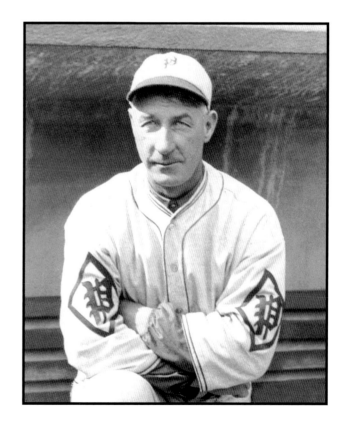

Burt Shotton's five years piloting the Phillies produced a temporary rise in the standings, but his greatest success came from leading the Brooklyn Dodgers to two World Series in the late 1940's. Shotton had enjoyed a long playing career as an outfielder, primarily with the Browns and Cardinals. When his playing days were over, Shotton began managing in the Cardinals farm system. The Phillies came calling three years later.

Shotton's arrival coincided with a remarkable infusion of offensive talent. Rookie sluggers Chuck Klein, Pinky Whitney and Don Hurst's debut in 1928 was followed by the arrival of Lefty O'Doul the following year. Together, the foursome gave the Phillies a formidable middle of the line-up.

The result was that in Shotton's second season at the helm, the Phillies won 71 games and finished in fifth place. By 1932, the Phillies 78-76 record, good for fourth place, meant their first winning season in 15 years. But when the team slipped to seventh place the following season, Shotton was fired.

Shotton spent a single season in 1934 as a coach with Cincinnati before returning to manage in the Cardinals farm system. When his mentor, and Cardinals G.M., Branch Rickey left St. Louis in 1942, so did Shotton. Ricky moved on to Brooklyn, where he later named Shotton manager for 1947. That season, Shotton's Dodgers won the National League pennant, but lost to the Yankees in the World Series in seven games. In 1949, Shotton took Brooklyn back to the Series, but was again topped by the Yankees in five games. He was fired after a second-place finish in 1950.

Chuck Klein
Outfielder, 1928 - 1933

The arrival of a 23 year-old rookie outfielder named Chuck Klein midway through the 1928 season was greeted with little fanfare by the fans or the local press. After all, Klein was purchased by the Phillies for the bargain basement price of $7,500 and had only 102 games of professional experience in the minor leagues. In fact, Klein's 26 home runs in 88 games for Ft. Wayne in the lowly Class B Central League meant little to a Phillies team struggling along towards an eventual 43-109 record and another last-place finish.

Klein made his major league debut on July 30 at the Baker Bowl against the Cardinals. Sent in to pinch hit, he popped out. The next day, however, he hit a double off an aging Grover Cleveland Alexander for his first major league hit in an 18-5 Phillies loss. Klein then started every game for the remainder of the season. By season's end, he had batted .360 and hit 11 home runs.

Best of all, Klein would quickly show Phillies fans it was no fluke.

Arthur "Pinky" Whitney
Third Baseman, 1928 - 1933; 1936 - 1939

Pinky Whitney was a hard-hitting glove man who drove in more than 100 runs in four of his first five seasons with the Phillies. As a rookie in 1928, Whitney hit .301 and drove in 103 runs. For an encore, he produced 115 RBI to go with his .327 average. 1929 was also the first of Whitney's two consecutive seasons with at least 200 hits and 40 doubles. In 1931, Whitney had an RBI in ten straight games, still the franchise record.

But Whitney also excelled in the field. While with the Phillies, he led all N.L. third basemen in putouts, assists and double plays three times in his first four seasons.

In 1933, the Phillies traded Whitney to the Boston Braves for two players and cash. But the Braves relied more on pitching and without the protection of several other sluggers in the lineup, Whitney's run production fell off dramatically in Boston.

Early in 1936, he was shipped back to the Phillies. The move seemed to agree with him as he hit .341 in 1937. But it would also would be Whitney's final season as an everyday player and he was released after the 1939 season.

Chuck Klein's eyes
1929

In his first full season in the majors, slugger Chuck Klein led the National League with 43 home runs. For good measure, he hit .356 and drove in 145 runs for the Phillies. Sportswriters were at a loss to explain his success. They questioned how a hitter could succeed by "putting his foot in the bucket", baseball lingo for pulling away from the pitch.

When questioned about his unorthodox batting style, Klein told a reporter,

"What? I put my foot in the bucket? Well, maybe I never noticed that before. You see, I've been so busy hitting the ball that I don't notice where my foot is. And furthermore, if I keep hitting at my present pace, I don't care if my foot goes into the dugout."

Klein's focus continued to be on his hitting. In 1930, he'd have his best season yet.

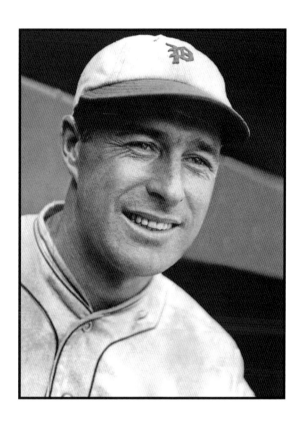

Francis "Lefty" O'Doul
Outfielder, 1929 - 1930

Lefty O'Doul's time in Philadelphia was short, but his exploits at the plate left their mark on the record books. O'Doul was originally a pitcher. He worked out of the bullpen for both the Yankees and the Red Sox for several seasons before an arm injury got him shipped back to the minor leagues.

Forced to concentrate on his hitting, O'Doul spent the next four seasons tearing up the Pacific Coast League. When he hit .378 and was named the league MVP in 1927, he got a promotion back to the big leagues, courtesy of the New York Giants. Despite hitting .319 for the Giants, O'Doul was traded to the Phillies for outfielder Freddy Leach.

O'Doul soon made the Giants regret the deal as he had the greatest season of his career. He won the National League batting title with a .398 average while hitting 32 home runs and knocking in 122 runs. Equally impressive was O'Doul's racking up 254 hits to set a new single season record.

O'Doul later recalled how he set the mark, telling *The Sporting News*, "It was the last day of the season and we were playing a doubleheader with the Giants in the old Baker Bowl. Going into the first game, I had 248 hits behind me and everyone knew that I was shooting for the great Rogers Hornsby's record of 250 hits in a season. So McGraw started Carl Hubbell, a lefthander. I believe McGraw did not want me to break that record. All I did in that first game was go four-for-four off Hubbell. In the second game, McGraw starts another lefthander. I got two more hits, to bring my record to 254."

Although the Giants' Bill Terry would tie O'Doul's mark the very next season, it remains the National League's single season high-water mark to this day.

Don Hurst
First Baseman, 1928 - 1934

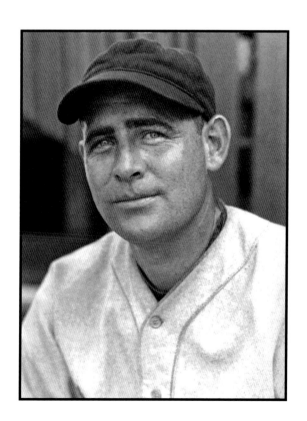

Don Hurst was a big, strong slugger who twice knocked in 125 or more runs for the Phillies in his brief major league career. Hurst was still in Cardinals' minor league system when he was included in the deal that sent catcher Jimmie Wilson to St. Louis. The Phillies promptly installed Hurst as their everyday first baseman and he paid immediate dividends. In his first game with the Phillies, Hurst reached base all four times he batted, going 2-2 with a triple and an RBI.

But Hurst was among that rare breed of batters who could hit for both power and average. In 1929, Hurst hit 31 home runs, including at least one in four straight games, and his 125 RBI were second most on the team. When he produced a .304 average, it also marked the first of four straight seasons hitting above .300.

In 1932, Hurst put it all together as he hit .339 and his 143 RBI were tops in the National League. For his exploits, Hurst thought he deserved more money. The following spring he held out, missing training camp, and never recovered. Hurst's batting average and power stats fell off sharply and when he started slowly again in 1934, the Phillies dealt him to the Chicago Cubs for Dolf Camilli.

It turned out to be a great trade for the Phillies and the end of the line for Hurst. He played in only 51 games, batted .199, and was released. Hurst played for several seasons in the American Association and the PCL, before trying his hand briefly as a manager in the low minors.

In 1952, Hurst died at the age of 47.

Lefty O'Doul and Chuck Klein
Spring Training, 1930

In 1929, the Phillies were an offensive juggernaut. In addition to having four players with at least 200 hits, Philadelphia led the National League in home runs and team batting average. Chuck Klein's 43 home runs led the league and Lefty O'Doul won the batting title.

The following season, the Phillies were at it again. Klein hit .386 and O'Doul .383 to finish three-four in the N.L. batting race. In addition, Klein's 40 home runs and 170 RBI were second most in the league.

However, all that firepower couldn't keep the Phillies from finishing in last place. Hampered by a pitching staff that was simply dreadful, the Phillies finished 52-102. They issued the most walks in the National League, had only one starter with a winning record and the team ERA of 6.71 was the highest ever recorded by any major league pitching staff in 20th Century.

To make matters worse, O'Doul was traded to Brooklyn following the 1930 season, where he would produce another N.L. batting title in 1932.

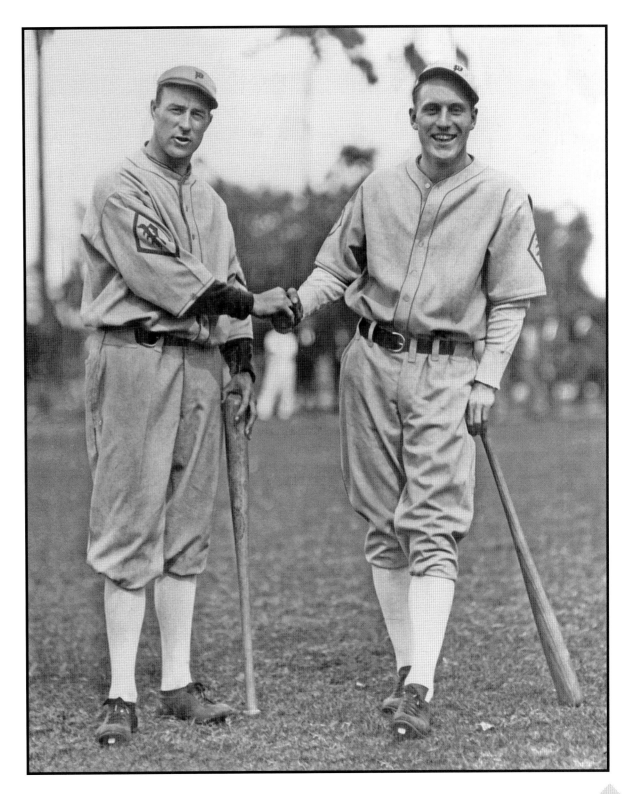

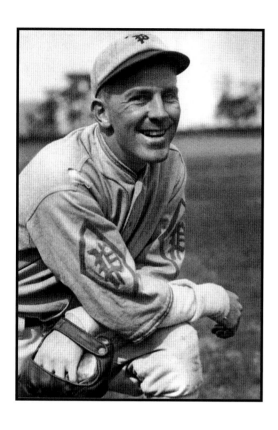

Dick Bartell
Shortstop, 1931 - 1934

Dick Bartell's hustling style of play and willingness to mix it up with opposing players got him nicknamed "Rowdy Richard". Bartell was originally with the Pirates, for whom he hit better than .300 three straight seasons. But curiously, the Phillies were able to pry him away in time for the 1931 season.

With Philadelphia, Bartell was usually near the top of the batting order and he excelled at getting on base. Twice, in 1932 and 1934, he scored more than 100 runs for the Phillies. In 1933, he was chosen to play for the National League in the first-ever All-Star game.

But it was Bartell's style of play around the second base bag that got him most of the notoriety. In an era when players routinely flashed their spikes to get an advantage, Bartell gave as good as he got. In 1935, a New York sportswriter called Bartell " probably the most-hated gent in the National League". Bartell told the reporter, "I've never gone out of my way for trouble and I've never side-stepped. All that talk that I've cut players deliberately is a lot of rot. If some of these guys around figure on getting tough, why, that'll be all right with me."

But the Phillies of the 1930's were constantly selling off their players to help pay the bills and in 1935 it was Bartell's turn to go. The New York Giants sent four players and cash to the Phillies for Bartell. With New York, Bartell obviously found the dimensions of the Polo Grounds to his liking as he twice hit 14 home runs in a season and helped the Giants to two straight World Series appearances.

The remainder of his career in the majors was spent with four different teams before military service in World War II intervened in 1943. Bartell later managed in the minors and coached in the majors with several different clubs.

Phil Collins
Pitcher, 1929 - 1935

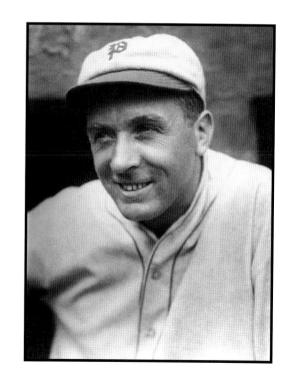

Phil Collins spent six years pitching for the Phillies, but was never much more than a .500 pitcher. In his rookie season, Collins was initially used as a starter, but when he won only one of his first 11 starts, he was moved to the bullpen.

In 1930, Collins gradually earned a place in the Phillies rotation. In early June, he won six of seven starts. The only blemish on his record during that stretch was a 1-0 loss to the Pirates. In September, Collins shut out Boston 1-0, but four straight losses to end the season left him with a 16-11 record.

Collins got off to a horrible start in 1931, and by the end of July his record stood at 4-11. Then, he ran off eight straight victories including identical 3-0 shutouts of the Pirates and the Giants. He finished the season 12-16 despite a career-low ERA of 3.86.

In 1932, Collins won 14 games for the Phillies, but five of those wins came in relief. In his other nine wins, the Phillies scored eight or more runs in eight of them. Most of Collins' 12 losses were by lopsided scores.

Collin's mannerisms on the mound got him nicknamed "Fidgety Phil". He worked slowly, adjusting his uniform, pulling at his cap and generally frustrating opposing hitters with his herky-jerky delivery. But Collins could certainly hold his own at the plate. In 1929 he hit a grand slam and in 1930 he hit .253 including two home runs in one game against Pittsburgh.

Early in 1935, the Phillies sold Collins to the St. Louis Cardinals. It was his final season in the big leagues.

Collins retired to his native Chicago and briefly ran a tavern before working as a prison guard. He died at the age of 46.

Chuck Klein and Bill Terry
The Polo Grounds, 1931

Prior to the Giants' home opener, two of the National League's leading hitters posed for the cameras at the Polo Grounds. In 1930, Chuck Klein had posted some amazing offensive numbers. In addition to all the run production, Klein had also put together two 26-game hitting streaks in the same season. In almost any other year, his stats would have topped the National League.

Klein hit .386, but Terry led the N.L. at .401. Klein had 250 hits, but Terry had 254. Klein's 59 doubles did rank him number one, but his 40 home runs and 170 RBI were both second best behind the Cubs' Hack Wilson.

In 1931, Klein would hit 31 home runs and drive in 121 runs to led the National League in both categories.

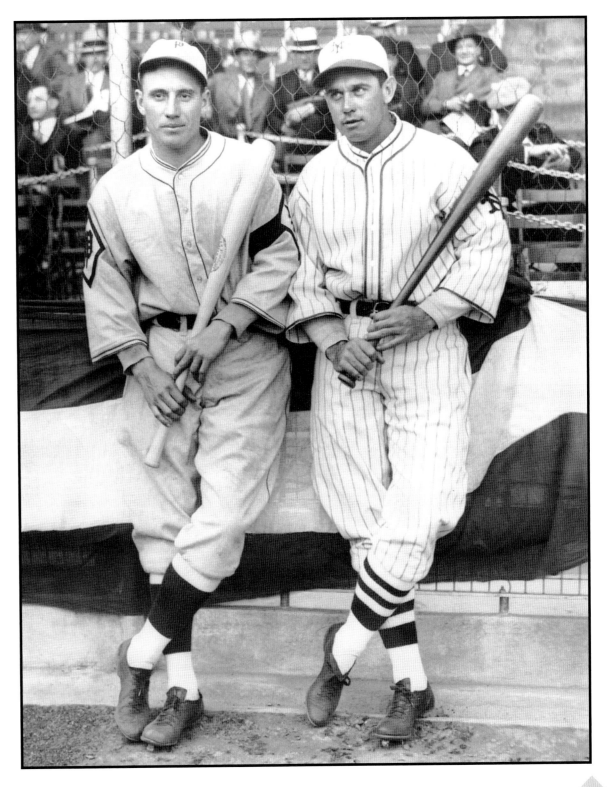

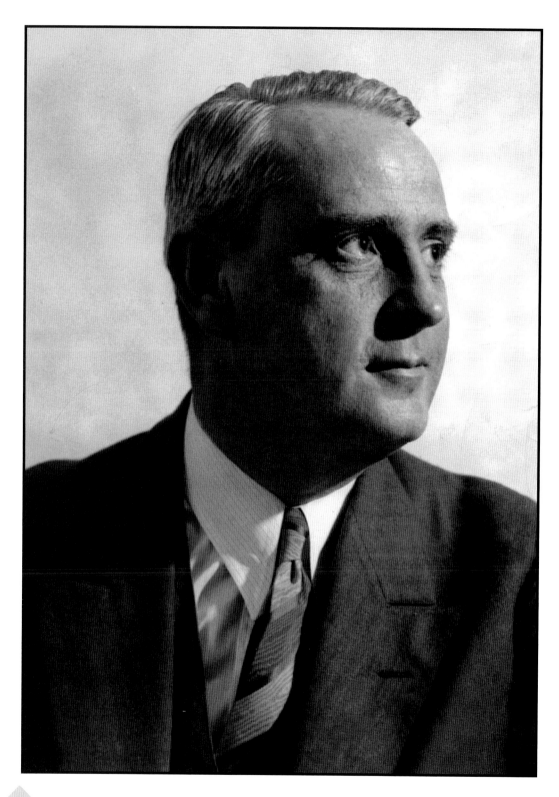

Gerry Nugent
Owner, 1932 - 1942

Gerry Nugent's tenure as owner of the Phillies is best remembered for a continually revolving roster of players and the constant shortage of cash. Nugent originally joined the Phillies front office in 1926 as an assistant to owner William F. Baker. In 1932, the 40 year-old Nugent was named team President. Interestingly, the majority of the stock in the Phillies was owned by his wife, Mae, who had been Baker's secretary.

Nugent was a shrewd judge of talent who excelled at scouring the minor leagues for unknown players. It was Nugent who convinced Baker to purchase Chuck Klein for $7500 in 1928. Nugent also acquired Don Hurst, Pinky Whitney and Claude Passeau when they were all still playing in the minor leagues. In fact, Nugent's ability to spot and develop talent was exceeded only by his inability to hang on to it.

But in fairness, Nugent was at the mercy of several factors outside his control. The Phillies hadn't had a winning season in over a decade when Nugent assumed control in 1932. The steadily deteriorating condition of the Baker Bowl kept fans away in droves and the Depression caused financial hardships for all but the most well-heeled owners. Finally, the Phillies wouldn't play night games until 1939, after they had moved to Shibe Park. As a result, during the decade of Nugent's reign, the Phillies had only one season where they drew more than 250,000 fans.

In an effort to spike attendance, Nugent got the ban on Sunday baseball lifted in 1934. He introduced Ladies Days and formed a knothole gang for school kids. In 1938, he finally moved the team out of the Baker Bowl, but with no other revenue stream except ticket sales, the team rarely met its reported $350,000 annual operating costs. The annual shortfall was made up for with player sales to the wealthier clubs like the Cubs and the Giants.

Finally, in November of 1942, the National League's board of directors met to discuss the sale of the Phillies. Nugent was quickly bought out as the league looked for a new owner with deeper pockets. Nugent was later named President of the Class B Inter-State league, a position he held for six years until he became a stockbroker in 1952.

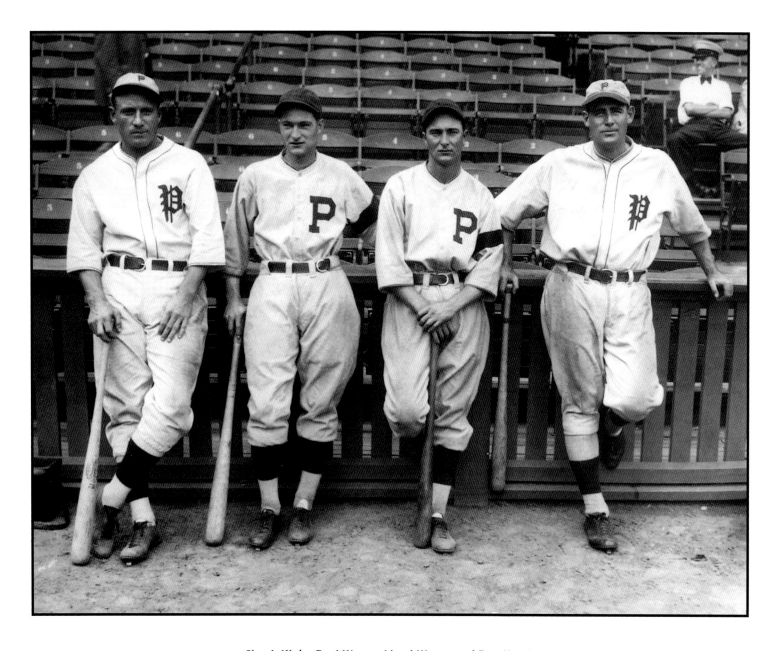

Chuck Klein, Paul Waner, Lloyd Waner and Don Hurst
Baker Bowl, 1932

In 1932, four of the most lethal bats in the National League resided in the state of Pennsylvania. Prior to an August game between the Pirates and the Phillies, the quartet posed for the cameras.

Paul and Lloyd Waner, both future Hall of Famers, would star together in Pittsburgh for 14 seasons. In 1932, Paul would hit .341 and led the N.L with 62 doubles. Lloyd would post a .333 average as the Pirates finished in second place.

Chuck Klein batted .348 and led the National League in hits, home runs and stolen bases. Don Hurst hit .339, belted 24 home runs and led the N.L with 143 RBI. Phillies fans would have to be content with a fourth-place finish, the club's best showing in 15 years.

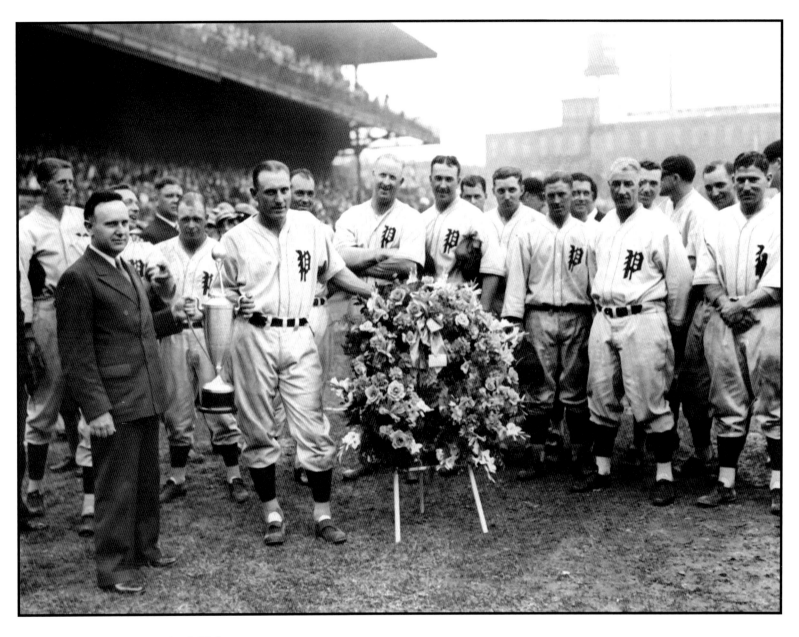

Chuck Klein
Baker Bowl, 1933

For his offensive fireworks in 1932, Chuck Klein was named the National League's Most Valuable Player. The following season, between games of a May doubleheader with the Cubs, Klein was presented with *The Sporting News* trophy.

Surrounded by his teammates, Klein accepted a floral wreath along with the silver loving cup from C. William Duncan, President of the Philadelphia

Sportswriters Association and a columnist for *The Philadelphia Public Ledger*.

In 1933, Klein would win the National League's triple crown, yet the sportswriters would name New York Giants pitcher Carl Hubbell the league MVP. As a further shock to Phillies fans, Klein would be traded to the Chicago Cubs after the season ended.

Jim "Jumbo" Elliott
Pitcher, 1931 - 1934

Pitcher Jumbo Elliott's best year in the majors was his first season with the Phillies. Elliott came to the Phillies from the Dodgers in the deal that sent Lefty O'Doul to Brooklyn. Elliott's' previous five years with the Dodgers had produced a 26-38 record. Despite a 10-7 record in 1930 for Brooklyn, not much was expected from him.

With the Phillies, Elliott made 30 starts and was a modest 16-14 . However, he worked extensively out of the bullpen, earning another three wins, and made 52 appearances to lead the National League. Although three other Phillies starters had lower ERA's than Elliott's 4.27, he was the only starter with a winning record. The highlights were a pair of 1-0 shutouts over the Pirates and the Reds.

Elliott's 19 wins for the Phillies in 1931 made him the co-leader in the National League that season. It was also the most victories by a Phillies pitcher in 14 years and marked the only time between 1900 and 1981 that the National League didn't have at least one 20-game winner.

Elliott's remaining seasons with the Phillies were far less impressive. He was a combined 17-21 before being traded to the Braves early in the 1934 season. Elliott pitched in a total of seven games for the Boston before being released that same season. It was his final year in the major leagues.

Virgil "Spud" Davis
Catcher, 1928 - 1933; 1938 - 1939

Spud Davis was a superb-hitting catcher who spent two tours of duty with the Phillies. Davis had caught a total of two games for the St. Louis Cardinals prior to trading spots behind the plate with veteran Jimmie Wilson when the two clubs swapped catchers in 1928.

Davis quickly developed a reputation as the best hitting catcher in the N.L. Beginning in 1929, he hit better than .300 for five straight seasons with the Phillies.

Davis was more of a doubles hitter although he did twice hit 14 home runs in single season for Philadelphia. In 1932, he somehow managed to leg out five triples to go with his .336 average. In addition, his 70 RBI were the second most by a catcher in the N.L. In 1933, the only reason Davis's .349 average didn't win the National League batting title was because his teammate Chuck Klein hit .368.

But all that success earned Davis a ticket out of Philadelphia. Following the 1933 season, he and Jimmie Wilson were once again swapped for each other. Davis spent four-plus seasons with the Cardinals and the Reds before rejoining the Phillies in 1938. After hitting .309 in 1939, Davis was on the move again, this time to the Pirates. There he played another four seasons as a back-up before retiring.

Davis later worked as a scout.

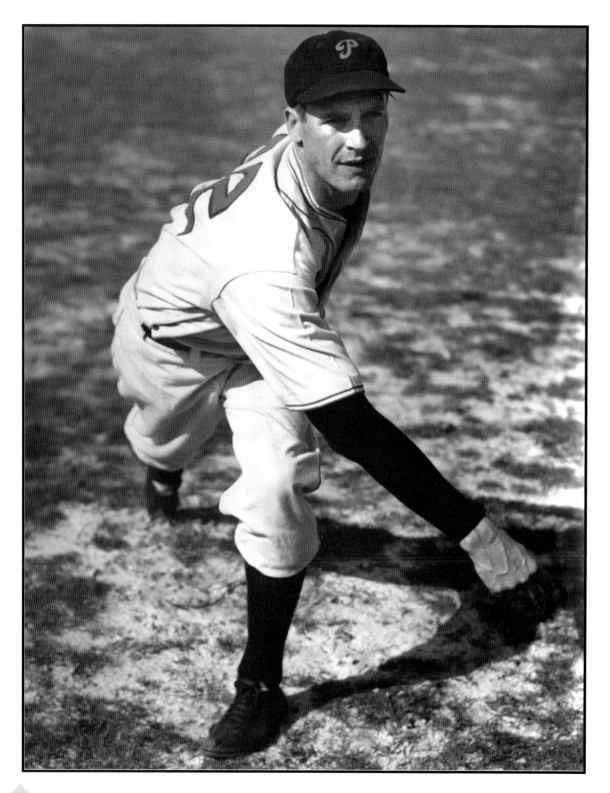

Curt Davis
Pitcher, 1934 - 1936

Curt Davis was a big, strong right-hander whose time in Philadelphia was entirely too short. Davis was already 30 years old when he joined the Phillies. His five previous years pitching in the Pacific Coast League had produced consecutive 20-win seasons. Davis soon proved to be one of owner Gerry Nugent's best bargains when the Phillies purchased his contract for $7500.

Davis was 19-17 as a rookie for the Phillies in 1934, but deserved a much better fate. In 10 of his losses, the Phillies scored one run or less. He also had the third-lowest ERA in the N. L. while leading the league in appearances.

In 1935, Davis began the season with a sore arm, winning just one of his first six starts. But he rebounded to win seven of his next eight including back-to-back shutouts of the Reds and Braves in late July before finishing the year 16-14.

Davis opened the 1936 season with a four-hitter against the Boston Braves, but won just one of his next seven starts. By mid-May his record was 2-4. Trade rumors involving Davis had filled the sports pages during the off-season. Finally, on May 21, the Phillies shipped Davis and outfielder Ethan Allen to the Chicago Cubs for slugger Chuck Klein and cash.

With Chicago, Davis was a combined 21-14 before being traded to the St. Louis Cardinals in 1938 as part of the Dizzy Dean deal. In 1939, Davis had his best season in the majors for St. Louis, winning 22 games. By 1940, Davis was in Brooklyn, where he was a consistent winner during another six seasons for the Dodgers before retiring in 1946.

William "Bucky" Walters
Third Baseman/Pitcher, 1934 - 1938

Bucky Walters' conversion from an infielder to a pitcher made him a star in the National League, but his greatest days came after he left Philadelphia. Walters had brief trials with both the Braves and the Red Sox before being acquired by the Phillies in 1934.

But Phillies manager Jimmie Wilson was impressed by Walters' strong arm and began convincing him that, due to his limitations as a hitter, his future lay on the mound. Early on, Walters battled wildness as he learned his new position, but gradually he began showing signs of things to come.

In 1935, Walters made 22 starts and posted a 9-9 record. But a closer look at his record indicates his rapid progress. In his second start of the season, Walters allowed just four hits in beating the defending champion Cardinals 2-1. Nine days later he beat the Chicago Cubs 1-0 and in August he beat the New York Giants twice in four days, the second time 1-0.

Walters' 1936 season was a step backward. Although he recorded four shutouts, in many of his starts Walters simply gave up two many runs for the Phillies' hitters to overcome. As a result, he finished with an 11-21 record.

In 1937, Walters opened the season with a 1-0 defeat of the Boston Braves. But he soon proved frustratingly inconsistent, never winning more than two consecutive starts all season and ended the year with a 14-15 record.

By 1938, Walters' mound exploits had attracted the interest of rival clubs, who began approaching the Phillies front office with trade offers. In mid-June, the Cincinnati Reds offered pitcher Al Hollingsworth, veteran catcher Spud Davis and $50,000. Always in need of cash, the Phillies accepted.

The deal proved shortsighted. The next season, Walters was reunited with his old manager, Jimmie Wilson, now a coach with the Reds, in Cincinnati. Wilson helped Walters regain his confidence. In 1939, Walters won 27 games, and led the N.L. in ERA, complete games and strikeouts. When the Reds repeated as league champions in 1940, Walters won 22 games and a second straight ERA crown. To make matters worse, Hollingsworth and Davis would both be gone from the Phillies by the end of 1939.

In 1944, Walters won 23 games.

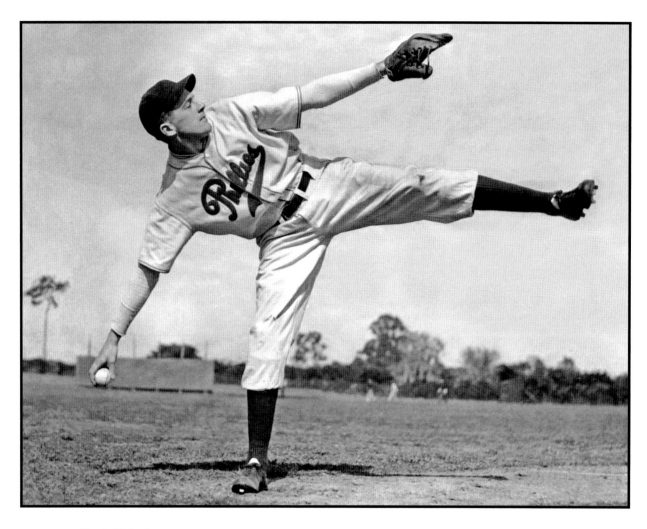

Hugh Mulcahy
Pitcher, 1935 - 1940; 1945 - 1946

Pitcher Hugh Mulcahy was the first major league player inducted into the military during World War II, but his time with the Phillies earned him a dubious nickname. Mulcahy was another of manager Jimmie Wilson's pitching projects. Like teammate Bucky Walters, Mulcahy was a converted infielder whose arm strength got him a trial on the mound.

Mulcahy made his Phillies debut in 1935 with a single inning of relief work versus the Pirates at Forbes Field. He faced Lloyd Waner, Paul Waner and Arky Vaughn, all three future Hall of Famers, and retired them in order. But when Mulcahy failed to win any of his five starts, he was shipped back to the minors. Urged to abandon his sidearm delivery, Mulcahy promptly won 25 games to lead the Class A New York-Penn League in wins. It earned him a return trip to the big leagues.

In 1937, Mulcahy lost 18 games as he struggled with his control, leading the

N.L. in walks. The lone bright spot was a 3-0 shutout of the Reds in June. The following season, Mulcahy was 10-20 to lead the N.L. in losses. When he posted a 9-16 season in 1939, the sportswriters in the press box began referring to him as "losing pitcher" Mulcahy.

Mulcahy's record of 13-22 in 1940 meant he again led the National League in losses. But Mulcahy pitched better than his overall record would indicate. He beat the defending champion Reds three times in five starts and posted three shutouts. In July he reeled off five straight wins and in his final start before going off to war, he beat Carl Hubbell and the Giants 6-0 at the Polo Grounds.

Mulcahy missed the next four seasons serving in the Pacific. When he returned to the Phillies in 1945, he'd lost 25 pounds and his fastball. Mulcahy won just three more games for the Phillies before returning to pitch in the minors until 1950.

Dolf Camilli
First Baseman, 1934 - 1937

Dolf Camilli's first major league hit was a home run against the Phillies to win a game at Wrigley Field. Phillies manager Jimmie Wilson was impressed enough to have owner Gerry Nugent trade slugger Don Hurst to the Cubs the following June for Camilli. From the Phillies' perspective, the timing could not have been better. Hurst, just one full season removed from leading the N.L. with 143 RBI, would play only 51 games for the Cubs before being released.

Camilli would become the Phillies main power source and earn a reputation as the league's most graceful first baseman. Beginning in 1935, Camilli hit at least 25 home runs for three straight seasons. In 1936, he drove in 102 runs. Once he changed his stance at the plate to cut down on strikeouts, Camilli's batting average rose steadily, peaking at .339 in 1937.

But like so many other Phillies of the 1930's, Camilli's accomplishments only made him more desirable. In the Spring of 1938, Camilli was dealt to the Brooklyn Dodgers for a weak-hitting outfielder named Eddie Morgan and $45,000. Morgan never played a game for the Phillies, the money was soon spent and Camilli became a star for the Dodgers.

In 1941, Camilli led the N.L. with 34 home runs and 120 RBI to help propel the Dodgers to their first pennant in 21 years. For his efforts, Camilli was named National League MVP. When Brooklyn tried to trade Camilli to the Giants in 1943, he retired rather than join the Dodgers' bitter rival.

He managed briefly in the PCL before becoming a scout for the Phillies and, later, the Yankees.

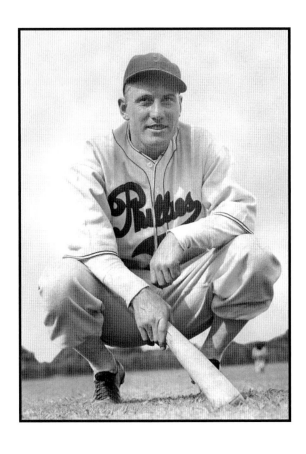

Chuck Klein
Outfielder, 1936 - 1939

When Chuck Klein returned to the Phillies in May of 1936, he was only 31 years old, but his best days were already behind him. Klein's best season in Chicago had produced 20 home runs and 80 RBI, numbers far below his glory days with the Phillies.

In 117 games following the trade, Klein hit .309 with 20 homers and 86 RBI. When combined with his output for the Cubs, Klein ended the year with 104 RBI. But 1936 would be the last time he ever knocked in more than 100 runs in single season.

Over the next two-plus years, Klein's offensive numbers continued their steady decline. In 1938, he hit a total of eight home runs and batted just .247. The following June, having played in only 25 games and produced just one home run and nine RBI, Klein was released by the Phillies.

He signed with Pittsburgh the next day. There, Klein managed to hit .300 with 11 home runs and 47 RBI over the final 85 games of the season. The following March, the Pirates let him go.

Claude Passeau
Pitcher, 1936 - 1939

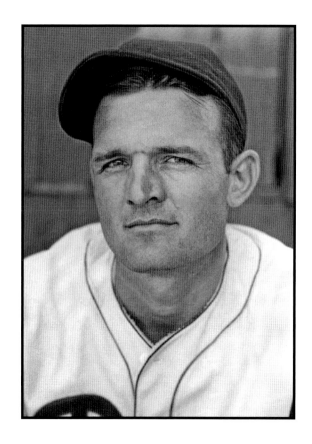

Righty Claude Passeau used his blazing fastball to win 20 games the year after he left the Phillies. Passeau had one major league start with the Pirates in 1935 before he was included as a "throw-in" in a deal with the Phillies. Passeau spent the first half of the 1936 season in the bullpen, but was finally given his first start on July 4 against Brooklyn. He shut out the Dodgers 4-0. When he won four of his next six starts, he was in the Phillies rotation to stay.

In 1937, Passeau quickly became the workhorse of the Phillies' pitching staff. His 34 starts and over 290 innings of work led the National League. His 14-18 record included a 6-0 shutout of the Giants at the Polo Grounds in May. Passeau's success was based on his speed. He later recalled, "I never learned how to throw a curveball. I'd throw a fastball and it would sail. That's what I got by on. I was one who would start you off with a fastball. They knew what I was throwing. I would throw for the middle of the plate and it would sail one way or the other. They didn't take very many pitches on me"

Passeau did develop a reputation for intimidating hitters. "The only fella I ever threw at to hit, that was Leo Durocher, and I hit him. He tried to bunt to hurry up a game before a rain. I let him have it. I guarantee you, right in the chest."

Early in 1939, the Phillies shipped Passeau to the Chicago Cubs for three players and a reported $50,000. In Chicago, Passeau flourished. In 1940, he won 20 games and had the second lowest-ERA in the National League. During the war years, Passeau was a consistent winner.

When the Cubs won the N.L. pennant in 1945, Passeau was 17-9 with five shutouts. In the World Series, he won Game 3 on a one-hit shutout of the Detroit Tigers. His final season in the majors was 1947.

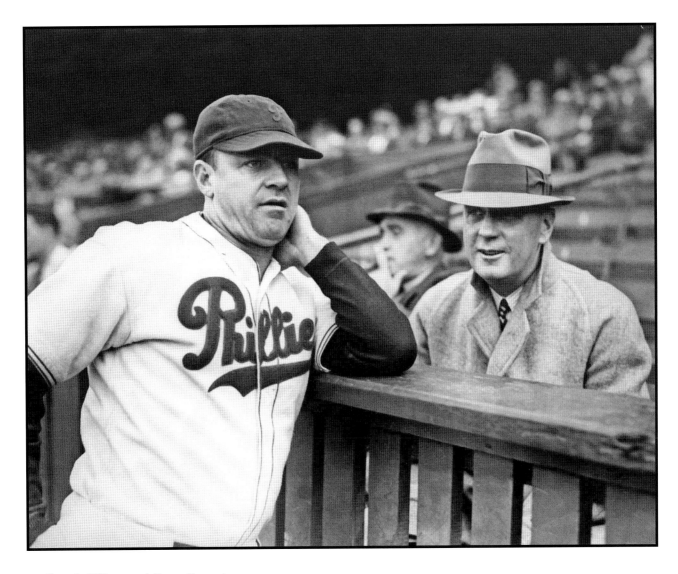

Jimmie Wilson and Gerry Nugent
Baker Bowl, 1937

At the time this picture was taken, manager Jimmie Wilson's time with the Phillies was just about up. The constant losing and the annual sale of the club's best players took it's toll. Wilson was released by Nugent after the 1938 season. When he landed in Chicago in 1941 as manager of the Cubs, Wilson recalled his days in Philadelphia for an article in *The Saturday Evening Post*.

"You know, it's a great club for young players to be with. All you have to do with the Phillies is hustle and you stand out like a lighthouse in a thin fog. You see, there's really no reason to hustle with the Phils. You know you're going to lose two out of every three games you play. But you know, too, there'll be a sale soon. And if you hustle, you'll look so much better than the bums around you that the other clubs will think you're a great player. First thing you know, the Phils have a bunch of cash and you're out from behind the eight ball."

Wilson also told the reporter about the Phillies' scouting system. While he managed the Phillies, the entire scouting department was one guy, little Patsy O'Rourke. O'Rourke was supposed to watch the Pacific Coast League, the American Association, the International and the Texas Leagues, besides all the lesser circuits. "Maybe you could do it, but I don't know where O'Rourke looked. Every time I looked up in the stands, there he was."

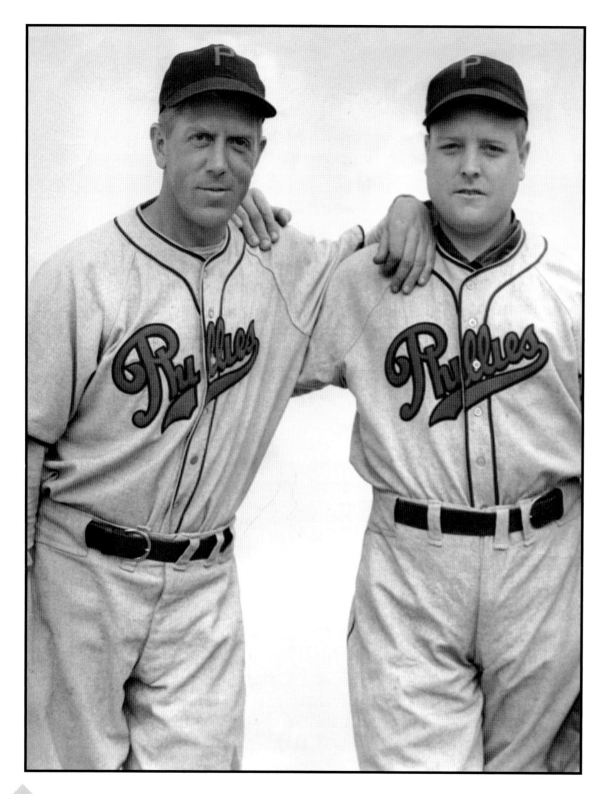

Syl and Si Johnson
1940

They shared the same last name, they both pitched primarily in the National League and for one short season, they were teammates.

Sylvester Johnson pitched for almost 20 years in the major leagues, primarily with the Cardinals and Phillies. Although he was used as both a starter and a reliever, he was often injured and won more than 12 games only once. In 1927, while on a rehab assignment in the Cardinals farm system, he threw a no-hitter for Syracuse.

Johnson's 10 wins for the Phillies in 1935 marked his only winning season in Philadelphia. When the Phillies released him in 1940, Johnson, then 40, continued pitching in the Pacific Coast League for another five seasons.

Silas Johnson had already spent eight full seasons in the National League with the Reds and Cardinals by the time he joined the Phillies in 1940. He was a combined 26-48 in four seasons with Philadelphia before military service interrupted his career in 1943.

When he returned in 1946, he was immediately sold to the Boston Braves, with whom he finished up in 1947.

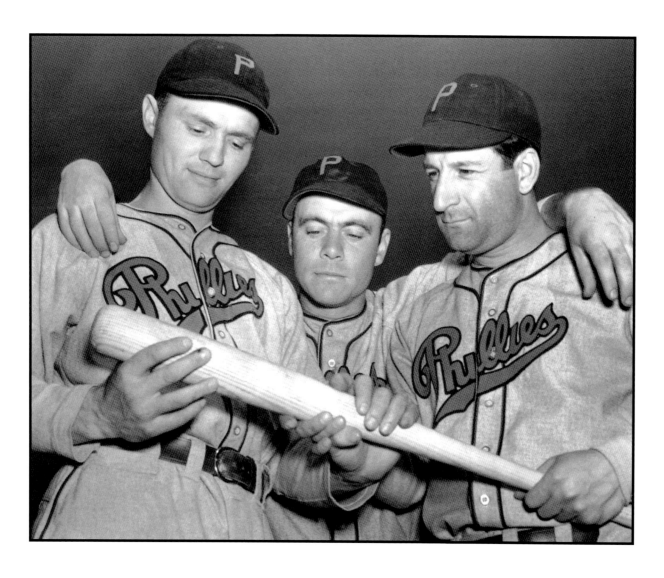

Pinky May, Kirby Higbe and Morrie Arnovich
Spring Training, 1940

As the decade of the 1930's came to an end, the Phillies' ever-changing roster of players tested the loyalty of even the most ardent fan.

Merrill "Pinky" May manned third base for the Phillies for five years beginning in 1939. May was a line-drive hitter with almost no power. He hit a total of four home runs in over 2200 at-bats with the Phillies. He entered the Navy in 1943 and never played in the major leagues again. In the late 1940's, May began managing in the minor leagues, which he did for over 25 years. His son, Milt, was a catcher in the majors during the 1970's and 80's.

Pitcher Kirby Higbe joined the Phillies in 1939 from the Chicago Cubs. Higbe battled wildness, leading the N.L. in walks twice for the Phillies. But in 1940, he also led the league in strikeouts and won 14 games. The Phillies promptly sold Higbe to the Brooklyn Dodgers for three players and $100,000. The next year, Higbe went 22-9 to lead the National League in victories and help the Dodgers win the pennant.

Morrie Arnovich spent three full seasons patrolling left field for the Phillies. In 1937, he had a hit in seven straight at-bats and hit 10 home runs. His 72 RBI in 1938 were tops on the club. Arnovich hit a career-high .324 in 1939 and was named to the All-Star team, but was dealt to the Reds the following season. Arnovich spent 1941 with the Giants before military service cost him four full seasons. When he returned in 1946, he had three at-bats before retiring. He died prematurely at age 48 in 1959.

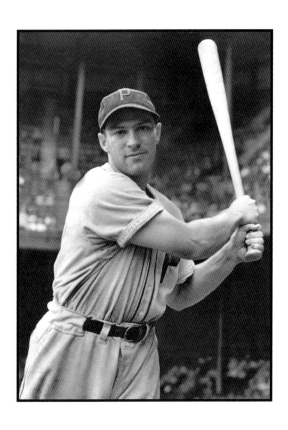

Danny Litwhiler
Outfielder, 1940 - 1943

Outfielder Danny Litwhiler played an entire season without making a single error, but his greatest contributions to the game came long after he stopped playing. Litwhiler joined the Phillies late in the 1940 season. He immediately proved his prowess at the plate by running off a 21-game hitting streak and hitting .345.

In 1941, Litwhiler hit .305 and belted 18 home runs to lead the Phillies. Litwhiler played much of the second half of the 1942 season with a jammed shoulder, but still became the first major-leaguer to ever play an entire season without making a single error. However, the bum limb also affected his performance at the plate as his power numbers dropped off.

The Phillies traded Litwhiler to the Cardinals in 1943, where he played in two straight World Series. Following a year of military service, Litwhiler played with the Braves and Reds for several seasons before managing in the minor leagues. In 1955, he became the baseball coach at Florida State and took his teams to three college World Series in eight seasons. In 1964, Litwhiler took over the program at Michigan State, where he spent 19 seasons.

It was while coaching in college that Litwhiler began developing many of the tools we now associate with the modern game. He introduced the radar gun to judge pitch speed, helped develop a product, later named Diamond Grit, to help dry saturated infields and pioneered the use of several instructional gadgets to teach young players the fundamentals of the game.

Ron Northey
Outfielder, 1942 - 1944; 1946 - 1947

Ron Northey was a strong-armed outfielder with a penchant for hitting dramatic home runs. Northey was signed by the Phillies in 1941 after leading the Eastern League in RBI that season.

In 1943, the residents of Northey's home town in rural Pennsylvania honored him with "Ron Northey Day" at Shibe Park and presented him with a slew of gifts. Northey repaid their generosity by getting seven hits in 10 at-bats in the day's doubleheader.

Northey was considered by most to have one of the strongest arms in the game. In 1944, he led all National League outfielders in assists. That same season, Northey broke up a scoreless game in the 15th inning with a home run to beat the Boston Braves. Two months later, in the same stadium, Northey hit a grand slam in the ninth inning to beat the Braves 9-7. These were two of the 22 home runs he would hit that season to go with his 104 RBI, both the third-highest totals in the N.L.

Northey missed the 1945 season due to military service. When he returned the next year, he hit 16 home runs, but the Phillies traded him to the Cardinals early the next season for Harry Walker. Northey played another seven seasons, all as a reserve, before rejoining the Phillies in 1957 for a final 33 games. In his first game back in Philadelphia, Northey hit a pinch-hit home run.

He later served as a coach with Pittsburgh.

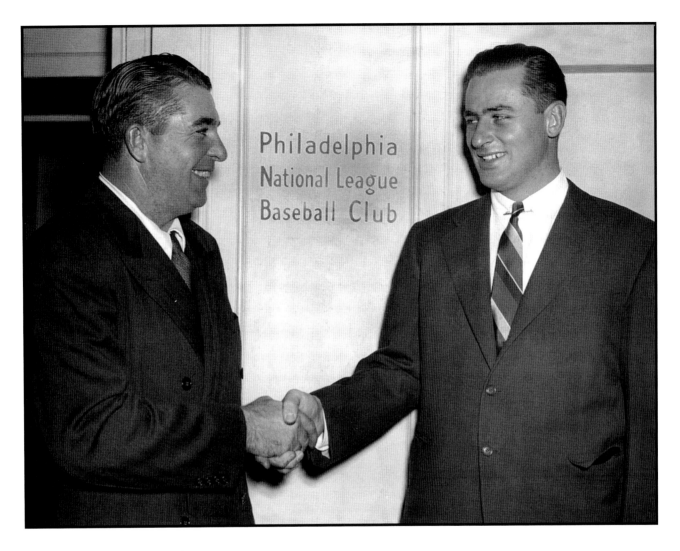

Freddie Fitzsimmons and Bob Carpenter
1943

When the National League forced Phillies owner Gerry Nugent to sell the club at the end of 1942, a syndicate of local businessmen, led by 33-year old William Cox, took control of the club. But when it was discovered that Cox bet on baseball games involving the Phillies, he was banned for life by Commissioner Landis and the league began looking for a new owner.

Bob Carpenter(shown above with Phillies manager Freddie Fitzsimmons) was an heir to the du Pont family fortune and lived in nearby Wilmington. At age 28, he was running the Wilmington Blue Rocks minor league club and promoting boxing matches. Carpenter inherited a Phillies team that had only one minor league affiliate, a single scout and very little talent on the major league roster. His first move was to hire former major league pitcher Herb Pennock as the team's general manager.

Together, Pennock and Carpenter slowly rebuilt the organization from the ground up. They hired scouts, eventually signed working agreements with 11 new minor league clubs and began signing fresh talent. When Carpenter left in 1944 for military service, Pennock ran things in his absence.

By 1946, the Phillies had risen to fifth place in the standings, their best showing since 1932. Better yet, the Phillies became the first major league club to draw more than 1 million fans that season. When Pennock died early in 1948, Carpenter took over day to day operations of the club.

Finally, with the club on sound financial footing, better days seemed right around the corner.

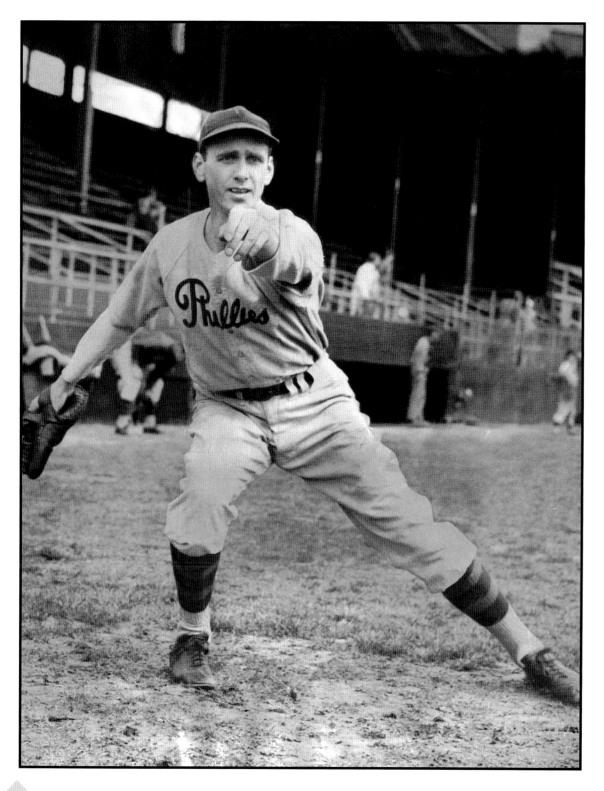

Ken Raffensberger
Pitcher, 1943 - 1947

Lanky Ken Raffensberger twice led the National League in shutouts, but didn't become a consistent winner until long after he left the Phillies. Raffensberger was signed by the Phillies after he won 19 games in the Pacific Coast League in 1943.

Raffensberger was a left-handed control pitcher who relied on a big, sweeping curveball and rarely walked opposing hitters. Stan Musial considered him the toughest pitcher he had to face. In 1944, Raffensberger won four of his first five starts including a 2-0 blanking of the Reds in May. But he got little run support from his teammates as the Phillies scored two runs or less in 12 of his defeats. As a result, he finished the season 13-20 to lead the N.L. in losses. The following year, he made just four starts before joining the Navy.

When Raffensberger returned in 1946, he was used as both a starter and a reliever. Although his six saves led the league, his 8-15 record in 23 starts soon got him traded to Cincinnati the following June. But pitching for a second-division club like the Reds was only slightly better than toiling for the Phillies. During his 10 full seasons in the majors, Raffensberger never pitched for team that finished higher than fifth place.

In 1948, Raffensberger threw a pair of one-hitters against the St. Louis Cardinals. The following year, he won 18 games and led the N.L. in starts and shutouts. One of his five shutouts was a third one-hitter against Brooklyn. During his time with the Reds, Raffensberger would come within a single safety of a no-hitter four times.

In 1952, Raffensberger won 17 games and his six shutouts again led the league. However, two years later he was released by the Reds. After one final season pitching in the minor leagues, Raffensberger managed in the low minors for two seasons before retiring in 1957.

Granny and Garvin Hamner
Ebbets Field, 1945

With the major leagues experiencing a talent shortage due to World War II, teams filled out their rosters any way they could. In 1944, the Phillies signed a 17-year old shortstop, named Granville "Granny" Hamner. The next, season, he brought his 20-year old brother, Garvin, along with him. Together, the pair began the 1945 season as the Phillies double-play combination.

But neither brother proved a match for major league pitching. Granny played in just 14 games, batted .171 and was shipped off to the minors to gain more experience. By 1948, at age 21, he would be back with the Phillies to stay. Garvin played in 32 games, batted .198, and was also shipped out. He never played in the major leagues again.

The patches both brothers are shown wearing on their left sleeves were the newly designed logo for the Phillies, which beginning 1944, were also called the "Blue Jays". But the alternate name, the result of a fans' write-in contest, never really took. By 1947, all references to it were gone.

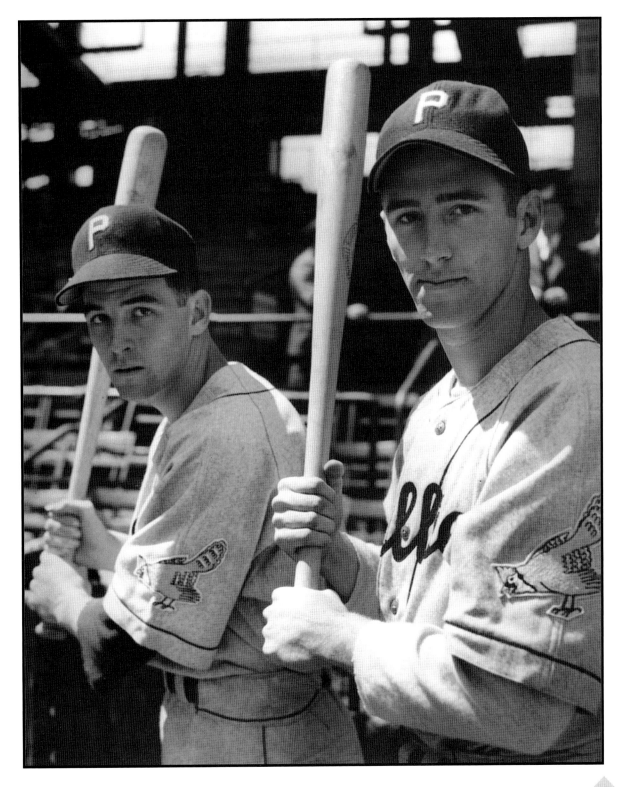

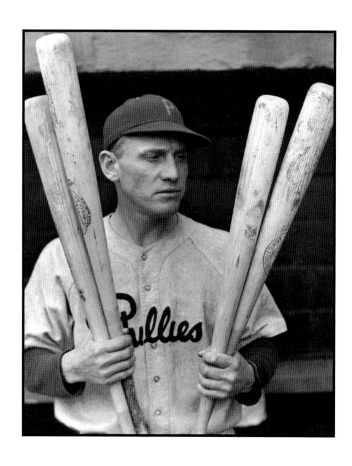

Chuck Klein
1943

When the Pittsburgh Pirates released Chuck Klein in the spring of 1940, he returned to the Phillies. That year, he had his last season as an everyday player. Klein started 98 games in his familiar right field, but hit just .218 and managed only seven home runs.

In 1941, Klein hit his 300th, and final, home run of his career. The Phillies soon made him a coach and he was still occasionally used as a pinch-hitter. In 1944, Klein had seven at-bats. At age 39 he was finally done.

Life after baseball proved hard for Klein. He operated a bar in northeast Philadelphia following his retirement. But Klein's drinking left him weak and malnourished. In 1947, he returned to his native Indianapolis to live with his brother and sister-in-law. Klein lived out his days as an invalid after suffering a stroke. He died in 1958.

Chuck Klein was elected to the Hall of Fame by the Veteran's Committee in 1980.

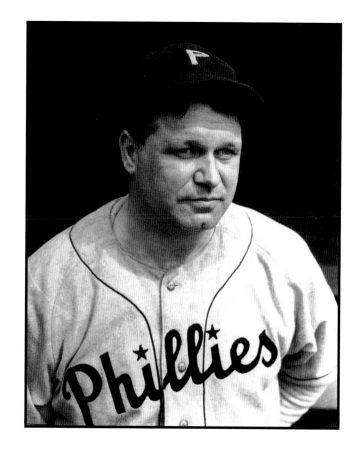

Jimmie Foxx
1945

Jimmie Foxx had starred in Philadelphia for a decade with the Athletics. After spending another six full seasons with the Boston Red Sox, Foxx had amassed 519 home runs and nearly 1850 RBI. Following a trade to the Chicago Cubs in 1942, Foxx soon became a nomad. When the Cubs released him in July of 1944, Foxx began looking for steady work wherever it took him. He managed Portsmouth in the Piedmont League for the final month of the 1944 season.

In 1945, with major league clubs trying to solve their manpower shortages due to the war, the Phillies signed the 37 year-old Foxx. Alternating between first and third base, Foxx started 54 games and was the team's primary pinch-hitter. He banged out 7 home runs and hit .268.

But Foxx was also used as a pitcher for the Phillies. He started two games, winning one of them. Better still, he allowed only 13 hits in almost 23 innings of work for an ERA of 1.59.

1945 was Foxx's final season as an active player. In 1947 and 1949 he managed briefly in the minors. He was elected to the Hall of Fame in 1951 and died in Miami in 1967.

Ben Chapman
Manager, 1945 - 1948

Ben Chapman's tenure as Phillies manager produced a momentary rise in the standings, but it was his treatment of Jackie Robinson for which he is best remembered. Chapman took over as the Phillies' skipper in July of 1945 when Freddie Fitzsimmons resigned. Chapman had been a terrific player in his own right as a speedy outfielder who led the American League in stolen bases four times.

In Philadelphia, Chapman inherited a team that was 17-50 over the first half of the 1945 season. Talent was in such short supply that Chapman, at age 36, decided to occasionally take the mound himself. He pitched a total of seven innings in three relief appearances. Chapman walked six, struck out four and allowed six earned runs. In 1946, he pitched a single inning of relief.

When he wasn't on the mound, Chapman was trying out his "win at all costs" style of managing. In 1942, while managing Richmond in the minor leagues, Chapman had slugged an umpire and was suspended for an entire season. In the majors with the Phillies, he fought with umpires constantly. In an effort to change the club's losing attitude, Chapman fined his players if they even mentioned the phrase, "last place".

Initially, it seemed to work. In 1946, the Phillies finished in fifth place, their highest showing in 15 years and drew more than 1 million fans for the first time in the club's history. Chapman was rewarded with a two year contract extension.

During the first week of the 1947 season, the Phillies traveled to Brooklyn to play the Dodgers in a three-game series at Ebbets Field. Brooklyn's rookie first baseman, Jackie Robinson, quickly drew the attention of Chapman, who was from Alabama. The vicious racial insults directed at Robinson from the Phillies dugout grew so deafening that National League President Ford Frick finally issued a warning to the Phillies. Later that season, Robinson was persuaded to pose for a photo with Chapman in an effort to de-fuse the situation. Robinson later recalled, "I can think of no occasion where I had more difficulty in swallowing my pride... than in agreeing to pose for a photograph with a man for whom I had the lowest regard."

With the Phillies stuck in sixth place, Chapman was fired midway through the 1948 season. He never managed in the major leagues again. In interviews late in life, Chapman defended his actions towards Robinson and remained unapologetic.

Del Ennis
Outfielder, 1946 - 1956

The arrival of slugger Del Ennis provided the Phillies with their most consistent power source since Chuck Klein. Ennis had spent a single season in the minors before enlisting in the Navy for the next two years during World War II. When Ennis joined the Phillies in 1946, he quickly played himself into the everyday lineup. By mid-season, he was chosen to the N.L. All-Star team. When the year was over, Ennis' .313 average and 73 RBI got him voted *The Sporting News* Rookie of the Year.

In 1947, although his batting average fell off to .275, Ennis' 81 RBI were tops on a Phillies club where no other player had more than 51. That same year, Ennis put together a 19-game hitting streak. The following season, Ennis hit a career-high 30 home runs. In 1950, he would have the greatest year of his career.

Ralph "Putsy" Caballero
Infielder, 1944 - 1945; 1947 - 1952

Putsy Caballero was light-hitting middle infielder who made his major league debut at the age of 16. Signed right out of high school by the Phillies in 1944, Caballero joined the club for the final three weeks of the season. With most of the Phillies' veteran players in the military, youngsters like Caballero were pressed into service. He went hitless in four at-bats and was quickly dispatched to the minors, where Caballero spent most of the next three seasons.

In 1948, though still just 20 years old, Caballero played in 113 games for Philadelphia, alternating between second and third base. Although he had almost no power, Caballero stroked 12 doubles and batted .245. Over the next three years, he was used primarily as a defensive replacement and pinch runner. In 1951, Caballero hit the only home run of his major league career against the Giants at the Polo Grounds. The next year was his last with the Phillies.

Caballero played another three years in the minor leagues before retiring to his native New Orleans, where he operated a pest-control business.

Ken Heintzelman
Pitcher, 1947 - 1952

Lefty Ken Heintzelman spent over a decade pitching in the National League, but had only one dominating season. Heintzelman spent his first five-plus seasons in the major leagues with Pittsburgh. His first full season for the Pirates was 1940 when he was 8-8. In 1942, Heintzelman was 8-11, but managed to throw three shutouts including a two-hitter against the New York Giants. But like many other big league players of his era, Heintzelman's career was interrupted by military service, costing him three full seasons.

When he re-joined the Pirates in 1946, Heintzelman was 8-12 as Pittsburgh finished in seventh place. Despite throwing shutouts against the eventual champion Cardinals and the third-place Cubs, Heintzelman was sold to the Phillies the following May.

With the Phillies, Heintzelman was a combined 13-21 over the next two seasons. The lone highlight came in 1948, when he threw a one-hitter against the Giants at Shibe Park. The next year, at age 33, Heintzelman would suddenly become the Phillies most reliable starter.

Willie "Puddinhead" Jones
Third Baseman, 1947 - 1959

Willie Jones was a big, strong country boy from the Carolinas who combined a slick glove with a powerful bat. Nicknamed "Puddinhead" by his childhood friends after a character in a film, Jones would eventually spend more than a decade manning the hot corner for the Phillies.

At the plate, Jones' booming bat provided an offensive jolt to the Phillies lineup. Early in the 1949 season, Jones had four doubles in a game against the Braves. That same year, he hit a triple and a home run in the same inning against the Reds. When the Phillies won the National League pennant in 1950, Jones' 25 home runs and 88 RBI were both second best on the club. In 1956, he had an 18-game hitting streak and in 1958, Jones drove in eight runs in one game against

St. Louis with two home runs and a triple. It was one of 12 times Jones hit two home runs in a single game.

In the field, Jones's quickness and strong throwing arm routinely had him leading N.L. third basemen in putouts and double plays. Although he was plagued for many years by bad feet, Jones' defensive skills had him ranked among the best third-sackers of his era.

In 1959, the Phillies shipped Jones to the Cleveland Indians, where he played just 11 games before finishing up with the Cincinnati Reds. When he retired in 1961, he stayed in Cincinnati and became a car salesman.

Harry "The Hat" Walker
Spring Training, 1948

Harry Walker spent less than two full seasons with the Phillies, but produced the team's first N.L. batting title in 14 years. Walker had already played parts of five seasons with the St. Louis Cardinals, where he drove in Enos Slaughter with the winning run in Game 7 of the 1946 World Series. But just a month into the 1947 season, Walker was traded to the Phillies for slugger Ron Northey.

The change of scenery gave Walker a chance to play every day as the Phillies' centerfielder and his batting average took off. Walker was named to the All-Star team and finished the season with a .363 average as his 16 triples led the National League. The feat marked the only time that a pair of brothers had won batting titles in the majors. Walker's brother, Dixie, had hit .357 for the Brooklyn Dodgers in 1944.

Walker's nickname came as a result of his constant fidgeting with his cap prior to stepping into the batters' box and often, between pitches. The press reported that Walker went through as many as two dozen caps in a single season. Walker is shown here searching for just the right fit with Phillies equipment manager "Unk" Russell.

But when Walker couldn't duplicate his performance in 1948, and hit just .292, he was traded to the Cubs after the season ended. Walker played only one more season as a regular before returning to the Cardinals as a backup for parts of another two years.

In 1951, Walker began managing in the Cardinals farm system and in 1955 he piloted St. Louis for one season. He later managed the Pirates and Astros.

Eddie Sawyer
Manager, 1948 - 1952; 1958 - 1960

In 1950, Eddie Sawyer directed the Phillies to their first National League pennant in 35 years. A rarity as a college educated ballplayer, Sawyer was a highly regarded outfield prospect in the Yankees' chain until a shoulder injury sidelined him. In 1939, at age 28, Sawyer began managing in the minor leagues, winning several league titles as he worked his way up the ladder. In 1944, he took over as manager in Utica, then the Phillies' top farm club. There, he was responsible for moving a young catcher named Richie Ashburn to the outfield.

When the Phillies fired Ben Chapman midway through the 1948 season, they promoted Sawyer as his replacement. Despite Sawyer's track record in the minors, some of the press questioned the wisdom of hiring someone who'd never played a single day in the major leagues.

Sawyer's arrival in Philadelphia coincided with the blossoming of the Phillies' young talent. Richie Ashburn, pitcher Robin Roberts and infielder Granny Hamner were all just 21 and third baseman Willie Jones was 22. Together, they helped form a nucleus that would propel the Phillies to a pennant in 1950.

But Sawyer's success with the Phillies would prove short-lived. In 1951, the team had a losing record and finished in fifth place. The following season, with the team struggling along in fourth place, Sawyer was fired.

In 1958, he was brought back as Phillies manager and took over a team mired in seventh place. Sawyer's Phillies finished last in both 1958 and 1959 and one game into the 1960 season, he abruptly quit, telling reporters "I'm 49 years old, and I want to live to be 50."

Richie Ashburn
Spring Training, 1948

Richie Ashburn was in demand long before he ever joined the Phillies. In fact, Ashburn began drawing the attention of several other major league clubs as a 16 year-old in his native Nebraska. In 1943, Ashburn attended a try-out camp held by the St.Louis Cardinals, but was prevented from signing a contract because of his age. The next year, the Cleveland Indians got Ashburn's signature on a contract only to have the deal voided by Comissioner Landis. When Ashburn signed with a Chicago Cubs farm team, that deal was also voided by the league because it promised Ashburn a bonus if he was sold to a major league club, a clear violation of the rules. After returning to Nebraska to attend college, Ashburn decided to take the Phillies' offer because he thought it would more quickly lead to playing in the majors.

Ashburn reported to the Phillies farm club in Utica in 1945 as a catcher. But only a month into the season, Utica manager Eddie Sawyer converted the speedy Ashburn to an outfielder to cut down on the wear and tear on his legs. Ashburn finished the season with a .312 average. Following a year and a half hitch in the military, Ashburn rejoined Utica in 1947 and hit .362 while leading the Eastern League in hits and runs scored.

When Ashburn started spring training with the Phillies in 1948, it was assumed he would spend that season with Toronto, the Phillies' top farm club. But Ashburn's play in Florida convinced manager Ben Chapman to keep him on the roster when the team went north. The Phillies' regular centerfielder, Harry Walker, who'd just won a batting title, was a holdout that spring, allowing the young Ashburn a chance to show his skills. Ashburn immediately made the most of the opportunity.

Ashburn opened the 1948 season in centerfield against the Boston Braves at Shibe Park. He got off to a red-hot start, going 10 for 21 in his first four games. In mid-May he began a 23-game hitting streak. By July 1, his average stood at .349. He was the only rookie selected to the N.L. All-Star team and by late August he had stolen a league-high 32 bases. Then, Ashburn broke his finger sliding into second base against the Pirates at Forbes Field. He missed the remainder of the season, but was chosen Rookie of the Year by *The Sporting News*.

Ashburn's performance made veteran outfielder Harry Walker expendable and he was dealt to the Cubs a week after the season ended. The Phillies were convinced they had found a suitable replacement.

Robin Roberts
1948

Pitcher Robin Roberts was attending Michigan State on a basketball scholarship when the Phillies offered him a $25,000 bonus to turn pro. In 1948, Roberts went to spring training with the Phillies before being assigned to the team's Class B affiliate in Wilmington. In his first professional start, Roberts struck out 17 and held Harrisburg to five hits and a single run in nine innings of work. By mid-June, Roberts was 9-1 and had struck out 121 in 96 innings. His ERA of 2.06 convinced the Phillies front office he was ready for the major leagues. Roberts was 21.

On June 17, Roberts was told to report to the Phillies. The next day, he took the train to Philadelphia where the Phillies were set to open a series against Pittsburgh. That night, Roberts held the Pirates to five hits over eight innings, but lost 2-0. Five days later, Roberts beat Cincinnati 3-2 at Shibe Park for his first major league victory. Roberts made another 14 starts in 1948 and finished the season 7-9, although he deserved a much better fate. In all nine of his losses the Phillies failed to score more than two runs.

In 1949, Roberts was 15-15 with three shutouts. Beginning in mid-May, he ran off six straight wins. But the 1949 Phillies scored the third-fewest runs in the National League that season and ended up costing Roberts several close decisions. He lost four games by scores of 1-0 and 2-0.

However, 1950 would see Roberts develop into one of the game's most dominant pitchers.

Russ Meyer
Pitcher, 1949 - 1952

Volatile Russ Meyer's best season of his major league career was his first with the Phillies. Meyer pitched parts of three seasons with the Chicago Cubs, mostly as a reliever, before being sold to the Phillies after the 1948 season. He was a tall, thin right-hander whose temperamental antics on the mound earned him the nickname "the Mad Monk". Meyer routinely fought with umpires, tore up locker rooms and shredded his equipment when things didn't go his way.

In 1949, Meyer got off to a poor start, winning just two of his first seven starts. But he finished strong, winning eight of his final nine to end up 17-8 for the Phillies with two shutouts. In addition, his ERA of 3.08 was the lowest among N.L. right-handers.

Meyer hurt his arm the following Spring, limiting him to 25 starts. But when the Phillies needed him the most, Meyer came through. As the 1950 pennant race wound down, the Phillies were clinging to a slim lead over the second-place Dodgers. In early September, the Phillies lost three straight games to Brooklyn to drop their lead to 4½ games. Meyer's 4-3 defeat of the Dodgers in the series' final game stopped the bleeding.

Meyer was a combined 21-23 over the next two seasons for the Phillies before being traded to Brooklyn in 1953. There he went 15-5 to help the Dodgers win the N.L pennant. But it was his famous temper which got most of the headlines when he blew up during a May game in Philadelphia. Meyer charged home plate umpire Augie Donatelli and had to be held back by his own catcher, Roy Campanella. Before he exited the game, Meyer had heaved the rosin bag 30 feet into the air, thrown his glove into the dugout and made an obscene gesture towards Donatelli from the dugout, all of which was caught by the TV cameras. Meyer was fined and suspended.

Meyer continued pitching in the majors until an arm injury forced him to retire early in 1959. He later became a pitching coach in the Yankees minor-league system.

Dick Sisler
First Baseman/Outfielder, 1948 - 1951

Dick Sisler hit the most important home run in Phillies history. The son of Hall of Famer George Sisler, he joined the Phillies in 1948 following a trade with the Cardinals. Sisler was immediately installed as the Phillies everyday first baseman.

But Sisler proved a mediocre fielder and in 1950, the Phillies moved him to left field to keep his bat in the line-up. He responded with the best year of his career. In early May, Sisler had a hit in eight consecutive at-bats against the Cardinals in St. Louis. For the season, he hit .296 with 13 home runs and 83 RBI, all personal bests. But the decisive blow came on the final day of the 1950 season and gave the Phillies their first N.L. pennant in 35 years.

Facing the Dodgers in Brooklyn on the final weekend of the season, the Phillies held a two-game lead with two games to play. When Brooklyn beat the Phillies 7-3 on Saturday, a second Dodger victory would force a one-game playoff. The Phillies started their ace, Robin Roberts, and the Dodgers countered with 19-game winner Don Newcombe. The two battled to a 1-1 tie through nine innings.

Sisler, who already had three hits in the game, came to bat in the top of the 10th with two men on base. His home run into the left field grandstand give the Phillies a 4-1 lead. When Roberts shut down the Dodgers in the bottom of the inning, all of Philadelphia went wild. Best of all, Sisler's father, George, working as a scout for Brooklyn, was in the stands to watch his son's heroics.

Sisler played another season with the Phillies, before being traded to the Reds in 1952. He finished up back in St. Louis with the Cardinals for one more year before retiring. Sisler later managed the Reds for two seasons and worked as coach for several major league clubs.

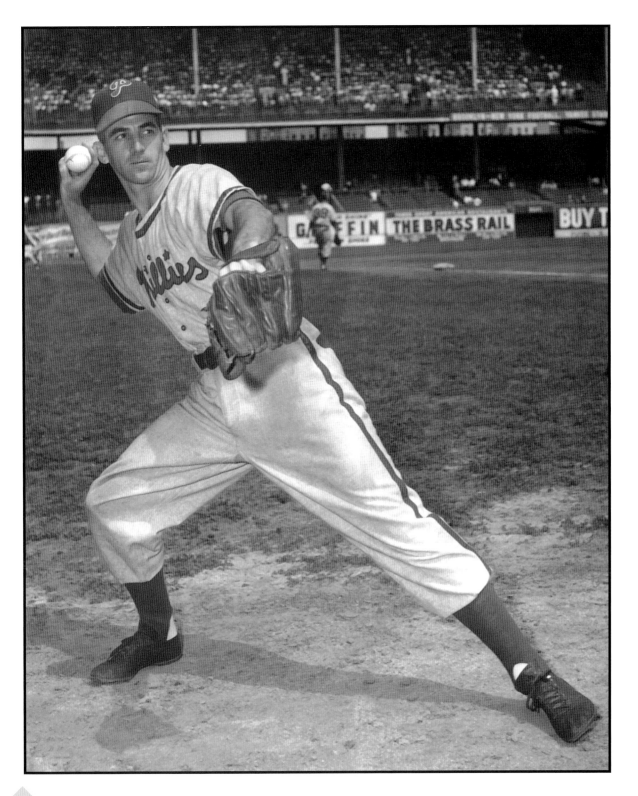

Granny Hamner
Infielder, 1944 - 1959

Granny Hamner spent a decade anchoring the Phillies infield. Rushed to the majors in 1944 as a 16 year-old, Hamner bounced back and forth between the major and minor leagues for four seasons before becoming a regular in 1948. Initially stationed at second base, Hamner's range and exceptionally strong arm got him moved to shortstop the next year.

Hamner displayed above-average power for a middle infielder. He had four seasons with more than 30 doubles and hit a career-high 21 home runs in 1953. Hamner also gained a reputation for being extremely productive with runners on base as he had four seasons with more than 80 RBI.

In the field, Hamner's glove work got him selected to three straight All-Star teams starting in 1952. He also proved to be extremely durable. Hamner played in 477 consecutive games between 1949 and 1951.

But a knee injury suffered in a collision at second base cost Hamner most of the 1958 season. The following year, he was shipped to the Cleveland Indians, who released him after the season. Hamner attempted a brief comeback as a pitcher with the Kansas City Athletics in 1962, but he gave up 10 hits and six walks in four innings of work and called it quits.

Ken Heintzelman and Andy Seminick
Polo Grounds, 1949

Along with the infusion of young talent, one of the main reasons for the Phillies' dramatic climb to a third-place finish in 1949 was the performance of veterans like pitcher Ken Heintzelman and catcher Andy Seminick.

Heintzelman got things off to a roaring start on Opening Day against the Boston Braves when he threw a 4-0 shutout. When Heintzelman threw his next shutout, 1-0 over the Cubs, on June 4, it began a stretch of eight wins in his next nine starts. By the time the season was over, Heintzelman had won 17 games and his five shutouts led the National League.

Seminick did his part by smacking 24 home runs, second most for the Phillies behind only Del Ennis' 25. On a Phillies team that relied more on pitching than offense to win games, Seminick's contribution cannot be overlooked. That he did it in only 334 at-bats, while splitting playing time with Stan Lopata, makes it even better.

The Phillies' 81-73 record was their first winning season since 1932 and only their second since 1917.

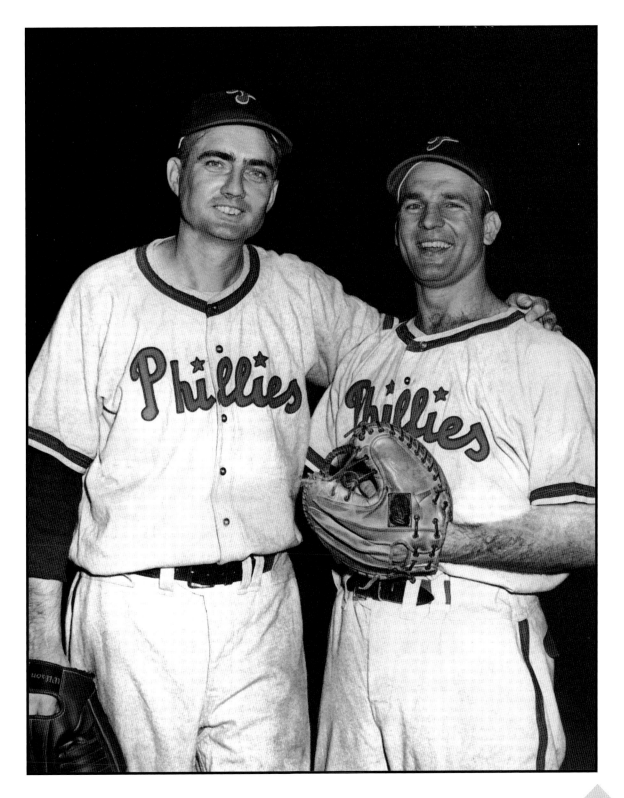

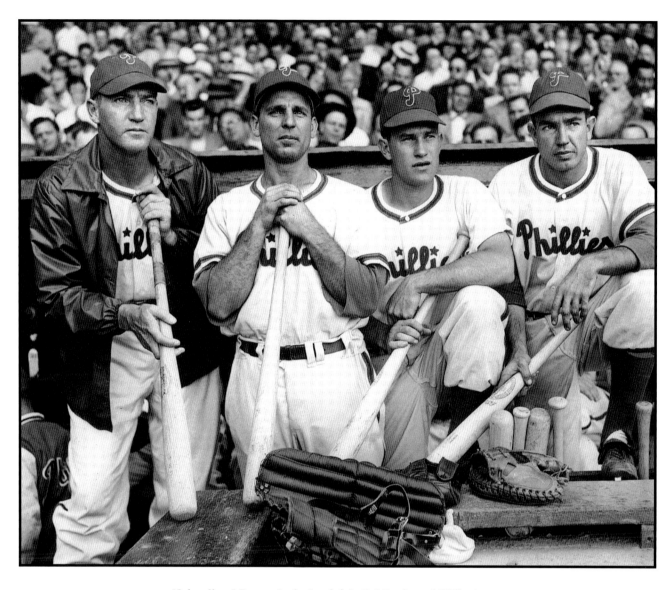

"Schoolboy" Rowe, Andy Seminick, Del Ennis and Willie Jones
Shibe Park, 1949

One of the highlights of the 1949 season came on June 2 against the Cincinnati Reds. As the bottom of the eighth began the Phillies were trailing 3-2. Reds pitcher, and former Phillie, Ken Raffensberger had allowed just four hits in the first seven innings.

Leadoff hitter Del Ennis, belted the first pitch he saw into the upper deck in leftfield tying the game. Phillies catcher Andy Seminick hit the very next pitch onto the grandstand roof in left field for his second home run of the game. Two batters later, it was Willie "Puddinhead" Jones' turn and he too homered to left. After a pop out by Phillies second baseman Eddie Miller, pitcher "Schoolboy"

Rowe got into the act by driving a pitch into the upper deck in leftfield.

It was the Phillies' fourth home run of the inning and they weren't done yet. The next four hitters all reached base safely, bringing Seminick back to the plate for the second time. He made it five round-trippers in one inning by driving his second home run of the inning, and third of the game, into the stands in left. Jones later drove in the inning's tenth, and final, run with a triple to make it 12-3 for the Phillies. Rowe was the winning pitcher.

The feat remains, to this day, the only time a Phillies team has ever hit five home runs in a single inning.

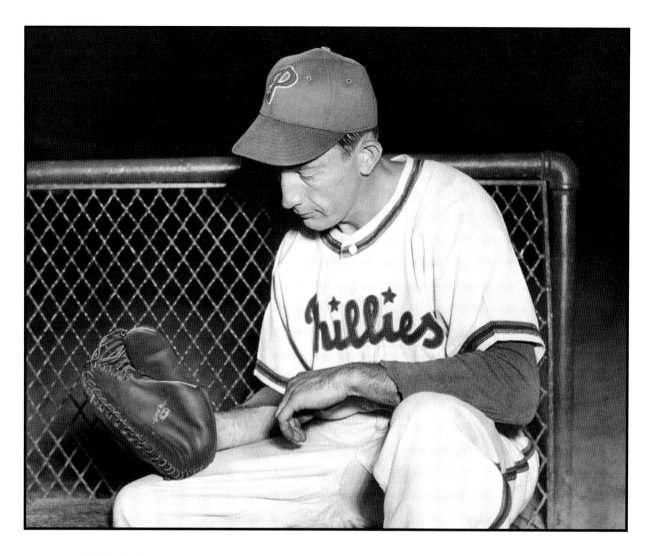

Eddie Waitkus
First Baseman, 1949 - 1953; 1955

Eddie Waitkus was a slick-fielding first baseman who is best remembered for being shot by a female fan in his hotel room. Waitkus had already spent three full seasons with the Chicago Cubs prior to being traded to the Phillies in 1949. While playing for the Cubs, Waitkus had unknowingly become the object of infatuation for a young female fan named Ruth Ann Steinhagen. Though the pair had never met, Steinhagen decided to change all that.

In June of 1949, when the Phillies visited Chicago, she checked into the Phillies' downtown Chicago hotel. Steinhagen then sent a note to the hotel's front desk telling Waitkus she needed to see him. When Waitkus arrived just before midnight, Steinhagen went to the closet in her room, pulled out a .22-caliber rifle and shot Waitkus in the stomach. She then calmly called the front desk to summon help. Waitkus eventually needed four operations to remove the bullet lodged in his abdomen and missed the remainder of the 1949 season.

Waitkus recovered and played another three seasons as the Phillies' everyday first baseman. Steinhagen spent three years in a mental hospital before being declared "fully cured" and released. The shooting was the basis for the storyline used in the 1952 novel, "The Natural" by Bernard Malamud. It was later made into a movie starring Robert Redford.

Following the 1953 season, the Phillies sold Waitkus to the Baltimore Orioles. He rejoined the Phillies in 1955 for a handful of games before retiring. Waitkus died in 1972 at age 53 of cancer.

Del Ennis
Spring Training, c. 1950

In 1950, Del Ennis had the greatest season of his long career and helped power the Phillies to their first N.L. pennant in 35 years. Ennis batted .311 and hit 31 home runs and his 126 RBI were the most in the National League. In July, Ennis had seven RBI in a single game against the Cubs. That same month, he drove in 39 runs, still the fourth-highest total for a single month in team history. When the 1950 season was over, Ennis had twice hit a home run in four straight games. In the World Series against the Yankees, however, Ennis was just two for 14 as New York swept the Phillies in four straight games.

During his 11 seasons with the Phillies, Ennis had six years with more than 100 RBI. In addition, Ennis hit 25 or more home runs seven times with the Phillies. When he was traded to the Cardinals in 1957, Ennis' 259 home runs were the most ever by a Phillie, a mark later eclipsed by Mike Schmidt. In fact, Ennis and Schmidt are the only two Phillies in the entire 20th Century to drive in more than 1,000 runs for Philadelphia.

Ennis' last big season was his first in St. Louis. His 105 RBI were the most on the Cardinals. But in 1958, Ennis' power suddenly evaporated and he began riding the bench. Although he was only 34, Ennis decided to retire after the 1959 season. He spent the next three decades operating his bowling alley in Montgomery county. Ennis died in 1996.

Andy Seminick
Catcher, 1943 - 1951; 1955 - 1957

Andy Seminick's first major league hit was a home run, but it was his nearly 30 years in the Phillies organization which endeared him to two generations of players and fans.

Seminick got a late season call-up in 1943 and made his debut against the Giants at Shibe Park. In the second game of a doubleheader, Seminick hit a home run in the seventh inning of a 6-3 Phillies loss. He spent most of the next two seasons back in the minor leagues, before finally taking over as the Phillies' everyday signal-caller in 1946. Seminick's best two seasons coincided with the Phillies rise in the standings. In both 1949 and 1950, he hit 24 home runs.

Seminick was a tough, no-nonsense backstop who never shied away from a confrontation at home plate. In the final week of the 1950 season, he was bowled over by the Giants' Monte Irvin at the Polo Grounds. Yet, Seminick insisted on playing every inning of the 1950 World Series only to have doctors later discover that his ankle was broken.

In 1951, Seminick was beaned by the Cardinals' Max Lanier and suffered a concussion. The next year, the Phillies traded him to the Reds. Early in 1955, the Reds sent him back. After playing sparingly in 1956, Seminick spent two seasons as a coach with the Phillies before turning to managing in the minor leagues. It was there that Seminick helped tutor the next generation of young Phillies like Mike Schmidt and Greg Luzinski.

Seminick later became a roving minor-league instructor and scouted for the Phillies until his retirement in 1986. He died in 2004.

Bill Nicholson
Outfielder, 1949 - 1953

Bill Nicholson was a big, free-swinging slugger whose best years were behind him by the time he joined the Phillies in 1949. During his nine full seasons with the Chicago Cubs, Nicholson had hit 25 or more home runs five times. Turned down for military service because he was color-blind, Nicholson feasted on war-time pitching. In 1943 and 1944, he led all National League hitters in both home runs and RBI. In 1944, Nicholson hit four home runs in a game against the New York Giants at the Polo Grounds. When he came to bat a fifth time with the bases loaded, the Giants walked him intentionally, forcing in a run, rather than risk losing their 12-9 lead.

In Philadelphia, Nicholson served as the team's fourth outfielder, backing up the trio of Ashburn, Ennis and Sisler. But a shoulder injury cost him playing time and his .234 average in 1949 soon got him relegated to pinch hitting duty. His biggest contributions to the Phillies' 1950 N.L. pennant were a pair of game-winning home runs against the Dodgers in early July.

Late in 1950, doctors discovered Nicholson had diabetes, causing him to sit out the World Series. His final three seasons with the Phillies were all spent as a reserve. He retired after the 1953 season.

Jim Konstanty
Pitcher, 1948 - 1954

Jim Konstanty was an unlikely candidate for pitching success in the major leagues. His scholarly appearance and limited repertoire of pitches did little to instill confidence in either Konstanty or the ball clubs he pitched for.

Konstanty, whose given first name was Casimir, was a four-sport athlete at Syracuse who didn't begin pitching until he'd left college. In fact, Konstanty used his degree to teach high school phys-ed while playing minor league ball during the summer. Although he pitched briefly for the Cincinnati Reds during the season of 1944, his Navy service interrupted Konstanty's progress. He spent most of the next three seasons back in the minor leagues. There, Konstanty's performance did little to advance his career until he got a new manager in 1948.

When Eddie Sawyer took over at Toronto, the Phillies top farm club, in 1948, he moved Konstanty to the bullpen. When Sawyer moved on to the Phillies, he took Konstanty with him. Konstanty later told a reporter, "Eddie brought me up …when I didn't think I had a Chinaman's chance of making the grade. He saw something in me that nobody else saw-including myself."

In 1949, Konstanty's reliance on nothing but off-speed pitches proved effective as he pitched in 53 games, all in relief, and finished with a record of 9-5. Unlike most modern relief pitchers, who rely mostly on speed, Konstanty, threw only two pitches, a slider and a change-up. He told an interviewer, "They told me I couldn't make it in the majors with only two pitches, but I got away with it. When I threw a fastball, I got killed."

In 1950, Konstanty would set a new major league record for durability as the Phillies would win 91 games and capture the N.L. pennant.

Gene Kelly
Broadcaster, 1950 - 1959

Gene Kelly was the radio voice of the Phillies for a decade during the 1950's. Kelly, who was born in Brooklyn, began his radio career soon after graduating from Marshall in 1941. Kelly stood an imposing 6'7" tall, but when his athletic career as a minor league pitcher was derailed by arm trouble, he turned to radio.

The Phillies had begun broadcasting their games over the air in 1936, but until 1950 only the home games were actually attended by the announcers. The team's road games were recreated in the studio from the Western Union teletype account of the games. When veteran announcer Byrum Saam, who'd begun doing both the Phillies and Athletics games in 1939, moved over to doing the A's exclusively, Kelly was given the microphone for the Phillies broadcasts.

Kelly worked with several play-by-play partners during his time with the Phillies, and the team's games were carried by an ever-changing line-up of stations. In the baseball off-season, Kelly worked as the voice of Philadelphia Warriors basketball.

In 1959, Kelly was fired and replaced by Saam and he moved on to doing two seasons of Cincinnati Reds games with legendary Reds announcer Waite Hoyt. Kelly also continued calling a variety of college football and basketball games for several years until a stroke in 1965 curtailed his travel schedule. Kelly did some 76'ers basketball games in 1970 and passed away in 1979.

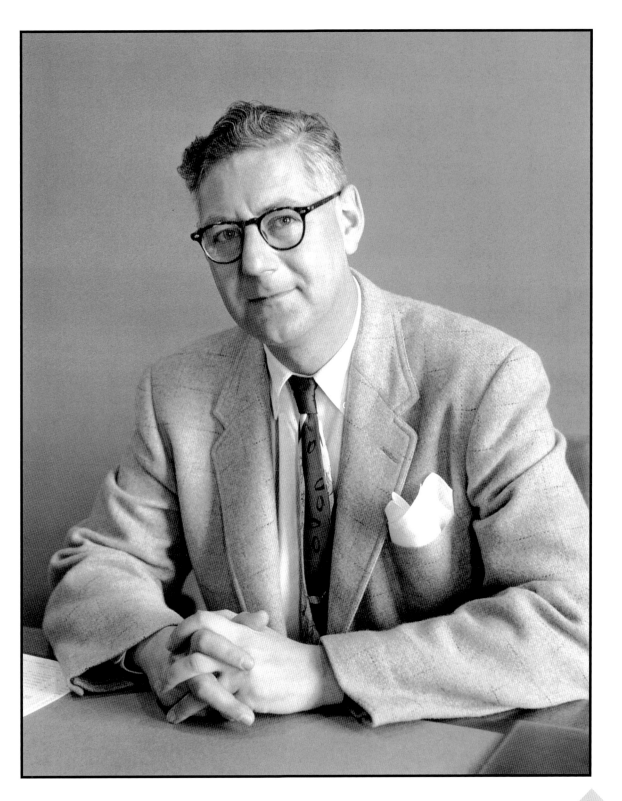

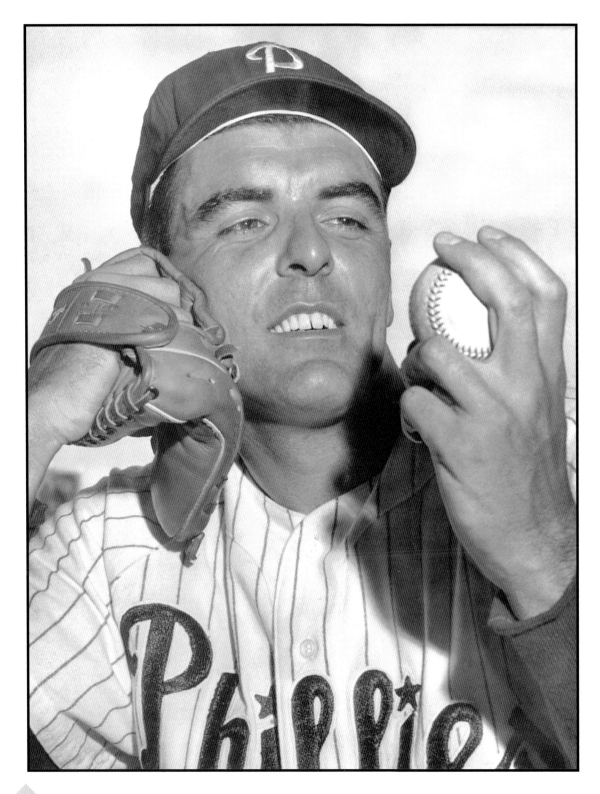

Curt Simmons
Pitcher, 1947 - 1950; 1952 - 1960

Curt Simmons was a high-priced "bonus baby" who made his debut in the major leagues at age 18 and eventually developed into one of the Phillies' most dependable starters.

Simmons was signed by the Phillies in 1947 for $65,000 and immediately sent to Wilmington. He struck out 197 batters in 147 innings, went 13-5 and was told to join the Phillies for the final week of their season. On the last day of the season, Simmons beat the Giants at Shibe Park 3-1 by striking out nine and allowing just five hits.

The following year, Simmons got off to a much rougher start. In his first outing, facing the Boston Braves, Simmons couldn't find home plate as he walked seven of the 14 batters he faced. He was knocked out of the game in the second inning trailing 4-0. Simmons' lack of control would haunt him during his first two seasons with the Phillies. He relied too much on his blazing speed, rarely finished his starts, and was combined 11-23.

In 1950, Simmons, still only 21, finally put it all together and won 17 games. But military service kept him out of the World Series and he missed the entire 1951 season. When he returned in 1952, Simmons picked up right where he'd left off. He won four of his first six starts, and was chosen to start the All-Star game. Simmons finished the year 14-8 and his six shutouts led the National League.

In 1953, he came within a single hit of a perfect game against the Milwaukee Braves. On May 16, Simmons gave up a single to the Braves' lead-off hitter, Bill Bruton, then retired the next 27 men in order to win 3-0. He ended the season with 16 wins.

As Simmons began the 1954 season, he had already won 73 games in the major leagues. Better yet, he was just 25 years old.

Bob Miller
Pitcher, 1949 - 1958

Bob Miller won 11 games for the Phillies in 1950, but injuries short-circuited his career as a starting pitcher and got him sent to the bullpen. Miller joined the Phillies late in 1949 after winning 19 games at Terre Haute.

The following spring, Miller was initially used in relief, but when veteran starters Russ Meyer and Ken Heintzelman struggled early in the season, Miller was given the opportunity to start. He quickly made the most of it. In his first, Miller beat the Boston Braves 2-1 by allowing just six hits. A week later, he beat St. Louis. Miller then proceeded to throw consecutive shutouts against Pittsburgh and Cincinnati. By the time he allowed a run to the Pirates in his next start, Miller had thrown over 22 straight scoreless innings. Eventually Miller ran his record to 8-0.

But in late June, Miller injured his back when he tripped over a step while carrying his bags to a waiting train. As a result, Miller missed a month. When he returned, he wasn't the same. Over the remainder of the season, Miller won just three of his final nine starts. In the World Series against the Yankees, Miller started Game 4, but he was pulled in the very first inning with the Phillies trailing 2-0.

By 1952, Miller was back in the minors. He would return to the Phillies in 1953 and win 8 games, but Miller lacked the stamina to finish games and the Phillies soon moved him to the bullpen. For the next three seasons, Miller was a key member of the Phillies relief corps. But in 1957, Miller broke his wrist when he fell over his children's toys at home. The following year, he retired.

Miller went into the insurance business and in 1965 became the head baseball coach at the University of Detroit.

Emory "Bubba" Church
Pitcher, 1950 - 1952

The most successful seasons of Bubba Church's major league career were his two years with the Phillies. Like Curt Simmons and Bob Miller, Church was another of the Phillies' strong-armed farmhands who moved quickly through the system. Church's 15 wins at Toronto in 1949 got him a ticket to the big leagues, where he was initially used out of the bullpen.

By the middle of 1950, Church was pressed into a starting role and he produced some memorable wins to help the Phillies capture the N.L. crown. He won five of his first six starts, including a pair of shutouts over the Cubs and Reds. But in mid-September, Church took a line drive in the face off the bat of Ted Kluszewski. He was carried off the field on a stretcher, made one final start, and wasn't used in the World Series.

In 1951, Church got off slowly, winning just three of his first eight starts. But beginning in late May, he reeled off five straight wins including back-to-back shutouts of the Pirates and Braves. Church ended the year with 15 victories and notched four shutouts. The highlight of the season was a one-hitter against the Pirates in August.

The next year, Church upset Phillies manger Eddie Sawyer by showing up to training camp out of shape. As a result, he pitched in only two games, before being traded to Cincinnati in May. His final three-plus years in the majors, split between the Reds and the Cubs, never produced another winning season. In 1955, Church retired rather than accept an assignment to the Pacific Coast League.

He returned to his native Alabama and went into the linen supply business.

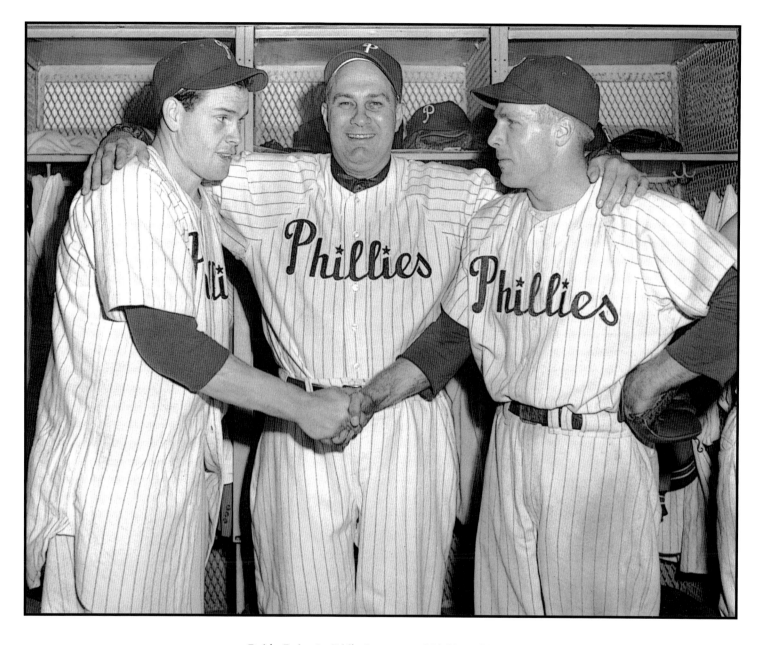

Robin Roberts, Eddie Sawyer and Richie Ashburn
Shibe Park, 1950

On May 16, 1950 pitcher Robin Roberts and the Cincinnati Reds' ace, Ewell Blackwell, engaged in an old-fashioned pitching duel. The Phillies Richie Ashburn scored the only run of the game in the bottom of the first inning. Blackwell limited the Phillies to just three hits, but Roberts was even better. The Reds got just two hits off Roberts as he blanked the Reds 1-0. Photographers were on hand in the clubhouse after the game to record the event.

It was Roberts' fifth win in his first six starts and one of five shutouts he would post that season. In late July, Roberts threw three consecutive shutouts of the Reds, Cubs and Pirates.

In the final game of the season, with the Dodgers just one game behind the Phillies, Roberts beat Brooklyn 4-1 to give the Phillies their first N.L. pennant in 35 years. Fittingly, it was Roberts' 20th win of the year.

**Willie Jones, Dick Sisler, Jim Konstanty and Robin Roberts
Ebbets Field, 1950**

In 1950, the Phillies success meant four players were chosen to the National League All-Star team. Third baseman Willie "Puddinhead" Jones would go on to hit a career-high 25 home runs that season.

Dick Sisler's three run-homer in the final game of the season would clinch the pennant for the Phillies. Reliever Jim Konstanty would set a new record by pitching in 74 games and be named the league's MVP.

Robin Roberts would be named to start the All-Star game in Chicago and produce his first 20-win season.

Richie Ashburn
Outfielder, 1948 - 1959

Richie Ashburn's mix of speed and defense got him recognized as one of the National League's premier centerfielders. In the field, Ashburn played very shallow, preferring to go back on fly balls, rather than let anything drop in front of him. His range allowed him to track down almost anything hit his way. During 12 seasons with the Phillies, Ashburn led the league in putouts nine times. More impressively, he remains the only player to ever record 500 or more putouts four times. At a time when the National League had centerfielders like Willie Mays and Duke Snider, Ashburn was named to four All-Star teams.

At the plate, Ashburn had several remarkable seasons. In 1950, his 14 triples led the National League. The next year, Ashburn hit .344, second only to Stan Musical's .355, and his 221 hits were the most in the major leagues. In fact, Ashburn would lead the N.L. in hits three times and win two batting titles.

But Ashburn was also an extremely patient hitter, often fouling off pitch after pitch until he got one he liked. As the Phillies lead-off hitter, Ashburn recognized the value of reaching base anyway he could. The result was that he led the National League in walks four times. Early in his career, Ashburn routinely bunted for base hits, until opposing infielders began playing him on the infield grass. Ashburn countered by chocking up on the bat and slashing the ball through the drawn-in infield.

Ashburn also proved remarkably durable. In June of 1950, Ashburn began a consecutive games streak that lasted through the end of the 1954 season, a stretch of 731 games. After missing a total of 14 games in 1955, Ashburn immediately began another streak, playing in every game for the next two seasons.

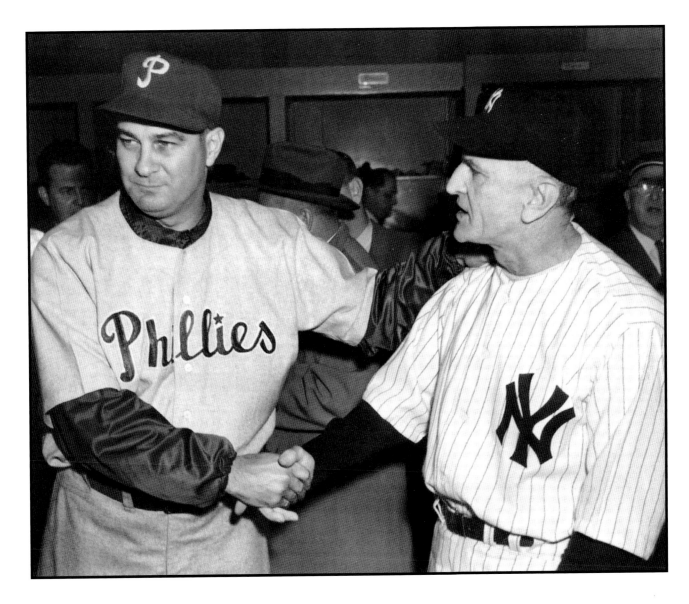

Eddie Sawyer and Casey Stengel
World Series, 1950

The 1950 World Series between the Phillies and the New York Yankees came down to pitching. The Phillies shocked everyone by handing the ball to reliever Jim Konstanty in Game 1. Konstanty held the Yankees to a single run, but it was not enough as the Yankees' Vic Raschi allowed just two hits and won 1-0.

In Game 2, Allie Reynolds and Robin Roberts battled each other to a 1-1 tie through nine innings until the Yankees' Joe DiMaggio hit a home run in the tenth to give the Yankees a 2-1 victory. Game 3 saw the Phillies squander a 2-1 lead in the eighth inning and lose 3-2.

In Game 4, the Yankees' Whitey Ford held the Phillies scoreless until the ninth inning and won 5-2 to complete the four-game sweep. Following Game 4, Phillies manager Eddie Sawyer sought out Yankees manager Casey Stengel to offer his congratulations.

For the Series, the Phillies hit just .202 and scored a total of five runs. Although the Yankees batted only .222 as a team, their pitching staff's ERA of 0.73 proved the difference.

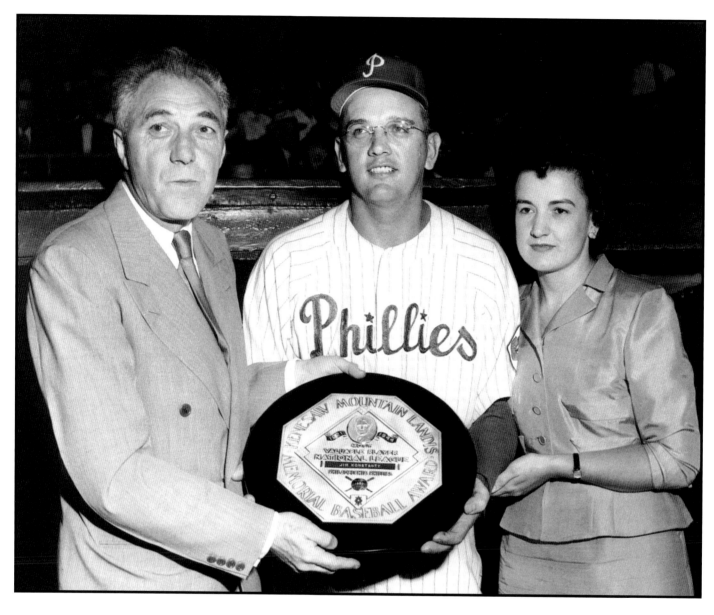

Commissioner Ford Frick and Jim Konstanty
Connie Mack Stadium, 1951

Jim Konstanty's performance out of the bullpen was the dominant factor in the Phillies capturing the National League pennant in 1950. Konstanty appeared in 74 games to establish a new major league record. Better still, he allowed just 108 hits in 152 innings of work. Konstanty was the first relief pitcher to ever win the MVP award.

Unlike the closers of today, Konstanty was often called upon to pitch an extended number of innings. On September 16, the Phillies and Reds played a doubleheader at Shibe Park. In the second game, the Phillies trailed 5-0 in the seventh inning before eventually tying the score in the ninth. Konstanty was brought in in the eighth inning and pitched nine scoreless innings before the Phillies finally won the game in the 18th inning. That same season, he threw nine innings of relief against Pittsburgh.

The following year, Konstanty, accompanied by his wife, was presented the league's Most Valuable Player award by Ford Frick.

Robin Roberts
The Polo Grounds, 1953

By 1953, Robin Roberts had firmly established himself as the workhorse of the National League. Beginning in 1950, Roberts would lead the N.L in starts for six straight seasons. During that same period, he threw more than 300 innings every season and led the league in that category five times.

Roberts' 28 wins in 1952 were the most by any pitcher in the majors in eight years. It also marked his third consecutive 20-win season, a streak that would reach six straight by 1955. Since 1940, the only other major league pitchers to equal Roberts' six straight 20-win seasons were Warren Spahn and Ferguson Jenkins. It is highly unlikely any future candidates will emerge to challenge the mark.

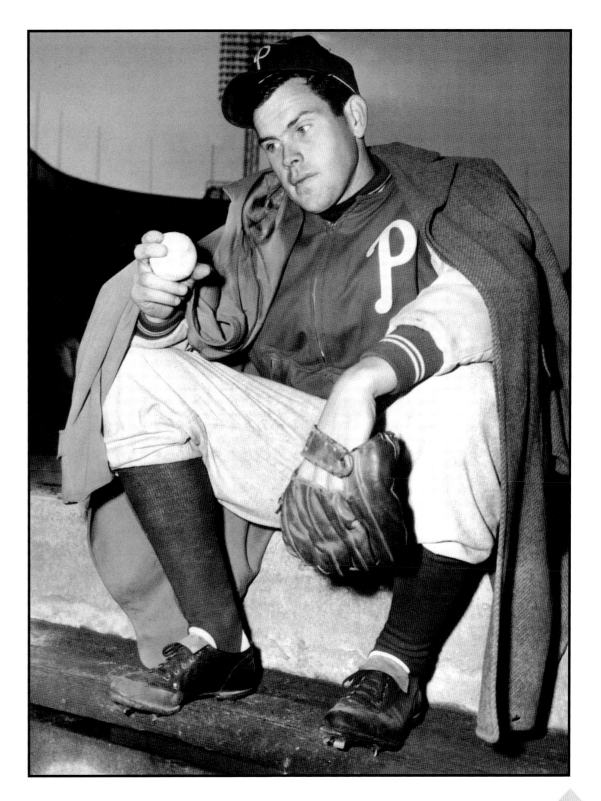

Stan Lopata
Catcher, 1948 - 1958

Stan Lopata spent most of his major league career as a back-up until a change in his batting stance turned him into a home run hitter. Lopata joined the Phillies in 1948 and spent several seasons as an understudy to veteran Andy Seminick. When Seminick left after the 1951 season, and was replaced by Smoky Burgess, Lopata continued to share time behind the plate.

But midway through the 1954 season, Lopata acted on a piece of hitting advice from the great Rogers Hornsby. Hornsby told Lopata he wasn't getting a good enough look at each pitch and the next day, Lopata began crouching at the plate. Lopata, who'd never hit more than eight home runs in any of his previous six seasons with the Phillies, ended the year with 14. In 1955, he hit 22.

Lopata's power surge got him more playing time. In 1956, he hit 32 home runs to lead the Phillies and drove in a career-high 95 runs. But a series of injuries cost him playing time over the next two seasons and his home run total dropped off dramatically. In 1959, the Phillies shipped Lopata to the Milwaukee Braves, where he backed up veteran Del Crandall for parts of two seasons before retiring in 1960.

Forrest "Smoky" Burgess
Catcher, 1952 - 1955

Smoky Burgess was a five-time All-Star who developed into one of the game's great pinch-hitters. Burgess played 18 seasons in the majors with five different teams. He came to the Phillies in 1952 and spent the next three years as the team's primary catcher. But the emergence of Stan Lopata made Burgess expendable and, early in 1955, he was traded to the Reds. Burgess responded with the best season of his career as he hit 21 home runs, drove in 78 and batted .301.

Burgess later played for the Pirates and the White Sox. In the 1960 World Series with Pittsburgh, he was six for 18. When he retired after the 1967 season, his 145 career pinch hits were the all-time record, a mark later eclipsed by the Dodgers' Manny Mota in 1979. Burgess died in 1991.

**Curt Simmons and Robin Roberts
Connie Mack Stadium**

During the decade of the 1950's, few other National League teams boasted a one-two pitching punch like the Phillies. Robin Roberts(with 199) and Curt Simmons(with 103) combined to win 302 games for the Phillies during the decade. In fact, only the Braves' duo of Warren Spahn and Lew Burdette, who combined for 338 wins during the 1950's, eclipsed the win total of Roberts and Simmons among National League hurlers.

Unfortunately for Phillies fans, all that success on the mound was rewarded with only three winning seasons by the Phillies during the 1950's.

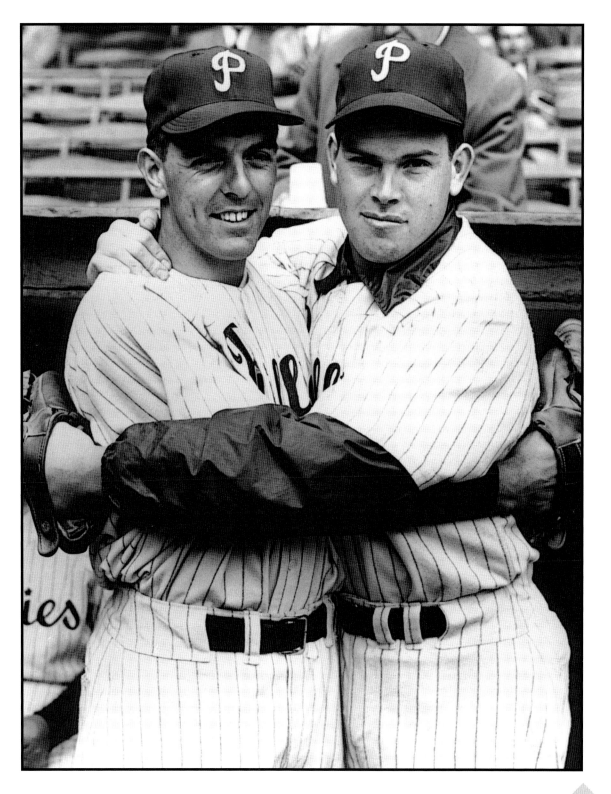

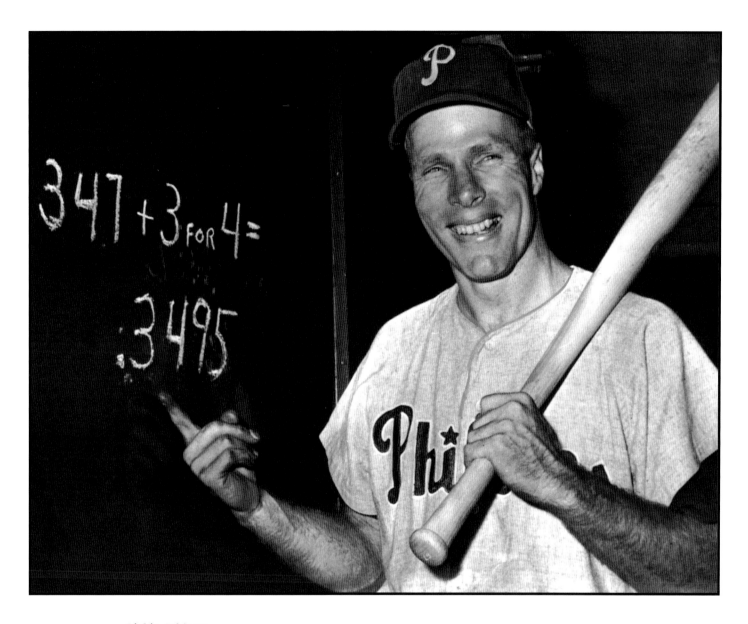

Richie Ashburn
Forbes Field, 1958

In 1958, Richie Ashburn won his second National League batting title, but he had to wait until the final day of the season to claim the crown. With one game left to play in the season, Ashburn was just percentage points ahead of the Giants' Willie Mays for the batting title.

Facing the Pirates at Forbes Field, Ashburn knocked out three singles in four at-bats to finish the year at .349. Later that same day, Mays went three for five against the Cardinals to end up at .347.

In an interview published in *The Saturday Evening Post*, Ashburn explained his approach at the plate. "For one thing, I change bats a lot. Sometimes I use a different bat every time up in a game. My bats are all the same size, but they vary in weight. Generally they run from 32 ounces up to 34 ½ ounces. With a heavier bat, you just meet the ball. I use it to get my timing back when I'm in a slump. Also, I use heavier bats against fast-ball pitchers. But I often change bats just on hunches, especially when I'm not going good."

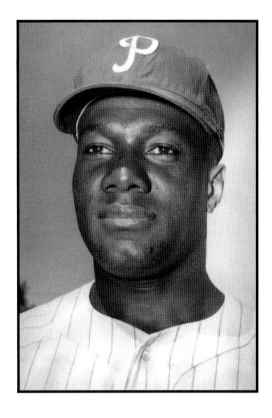

John Kennedy
Infielder, 1957

John Kennedy was the first African-American to play for the Phillies. A full ten years after Jackie Robinson had debuted with the Brooklyn Dodgers in 1947, the Phillies finally signed a black ballplayer. The move made them the last team in the National League to integrate their roster.

Kennedy had played three seasons in the Negro Leagues with the Birmingham Black Barons and the Kansas City Monarchs prior to going to spring training with the Phillies in 1957. When Kennedy hit over .330 that spring, he made the trip north to begin the season. But his stay in the big leagues proved a short one. Kennedy was used as a late-inning defensive replacement and saw action in just five games. He got two at-bats before being sent back to the minor leagues.

Kennedy continued playing in the minors for another three seasons, but never played in the majors again. He later worked for 15 years in a steel mill in Ohio and died in 1998.

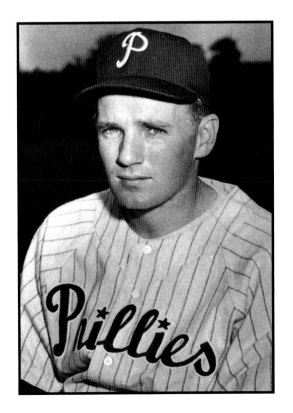

Jack Sanford
Pitcher, 1956 -1958

Jack Sanford won 19 games for the Phillies in 1957 and was named the National League's Rookie of the Year. Sanford proved to be a late-bloomer, spending almost a decade in the Phillies' farm system before debuting at the age of 27.

In his first full season in 1957, Sanford came out blazing. In early May, he struck out 10 hitters in back-to-back wins over the Cubs and Pirates. In June Sanford shut out the Dodgers on two hits and followed that up with 1-0 win over the Cubs in which he gave up just three hits and struck out 13. On July 11, he took a perfect game into the eighth inning against Chicago before allowing a single by Dale Long in a 3-1 victory. Sanford's success in the first half got him chosen to the National League All-Star team and by late July his record was 13-3.

Sanford finished 1957 with a 19-8 record and his 188 strikeouts led the league. But when he failed to match that success the following year, going 10-13, the Phillies decided to trade him to the Giants. Phillies owner Bob Carpenter quickly regretted the deal as Sanford won 15 games for San Francisco the next season. In 1959, Sanford was just 12-14, but his six shutouts led the National League.

In 1962, Sanford had a phenomenal year, winning 24 games and helping the Giants capture the N.L. pennant. At one point he reeled off 16 straight wins to tie the all-time mark. In the World Series against the Yankees, Sanford won Game 2 on a three-hitter, 2-0. He lost Game 5 despite striking out 10 and lost the crucial Game 7 to Ralph Terry 1-0.

Sanford would pitch for another five seasons before retiring in 1967.

Richie Ashburn
Spring Training, 1959

As Richie Ashburn reported to Florida for training camp in 1959, he was coming off the best season of his career. He'd just won his second batting title, led the National League in hits, walks and triples, and stolen 30 bases. About to turn 32, there was no way for him to know it would be his final season with the Phillies.

Ashburn's offensive numbers fell off in almost every major category in 1959. He hit .266, the lowest average in his 12 years with Philadelphia. That off-season, the Phillies front office, eager to make room for a young Johnny Callison, decided to trade Ashburn to the Chicago Cubs for three players. What they got in return wasn't much.

Veteran infielder Alvin Dark was already 37 and by late June, he was gone in a trade to Milwaukee. Minor league infielder Jim Woods would play a total of 34 games for the Phillies and never be heard from again. The final player in the deal was pitcher John Buzhardt, who'd thrown a one-hitter against the Phillies the previous May. Buzhardt would go a combined 11-34 in two full seasons with the Phillies and be sent to the White Sox in 1962. There, he had three very good seasons beginning in 1963.

For his part, Ashburn spent two productive years with the Cubs before being traded to the expansion New York Mets. The 1962 Mets lost 120 games, still the modern day mark for futility. Ashburn hit .306 and decided he'd seen enough bad baseball. He accepted an offer to return to Philadelphia and begin broadcasting Phillies games.

At age 36, Richie Ashburn was returning to the city where it all began.

Robin Roberts and Gene Mauch
Connie Mack Stadium, 1960

When the Phillies finished in last place in 1959 and lost the opening game of the 1960 season to Cincinnati 9-4, manager Eddie Sawyer quit. He was replaced for one game by Phillies coach Andy Cohen as the front office scrambled to find a permanent replacement.

Gene Mauch was managing in the Red Sox farm system at Minneapolis when the Phillies came calling. As a player, Mauch had been a journeyman, bouncing between the high minors and the majors for 15 seasons as a middle infielder. He had played sparingly for six different major league clubs and had slightly more than 300 games of experience in the major leagues. Mauch took over a ball club that had very little talent and hadn't had a winning season

since 1953.

Mauch's Phillies would finish 1960 at 59-95 and remain at the bottom of the National League standings. In 1961, it got worse. The team lost 107 games including a streak of 23 straight. Mauch fought openly with veteran Robin Roberts, whose 1-10 record that season prompted Mauch to tell the press that Roberts "was throwing like Betsy Ross."

When the 1961 season was over, Roberts' career with the Phillies was too. He was traded to Baltimore and pitched for another five years before retiring after the 1966 season. Roberts' 286 career wins got him elected to the Hall of Fame in 1976.

Ruben Amaro, Sr.
Infielder, 1960 - 1965

Ruben Amaro was a versatile glove man who could play all four infield positions. Amaro's father had been a superb player in Mexico, but had forbidden his son to follow in his footsteps. The younger Amaro ignored his father's pleadings and originally signed with the Cardinals before being traded to the Phillies in 1958.

Amaro's grace and range impressed manager Gene Mauch, who raved about his ability to get to balls other shortstops couldn't reach. In 1961, Amaro was the team's everyday shortstop and hit .257. However, he missed half the following season serving in the Army reserves and when Amaro returned, Mauch had given his position to Bobby Wine. As a result, Amaro began rotating around the Phillies infield, playing both first and third base.

Although he had almost no power at the plate, Amaro did manage to hit four home runs and drive in 34 runs in 1964. His .264 batting average that season was the highest of his career and he won a Gold Glove award for his defense.

But following the 1965 season, the Phillies traded Amaro to the Yankees. Amaro played another four seasons in the American League, but was a regular in only one of them. After spending one final season in the Pacific Coast League, Amaro began a long career as a scout and minor league manager. He also coached with the Phillies and the Cubs in the 1980's.

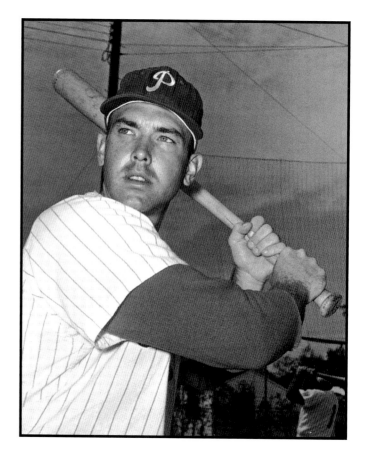

Clay Dalrymple
Catcher, 1960 - 1968

Clay Dalrymple's defensive skills kept him behind the plate for seven years as the Phillies' everyday catcher. In fact, Dalrymple's strong throwing arm and signal-calling more than made up for his shortcomings with the bat. His best offensive season came in 1962, when he hit 11 home runs and drove in a career-best 54 runs. However, his batting average dropped each of the next three seasons, hitting .213 in 1965. His lack of offensive production soon became a source of frustration for Phillies fans.

In 1966, Dalrymple began a streak of 99 straight games without an error. But a .172 batting average in 1967 finally cost him his spot in the starting line-up. Dalrymple caught just 80 games in 1968 and was traded after the season to Baltimore. With the Orioles, he played sparingly and was released after the 1971 season.

Tony Gonzalez
Outfielder, 1960 - 1968

Cuban Tony Gonzalez was a superb defensive outfielder who could hit for both power and average. Gonzalez debuted in the major leagues with the Cincinnati Reds in 1960. But the Reds' veteran outfield of Frank Robinson, Vada Pinson and Gus Bell left little playing time for Gonzalez and he was traded to the Phillies in late June.

In Philadelphia, Gonzalez quickly became a fixture in the Phillies outfield. Although he stood 5'9" and weighed just 170 pounds, Gonzalez had surprising power. In 1962, Gonzalez hit 20 home runs and stole 17 bases to go with his .302 average. He also played the entire season in the outfield without making a single error. The following season, he hit .306.

Gonzalez's greatest season came in 1967, when he hit .339 to finish second in the N.L. batting race behind Roberto Clemente. That same year, he also led all National League outfielders in fielding percentage.

But in 1968, Gonzalez's batting average slipped to .268 and the Phillies left him unprotected in that offseason's expansion draft. The San Diego Padres selected Gonzalez, but he played just 53 games before being traded to the Atlanta Braves. In the 1969 NLCS against the New York Mets, Gonzalez hit .357 with a home run. He spent 1971 with the California Angels before calling it quits.

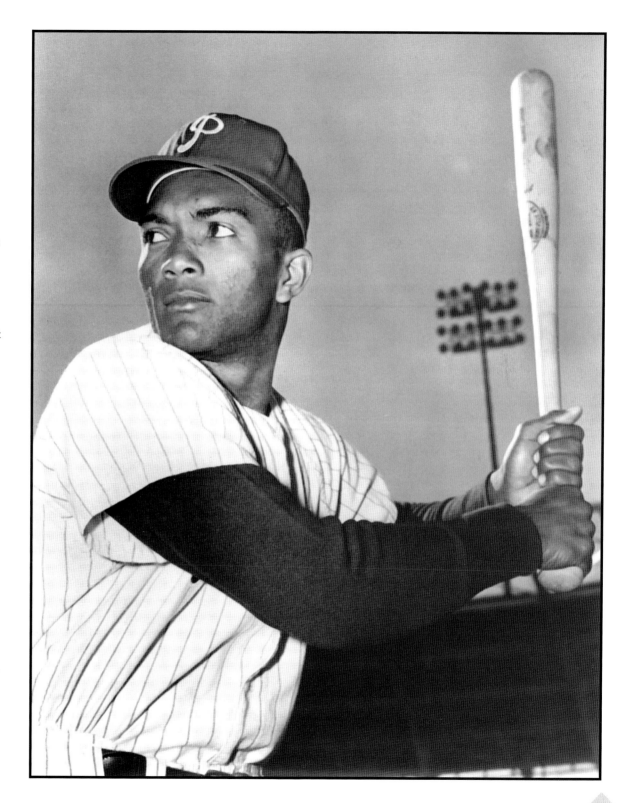

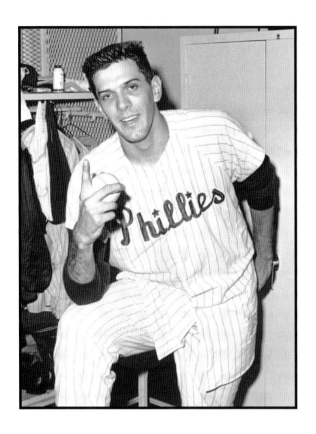

Art Mahaffey
Pitcher, 1960 - 1965

Art Mahaffey set the Phillies' franchise record by striking out 17 batters, but arm problems short-circuited his major league career. Mahaffey joined the Phillies midway through the 1960 season and was 7-3 in 12 starts including a two-hit shutout of the Giants.

In 1961, Mahaffey lost his first start 2-0 to San Francisco despite allowing just three hits. But on April 23, he was simply overpowering as he struck out 17 Cubs to win 6-0 at Connie Mack Stadium. However, the 1961 Phillies were a dreadful club and would end the season with 107 losses. As a result, Mahaffey deserved a better fate than his 11-19 record would indicate. On August 22, Mahaffey came within a single safety of a no-hitter against the Cubs. In his very next start he blanked the Braves 3-0.

The following season, Mahaffey's record caught up with his talent. By August 11, he'd won 16 games and seemed headed for a 20-win season. But he'd also thrown over 200 innings including 17 complete games. Over the final six weeks of the season, Mahaffey simply wore down. He won just three of his final 11 starts and finished the season with 19 victories. He threw a total of 274 innings for a Phillies staff where no other pitcher had more than 182. In the end, Mahaffey's 20 complete games were the second most in the major leagues behind only Warren Spahn's 22.

But all those innings soon took a toll and Mahaffey's workload dropped off dramatically in 1963. He made just 22 starts and struggled through injuries to a 7-10 record.

As Mahaffey's ERA ballooned and his effectiveness waned, Mauch lost confidence in the right-hander. A 2-5 record for the Phillies in 1965 got Mahaffey traded to the Cardinals a month after the season ended. Mahaffey pitched a total of 35 innings for St. Louis in 1966 before being released.

He later returned to the Philadelphia area and went into the insurance business.

Tony Taylor
Infielder, 1960 - 1971; 1974 - 1976

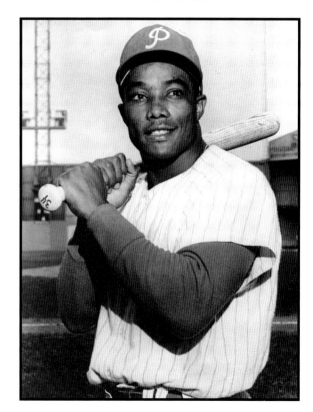

Versatile Tony Taylor's hustling style and his ability to play anywhere in the infield made him a fan favorite in Philadelphia for 15 years. Traded to the Phillies by the Cubs early in the 1960 season, Taylor responded by swiping 26 bases and batting .284. It was one of six times Taylor would steal more than 20 bases in a single season. In fact, during his time with the Phillies, Taylor stole home six times.

Taylor spent his first five seasons with the Phillies as the team's everyday second baseman. But the development of Cookie Rojas shifted Taylor to a utility role, filling in wherever he was needed. Early in 1966, he took over at third base for two months when Richie Allen went down and the following spring Taylor subbed for first baseman Bill White and Rojas at second when both were sidelined with injuries.

In 1970, Taylor hit .301 and belted a career-high nine home runs. But it would also mark his final season as an everyday player. The following year, he was dealt to Detroit for two minor-league pitchers. With the Tigers, Taylor hit .303 in 1972 to help the Tigers win a division title.

Released by the Tigers after the 1973 season, Taylor rejoined the Phillies for another three seasons. He served as the team's primary pinch hitter and his 17 pinch hits in 1974 led the National League.

After retiring in 1976, Taylor later coached with the Phillies and the Marlins.

Ray Culp
Pitcher, 1963 - 1966

Ray Culp twice won 14 games for the Phillies, but recurring arm problems got him shipped out of town prematurely. Culp was signed by the Phillies right out of high school for $100,000. He struggled with his command throughout his first two years in the minors before winning 13 games in 1962 for the Phillies' Class A affiliate. The following Spring, injuries to several veteran pitchers got Culp added to the Phillies roster as the team broke camp.

In his second start, Culp shut out Houston 7-0 on three hits. In June he won four of his six starts, including shutouts of the Cardinals and Mets. His two losses that month were 3-0 to Warren Spahn and the Braves despite allowing just two hits and a 2-1 loss to the Reds. By the All-Star break, Culp had won 10 games. But his over-reliance on breaking pitches strained his elbow and Culp failed to win any of his six starts in July. Although he led the N.L in walks, Culp finished the year 14-11.

But Culp continued to be plagued by a sore arm and in 1964 he was 8-7 in 19 starts. The highlight was a one-hitter against the Cubs in late June. But Mauch moved him to the bullpen for part of the season and refused to start him down the stretch as the team squandered the lead late in the season.

In 1965, Culp rebounded to win 14 games. But 1966 was another injury-plagued season as Culp made only 12 starts and finished up 7-4. The Phillies grew frustrated by Culp's inconsistency and dealt him to the Cubs that off-season. After a single mediocre season in Chicago, Culp was traded again, this time to the Boston Red Sox.

Backed by a stronger team, Culp became a consistent winner for Boston. In 1968, he won 16 games and threw six shutouts. Better still, Culp won 17 games in each of the next two seasons. He retired after the 1973 season, having compiled a 71-58 record for the Red Sox.

Bobby Wine
Shortstop, 1960; 1962 - 1968

Bobby Wine spent eight years with the Phillies, but recurring back problems limited him to just five seasons as the team's everyday shortstop. Wine hit well over .300 in his first two seasons in the minors, but a beaning caused him to begin pulling off inside pitches and his batting average plummeted. As a result, Wine realized his glove would be his ticket to the majors.

Initially Wine was used by the Phillies at both shortstop and third base. But in 1963, he took over at short and the result was a Gold Glove award. In fact, manager Gene Mauch was so enamored with Wine's defense that he kept playing him every day despite Wine's anemic performance at the plate. In four of Wine's five full seasons with the Phillies, he hit under .230.

In 1966, Wine missed six weeks with a strained back, but came back to lead all National League shortstops in fielding in 1967. But in 1968, he played in only 27 games before back surgery ended his season. It also ended his time with the Phillies. Wine was selected by the Montreal Expos in the 1969 expansion draft, where he was reunited with this former manager, Gene Mauch.

With Montreal, Wine spent three full years as the Expos' regular shortstop before retiring early in 1972. He immediately rejoined the Phillies as a coach, where he remained through the 1983 season. Wine later spent several seasons as a coach with the Atlanta Braves.

Gene Mauch
Manager, 1960 - 1968

Gene Mauch's fiery style transformed the Phillies into pennant contenders but his legacy will always be tied to the team's historic collapse in the final days of the 1964 season. Mauch was managing in the minor leagues when he was tapped to replace Eddie Sawyer just two games into the 1960 season. Mauch's first two years at the helm were a disaster, as the Phillies finished 47-107 in 1961. It was their worst showing since 1945. In fairness to Mauch, he had very little talent to work with. Veteran performers like Richie Ashburn were gone, replaced by a slew of unproven rookies who were forced to perfect their craft at the major league level.

Mauch was a disciplinarian who drilled his young team in the fundamentals and, in 1962, it finally began to pay off as the Phillies finished 81-80 and Mauch was named the National League's Manager of the Year. The team's fourth-place finish in 1963 provided the fans with their first real sign of hope in over a decade.

In 1964, the nucleus of young players like Johnny Callison and Chris Short was given a major jolt with the additions of rookie slugger Richie Allen and veteran pitcher Jim Bunning. The result was the Phillies started off strong and had built up a 6½ game lead by late September. Then it all turned sour. The Phillies were swept in a three-game series by the Cincinnati Reds, lost four straight to Milwaukee and dropped the next three to the Cardinals. The 10-game losing streak cost the Phillies the N.L. pennant as they finished tied for second place with the Reds, a single game behind the Cardinals.

Mauch was roundly criticized by the press and fans alike for his handling of the pitching staff during the season's final two weeks. His over-reliance on Bunning and Short, repeatedly pitching them on just two day's rest, was seen as a panicky move. But none of it would have mattered if the Reds and Cardinals had not chosen the final two weeks of the season to go on tear of their own.

While the Phillies were dropping 10 straight, the Reds won nine in a row and the Cardinals reeled off eight straight victories. The notoriety of the Phillies collapse wouldn't be eclipsed for another 33 years until the 2007 New York Mets imploded in the finals days of the season, dropping 12 of their last 17 games to be edged out by, ironically, the Phillies for the N.L.'s Eastern Division title.

For his part, Mauch continued managing the Phillies until midway through the 1968 season, when his constant battles with Richie Allen led to his firing. Mauch would enjoy a long career managing in the majors with the Expos, Twins and Angels. His only division titles came with California in 1982 and 1986. But Mauch's 26 seasons as a big league skipper never resulted in a trip to the World Series. He died in 2005.

Johnny Callison
Outfielder, 1960 - 1969

Slugger Johnny Callison spent a decade patrolling right field for the Phillies and twice drove in more than 100 runs. Callison was originally signed by the White Sox and rushed to the majors at age 19. But he wasn't ready to handle big league pitching and was back toiling in the minors when he was traded to the Phillies following the 1959 season.

Early on, Callison struggled though a series of injuries that hampered his development, before finally breaking out in 1962, when he hit .300 for the only time in his career. That same season, his 10 triples were tied for most in the National League. It also marked the first time in 30 years(since Chuck Klein in 1932) that a Phillie had a season with at least 10 home runs, doubles, triples and stolen bases. The next season, Callison hit for the cycle against the Pirates at Forbes Field.

In the 1964 All-Star game, Callison hit a dramatic three-run homer with two outs in the ninth inning to give the N.L. a 7-4 win. During the Phillies 10-game losing streak late in the season, Callison hit three home runs in a single game against Milwaukee. His 31 home runs and 104 RBI that season would get him chosen second to Ken Boyer in the National League MVP voting.

In 1965, Callison produced another huge year at the plate. In June, he once again hit three home runs in a single game, this time against the Cubs. His 32 home runs and 101 RBI were both tops on the Phillies and his 16 triples led the National League. The following year, Callison's 40 doubles were the most in the major leagues.

Callison also garnered rave reviews for his play in the field. He possessed an exceptionally accurate throwing arm and beginning in 1962, Callison led all N.L. right fielders in assists for four straight seasons. He was selected to three All-Star teams.

Although only 30, Callison was traded to the Cubs after the 1969 season. With Chicago, he played two years, but his offensive numbers declined steadily and he was traded to the Yankees in 1972. Callison's two seasons in New York were spent as a reserve and he retired following the 1973 season.

Jim Bunning
Pitcher, 1964 - 1967; 1970 - 1971

Jim Bunning's time with the Phillies was short, but his exploits helped transform the ball club into a perennial pennant contender. Bunning had already won 20 games and thrown a no-hitter for the Detroit Tigers during his first seven full seasons in the American League. But a 12-13 record for the Tigers in 1963 had caused the Detroit front office to make him available. The Phillies, desperate to add a proven starter to the top of their rotation, jumped at the chance to get Bunning.

In his first season for the Phillies, Bunning immediately proved his worth by posting a 19-8 record with five shutouts. The highlight came on June 21, Father's Day, in the first game of a doubleheader against the Mets at Shea Stadium. Bunning needed only 90 pitches to set down 27 Mets batters in order. It was the first perfect game in the National League in 84 years and made Bunning the only pitcher in the 20th Century to throw a no-hitter in both leagues.

Despite the disappointing conclusion to that season's pennant race, Bunning's 19-8 record in 1964 could easily have been even better. In seven of his starts, Bunning was given a no-decision despite the Phillies eventually winning the game. For example, on June 3, he threw 10 scoreless innings against Don Drysdale and the Dodgers in a game the Phillies won 1-0 in 11 innings. Better still, Bunning's ERA of 2.63 was the fifth-lowest in the National League.

The Phillies had found their new ace.

Richie Allen
Spring Training, 1964

In 1963, Richie Allen hit 33 home runs for Little Rock and earned a late-season call up to the Phillies. In 10 games, Allen batted .292 with a double, triple and two RBI. When Allen showed up in Clearwater the next Spring for camp, no one in the Phillies organization could have predicted the kind of rookie season he would have in 1964.

So when Phillies manager Gene Mauch announced during training camp that he was prepared to give the starting third baseman's job to Allen, it raised a lot of eyebrows among the press and fans alike. But Allen's prodigious talents at the plate soon helped convince them all to overlook his defensive struggles which eventually resulted in a league-leading 41 errors. To his credit, Allen started all 162 games at third base.

Thus, Allen's booming bat provided protection in the lineup for Johnny Callison and helped power the Phillies into first place by mid-July. By season's end, Allen had racked up 201 hits, batted .318 and led the National League in triples and runs scored. His 29 home runs and 91 RBI were both the second highest totals on the team. For his efforts, Allen was voted the N.L.'s Rookie of the Year.

The Phillies' bitter disappointment at squandering the pennant was lessened somewhat by knowing they had found their new power source.

**Pete Rose, Gene Mauch and Richie Allen
Connie Mack Stadium, 1964**

Phillies Manager Gene Mauch is shown flanked by two of the hottest rookies in the National League. Reds second baseman Pete Rose had been named the National League's Rookie of the Year in 1963. When the 1964 season was over, sportswriters would bestow the same honor on Richie Allen.

Recalling that season, Mauch would later tell reporters, "I never enjoyed a player more than Richie Allen in 1964." However, the relationship between Mauch and Allen would eventually deteriorate, costing Mauch his job by 1968. Allen would leave town the following year, traded to the Cardinals.

In a strange twist of fate, fifteen years after this photo was taken, Pete Rose would join the Phillies as a free agent in 1979 after 16 seasons with the Reds.

Chris Short
Pitcher, 1959 - 1972

Chris Short was a big, strong left-hander who won 20 games for the Phillies in 1966. Short spent just two years in the Phillies farm system before making two starts for the Phillies early in 1960 season. But when he walked 10 batters in 14 innings, Short proved he wasn't ready for the majors and the team sent him to Buffalo for more seasoning. The following year, he was in the big leagues to stay.

Short spent most of the next three seasons in Philadelphia working out of the bullpen. Manager Gene Mauch disliked rookies, particularly young pitchers who struggled, and Short got only an occasional starting assignment. When he added a curveball to his pitching repertoire, Short's career really took off.

In 1964, Short began the year in the bullpen, but when he was given a chance to start he made the most of it. Short won eight of his first 12 starts, including three shutouts. In three of other four games, the Phillies were held scoreless. By the end of the season, Short had made 31 starts and posted a 17-9 record. His ERA of 2.20 was the third-lowest in the National League behind only Sandy Koufax and Don Drysdale. Short's days as a reliever for the Phillies were over.

Short won 18 games for the Phillies in 1965. He opened the year with a four-hit shutout of Houston in the first regular- season game ever played in the Astrodome. By the All-Star break, Short had thrown five shutouts. In his final start of the season, Short pitched 15 scoreless innings against the New York Mets and struck out 18. His 297 innings of work that season were the fourth most in the N.L.

In 1966, Short was 20-10 for the fourth place Phillies. After a sub-par season in 1967, Short came back to win 19 games the next year. But it was his last great year as back surgery caused Short to miss almost the entire 1969 season. He was never the same. His three final years with the Phillies produced a combined record of 17-31.

Short was released by the Phillies after the 1972 season. He pitched for the Milwaukee Brewers for one final year before retiring. In 1988, Short suffered a brain aneurysm and lapsed into a coma. He never recovered and died in 1991.

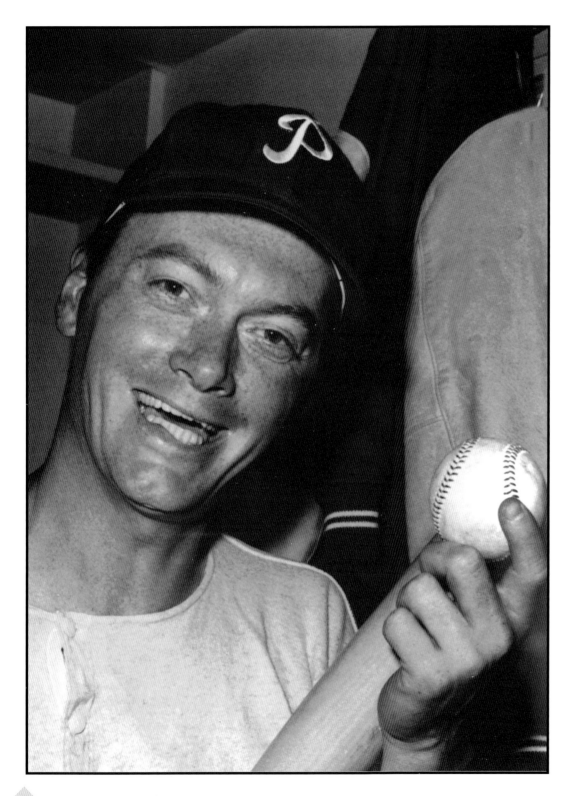

Jim Bunning
Shea Stadium, 1965

In 1965, Jim Bunning won another 19 games for the Phillies. On May 5, Bunning blanked the New York Mets 1-0 on four hits and, for good measure, hit a home run off Warren Spahn for the only run of the game. It was just one of seven shutouts that season for Bunning. Local photographers were in the Phillies locker room after the game to record the feat.

Bunning delivered another strong effort in 1966. On May 26, he threw 10 scoreless innings against the Giants in a game the Phillies lost 1-0 in 11 innings. On June 7, he struck out 14 Cincinnati Reds hitters, allowed just three hits and won 5-1. Three weeks later, he blanked the Mets 1-0 on two hits. In late July, Bunning and the Dodgers' Sandy Koufax both threw 11 innings of one-run ball before the L.A. won the game 2-1 in 12 innings. By season's end, he'd recorded 19 wins and led the National League in starts and shutouts.

In 1967, Bunning posted a 17-15 record, but he lost five games by the identical score of 1-0. Thus, if the Phillies' lackluster offense had provided better run support, Bunning surely would have notched another 20-win season. As it was, only three of the National League's 10 teams scored less runs in 1967 than the Phillies. For his part, Bunning's ERA of 2.29 was the second best in the league that season.

Despite Bunning leading the N.L. in starts, innings pitched, strikeouts and shutouts, the team's front office decided his best days were behind him and traded the 36 year-old to the Pittsburgh Pirates. The Phillies' suspicions proved correct as Bunning struggled through two mediocre seasons with the Pirates and Dodgers, going a combined 17-24 before returning to the Phillies in 1970.

Bunning was 10-15 for the Phillies in 1970, including winning the first game the Phillies played in Veteran's Stadium, and retired the following season. He spent five seasons managing in the minors before returning to his native Kentucky and eventually entering politics. In 1986, he was elected to the U.S. House of Representatives and in 1998 he began serving as United States Senator.

Bunning was elected to the Hall of Fame in 1996.

**Bill Campbell, Richie Ashburn and
Byrum Saam
Connie Mack Stadium, 1965**

By Saam had originally begun
broadcasting Phillies games on the radio in
1939. For the next 11 seasons, he also called
games for the Athletics as well. When the
Athletics left town after the 1954 season,
Saam returned to doing Phillies games,
along with the duo of Gene Kelly and
Claude Haring.

In 1963, former Phillies star Richie
Ashburn and Bill Campbell both joined Saam
in the broadcast booth. The trio would stay
together through the 1970 season.

Saam would retire after the 1975 season.

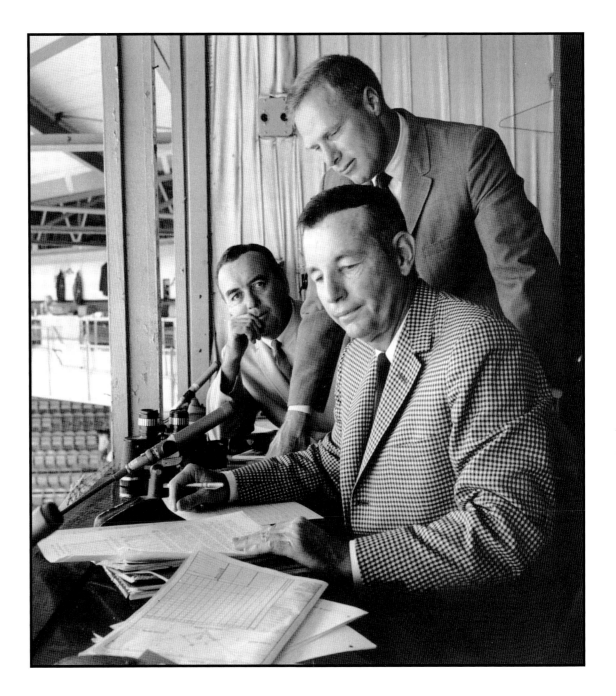

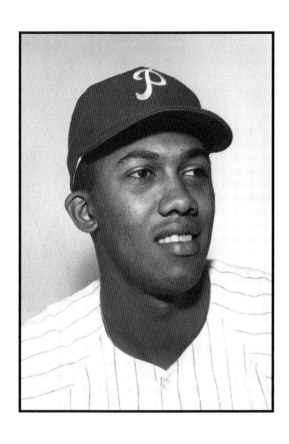

Ferguson Jenkins
Pitcher, 1965 - 1966

Ferguson Jenkins is the "one that got away" from the Phillies. Jenkins would pitch a total of eight games, all in relief, for the Phillies before being shipped to the Chicago Cubs in arguably the worst trade in franchise history.

Jenkins was signed by the Phillies right out of high school in his native Canada, where he was a five-sport star. His 7-2 record for Miami in the Class D Florida State League got him invited to training camp in 1963, but he was quickly returned to the minors where he won 12 games in 1964. By late the following year, he was called up to join the Phillies for the final month of the 1965 season.

Jenkins made his major league debut in relief on September 10 and ended the season throwing a total of 12 1/3 innings over seven appearances. He allowed a total of seven hits, gave up three runs and struck out 10. His ERA of 2.19 apparently went unnoticed. That off season, Jenkins pitched winter ball in Puerto Rico.

In 1966, Jenkins pitched in only one game for the Phillies. On April 20, Jenkins entered a game against the Braves with the Phillies already trailing 4-0. He pitched 2 1/3 innings giving up three hits and one earned run. The Phillies eventually lost the game 8-1. The next day, Jenkins was included in a multi-player deal with Chicago. The Phillies got two veteran pitchers, Bob Buhl and Larry Jackson. The price was Jenkins, outfielder Adolfo Phillips and reserve outfielder John Herrnstein.

Buhl was 37 and would win just six games for the Phillies before being released. Jackson was about to turn 35 and would put together three solid years for the Phillies before retiring after the 1968 season.

In Chicago, Jenkins would develop into one of the National League's most dominating pitchers. Beginning in 1967, he won at least 20 games for six straight years. By the time Jenkins finished pitching in the majors in 1983, he'd won a total of 284 games and thrown 49 career shutouts.

He was elected to the Hall of Fame in 1991.

Bill White
First Baseman, 1966 - 1968

Bill White came to the Phillies from the St. Louis Cardinals in 1966 in deal designed to shore up the Phillies sagging offense. White was a veteran of eight full seasons in the National League and had hit at least 20 home runs six times. Starting in 1962, he had driven in more than 100 runs for St. Louis for three straight years.

With the Phillies in 1966, White delivered another robust offensive season, hitting 22 home runs to go along with his 103 RBI. He provided a left-handed compliment to Richie Allen's power in the Phillies lineup and White's graceful glove work around first base gave the Phillies their most complete first baseman in two decades.

But that off-season, White tore his achillies heal playing racquetball and missed almost half of the 1967 season. When he did play it was often as a pinch hitter. As a result, White's power numbers dropped dramatically. He hit a total of just 17 home runs over two seasons for the Phillies before being traded back to St. Louis. But 1969 would be White's final year in the majors. At age 35, he was through.

In 1970, White turned to broadcasting, working for a local Philadelphia TV station for a year, before doing games for the Yankees network for the next 18 seasons. In 1989, he was named President of the National League.

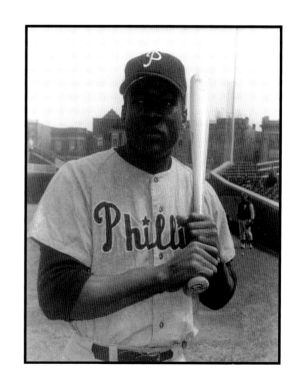

Octavio "Cookie" Rojas
Infielder/Outfielder, 1963 - 1969

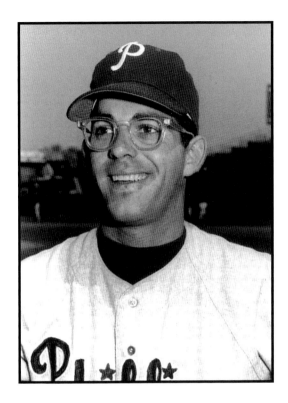

Cookie Rojas spent seven seasons as the Phillies' primary utility player. Originally a second baseman in the Reds chain, Rojas got his first major league hit off the Dodgers' Sandy Koufax. That off-season, he was traded to the Phillies. Manager Gene Mauch soon began using Rojas as the team's "super-sub", rotating him among all four infield and all three outfield positions. He even occasionally caught a game behind the plate.

Rojas had his best season for the Phillies in 1965, when he hit .303 and was selected to the All-Star team. A superb contact hitter, Rojas struck out just 33 times that season in over 520 at-bats. But it was really his versatility that made his so valuable to the Phillies.

In 1970, Rojas was part of the multi-player deal that sent Richie Allen to the Cardinals for Tim McCarver and Curt Flood. But Rojas was quickly traded again, this time to the expansion Kansas City Royals.

Rojas would play five-plus seasons as the Royals' regular second baseman. Beginning in 1971, he was selected to four straight A.L. All-Star teams. Rojas retired after the 1977 season and spent the next four years as a coach with the Chicago Cubs. In 1982 he joined the California Angels as a scout and in 1988 succeeded Gene Mauch as manager for a single season. He later worked as a coach and a broadcaster with the Florida Marlins.

Rick Wise
Pitcher, 1964; 1966 - 1971

Rick Wise threw a no-hitter for the Phillies in 1971 and was traded to St. Louis in the deal that brought Steve Carlton to the Phillies. In 1964, Wise made his debut in the majors at age 18 after pitching just 12 games in the minor leagues. Wise won five of his eight starts before being sent back to the minors, where he spent the entire 1965 season.

Over the next several seasons, Wise gradually expanded his arsenal of off-speed pitches to compliment his fastball and began winning on a more consistent basis. In 1969, Wise won 15 games and had an ERA of 3.23. The highlight of the season were consecutive shutouts of the Astros and Padres in August.

On June 23, 1971, the Phillies were in Cincinnati to play the Reds at the newly-opened Riverfront Stadium. Wise came within a single walk of pitching a perfect game. For good measure, Wise also hit two home runs as the Phillies won 4-0. He finished the season 17-14 with four shutouts. Wise thought his efforts merited a big pay increase and he held out. Rather than meet his demands, the Phillies shipped him to the Cardinals for Steve Carlton, who was also seeking a big pay increase after winning 20 games for St. Louis in 1971.

Wise twice won 16 games for the Cardinals before being traded to the Boston Red Sox. In 1975, Wise was 19-12 as the Red Sox won the American League pennant. In the World Series against the Reds, Wise was the winning pitcher in Game 6 when Carlton Fisk's dramatic home run in the 12th inning won the game for Boston.

Wise pitched another six full seasons with Boston, Cleveland and San Diego before retiring early in 1982. He later spent over 20 years as a minor league pitching coach.

Richie Allen
Crosley Field, 1968

By 1968, Richie Allen had already put together four solid offensive seasons for the Phillies. His 40 home runs, 110 RBI and a .317 average in 1966 put Allen in the top four in all three Triple Crown categories. and made him one of the National League's most feared hitters. That off-season, Allen held out for a huge pay increase, until Phillies owner Bob Carpenter got involved in the negotiations and the two settled on a salary figure of $85,000, nearly double what Allen had made in 1966.

Allen was enjoying another big year in 1967 when a freak accident in late August put him out for the remainder the year. Allen severed two tendons and damaged nerves in his right arm when he put his fist though the headlight an old car he was pushing on the street in front of his home. For a time, doctors were unsure if Allen could continue playing.

But in 1968 Allen returned to form and hit 33 home runs, including three in one game against the Mets. The following season, Allen hit a home run in five straight games.

But Allen's erratic behavior on and off the field began to draw headlines in the local press. In May 1969, he missed a team flight to St. Louis. Six weeks later, he missed a doubleheader with the Mets. The Phillies suspended Allen for a month. He responded by demanding to be traded. In early August, Allen began spelling out words in the infield dirt around first base between innings. The press had a field day with the disgruntled Allen, who responded to their criticisms by changing his clothes in an equipment closet outside the Phillies clubhouse. Finally, fed up with the actions of their star player, the Phillies obliged Allen's request that off-season and dealt him to the Cardinals.

Allen became a baseball nomad, playing for three different teams over the next three years. In 1972, he landed in Chicago with the White Sox, where he led the American League in home runs and RBI that season.

By the time Allen returned to the Phillies in 1975, he'd already hit a total of 319 home runs in the majors. Unfortunately, he'd hit only 27 more for the Phils before ending his career with the Oakland A's in 1977.

Woodie Fryman
Pitcher, 1968 - 1972

Woodie Fryman pitched 18 seasons in the major leagues and threw four one-hitters, but rarely posted a winning record. Fryman won 12 games as a rookie for the Pirates in 1966, including a three-hit shutout of the Phillies in June. The following season he struck out 15 Phillies, allowed just three hits and beat Philadelphia 3-0 at Forbes Field. Despite a 3-8 record for the Pirates in 1967, the Phillies insisted that Fryman be included as part of the deal that off-season for Jim Bunning.

A big, strong left-hander who relied on an overpowering fastball, Fryman got off to a great start for the Phillies in 1968. In his third start of the season, he blanked Houston on two hits and in May Fryman shut out the Cardinals and Mets in consecutive starts on a total of eight hits. By the time he beat Gaylord Perry and the Giants 2-1 on June 5, his record was 8-4. But Fryman had a poor second half of the season to finish 12-14.

Fryman won another 12 games for the Phillies in 1969, but missed almost half of the 1970 season with elbow trouble. In 1971, he spent the first half of the season in the bullpen, then won 10 of his 17 starts including shutouts of the Expos and Dodgers.

But when Fryman got off to a slow start in 1972, the Phillies traded him to Detroit. There he went 10-3 over the second half of the season to help pitch the Tigers to the American League's Eastern Division title. But a 6-13 and a 6-9 record the next two seasons got him shipped to Montreal.

In 1975, Fryman was just 9-12 for the Expos, but put together a stretch of 32 2/3 consecutive scoreless innings. However, 1976 would mark Fryman's last big season as starter as he was 13-13 for the Expos. Fryman pitched for the Reds and the Cubs briefly before returning to Montreal in 1978 where he was soon used exclusively as a reliever for another four-plus seasons until his retirement in 1983.

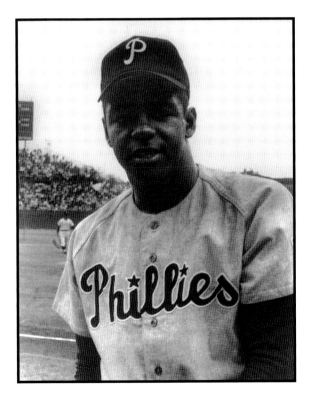

Larry Hisle
Outfielder, 1968 - 1971

Larry Hisle hit 20 home runs for the Phillies in his first full season in the majors, but Philadelphia gave up on the young slugger prematurely and his best days occurred in the American League. Hisle was a superb all-around athlete who played one season of college basketball at Ohio State before the Phillies convinced him to concentrate on baseball. When he hit .303 in the Pacific Coast League in 1968, Hisle got a late season call-up with the Phillies.

He began the following season with the Phillies on a tear, getting four hits in game for the second time by mid-May. In June, he hit two home runs in a game against the Mets. By the end of 1969, Hisle's 20 home runs were the second-most on the Phillies behind only Richie Allen's 32.

But the following season, Hisle struggled at the plate, lost his confidence and finished the year with a .205 average and just 10 home runs. By the middle of 1971, he was back in the minor leagues. The Phillies later traded him to the Dodgers for Tommy Hutton and Hisle was all but forgotten until he was acquired by the Minnesota Twins in 1973.

With the Twins, Hisle gradually fulfilled his potential and in 1976, he drove in 96 runs and stole 31 bases. In 1977, Hisle hit 28 home runs and his 119 RBI were tops in the American League. For good measure, he hit .302 and stole 21 bases. But after the 1977 season, Hisle and the Twins couldn't agree on a new contract and Hisle signed with the Milwaukee Brewers as a free agent.

But Hisle's 34 home runs and 115 RBI for the Brewers in 1978 were his only productive season there. Shoulder injuries sapped Hisle of his power and despite playing sporadically for parts of another four seasons, Hisle never hit more than six home runs in any of them and was out of the major leagues by 1982.

Deron Johnson
First Baseman, 1969 - 1973

Deron Johnson spent three seasons as the main power source in the middle of the Phillies line-up. Johnson began his major league career with the Yankees, but his career only took off once he joined the Cincinnati Reds in 1964. In 1965, Johnson hit 32 home runs and drove in 130 runs to lead the National League in RBI. But his numbers dropped off dramatically each of the next two seasons, prompting a trade to the Braves. When he batted .208 and hit just eight home runs for Atlanta in 1968, he was sold to the Phillies. Johnson quickly made the Phillies' investment pay off.

Johnson drove in 80 runs for the Phillies that first season, despite missing a month with a pulled hamstring. In 1970, he hit 27 home runs to go with 93 RBI. In 1971, Johnson hit three home runs in a July game against Montreal at Veterans Stadium. By season's end, he'd hit 34 home runs and driven in 95 for a Phillies team that lost 95 games and finished sixth.

Johnson began the 1972 season with 11 RBI in his first 10 games, but nagging leg injuries cost him playing time and he hit just nine home runs and batted .213. Early the next year, he was traded to Oakland, where he helped the A's win the World Series. Johnson played another three seasons, all in the American League, before retiring in 1976.

Johnson served 15 seasons as a coach with six different major league clubs, including three years with the Phillies, before his death from cancer in 1992 at age 53.

Greg "The Bull" Luzinski
Outfielder, 1970 - 1980

Greg Luzinski was a first-round draft pick whose mammoth home runs thrilled Phillies fans for nearly a decade. Luzinski's reputation as a slugger was well known long before he ever got to the major leagues as he hit more than 30 home runs for three straight years while playing in the Phillies' farm system. When he got a late season call-up for the final month of the 1971 season, Luzinski batted .300 and hit safely in 24 of the 28 games he played in. His first home run landed in the fifth deck of the left field stands at Veterans Stadium.

In 1972, Luzinski hit a ball off the top of the Liberty Bell logo in dead centerfield at the Vet, estimated at over 500 feet. His 18 home runs and 68 RBI that year led the Phillies as Luzinski took over as the team's everyday leftfielder.

Luzinski hit 29 home runs and drove in 97 runs in 1973 to lead the club in both categories for the second straight year. Four times that season, he hit two home runs in a single game and he made only two errors all season to lead all N.L. outfielders in fielding percentage.

But Luzinski missed two months in the middle of the 1974 season due to knee surgery and played in just 85 games. He came back stronger than ever in 1975 to help power the Phillies to their best season in a decade. Luzinski hit 34 home runs and his 120 RBI led the National League.

Best of all, Luzinski's most productive offensive seasons were right around the corner.

Guillermo "Willie" Montanez
Outfielder/First Baseman, 1970 - 1975; 1982

Willie Montanez hit 30 home runs and drove in 99 runs in his first full season in the majors to break Richie Allen's rookie home run record for the Phillies. Montanez came to the Phillies as compensation when veteran Curt Flood refused to report to the Phillies after being traded in the deal that sent Richie Allen to the St. Louis Cardinals in 1970. Montazez was originally a first baseman in the Cardinals chain, but the presence of veteran Deron Johnson at first base for the Phillies necessitated a change.

In 1971, Montanez had such a strong showing in training camp that manager Frank Lucchesi made him the starting centerfielder. Despite having to learn a new position at the major league level, Montanez responded with a breakout season. He hit 30 home runs and produced 99 RBI. As a result, he finished second in the National League Rookie of the Year balloting. In 1972, his 39 doubles led the National League. Early the next season, Montanez took over at first base following the trade of Deron Johnson to Oakland.

Montanez, who was Puerto Rican, was a flashy player who twirled his bat on the way to the plate and made one-handed catches with a swiping motion that got him branded a "hot dog" in the press. But Montanez could hit and in 1974 he led the Phillies with a .304 average and 33 doubles. He also had 13 game-winning RBI and put together a 24-game hitting streak.

But early in 1975, the Phillies traded Montanez to San Francisco for outfielder Gary Maddox. With the Giants, Montanez hit .305 for the remainder of the season and finished the year with 101 RBI. But he soon was on the move again, playing for six different clubs over the next six seasons.

Released by the Pirates early in 1982, Montanez went back to the minors in an effort to prolong his career. The Phillies brought Montanez back late that season, but he played in just 18 games, mostly as a pinch-hitter, hit .063 and retired.

Terry Harmon
Infielder, 1967; 1969 - 1977

Terry Harmon spent a decade as the Phillies' spare infielder, but his poor performance at the plate kept him from becoming an everyday player. Harmon alternated between second, third and shortstop whenever a veteran needed a day off or came up lame. He was considered a smooth fielder, whose long stays on the bench didn't seem to erode his skills with the glove. In 1971, Harmon set a major league record by handling 18 chances at second base in a nine-inning game against San Diego.

But for all Harmon's defensive skills in the field, he provided almost nothing at the plate. In 10 seasons with the Phillies, Harmon only twice hit as many as two home runs in a single season, In fact, his career total was four round-trippers in 1125 at-bats. In addition, Harmon never drove in more than 16 runs in any single season. Only once did he steal more than three bases in a season. 1972 and 1976 were the only two years Harmon hit better than .250.

When veteran Phillies second baseman Dave Cash signed with Montreal as a free agent after the 1976 season, the Phillies traded for veteran infielder Ted Sizemore rather than give Harmon the job. Harmon was released after the 1977 season. He never played in the majors again.

Wayne Twitchell
Pitcher, 1971 - 1977

Wayne Twitchell won 13 games for the Phillies in 1973, but his career was sidetracked by injuries. Twitchell was a first-round pick of the Astros in 1968, who blazed his way through the minor leagues on the strength of his overpowering fastball. But when he joined the Phillies in 1971, he quickly learned that he couldn't get by in the majors with just one pitch.

While spending his first season and a half with Philadelphia in the bullpen Twitchell worked to develop a slider to keep hitters off balance. Put into the Phillies rotation for the second half of the 1972 season, Twitchell was 3-8 in 15 starts. He did, however, show occasional flashes such as shutting out the Astros 4-0 in August.

In 1973, Twitchell didn't make his first start until early May. But when he blanked the Astros and Padres in consecutive starts in June and ran his record

to 6-3 by early July, he was selected to the National League All-Star team. Twitchell threw a second pair of shutouts against the Pirates and Cubs and by mid-September he'd won 13 games. But Twitchell's right knee was injured in a collision with the Cubs' Billy Williams while covering first base and he was out for the remainder of the season. He would finish the year with the third-lowest ERA in the National League behind only Tom Seaver and Don Sutton. That off-season, Twitchell re-injured the knee playing pick-up basketball.

As a result, Twitchell came to camp in 1974 on crutches and was slow to recover. He went 6-9 and had another losing season in 1975. By 1976, he was back in the bullpen where he struck out 67 batters in 62 innings of work.

But the Phillies traded him to the Expos the next season. He pitched briefly for the Yankees and Mariners before retiring in 1979.

Steve Carlton
Veterans Stadium, 1972

Steve Carlton had won 20 games for St. Louis in 1971 before being traded to the Phillies, but no one could have predicted the debut season Carlton would put together for Philadelphia.

Carlton got off to a very strong start, beating Ferguson Jenkins and the Cubs on a four-hitter in his Phillies debut. Four days later, he beat Bob Gibson and the Cardinals 1-0 on a three-hitter. In his third start, facing Juan Marichal and the Giants, Carlton gave up a single to the first batter and set down the next 26 in row to narrowly miss a no-hitter. He also struck out 14 Giants. It was just one of nine games that season where he struck out 10 or more batters.

But not all the close decisions went Carlton's way. On June 16, he threw 10 scoreless innings in a game the Phillies lost 1-0 in 11 innings. However, beginning in late July, he threw four complete-game shutouts in a stretch of five starts. By season's end, Carlton had thrown a total of eight shutouts, the most by a Phillies pitcher since Grover Cleveland Alexander in 1917.

When Carlton took the mound for the Phillies in 1972, it often meant a day off for the bullpen. Carlton threw 30 complete games that season, the most by a Phillies starter in 20 years. In this day of relief specialists, it's a mark almost certain to never again be equaled.

In addition, his 310 strikeouts that season made Carlton the first Phillies pitcher to ever top the 300 mark in a single season. Only Curt Shilling's 319 in 1997 has bettered Carlton's franchise mark.

Carlton's domination in 1972 would result in a 27-10 record and his 1.98 ERA would lead the National League. Despite the team's 59-97 record that year, Phillies fans very quickly stopped complaining about the trade that had sent Rick Wise to the Cardinals.

Larry Bowa
Shortstop, 1970 - 1981

Larry Bowa's stellar defensive work and fiery attitude made him a mainstay for the Phillies for over a decade. Bowa played college ball in his native Sacramento, where a Phillies scout sent to look him over saw Bowa thrown out of both games of a doubleheader. When his small size left him undrafted, Bowa signed with the Phillies as a free agent and was shipped to the minors.

In 1970, Bowa began the year as the Phillies' starting shortstop. Despite his early struggles at the plate, Bowa's defensive skills kept him in the lineup and in September he put together an 18-game hitting streak. In 1972, Bowa committed just nine errors all season, then the N.L. record for shortstops as he won his first Gold Glove award. That same season, Bowa's 13 triples led the major leagues.

Bowa's value to the Phillies extended beyond his work in the field. In 1974, Bowa stole 39 bases, the most by a Phillie since Hans Lobert's 41 in 1913. In 12 seasons with the Phillies, Bowa would swipe a total of 288 bases, including two steals of home. He consistently did the little things to help his team win that didn't always show up in the box scores including leading the league with 18 sacrifice bunts in 1972.

In 1978, Bowa led the Phillies in hits for the second straight season. He also won his second Gold Glove award and was selected to his fifth All-Star team. When the Phillies won their third straight division title in 1978, Bowa's 31 doubles and .294 average earned him third place in the National League's MVP balloting.

Bowa was traded to the Cubs after the 1981 season. He played three-plus seasons in Chicago and helped the Cubs to their first division title in 1984. In 1986, Bowa began managing in the minors and in 1987 he was named manager of the San Diego Padres. He was fired early the following season and immediately returned to the Phillies as a coach. He later coached with the Angels and Mariners.

In 2001, Bowa would take over as manager of the Phillies.

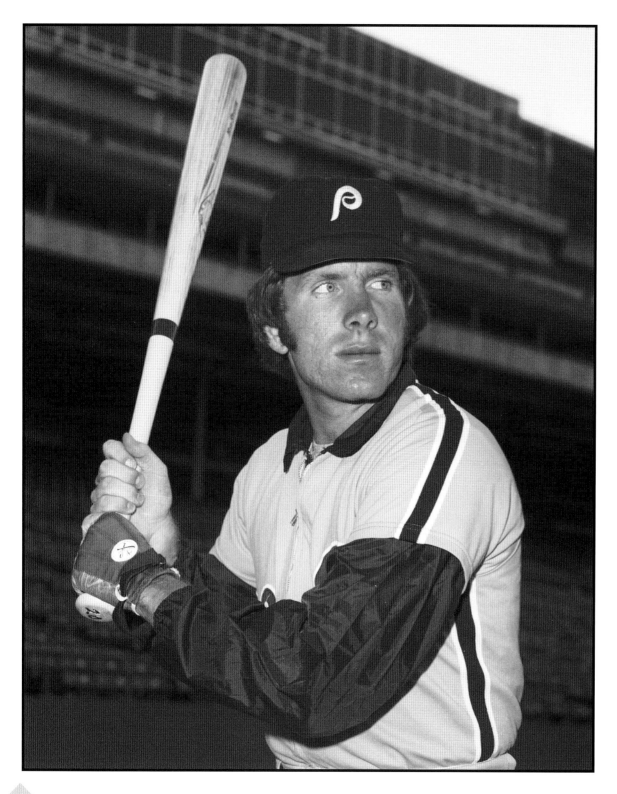

**Mike Schmidt
Candlestick Park, 1973**

As a college shortstop in his native Ohio, Mike Schmidt's surgically repaired knees scared off many big league clubs and 34 other players were chosen ahead of him in the 1971 draft. Schmidt spent just two seasons in the minors before joining the Phillies for the final three weeks of the 1972 season. But Schmidt's brief debut proved a mismatch as he batted 34 times and struck out 15.

In 1973, Schmidt managed to hit 18 homers and drive in 52 runs, but his alarmingly high number of strikeouts, 136 in 367 at-bats, had the Phillies front office determined to send him back to the minors. Only the pleading of manager Danny Ozark kept Schmidt on the Phillies roster. But even Ozark grew frustrated with the development of his young slugger. Schmidt himself would later concede, "All I wanted to do my first season was hit the ball out of sight." Ozark spent extended periods of time working with Schmidt in the batting cage to refine his hitting. That off-season, Schmidt even played winter ball in Puerto Rico in an effort to improve his game.

In 1974, Schmidt's hard work and determination finally bore fruit and produced a break-out season. Schmidt hit 36 home runs to lead the N. L. and his 116 RBI were the third-highest total in either league. Although his 138 whiffs led the National League, Schmidt raised his batting average nearly 90 points to a more respectable .282. Better still, the Phillies finally escaped last place, winning 80 games and finishing third in the N.L.'s Eastern Division.

Schmidt and the Phillies' best seasons were right around the corner.

Bob Boone
Catcher, 1972 - 1981

Bob Boone was a superb defensive catcher who spent nearly a decade behind the plate for the Phillies. Boone, whose father Ray had played in the major leagues, had been a third baseman while at Stanford, but was converted to catching by the Phillies while still in the low minors. There, Boone's strong arm and his ability to cut down opposing base runners got him a late-season call-up to the Phillies in 1972.

In 1973, Boone took over as the Phillies everyday catcher. He promptly led the league in assists and his strong showing behind the plate earned Boone a third-place finish in the National League's Rookie of the Year voting. The following season, he caught the second-most games of any catcher in the National League.

In 1976, Boone was selected to the N.L. All-Star team, an honor he would also earn in 1978 and 1979. At a time when the National League featured catchers like Johnny Bench and Gary Carter, both future Hall of Famers, Boone won two consecutive Gold Glove Awards while with the Phillies. In the 1980 World Series against the Royals, Boone caught all six games and batted .412 with two doubles and four RBI. But knee problems caused Boone to miss nearly half of the 1981 season and his offense suffered.

As a result, the Phillies sold Boone to the California Angels after the 1981 season. There he played another seven seasons and won another five Gold Glove awards. He played two additional years for the Kansas City Royals before retiring in 1990.

Beginning in 1995, Boone managed the Royals for parts of three seasons and in 2001 he took over the reigns of the Cincinnati Reds for another two-plus seasons, where he was reunited with his son, Aaron, the Red's third baseman. He later joined the Washington Nationals as a front office advisor.

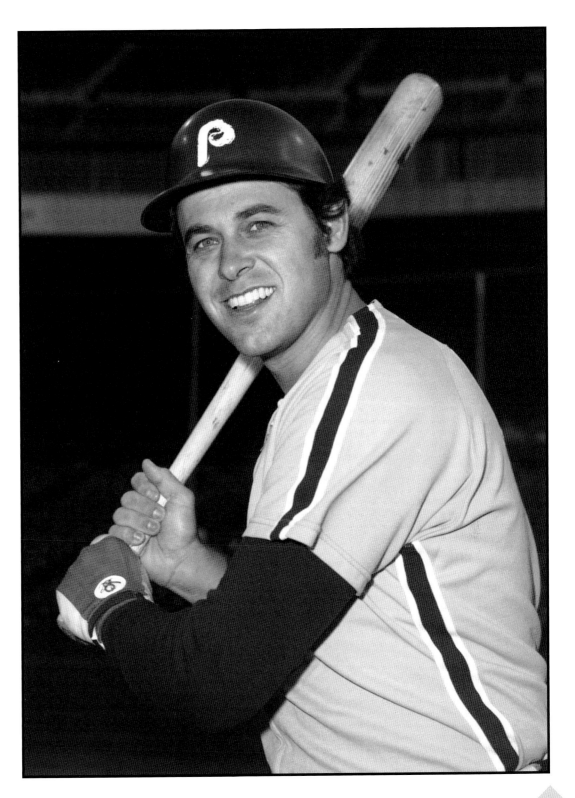

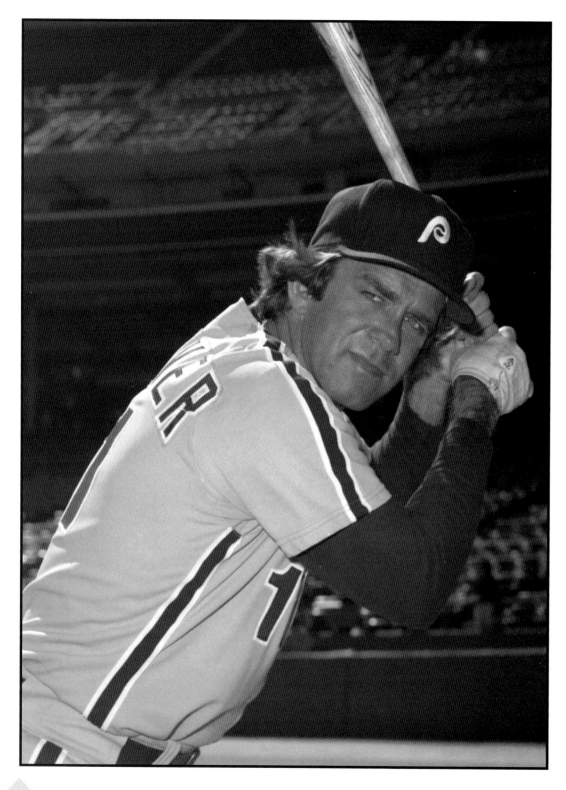

Tim McCarver
Catcher, 1970 - 1972; 1975 - 1980

Tim McCarver spent two tours of duty behind the plate with the Phillies and worked primarily as Steve Carlton's personal catcher. McCarver's first decade in the major leagues had been spent with the St. Louis Cardinals, where he and pitcher Bob Gibson worked in three World Series together.

McCarver was traded to the Phillies after the 1969 season in the same deal that sent Richie Allen to St. Louis. But McCarver missed nearly all the 1970 season with injuries and despite catching 125 games for the Phillies in 1971, he was shipped to the Montreal Expos early in the 1972 season.

When the Phillies front office brought McCarver back to Philadelphia in 1975, he was already 33 and it was hoped that his re-pairing with former battery-mate Steve Carlton would produce more wins. In fact, the return of McCarver was seen as the solution to Carlton's unhappiness with Bob Boone's signal calling.

Carlton's comfort level with McCarver is certainly part of the reason that the veteran lefthander enjoyed his first 20-win season in four years. When Carlton won another 23 games the next season, his reliance on McCarver became a forgone conclusion in the minds of the press, who began going to McCarver for post-game interviews in light of Carlton's famous silence towards the local media.

Although he was used primarily as a pinch hitter on the days he didn't catch Carlton, age and injuries slowly robbed McCarver of his talent and by the end of 1979, he was done. Thus, when Carlton won another 24 games in 1980, he did it without McCarver.

McCarver quickly embarked on a long career in broadcasting. Starting in 1980, McCarver spent three seasons as a color analyst on Phillies games before joining Ralph Kiner in the Mets booth for the next 16 seasons. He later worked on Yankees games and was part of the FOX network's national baseball telecast for many years.

Danny Ozark
Manager, 1973 - 1979

Danny Ozark guided Philadelphia to three consecutive division titles during his seven seasons as the Phillies' manager. As a player, Ozark was a slugging first baseman who spent 15 seasons in the Dodgers farm system, but never played a single day in the major leagues. In 1956, he began managing in the minor leagues and later served the Dodgers as a coach for eight years under manager Walter Alston.

Ozark was hired as Phillies manager in 1973, and took over a team that had produced five straight losing seasons and three consecutive last-place finishes. Ozark instantly began drilling his young team on the fundamentals and although the Phillies again finished in last place in 1973, they won 12 more games than the previous year.

In 1974, Ozark guided the Phillies to an 80-82 record and a third-place finish, their best showing in seven years. The infusion of young talent like Mike Schmidt and the front office's acquisition of several key veterans like Dave Cash and Jim Lonborg helped solidify the Phillies lineup. By 1975, the Phillies would find themselves in contention until the final two weeks of the season before finishing in second place. For his efforts, Ozark was named N.L. Manager of the Year.

By 1976, the mix of young talent and veteran players finally jelled as the Phillies got off to a great start and enjoyed a 10-game lead over their nearest rival at the All-Star break. Despite a late season swoon which saw their lead shrink to just three games by mid-September, the Phillies won 101 games and made the postseason for the first time since 1950. But a three-game sweep at the hands of the Cincinnati Reds in the LCS left Phillies fans feeling unfulfilled.

Ozark's club would again win 101 games in 1977, but a second straight loss in the divisional playoffs, this time to the Dodgers, was a bitter disappointment. When the Phillies failed to advance in the playoffs for the third straight season in 1978, the press and fans alike began questioning the team's mental toughness.

The following season, the Phillies' signing of veteran Pete Rose as a free-agent further raised expectations, but the team's poor play ultimately doomed them to a disappointing fourth place finish and cost Ozark his job on August 31.

Ozark returned to the Dodgers as a coach for three years and later spent two seasons coaching with the Giants before retiring after the 1984 season.

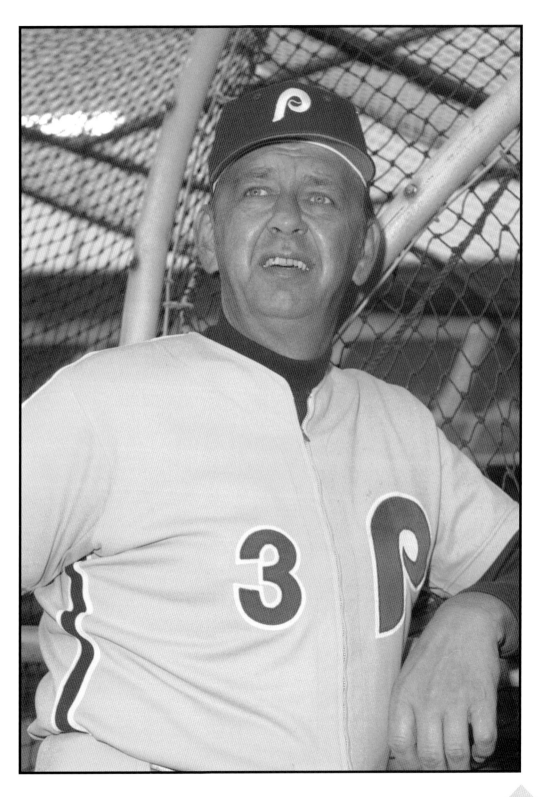

Jim Lonborg
Pitcher, 1973 - 1979

Jim Lonborg battled through injuries to win a total of 65 games during his six full seasons in the Phillies' starting rotation. Lonborg had begun his major league career with the Boston Red Sox, for whom he won 22 games and the Cy Young award in 1967. However, Lonborg tore knee ligaments that off-season while skiing and he struggled with numerous injuries during four more mediocre seasons before being traded to the Milwaukee Brewers for the 1972 season.

But when Lonborg won 14 games that year, he caught the eye of the Phillies, who were desperately looking for more pitching help. In his first season in Philadelphia, Lonborg broke a toe on his left foot, spent a month in the bullpen and finished the year with a 13-16 record.

In 1974, Lonborg rebounded to win 17 games for the Phillies. He threw 16 complete games, including three shutouts and even managed to hit a grand slam home run against the Expos in June.

Lonborg got off to a torrid start in 1975. He lost just one of his first nine starts and threw a pair of three-hit shutouts against Montreal. In mid-June, he posted a two-hitter against the Dodgers. But Lonborg just couldn't seem to stay healthy. In a June game versus the Cubs he pulled a back muscle and won just two more games that season to finish up 8-6.

In 1976, Lonborg was 18-10 for the Phillies and his ERA of 3.08 was the lowest on the Phillies starting staff. When the Phillies finally clinched the division in late September, it was Lonborg's complete game four-hitter in Montreal that did the trick. In the divisional series against the Reds, Lonborg started Game 2 and threw five hitless innings, but got the loss when the Reds rallied in the sixth to erase a 2-0 Phillies lead.

Lonborg began the 1977 season on the DL with shoulder problems and didn't make his first start until late May. For those brief periods when he was healthy, Lonborg was extremely effective. He was combined 8-1 in July and August, including a two-hit complete game win against the Dodgers, before finishing the year 11-4.

In 1978, Lonborg was again hampered by arm problems and his 8-10 record that year marked the end of the line with the Phillies. He made a single start in 1979, lasting only two innings against the Reds, before retiring.

He returned to Massachusetts, enrolled in dental school, and practiced dentistry for more than 20 years.

Dave Cash
Second Baseman, 1974 - 1976

Dave Cash's time with the Phillies was short, but his contributions on, and off the field, helped mold the Phillies into a consistent winner. Cash debuted in the majors with Pittsburgh, where he took over at second base for Pirates icon Bill Mazeroski and played on three straight division-winning clubs. The Phillies front office was determined to overhaul the Phillies lineup and acquired Cash to provide an offensive upgrade at second base and leadership in the clubhouse. Cash immediately did both.

In 1974, Cash played in all 162 games and banged out 206 hits, the most by a Phillie since Richie Ashburn's 215 in 1958. Better still, his .300 average and 20 stolen bases got him selected to the All-Star team that summer. He had two separate 13-game hitting streaks and struck out just 33 times in 687 at-bats. In the field, Cash led the National League in total chances, turned the most double plays of any second baseman in the N.L. and finished second in the Gold Glove balloting.

But for all his success in the field and at the plate, Cash's veteran leadership in the Phillies clubhouse may have been his greatest contribution to turning around the Phillies losing ways. He coined the phrase "Yes We Can" as the team's rallying cry and took a special interest in mentoring a struggling Mike Schmidt.

Cash recalled "When I came to the Phillies in 1974, Mike had all the tools, but he didn't have the confidence. He was constantly doubting himself. And the fans rode him pretty hard. I spent a lot of time with him, trying to get him to block out the crowd." Schmidt himself, later echoed those sentiments, "Dave Cash also helped me in terms of having a good, positive attitude around the clubhouse. He always seemed to say the right things to me. It was such a big difference from guys like Bowa, Luzinski and Montanez, who were ragging on me all the time, kidding me about striking out."

In 1975, Cash put up a second straight stellar offensive season. He hit .305 with 40 doubles and his 213 hits were the most in the either league. Cash thus became the first Phillies player since Chuck Klein in 1932-33 to have consecutive 200 hit seasons. He once again played in all 162 games and he had four hits in single game three times that season.

But 1976 would be Cash's final season in Philadelphia. Despite winning a Gold Glove, leading the National League in triples and hitting .308 in the playoffs, the Phillies let Cash depart as a free agent rather than sign him to a multi-year contract.

Cash played another three seasons with Montreal and one in San Diego before retiring in 1980.

Garry Maddox
Outfielder, 1975 - 1986

Speedy Garry Maddox won eight Gold Glove awards during his 12 seasons in Philadelphia earning him the nickname "the Secretary of Defense". Mets broadcaster and Hall of Famer Ralph Kiner may have gone one better when he summed up Maddox by saying, "Two-thirds of the earth is covered by water, the other third by Garry Maddox."

Maddox's first three big league seasons were spent in San Francisco with the Giants. But early in 1975, the Phillies sent popular first baseman Willie Montanez to the Giants for Maddox in move roundly criticized by many Phillies fans. But Maddox's performance in the field and at the plate quickly made believers out of the skeptics.

In his first full season with the Phillies, Maddox finished third in the race for the N.L. batting title with a .330 average and stole 29 bases. It was the fourth of Maddox's eventual eight consecutive seasons with 20 or more steals.

But it was Maddox's ability to cover so much real estate at Veterans Stadium that often had Phillies fans on their feet. For in the decades before the nightly cable sports shows, Maddox was his own human highlight film with his spectacular play in centerfield.

In 1978, Maddox put together a 20-game hit streak and his 34 doubles and 33 steals were both tops on the Phillies. But that production was overshadowed by a rare fielding miscue in the postseason. In the divisional playoffs with the Dodgers, Maddox dropped a routine fly ball in the 10th inning of a tie game to give Los Angeles the series in four games.

However, Maddox would redeem himself in the 1980 divisional series against the Houston Astros when he drove home the winning run in the 10th inning of Game 5 at the Astrodome. When Maddox also caught the final out of the game to send the Phillies to their first World Series in 30 years, his teammates carried him off the field on their shoulders.

But over the next several seasons, injuries began to cost Maddox playing time and back surgery following the 1985 season forced him to retire just two weeks in the 1986 season.

Dick Ruthven
Pitcher, 1973 - 1975; 1978 - 1983

Dick Ruthven joined the Phillies straight out of college, where he was an All-American at Fresno State. In his second start he matched up with Bob Gibson and limited the Cardinals to one run in seven-plus innings of work in a game the Phillies won 2-1. In his next start, Ruthven held the defending champion Cincinnati Reds to a single hit over seven innings as the Phillies won 1-0. And on July 1, Ruthven threw a complete game two-hit shutout against St. Louis and beat Gibson 1-0.

But Ruthven's performance on the mound didn't always translate into a winning record. In 1974, he posted a 9-13 record, but suffered from a lack of run support. In six of his losses, the Phillies were shut out and Ruthven lost a pair of 1-0 games to the Dodgers and Astros despite allowing just three hits in each game.

Ruthven spent the first half of the 1975 season in the minors and upon his recall in August, split time between starting and relieving. That off-season, the Phillies dealt him to the White Sox in the deal for veteran pitcher Jim Kaat.

Ruthven rejoined the Phillies two months into the 1978 season and paid immediate dividends. He was 13-5 for the Phillies over the remainder of the season as Philadelphia won its third straight divisional crown. In 1979, Ruthven began the year 6-0 before an elbow injury ended his season prematurely.

He recovered to win 17 games for the Phillies in 1980 and his two scoreless innings of relief in Game 5 of the divisional series against Houston sent the Phillies to the World Series. Ruthven started and lasted nine innings in Game 3 against Kansas City before the Royals rallied to win 4-3 in the 10th inning.

Ruthven continued pitching for the Phillies for another two-plus seasons before being traded to the Chicago Cubs early in 1983. There, he was a combined 22-26 over the next three years before being released by Chicago early in 1986.

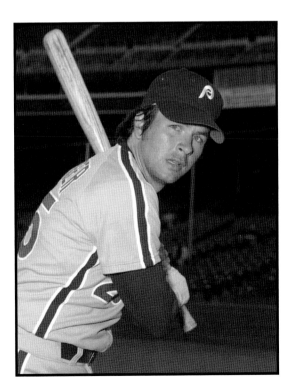

Del Unser
Outfielder/First Baseman, 1973 - 1974; 1979 - 1982

Del Unser was *The Sporting News'* American League Rookie of the Year in 1968 for the Washington Senators, but it was his postseason heroics as a pinch-hitter for the Phillies in 1980 for which he will always be remembered. Unser was already a veteran of five seasons in the American League when he was traded to the Phillies following the 1972 season.

Unser had two steady, if unspectacular, years as the Phillies' everyday centerfielder before being traded to the Mets in the deal for pitcher Tug McGraw. After another four years with the Mets and Expos, Unser was 34 and out of work. He signed with the Phillies and quickly developed an affinity for coming off the bench in key situations.

In 1979, Unser batted a career-high .298 and hit a home run in three consecutive pinch-hitting appearances. But he saved his best performance for when it mattered most. In the 1980 divisional playoffs against Houston, Unser's pinch-hit in the eighth inning of Game 5 tied the score and he later doubled and scored the winning run in the 11th inning. In the World Series against the Royals, Unser had a pinch-hit double in the eighth inning of Game 2 to start a rally and his double in Game 5 tied the game in the ninth inning. One batter later, Unser once again scored the winning run to put the Phillies up three games to two in the Series.

Unser's playing time dropped off sharply in 1981 and he was released early in 1982. He served as the Phillies hitting coach for four seasons from 1985 to 1988.

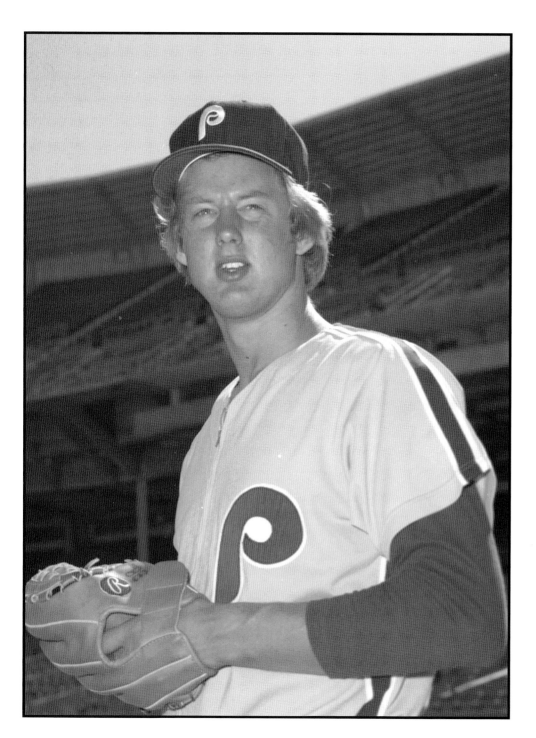

Larry Christenson
Pitcher, 1973 - 1983

Larry Christenson spent his entire major league career with the Phillies, but injuries often kept him on the sidelines and limited his effectiveness. As a 19-year old with just 35 innings of experience in rookie ball, Christenson was so impressive in his first training camp with the Phillies that they decided to keep him when the team went north. In his first start in the majors, Christenson threw a complete game five-hitter and beat the New York Mets 7-1. He came within a single pitch of a shutout until he uncorked a wild pitch with two outs in the ninth inning to score the Mets' only run of the game. Unfortunately for the Phillies and their fans, it would be the youngster's only victory of the season. Manager Danny Ozark had his young rookie on a tight leash as Christenson only made it past the third inning twice in his remaining eight starts and by June he was back in the minor leagues. That off-season, he had elbow surgery.

Christenson eventually worked his way back into the Phillies rotation and in 1975 he won 11 games including a pair of shutouts. In 1976, he won 13 games despite missing time with back problems. No slouch at the plate, Christenson also hit two home runs in a single game against the Mets that September.

In 1977, Christenson got off to a terrible start, winning just four of his first 11 starts. But beginning in early June, he suddenly blossomed into one of the National League's most consistent starters. At one point, he went 14 starts without a loss. Better still, Christenson won all seven of his starts in the final month of the season to finish the year at 19-6 and send the Phillies to the postseason for the second straight time.

But 1977 would prove to be pinnacle of Christenson's career in the majors as he produced just one winning season in his final six years with Philadelphia. In 1978, Christenson was 13-14 despite having the lowest ERA(3.24) of his career. That off-season, he broke his collarbone, missed almost half the 1979 season and was 5-10 in 17 starts.

In 1980, two separate groin injuries and elbow surgery limited him to 14 starts. Christenson started Game 4 of the World Series against Kansas City, but was knocked out in the first inning. He posted a 4-7 record in 1981.

In 1982, Christenson produced a 9-10 record despite three games with 10 or more strikeouts. But again, his off-season involved elbow surgery. A 2-4 record in nine starts in 1983 signaled the end of the line for Christenson as the Phillies released him. He was 29 years old.

Jim Kaat
Pitcher, 1976 - 1979

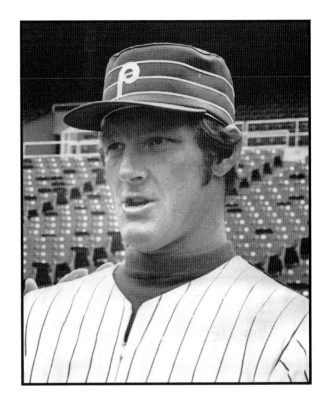

Jim Kaat was already 37 and a three-time 20 game winner in the majors when he joined the Phillies in 1976. In 1966, Kaat's 25 wins for the Minnesota Twins had led the American League. Better still, Kaat had just finished back to back 20-win seasons for the Chicago White Sox. That off-season, the Phillies sent three players, including pitcher Dick Ruthven and infielder Alan Bannister, to Chicago for Kaat.

Kaat's first year in Philadelphia produced a 12-14 record. That season, fans were well-advised to get to the ballpark on time when Kaat pitched as the big left-hander had six starts that he completed in two hours or less. In fact, on July 11, Kaat need just 1:36 to shut out the Padres 3-0 at the Vet. His best stretch came in mid-season as Kaat was undefeated in six starts in June including consecutive victories over the champion Reds. In the divisional playoffs against Cincinnati, Kaat started Game 3 and pitched six scoreless innings before the Reds rallied against the Phillies bullpen to sweep the series.

In 1977, Kaat began the season in the Phillies bullpen and struggled to a 6-11 record. Recognized as one of the greatest fielding pitchers of all time, Kaat also won his 16th consecutive Gold Glove award that season.

Kaat began the 1978 season with a three-hit shutout of the Cubs, but ended up with an 8-5 record in 24 starts. Just five weeks into the 1979 season, the Phillies sold Kaat to the Yankees. In New York, Kaat was converted into a reliever and his final five years in the majors were split between the Yankees and the Cardinals, with whom he spent his final season in 1983. Kaat finished his career with 283 wins and is one of just a handful of players to play in four different decades.

He later began a long career as a color analyst on the Twins and Yankees broadcasts.

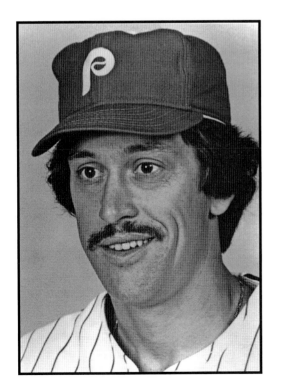

John Vukovich
Infielder, 1970 - 1971; 1976 - 1977; 1979 - 1981

John Vukovich's contributions to the Phillies organization far exceeded his performance on the field. As a career utility player, Vukovich played parts of 10 seasons in the major leagues with the Phillies, Brewers and Reds. But it was his long tenure as a coach with the Phillies for which he is most remembered.

In 1982, following his retirement, Vukovich immediately followed Dallas Green to Chicago and joined the Cubs as a coach. Six years later, he returned to the Phillies.

Over the next 17 seasons(and six different managers), Vukovich schooled the newest Phillies on the right way to play the game. His no-nonsense approach and blunt style made him a favorite of players and fans alike. Whether hitting fungos or pitching batting practice, Vukovich's love of the game was clear for all to see.

In 2001, Vukovich underwent brain surgery as doctors removed a benign tumor. He returned to coaching, but in 2004, Vukovich left the field and moved into the front office as an assistant to General Manager Ed Wade. Late in 2006, Vukovich's symptoms returned and he died the following March during spring training.

The Phillies wore a commemorative patch on their uniforms for the 2007 season and that July inducted Vukovich into the Phillies Wall of Fame.

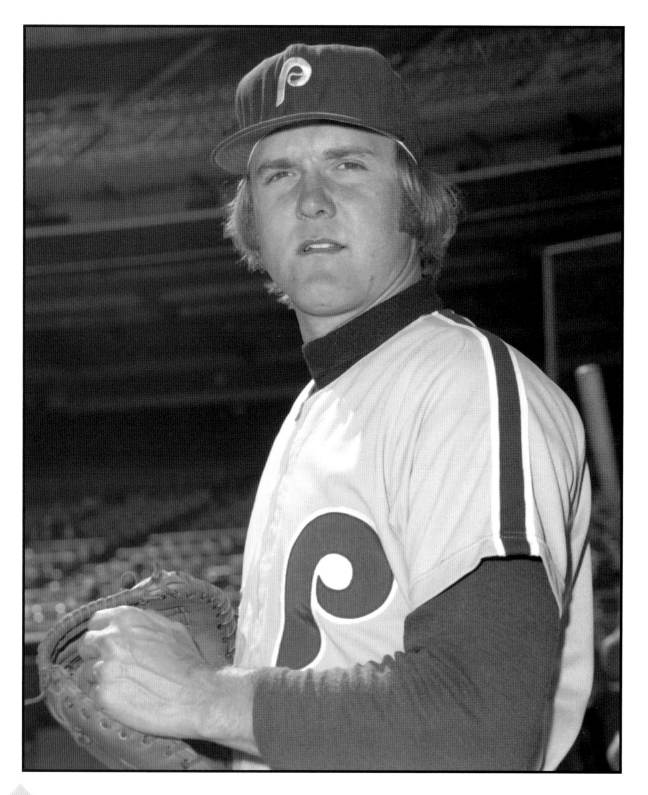

Frank "Tug" McGraw
Pitcher, 1975 - 1984

Tug McGraw's ability to close out games was a key ingredient in the Phillies capturing three straight divisional titles and, ultimately, their first World Series title in 1980. McGraw's first nine seasons in the majors were spent with the New York Mets, whom McGraw helped pitch to a pair of World Series appearances in 1969 and 1973. There his colorful personality and penchant for clubhouse pranks made him a favorite of the local media. But following a sub-par season in 1974, the Mets dealt McGraw to the Phillies.

In Philadelphia, McGraw quickly became the Phillies "go-to" guy in the late innings. He routinely pitched in 50-60 games each season and, beginning in 1975, his ERA was under 3.00 for three straight years.

Just as importantly, he kept his teammates loose. He told reporters that he named each of his pitches. There was the "Jamison" because "I like my whiskey straight"; the "Peggy Lee" which left hitters wondering "Is that all there is?" and even the "Cutty Sark", because "it sails". Through it all, McGraw got hitters out.

And when the Phillies finally ended decades of frustration by making it back to the World Series in 1980, McGraw was simply sensational. He would pitch the best baseball of his long career and lead the victory parade down Broad Street.

Greg Luzinski and Mike Schmidt
Veterans Stadium, 1976

When the Phillies won 101 games and clinched their first Eastern Divisional title in 1976, the team's offensive success was built around the bats of Mike Schmidt and Greg Luzinski. Schmidt's 38 home runs were the most in the National League and his 116 RBI ranked third. Luzinski batted .304 and drove in 97 runs to go with his 21 round-trippers. As a result, the Phillies scored the second most runs in the N.L. in 1976.

Unfortunately, their opponents in the playoffs, the Cincinnati Reds, had won 102 games while scoring the most runs in the majors in 15 years. The Reds were an offensive juggernaut, leading the National League in doubles, triples, home runs, batting average and stolen bases. For good effect, they also committed the fewest errors in either league. They were, after all, the defending World Champions for a reason.

Thus it was probably no surprise that the three-game series was a mismatch. The Phillies pitching staff simply couldn't keep the Reds hitters at bay. Cincinnati won the first two games by scores of 6-3 and 6-2 , banging out 10 hits in each game. In Game 3, played in Cincinnati, the Phillies held a 6-4 lead entering the bottom of the ninth before the back-to-back home runs by George Foster and Johnny Bench powered the Reds to a 7-6 win and a sweep.

The Phillies' quest for a championship would have to wait.

Andy Musser
Broadcaster, 1976 - 2001

Versatile Andy Musser spent 25 seasons in the Phillies broadcast booth. In 1976, Musser joined the team of Harry Kalas and Richie Ashburn following the retirement of veteran announcer By Saam. As a graduate of Syracuse University, Musser was a well-rounded broadcaster, known his meticulous preparation, who was equally at home calling a wide variety of sporting events.

In addition to calling Phillies games, Musser's resume included radio and TV work for both the Eagles and 76'ers games as well as Villanova basketball. He also called two Super Bowls, two Masters golf tournaments, a pair of World Series and one NCAA men's basketball finals.

Musser announced his retirement in 2001.

Chris Wheeler
Broadcaster, 1977 -

For over three decades, Chris Wheeler has taken his turn behind the mike to help call Phillies games. Wheeler originally joined the Phillies PR department in 1971 and six years later moved into the broadcast booth. Throughout the ensuing decades, Wheeler has worked alongside an ever-changing lineup of partners, but the one constant has been his unbridled enthusiasm and clear love of the game.

Greg Luzinski
Veterans Stadium

In 1977, Greg Luzinski drove in 130 runs for the Phillies, the most since Don Hurst's 143 in 1932. And it would be 2003 before another Phillie(Jim Thome) would better Luzinski's mark. In addition, Luzinski hit a career-high 39 home runs, including two grand slams and five multiple home run games.

Luzinski's production at the plate got him named the starting leftfielder for the National League in that summer's All-Star game, where he smashed a first inning home run off Baltimore's Jim Palmer to help power the N.L to a 7-5 win. By seasons' end, Luzinski had finished second to the Reds' George Foster in the MVP balloting.

In 1978, Luzinski made his third straight All-Star team as the leading vote-getter in the National League. His 35 home runs that season were the second most in the league and he led the Phillies in doubles, home runs, RBI and walks. On the next to last day of the season, Luzinski's three-run home run against Pittsburgh erased a 4-3 Pirates lead and helped clinch the Phillies' third straight division title.

Despite the Phillies failure to advance beyond the first round of the playoffs in three successive seasons, Luzinski certainly did his part to improve their chances. In the 16 divisional playoff games he appeared in from 1976 through 1980, Luzinski hit safely in all 16 with five doubles, five home runs and 12 RBI.

But following the 1980 season, the Phillies decided that the 30 year-old slugger was past his prime and they shipped him to the Chicago White Sox. There he put in another four seasons as the Sox' designated hitter, driving in 102 runs in 1982 and hitting 32 home runs in 1983 before retiring a year later with 307 career homers.

Arnold "Bake" McBride
Outfielder, 1977 - 1981

Speedy Bake McBride spent four seasons patrolling the outfield for Philadelphia until knee problems shortened his career. McBride was the National League Rookie of the Year with the Cardinals in 1974 before a mid-season trade to the Phillies in 1977.

Inserted at the top of the Phillies batting order, McBride hit .339 and stole 27 bases over the final half of the season as the Phillies won their second straight division title. Over the next three years, McBride's speed, when paired alongside centerfielder Garry Maddox gave the Phillies one of the league's finest defensive tandems.

In 1980, McBride drove in a career high 87 runs, hit 33 doubles and led the Phillies in triples for the second straight season. In addition, his 14 game-winning RBI were second only to Mike Schmidt's 17. As the regular season wound down, the Phillies led Montreal by a game with just 10 games to play. Facing the Expos in the first game of a three-game series at the Vet, McBride's home run in the bottom of the ninth inning broke a 1-1 tie and gave the Phillies the win. The blow proved vital as Montreal won the next two games and eventually finished just a single game behind the Phillies.

In Game 1 of the World Series against Kansas City, McBride's three-run homer erased a 4-2 Royals lead and powered the Phillies to a 7-6 win. McBride finished the six-game series with a .304 average and five RBI.

But McBride's aching knees required surgery just two months into the 1981 season, sidelining him for a month, and the subsequent player's strike limited him to just 58 games.

That off-season, the Phillies traded McBride to Cleveland, where he played sparingly for parts of two seasons before retiring in 1983.

Lonnie Smith
Outfielder, 1978 - 1981

Lonnie Smith's best and worst days as a ballplayer occurred after his brief time with the Phillies. As the Phillies' number one pick in the 1974 draft, Smith twice stole more than 50 bases in the minor leagues before getting two brief trials in the Phillies outfield. But his erratic fielding caused manager Danny Ozark to use him sparingly. When new manager Dallas Green took over, Smith's playing time increased dramatically and, in 1980, he enjoyed a breakout season, hitting .339 and stealing 33 bases to break Richie Ashburn's rookie stolen base record. As a result, Smith was named *The Sporting News'* Rookie of the Year.

However, despite hitting .324 during the strike-shortened season of 1981, Smith was traded to the Cardinals, with whom he would win a World Series in 1982. That season, Smith stole 68 bases for St. Louis and he scored 120 runs to lead the entire National League. After another two productive seasons for the Cardinals, Smith was traded to Kansas City early in the 1985 season. There he stole 40 bases and won a third World Series title.

But for all his success on the field, Smith's growing drug use nearly ended his baseball career prematurely. In 1985, Smith publicly admitted his drug use and he played the 1986 season in Kansas City under a cloud of suspicion. A year later, Smith was released by the Royals and found himself out of work. Smith contacted every major league club begging for a second chance. Only the Atlanta Braves responded and Smith was forced to return to the minor leagues to prove his value.

When he hit .300 for the Braves' top farm team in Richmond in 1988, Smith earned a return trip to the major leagues. Over the next three seasons, Smith slowly helped turn the hapless Braves from the doormats of the National League into contenders and he was an integral part of Atlanta's back-to-back N.L. champions in 1991 and 1992.

Smith played another two years with the Pirates and Orioles before retiring in 1994.

Greg Gross
Outfielder, 1979 - 1988

Greg Gross spent 10 seasons as the Phillies' primary pinch hitter and fourth outfielder. Gross began his career in the big leagues with the Houston Astros in 1973 and hit .314 the following year in his first full season. But Gross' line drive swing produced not a single home run in almost 1400 at-bats spanning three seasons. Houston was looking for more run production from their outfielders and, as a result, Gross was dealt to the Cubs after the 1976 season.

With Chicago, Gross hit .322 in part-time duty in 1977 and managed to hit five home runs. It was an odd statistic for a player who would hit a total of only seven round-trippers in his entire major league career. When Gross hit .265 and drove in just 39 runs for the Cubs in 1978, he was traded to the Phillies along with infielder Manny Trillo.

In Philadelphia, Gross joined a Phillies team that had just won its third consecutive divisional title and whose veteran outfield was set with Luzinski, Maddox and McBride. When one of the regulars did go down with an injury, Gross' steady play and accurate throwing arm proved more than capable of filling the void.

But as the years went by, more and more of Gross' playing time involved one at-bat, usually in the late innings. In the 1980 divisional playoffs versus Houston, Gross was three for four as a pinch hitter including a key bunt single off Nolan Ryan in the eighth inning of Game 5 that loaded the bases and helped the Phillies rally to re-take the lead. In 1982, Gross led the N.L with 19 pinch hits and by the time he left the Phillies after the 1988 season, his 140 career pinch hits ranked third all time behind only Manny Mota and Smoky Burgess.

In 1989, Gross returned to the Astros for a single season before retiring. In 1995, Gross began working in the Colorado Rockies system as a minor league hitting instructor and in 2001, he returned to the Phillies as a coach for four seasons.

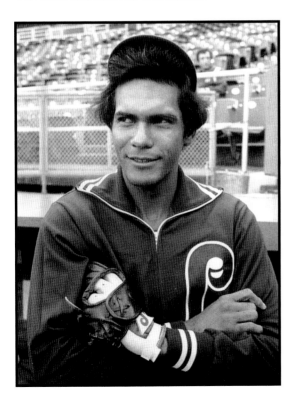

Manny Trillo
Second Baseman, 1979 - 1982

Manny Trillo's superb defensive skills during four seasons with the Phillies earned him accolades as one of the game's best glove men. He made his debut in the major leagues with Oakland before being traded to the Chicago Cubs in 1975. In Chicago, Trillo led the National League in assists for four straight seasons as the Cubs' second baseman. He also caught the eye of Phillies General Manager Paul Owens, who was looking for a veteran double play partner for shortstop Larry Bowa. Just prior to the beginning of training camp in 1979, Owens finally succeeded in landing Trillo and Greg Gross in a deal with the Cubs.

Trillo's range and strong arm won him his first Gold Glove award in his debut season in Philadelphia. It also earned him high praise from another veteran teammate, Pete Rose, who had also joined the Phillies that Spring. Rose later told reporters, "I don't compare guys. But Joe Morgan was and is the best offensive second baseman I've ever seen. Manny is the best defensive second baseman I have ever played with--or against."

Trillo's best work with the Phillies may have come during the postseason in 1980. In the divisional series against Houston, Trillo hit .381 with two doubles, a triple and four RBI as he was named series MVP. In the World Series versus Kansas City, he cut down a Royals base runner at the plate in Game 5 and later drove in the winning run in the top of the ninth for a 4-3 Phillies win.

In 1982, Trillo put together a string of 89 straight games without an error. He also won his third Gold Glove award. But the following season, Trillo, who was in the final year of a multi-year deal and seeking another long-term contract, was dealt to Cleveland as part of the package for outfielder Von Hayes.

Trillo wasn't with the Indians long, as he was traded to the Expos later that same season. He played another five-plus seasons with the Giants, Cubs and Reds before being released early in 1989.

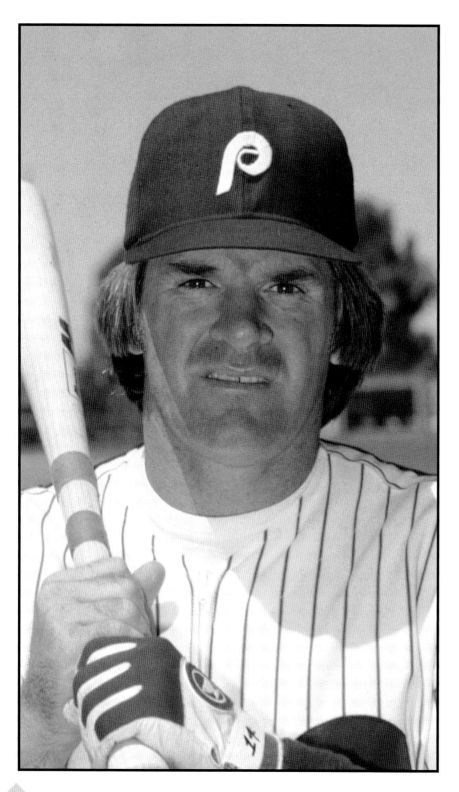

Pete Rose
First Baseman, 1979 - 1983

Pete Rose's veteran presence and winning style of play proved to be the final piece of the puzzle to the Phillies' first World Series title. Rose had already put in 16 seasons with his home-town Cincinnati Reds and won three batting titles before he signed with the Phillies as a free agent in 1979. Rose, at age 38, proved remarkably durable as he played in every game during his first two seasons with the Phillies. In 1979, he batted .331 and collected 208 hits while stealing a career-high 20 bases. In 1980, Rose's 42 doubles led the National League and his 185 hits were tops on the Phillies. Despite a drop of nearly 50 points in his batting average, Rose still managed to score more runs and produce more RBI than the previous season.

Rose's contributions off the field may have been equally important in driving the Phillies towards a championship. The headline-grabbing addition of Rose took some of the focus by the press and the fans off Schmidt, with positive results. In addition, Rose's success with the Reds, winning two World Series in 1975 and 1976, gave him the platform to instantly be treated as leader in the clubhouse. Schmidt told an interviewer, "From 1976 to 1978 our team captured the N.L. east title each season, but nothing seemed to go right for us in the playoffs. If you couldn't win in the playoffs, you were labeled a loser. The Phillies lived with that label until Pete Rose showed up. He was the finest team player I had ever seen. He always had something to say to pump you up, to play harder every game."

Rose's contributions on the field were evident for all to see in 1980. In Game 4 of the divisional series against the Astros, Rose scored all the way from first on Luzinski's double in the 10th inning to give the Phillies the lead. In Game 6 of the World Series against Kansas City, the Phillies were clinging to a 4-1 lead in the ninth inning when the Royals loaded the bases. A foul pop-up near the first base dugout was bobbled by Phillies catcher Bob Boone, but Rose bare-handed the ball out of the air for the inning's second out to help preserve the victory. Rose later told reporters his proudest moment of his time in Philadelphia was that ride down Broad Street in the Phillies victory parade.

During the strike-shortened season of 1981, Rose still managed to lead the National League with 140 hits while batting .325. But when the Phillies captured the division title in 1983, Rose's .245 average caused him to spend much of the final month of the season on the bench. Not seeing his name in the starting lineup everyday proved a shock to Rose, who proved his critics wrong by once again producing when the games counted the most. He was a combined 11 for 32 in the postseason.

But just days after the 1983 World Series, the Phillies released Rose, who, at age 42, was determined to still be an everyday player. He eventually signed with Montreal, but returned to Cincinnati later that same season as player/manager. In 1985, he broke Ty Cobb's all-time hit record of 4192 against the Padres at Riverfront Stadium. He finished up with 4256 hits before losing his job as Reds manager in 1988 when news of a betting scandal broke.

Dallas Green
Manager, 1979 - 1981

Dallas Green's brief tenure as manager produced the Phillies' first World Series title in franchise history. Green had originally spent parts of eight mediocre seasons as a pitcher in the major leagues before joining the Phillies front office in 1969. He was promoted to Director of Minor Leagues in 1972 and replaced Danny Ozark as Phillies skipper late in the 1979 season. Green's final six weeks of that season were spent evaluating the talent in the Phillies dugout with an eye towards making changes for the next season. That off-season, Green pleaded with General Manager Paul Owen not to trade outfielder Lonnie Smith, whose fielding miscues had gotten him in former manager Danny Ozark's doghouse. Instead, Green showed Smith he believed in him by starting him in the outfield for half that seasons' games. Smith responded with a breakout year.

Green was less encouraging with many of the team's veterans. His public tirades in the press questioning his players' efforts made for regular reading. Green also benched long-time veterans like Boone, Luzinski and Maddox. He refused to coddle his players and frequently sought to motivate his players by screaming at them. Some, notably Larry Bowa, screamed right back. During a doubleheader in Pittsburgh in late August, Green almost got into a fistfight with reliever Ron Reed in the Phillies dugout.

But Green's bombast did seem to jolt the Phillies out of their stupor. During the final month of the season, the team played it's best ball of the year, going 21-6, to edge Montreal out for the divisional title by a single game. When the Phillies got by Houston in the playoffs and beat Kansas City in six games to win the World Series, Green's methods were validated and he was retained as manager for the 1981 season.

The Phillies played better ball in 1981 and were in first place by mid-June when the players' strike cut the season in two. After a layoff of nearly two months, the Phillies had trouble recapturing their form and limped through a 25-27 record following the strike.

The Phillies ultimately lost a five game playoff series to Montreal and Dallas Green decided to leave town. Eager to get back to the front office, he accepted an offer from the Chicago Cubs to become their general manager. Green's eye for talent would serve him well in Chicago as he immediately began making deals to overhaul the Cubs roster.

In 1984, those efforts produced a division title for the Cubs, their first title of any kind since 1945. A loss to the San Diego Padres in the playoffs did little to dampen Green's reputation as a turn-around artist. But eventually, Green's failure to repeat his earlier success led to his dismissal after the 1987 season. He took over as manager of the Yankees in 1989, but didn't finish out the season and turned to scouting.

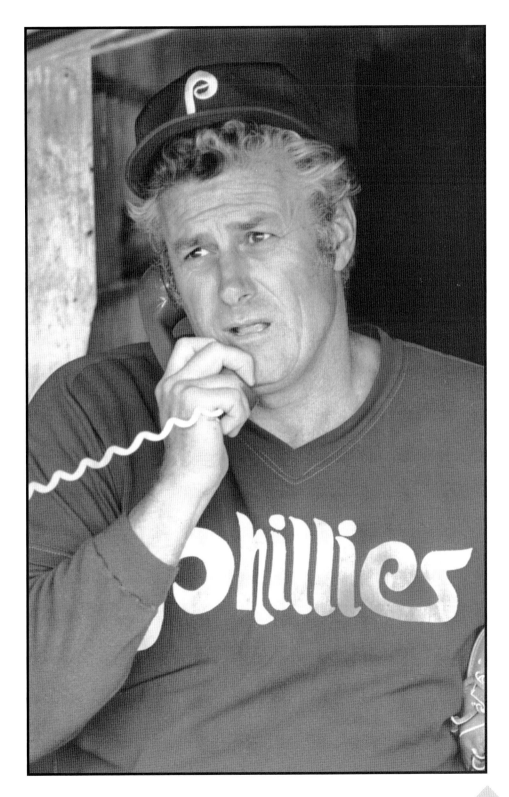

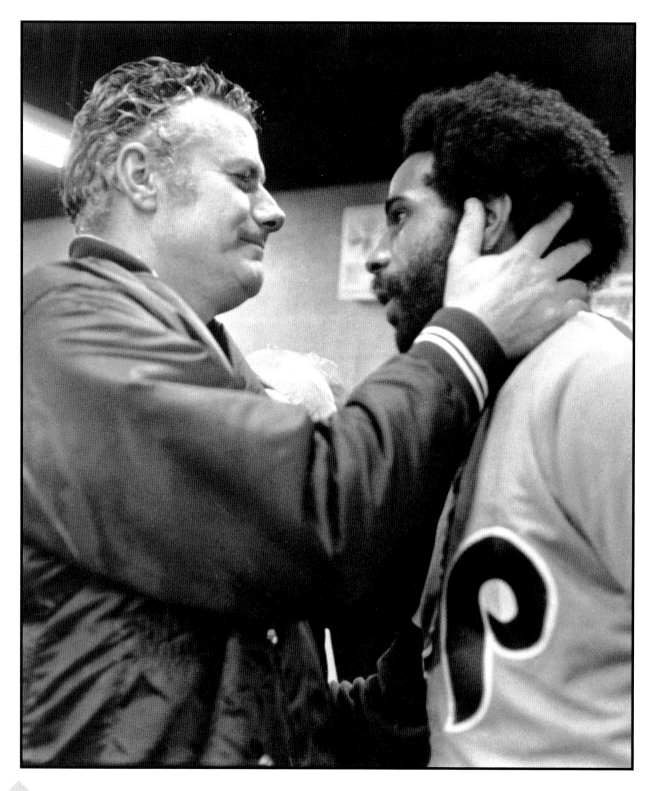

Dallas Green and Garry Maddox
Olympic Stadium, 1980

When the Phillies beat the Montreal Expos 6-4 in 11 innings and captured the Eastern Division crown on the next to last day of the 1980 season, photographers were in the Phillies clubhouse to document the celebration. Outfielder Garry Maddox and Manger Dallas Green had been at odds for weeks following Maddox's critical misplay of several fly balls. The result was Greens' benching of Maddox for the final week of the season.

Now with the champagne flowing and emotions running high, the player and manager sought each other out and embraced to put it all behind them. Their differences settled, Maddox would go on to bat .300 in the divisional playoffs against Houston, drive in the winning run in Game 5 and catch the final out to send the Phillies to their first World Series in 30 years.

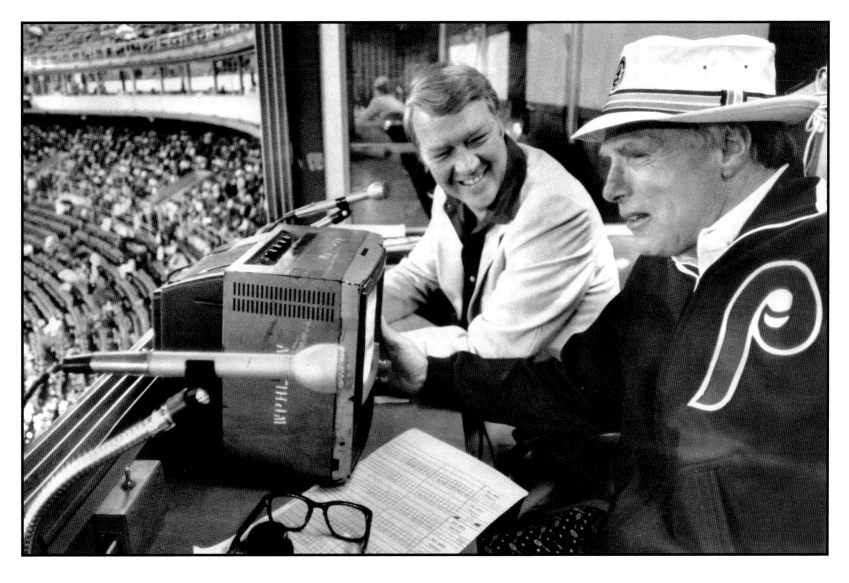

Harry Kalas and Richie Ashburn
Veterans Stadium, 1980

For the better part of three decades, Phillies fans were treated to a nightly conversation with Harry and Whitey. The duo's work together behind the microphone educated, informed and entertained two generations of Phillies fans.

After perfecting his trade in the minor leagues, Kalas was hired by the Houston Astros in 1965 to do their games. When Astros executive Bill Giles left Houston to join the Phillies in 1971, he thought the team should have a new voice to go with their new stadium. His choice was Kalas. But the addition of Kalas meant the departure of longtime announcer Bill Campbell. It was, at least initially, not a popular move among the locals. But Kalas soon won over

Phillies fans with his economical delivery and distinctive tone. His signature home run call, "It's outta here" quickly became his trademark. In 2002, Kalas received the Ford C. Frick award, given annually for broadcasting excellence.

Richie Ashburn had joined the Phillies broadcast team in 1963. For the next seven seasons, he shared the booth with Bill Campbell and By Saam. But it was his 27 seasons of work with Kalas for which the younger generation of Phillies fans will always remember Ashburn.

His death late in the 1997 season ended one of the longest running, and most beloved, partnerships in broadcasting.

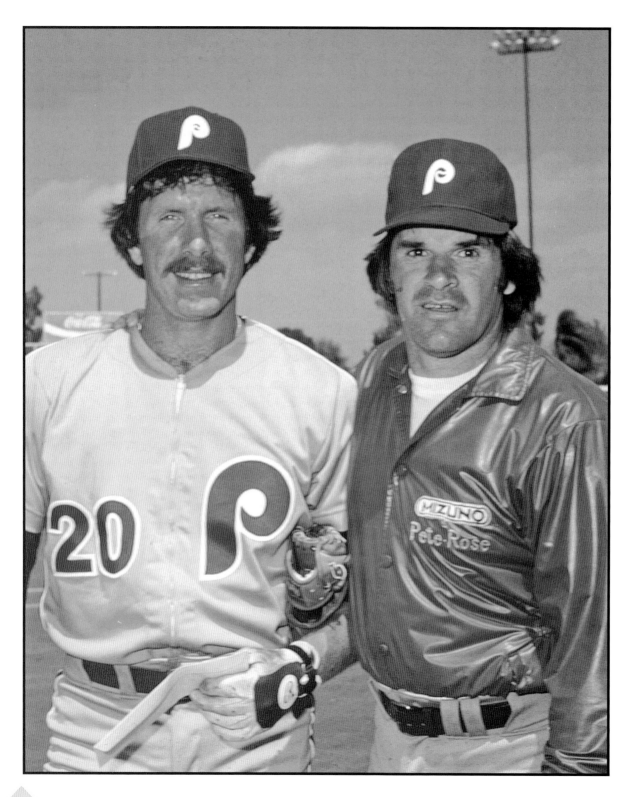

Mike Schmidt and Pete Rose
Spring Training, 1981

When the Phillies reported to spring training in Clearwater in 1981, they did so as World Series champions. Much of the previous season's success had come courtesy of the booming bat of veteran Mike Schmidt, who had put up the best offensive numbers of his nine-year career.

Schmidt's 48 home runs and 121 RBI were both tops in the National League and, as a result, he was chosen league MVP. In the World Series, Schmidt's .381 average, two home runs and seven RBI got him named MVP of the Series. In addition, Schmidt won his fifth straight Gold Glove award and had been the leading vote getter in the All-Star balloting.

In 1981, Schmidt would be well on his way to bettering those numbers when the season was interrupted by the player's strike. Despite playing in a total of just 102 games, Schmidt again led the N.L. with 31 home runs and 91 RBI. He hit .316 and also led the league in walks, runs scored and slugging percentage. All that production added up to a second straight National League MVP award for Schmidt.

For his part, Pete Rose also had a superb 1981 season. He hit .325 to finish second to Pittsburgh's Bill Madlock for the batting title and led the N.L. in hits for the seventh time to break Stan Musial's previous record of six. In the field, Rose also played 99 straight games without an error.

But both player's individual success was overshadowed by the Phillies failure in the postseason. A five-game playoff loss to Montreal prevented the Phillies from returning to the World Series.

Bill Giles
President/Owner, 1981 - 1997

When the Carpenter family, after nearly 40 years of ownership, decided to sell the Phillies in 1981, Giles put together a group of investors to buy the club. He was named President and took over day to day operations of the team. As the son of former National League president Warren Giles, it was a position he had been groomed for all his life. By 1981, Giles had already spent 20 years in professional baseball.

Giles would remain Phillies team President for the next 16 years as the ball club made two additional trips to the World Series in 1983 and 1993. In 1997, Giles was named Chairman of the team, allowing him to concentrate on getting a new stadium deal for the Phillies.

Through the Giles Family partnership, he continues his ownership stake in the team.

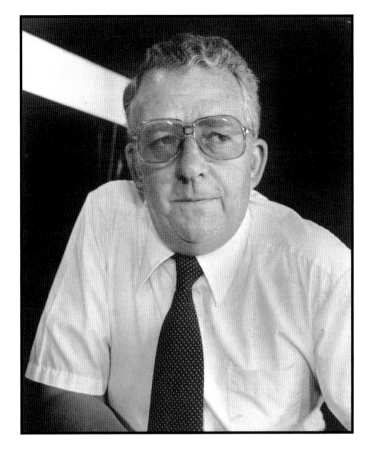

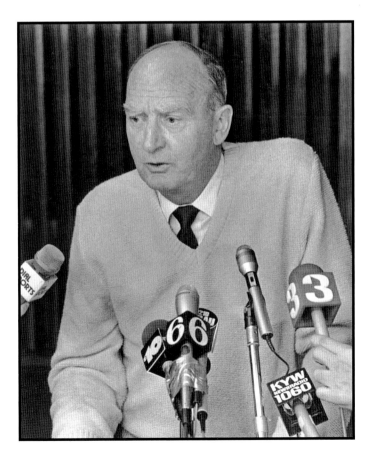

Paul Owens
General Manager, 1972 - 1983
Manager, 1983 - 1984

Paul Owens presided over the "golden age" of Phillies baseball in the 20th Century. Under his supervision, the team won five divisional titles, made it to two World Series, and won its' only championship. Owens had originally joined the Phillies in 1965 as their farm director. In 1972, he succeeded John Quinn as General Manager and began putting his stamp on the Phillies roster. Owens believed in evaluating talent up close, so he insisted on traveling with the ball club on the road, a rarity among executives in his position.

Owens was a shrewd judge of talent, making deals to bolster the emerging lineup of young players he had selected in the annual draft. It was Owens who acquired Tug McGraw, Garry Maddox and later, Bake McBride and Manny Trillo. More importantly, Owens rarely parted with players who enjoyed success after leaving the Phillies. His only major miscalculation, albeit a big one, came in his final deal as Phillies G.M. in early 1982 when he shipped Larry Bowa and Ryne Sandberg to the Cubs for infielder Ivan DeJesus.

In the middle of the 1983 season, with the Phillies struggling to play .500 ball, Owens took over as Phillies manager and guided the team to 47-30 record and a return trip to the World Series. He returned to the front office following the 1984 season. Owens died in 2003 and the team wore a commemorative patch on their uniform sleeves in his honor during the 2004 season.

Gary "Sarge" Matthews
Outfielder, 1981 - 1983

Gary Matthews was the National League Rookie of the Year in 1974 for the S.F. Giants and already a veteran of eight full seasons in the N.L. when the Phillies acquired him in a trade just prior to the 1981 season. Matthews was a gifted hitter whose most productive season had been in 1979 with the Atlanta Braves, for whom Matthews had hit .304 with 27 home runs and 90 RBI.

In Philadelphia, Matthews replaced the recently departed Greg Luzinski in left field and joined a veteran club which had just won a World Series. Despite the disruption of the player's strike mid-season, Matthews finished the 1981 season with a flourish. His .330 average, seven home runs and 31 RBI in September got him named N.L. Player of the Month. Matthews was 8 for 20 in the five-game divisional playoff series against Montreal.

In 1982, Matthews played in all 162 games and stole 21 bases to go along with his 19 home runs and 83 RBI. But Matthews split playing time in left with Greg Gross in 1983 and his offensive numbers declined. However, in the playoffs against the Dodgers, Matthews hit .429 with three home runs and eight RBI and was named series MVP.

The following spring, just before the Phillies broke camp, Matthews was dealt to the Cubs along with Bob Dernier. There, at age 33, he quickly became an integral part of the Cubs' improbable run to a division title. Matthews played three full seasons in Chicago before being traded to Seattle midway through the 1987 season. He retired that off-season.

Beginning in 1998, Matthews spent seven years as a coach with the Blue Jays, Brewers and Cubs before joining the Phillies broadcast team as an analyst in 2007.

Ryne Sandberg
Infielder, 1981

Ryne Sandberg's all-too brief tenure with the Phillies ranks among the team's worst decisions of all time. Just prior to the 1982 season, the Phillies front office decided they needed a younger body at shortstop. So, they traded 36 year-old Larry Bowa to the Chicago Cubs for 28 year-old Ivan De Jesus.

Unfortunately, the Phillies also included Sandberg in the deal. Sandberg was a lightly regarded minor league prospect who'd been drafted right out of high school by the Phillies in the 20th round in 1978. During his first four years in the minor leagues, Sandberg has twice batted .310 or better and shown some speed, twice stealing 32 bases in both Double A and Triple A.

But Sandberg's late season call-up to the Phillies for the final month of the 1981 season had done little to showcase his potential. He was used mainly as late-inning defensive replacement and got just six at-bats, producing a lone single. But former Phillies manager Dallas Green, who'd been the Phillies' farm director during Sandberg's time in the minors, was now the new General Manger in Chicago. He insisted Sandberg be part of the deal for DeJesus and the Phillies agreed. It proved to be a major miscalculation.

Over the next 15 seasons, Sandberg developed into one of the game's premier second baseman. In 1983, he won the first of nine straight Gold Glove awards. In 1984, Sandberg was named National League MVP as the Cubs won their first title of any kind in 30 years. He eventually hit a total of 282 home runs, including leading the N.L. with 40 in 1990 and stole 344 bases including a career-high 54 in 1985.

Sandberg was elected to the Hall of Fame in 2005.

Tug McGraw
Veterans Stadium, 1981 Playoffs

When the 1981 season was interrupted by the players strike on June 12, the Phillies were atop the National League's eastern division with a 34-21 record. When the season finally resumed in early August, the N.L. decided that the first-half winners in each division would face off against the second-half winners to determine who advanced in the playoffs.

As a result, the Phillies and Montreal Expos squared off in a five-game playoff series starting in Montreal on October 7. The Expos took the first two games by identical scores of 3-1. But the Phillies won Game 3 at the Vet 6-2.

In Game 4, with the score tied 5-5 after seven innings, the Phillies summoned reliever Tug McGraw to keep the Expos at bay. McGraw allowed just one hit over the final three innings as the Phillies won the game in the bottom of the tenth on a pinch-hit home run by George Vukovich.

But in the critical Game 5, the Expos' Steve Rogers got the best of Steve Carlton and the Phillies 3-0 to send the Phillies home with a disappointing finish to a disjointed season.

Steve Carlton
Spring Training, 1982

In his first 10 seasons with the Phillies, Steve Carlton had won 185 games and led the National League in wins three times. In addition, he had won the N.L.'s Cy Young Award in 1972, 1977 and 1980.

However, Carlton's performance early in 1982 would have convinced few observers that at age 37, he was on his way to a fourth record-setting season. Carlton began that year by losing his first four starts. But when he threw a 10-inning complete game against San Diego on April 30, winning 3-1, and two weeks later blanked the Giants on a two-hitter, he showed he could still dominate opposing lineups.

In early June, Carlton struck out 16 Cubs. It was one of 11 games that season where he struck out 10 or more batters. Later that same month. Carlton defeated the eventual champion Cardinals twice in consecutive starts by limiting St. Louis to a total of nine hits in 18 innings of work. That year, he won all five of his starts against St. Louis, two of them shutouts. Those two victories were part of a stretch where Carlton completed nine of ten straight starts. As a result, his 295 innings of work were the most in the majors. Carlton also led the N.L. in strikeouts, complete games and shutouts.

By seasons' end, his 23-11 record made Carlton the only 20-game winner in either league that season. For his efforts, he was presented with his fourth Cy Young Award.

Joe Morgan
Second Baseman, 1983

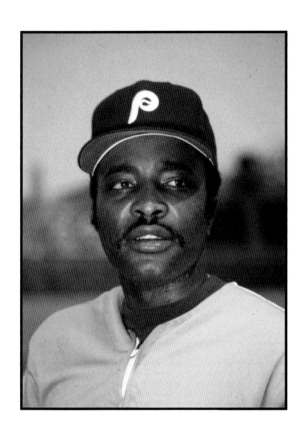

Joe Morgan's brief stay with the Phillies coincided with a return trip to the World Series. At age 39, Morgan was nearing the end of his time in the major leagues. He was brought in to fill the void at second base left by the departure of Manny Trillo. The Phillies front office also hoped Morgan would help mentor rookie Juan Samuel in the fine art of playing second base. Most of all, like his former Reds teammates Pete Rose and Tony Perez, Morgan knew what it took to win.

For most of the season, Morgan struggled to hit for average, but he did produce 20 doubles, 16 home runs and steal 18 bases. The Phillies' veteran-laden roster got nicknamed the "Wheeze Kids" by the local press as a tongue-in-cheek nod to the 1950 club known as the "Whiz Kids". But it was the performance of the veterans like Morgan down the stretch that allowed the Phillies to win 14 of their final 16 games and finish the season with 90 wins. In the final two weeks of the season, Morgan had three four-hit games.

In the World Series against the Baltimore Orioles, Morgan had a triple and two home runs. Two weeks later, the Phillies released Morgan and he signed with Oakland, where he finished out his career in 1984.

Morgan was elected to the Hall of Fame in 1990.

Tony Perez
First Baseman, 1983

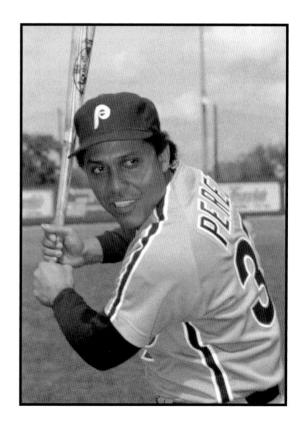

Tony Perez was another of the veteran players brought in to solidify the Phillies bench. At age 40, Perez' best offensive seasons were clearly behind him. His last big year at the plate had been in 1980 with the Boston Red Sox, when he hit 25 home runs and drove in 105 runs. The Phillies hoped Perez could provide a right-handed bat off the bench and occasionally spell Pete Rose at first base. Although his playing time was limited, Perez managed to do both.

In May, Perez had five RBI in a game against the Astros and in early June his three-run homer off the Cardinals' Bruce Sutter in the bottom of the ninth won a game at the Vet. In the playoffs against the Dodgers, he had a pinch-hit single in his only at-bat. In the World Series loss to Baltimore, Perez had a pair of singles in 10 at-bats.

When the season ended, Perez was sold back to Cincinnati, where he played sparingly for another three years before retiring after the 1986 season. In 1993, he was named manger of the Reds, but was fired just weeks into the season when the team started poorly. He later coached for the Florida Marlins.

Perez was elected to the Hall of Fame in 2000.

John Denny
Pitcher, 1982 - 1985

John Denny overcame a legendary temper to win 19 games and a Cy Young Award for the Phillies in 1983. Denny was already in his eighth season in the majors when the Phillies acquired him from Cleveland late in the 1982 season. In 1976, Denny won the National League ERA crown while with the St. Louis Cardinals. In 1981, he threw three consecutive complete-game shutouts for the Indians. But Denny's obvious talent was often overshadowed by his angry outbursts at umpires, coaches and even teammates. He took offense at the slightest misplay or whenever a close call didn't go his way.

Following the trade to Philadelphia in the final month of the 1982 season, Denny was winless in his four starts for the Phillies, but gave a glimpse of what he was capable of. In the final series of the season, Denny threw nine scoreless innings against the Mets, allowing only one hit, in a game the Phillies lost 2-1 in 10 innings. That off season, he worked out with Steve Carlton back in St. Louis. Denny also became a born-again Christian.

In 1983, Denny threw a two-hit shutout against the Astros in his fifth start of the year. It was one of a pair of two-hitters he would throw that season. Over the second half of the season, Denny was simply dominant. He was 13-2 in his 19 starts after the All-Star break. His ERA of 2.37 was the second lowest among National League starters. Even Denny's final record of 19-6 was not indicative of how well he pitched. Of his 36 starts, Denny allowed one earned run or less in 18 of them. As a result, the Phillies were 27-9 when Denny took the mound. In his six losses, the Phillies scored a total of seven runs. He was the runaway choice by the sportswriters for the N.L.'s Cy Young Award. In the World Series against the Orioles, Denny won Game 1 by limiting Baltimore to a single run through eight innings for the Phillies' only victory.

Denny pitched very well early in 1984 before an elbow injury in late May cost him the next two months of the season. As result, he produced a 7-7 record despite an ERA of 2.45. The Phillies again failed to give him much support as they scored a total of eight runs in his seven losses.

In 1985, Denny won only one of his first ten outings and never really regained his form. He finished up 11-14 and that off-season, the Phillies traded him to Cincinnati, where he pitched for just one year before retiring at age 33.

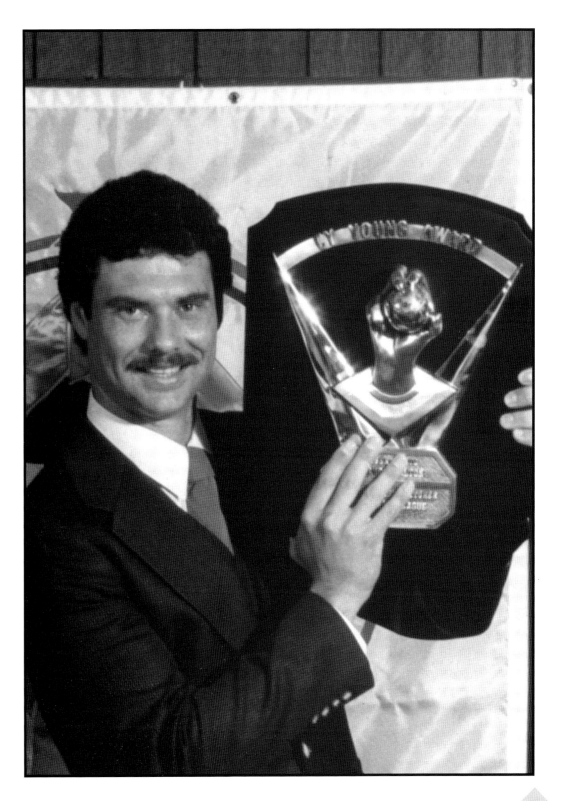

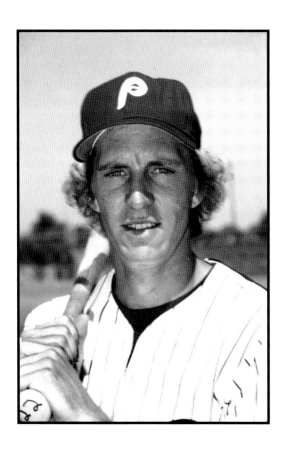

Bobby Dernier
Outfielder, 1980 - 1983; 1988 - 1989

Bobby Dernier stole his way to the major leagues, but his most productive seasons came in between his two stints with the Phillies. In the minors, Dernier stole more than 70 bases for three straight years. After two brief trials with the Phillies in 1980 and 1981, Dernier joined the club for good in 1982. That year, while sharing time in the outfield, he set a new Phillies rookie record by stealing 42 bases. When he swiped another 35 in 1983, he became the first Phillies player since Sherry Magee in 1909-10 to have consecutive 35-steal seasons.

But the Phillies mistakenly shipped Dernier to the Cubs along with outfielder Gary Matthews in 1984. There, he became the first Cubs outfielder to ever win a Gold Glove award as he batted .278. In addition, his 45 stolen bases were the most by a Cubs player in over 75 years. Over his first three seasons as the Cubs' regular centerfielder, Dernier banged out a total of 60 doubles and stole 103 bases. In 1987, Dernier batted .317 in part-time duty and hit a career-high eight home runs.

But after four strong years with Chicago, Dernier re-signed with Phillies for the 1988 season. However, a pair of trips to the disabled list limited his playing time to just 86 games. In 1989, Dernier's batting average slipped to .171 and he was released by the Phillies that off-season.

Larry Andersen
Pitcher, 1983 - 1986; 1993 - 1994

Reliever Larry Andersen spent parts of 17 seasons working out of the bullpen in the major leagues. Originally signed by Cleveland out of high school, Andersen pitched with the Indians and Mariners for parts of five seasons before being sold to the Phillies in the middle of the 1983 season.

In his first full season in Philadelphia, Andersen compiled a streak of 33 consecutive scoreless innings, the second longest such stretch in Phillies history. That year, Andersen threw 90 innings over 64 appearances and produced a stellar 2.38 ERA. He began 1985 on an equally strong note, throwing 15 straight scoreless innings, but struggled through much of the second half of the season to finish with an ERA of 4.32. When he had a couple of bad outings early in 1986, the Phillies released him.

Andersen promptly signed with the Houston Astros, where he pitched very effectively for four years until being shipped to the Boston Red Sox at the trading deadline in 1990 for a minor league prospect named Jeff Bagwell. Although Andersen helped Boston reach the postseason, it proved a very short-term gain for the Red Sox as Bagwell blossomed into a star in Houston and Andersen quickly left Boston as a free agent to sign with San Diego. There recurring arm problems limited Andersen's availability during the next two years before he returned to the Phillies in 1993.

Andersen's first season back with Philadelphia was highlighted by him averaging more than a strikeout an inning as the Phillies won their first divisional title in 10 years. But Andersen really struggled in the postseason against the Braves and Blue Jays, giving up a total of nine runs in six innings of work.

In 1994, Anderson struggled to come back from knee surgery and three trips to the D.L. ended his season in July. He spent the next three seasons as a pitching coach in the minor leagues before joining the Phillies broadcast team in 1998.

Von Hayes
Outfielder/First Baseman, 1983 - 1991

Speedy Von Hayes' up and down career with the Phillies made him a frequent target of the fans and press. Hayes was originally drafted by Cleveland out of college in 1979. In his first season in pro ball, he hit .329 to win a batting title in the Class A Midwest League. The following season he was in the majors, playing 43 games for the Indians. His first home run in the big leagues was off Baltimore's Jim Palmer.

The Phillies were so convinced of Hayes' talent they traded five players, including veteran Manny Trillo and shortstop Julio Franco, to the Indians for him. The hype surrounding the deal caused veteran Pete Rose to immediately refer to Hayes as Mr. "Five for One", a less than flattering moniker that was picked up by the local sportswriters.

In 1984, Hayes stole 48 bases and hit .292, but the Phillies' failure to repeat as divisional champions got most of the headlines. In 1985, Hayes became the first player in baseball history to ever hit two home runs in the first inning of a game when he connected against the Mets at the Vet in June.

In 1986, Hayes had a breakout season, hitting .305 and driving in 98 runs. His 46 doubles led the league and were the most by a Phillie in over 50 years. He also produced three separate hit streaks of 10 games each and scored 107 runs. But elbow surgery cost Hayes almost two months of the 1988 season and his power numbers dropped off sharply.

The sudden retirement of icon Mike Schmidt early in 1989 left Hayes as the Phillies' most senior servant. Two weeks later, Hayes signed a new three-year contract making him the highest paid Phillie. The resulting headlines, combined with the team's poor showing in the standings, made Hayes the focus of the fans' mounting frustrations. In fact, Hayes' career-high 26 home runs led the team that season, but did little to pacify the locals as the Phillies finished in last place with a 67-95 record.

When the Phillies produced their fourth straight losing season in 1990, despite Hayes leading the team with 17 home runs and 73 RBI, it served as more of a comment on the sorry state of the franchise than any indictment of Hayes. But when injuries cost Hayes half the 1991 season, the Phillies dealt him to the Angels that off-season. A year later, he retired.

In 2002, Hayes returned to the game and began coaching and managing in the minor leagues.

Juan Samuel
Second Baseman, 1983 - 1989

During his first four full seasons in the major leagues, Juan Samuel's rare combination of speed and power awed Phillies fans and rewrote the record books. Following a late-season trial with the Phillies in 1983, Samuel put together one of the most impressive rookie seasons in the history of the Phillies franchise. He banged out 191 hits, stole 72 bases and scored 105 runs. Samuel also hit 19 triples, 15 home runs and his 69 RBI were the most by a Phillies second baseman in 30 years. Only the performance of the Met's Doc Gooden kept Samuel from being named the National League's Rookie of the Year.

Over the next three seasons, Samuel continued to rack up extra base hits. Despite leading the National League in strikeouts for the fourth straight season, Samuel produced 37 doubles, 15 triples, 28 home runs and 100 RBI in 1987. That feat made him the first player to ever reach double figures in doubles, triples, home runs and stolen bases in his first four years in the majors.

But for all his success at the plate, Samuel struggled with his fielding. By the end of 1987, he'd committed a total of 100 errors in four-plus seasons. As a result, the Phillies brass decided to switch Samuel to the outfield. But when his offensive numbers dropped off dramatically, the Phillies shipped Samuel to the New York Mets for Lenny Dykstra and Roger McDowell midway through the 1989 season.

Samuel quickly became a baseball nomad, moving from team to team for the remainder of his career. He played another nine seasons, but changed teams six times. Samuel became a part-time player and never again put up the kind of offensive numbers he had in Philadelphia. He retired after the 1998 season.

Samuel spent the next eight years as a coach with the Tigers before trying his hand at managing in the Mets farm system of one season. In 2007, he returned to the majors as a coach with the Orioles.

Kevin Gross
Pitcher, 1983 - 1988

Kevin Gross was a first-round pick of the Phillies who threw a no-hitter for the Dodgers long after he left Philadelphia. Gross joined the Phillies midway through the 1983 season when starter Larry Christenson's elbow surgery ended his career. Gross joined the starting rotation and promptly won his first two starts. In 1984, he spent half the season in the bullpen and finished with an 8-5 record.

But Gross soon developed into the workhorse of the Phillies starting staff. From 1985 through 1988, he threw more than 200 innings every season. During three of those years, he led the Phillies in innings pitched and strikeouts. But the Phillies had only one winning season during Gross' five full years in the rotation and he often suffered from anemic run support. When he posted a 15-13 record in 1985, the Phillies scored a total of 15 runs in the 11 losses he logged as a starter. It got so bad that in both 1986 and 1988, Gross led the Phillies in victories despite winning only 12 games.

Gross was traded to Montreal following the 1988 season. There he was a combined 20-24 over the next two seasons before joining the Dodgers as a free agent in 1990.

In 1992, in the midst of an 8-13 season, Gross shocked everyone by throwing a no-hitter against the Giants at Dodger Stadium. Only a pair of walks and a hit-batsman prevented Gross from throwing a perfect game. He later pitched two seasons for the Texas Rangers and one for the California Angels before being released early in the 1997 season.

Jeff Stone
Outfielder, 1983 - 1987

Jeff Stone's exceptional speed got him to the major leagues but his inconsistent play made it a short stay. Stone's thievery on the base paths was well known long before he ever got to Philadelphia. In just his second year of pro ball, Stone stole an astounding 123 bases for the Phillies' Class A affiliate in the South Atlantic League. When Stone stole 90 or more bases in each of next two years, he got called up to the Phillies for the final three weeks of the 1983 season. Although he got only four at-bats, Stone produced a pair of triples, three RBI and stole four bases.

In 1984, it was eventually more of the same from Stone. After hitting .316 in Triple A, Stone was recalled by the Phillies in mid-June. He hit safely in 12 of his first 15 games, including nine games with two or more hits. But a pulled groin muscle temporarily sidelined Stone and he didn't return to form until the final month of the season. Still, he ended the year with a .362 batting average and 27 steals.

Stone began 1985 as the Phillies everyday leftfielder and got off to a great start, hitting .300 for the first month of the season. On April 20, he hit two home runs and drove in five runs against the Mets. But a month-long slump in May got him shipped back to the minors. Despite hitting .290 for the Phillies during the final seven weeks of the season, Stone began 1986 back in Triple A.

Over the next two seasons, Stone was constantly in and out of the Phillies lineup as he split time between the major and minor leagues. But eventually, the Phillies brass decided that Stone didn't provide enough offense, and when his stolen base totals failed to increase, he was traded to Baltimore just prior to the start of the 1988 season.

Stone played parts of another three seasons with the Orioles, Rangers and Red Sox before being released in 1990.

Steve Carlton
Riverfront Stadium, 1986

By 1986, Steve Carlton was 41 and coming off his first sub-par season. Carlton had missed almost half the 1985 season with shoulder problems, forcing him to go on the disabled list for the first time in his career. He made just 16 starts and was 1-8 as the Phillies gave him very little run support.

The following season soon proved more of the same. On Opening Day in Cincinnati, Carlton lasted only four innings but was charged with all seven runs in a 7-4 Phillies loss. He frequently struggled with his control, walking 45 batters in 83 innings of work and making it into the seventh inning only twice in 16 starts. Finally on June 24, the Phillies released Carlton.

Two weeks later, he signed with San Francisco and notched his 4,000th career strikeout against the Reds before being released. Five days later he joined the White Sox, made 10 starts and posted a 4-3 record. Carlton split 1987 between Cleveland and Minnesota, made 21 starts and was 6-14. The following spring the Twins released him three weeks into the season after he gave up 20 hits and 19 runs in less than 10 innings of work. After more than 5200 innings and 329 victories, Carlton was finally done.

His accomplishments as a Phillie remain among the games' all-time marks. Carlton had five of his six 20-win seasons with Philadelphia, threw six one-hitters and had a total of 55 complete-game shutouts. When Carlton retired in 1988, he, along with Nolan Ryan, were then the only two pitchers to ever record 4,000 strikeouts. In 1989, the Phillies retired Carlton's number 32.

In 1994, Carlton was elected to the Hall of Fame.

Don Carman
Pitcher, 1983 - 1990

Lefthander Don Carman split his time with the Phillies between the bullpen and the starting rotation with mixed results. In just his second season of pro ball, Carman won 14 games and led the Carolina League in strikeouts for the Phillies Class A affiliate. But he was soon converted to a reliever and had two brief trials with the Phillies in 1983 and 1984.

In 1985, Carman suddenly became the Phillies most reliable bullpen option. He appeared in 71 games and struck out 87 batters in 86 innings of work. Better still, he held opposing hitters to a .178 average and posted an ERA of 2.08.

As a starter, Carman didn't allow a run in his first 13 innings of work. In late August he threw eight perfect innings against the Giants before a double by catcher Bob Brenly to lead off the ninth inning cost him a perfect game. By season's end Carman was 7-3 in 14 starts. In his three losses, the Phillies scored a total of six runs.

But that off-season, Carman suffered a broken thumb on his pitching hand in a car accident. However, as the season progressed Carman got stronger with each outing. In late September he threw a complete game one-hitter against the Mets and ended the 1987 season with 13 wins. Unfortunately, he also set a new club record by surrendering 34 home runs.

Carman's 10-14 record in 1988 was only partially his fault. The Phillies gave him almost no support, scoring a total of 23 runs in his 14 losses. But the following Spring, when Carman struggled to return to form after off-season knee surgery, posting a 1-8 record in his first 11 starts, he was moved back to the bullpen. He ended the year with a 5-15 record.

A 6-2 record, all in relief, in 1990 would prove to be Carman's last with Philadelphia. He spent 1991 with Cincinnati and threw two innings for the Texas Rangers in 1992 before retiring.

Shane Rawley
Pitcher, 1984 - 1988

Shane Rawley's best season of his 12-year major league career came with the Phillies in 1987 when he won 17 games. Rawley pitched six-plus seasons in the American League with both the Mariners and Yankees prior to joining the Phillies via a trade in 1984. Converted from a reliever to a starter in New York, Rawley had been a .500 pitcher prior to his arrival in Philadelphia.

The Phillies immediately put Rawley into their rotation to replace veteran John Denny who'd miss two months with elbow problems. Rawley responded by going 10-6 with three complete games over the second half of the season. In 1985, Rawley was 13-8. The season's highpoint came in August, when he shut out the Dodgers twice in 10 days by allowing a total of 7 hits in 18 innings of work.

In 1986, Rawley was 11-7 with seven complete games when a broken bone in his shoulder ended his season in late July. The next year, Rawley came back stronger than ever. He faced the eventual champion Cardinals five times and lost only once. By the end of August he was 17-6 and looked headed for his first 20-win season. But he was winless in his last seven starts and finished 17-11.

Rawley actually had a lower ERA in 1988 over the previous season, but the results were far different. He was winless in his first six starts and in his final 11 starts, he made it past the sixth inning only once. The result was that Rawley finished the year with an 8-16 record. It also marked his final season with the Phillies.

The Phillies traded Rawley to Minnesota, where he was 5-12 as starter in 1989 before retiring at age 34.

Bruce Ruffin
Pitcher, 1986 - 1991

Lefty Bruce Ruffin was a ground-ball pitcher whose best year with the Phillies was his first. Ruffin was originally drafted by the Phillies in the 32nd round of the 1982 draft. But he decided to accept an offer from the University of Texas, where he soon won the 1983 College World Series by pitching on the same staff with Roger Clemens and Greg Swindell.

In 1985, the Phillies again picked Ruffin, this time in the second round. By the middle of 1986, Ruffin was called up to the Phillies when Steve Carlton was released. Ruffin pitched exceptionally well. He made 21 starts and gave up more than three earned runs only once. As a result, the Phillies were 15-6 in Ruffin's starts. Beginning in mid-August, he was undefeated in seven straight starts and finished the year with a 9-4 record. The local sports pages, not to mention the Phillies front office, began touting Ruffin as a future ace.

But Ruffin proved exceptionally streaky. In 1987, he won just three of his first 11 starts. Then, just as suddenly, Ruffin lost only twice in his next 11 outings. But he followed that up by winning just two of his last 13 and finished the year with a 11-14 record. When Ruffin was 4-6 in his first 14 starts in 1988 season, he was moved to the bullpen for the remainder of the season. Although he pitched in 55 games, Ruffin struggled with his control and finished up 6-10.

In 1989, Ruffin made two starts, allowing nine runs and 15 hits in just over six innings of work, and was quickly shipped back to the minors. Although he was back with the Phillies by early June, Ruffin ended the season with a second consecutive 6-10 record. In 1990, Ruffin's ERA ballooned to 5.38 and his 6-13 record was followed up by a 4-7 record in 1990 which signaled the end of the line in Philadelphia.

That off-season, Ruffin was traded to Milwaukee, where he pitched for a single season before joining the Colorado Rockies for another five years. He retired after the 1997 season.

Milt Thompson
Outfielder, 1986 - 1988; 1993 - 1994

Speedy Milt Thompson stole 46 bases and batted .302 for the Phillies in 1987, but his time in Philadelphia was interrupted by trade to the Cardinals. Thompson came to the Phillies in the same deal that brought reliever Steve Bedrosian from the Atlanta Braves.

After splitting 1986 between the major and the minor leagues, Thompson took over as the Phillies regular centerfielder the following year. That season, his range allowed him to rank second among all National League outfielders in putouts. In 1987, Thompson also collected five hits in seven at-bats during an August game against the Cubs. But when his offensive numbers dropped off in 1988, he was dealt to the Cardinals at seasons end.

In St. Louis, Thompson rebounded to hit 28 doubles and drive in a career-high 68 runs in 1989. But Thompson's playing time decreased in each of the next three seasons and he was soon being used as the Cardinals' primary pinch hitter.

In 1993, Thompson returned to the Phillies. Although he shared time in leftfield with Pete Incaviglia, he played stellar defense, making just one error all season. In the World Series against Toronto, Thompson hit .313 and produced a club-record five RBI in Game 4.

Halfway through the 1994 season, the Phillies traded Thompson again, this time to the Astros. But by 1995, Thompson was 36 and his greatly reduced playing time produced a .220 average. In 1996, he split his final year in the majors between the Dodgers and the Rockies.

In 2004, he returned to the Phillies as a coach.

Steve Bedrosian
Pitcher, 1986 - 1989

Steve Bedrosian's brief time in Philadelphia included leading the National League in saves in 1987 and winning the Cy Young Award. Bedrosian's debut in the majors had come with the Atlanta Braves in 1981. By his second season, Bedrosian was already the workhorse of the Atlanta bullpen, throwing more than 130 innings. In 1983, he made 70 appearances and notched 19 saves. But Atlanta's signing of free-agent closer Bruce Sutter in 1985 got Bedrosian moved to the Braves rotation. There he made 37 starts, but his 7-15 record as a starter for the hapless Braves made him expendable. The Phillies packaged catcher Ozzie Virgil and pitching prospect Pete Smith together and dealt the pair to Atlanta for Bedrosian and outfielder Milt Thompson.

In Philadelphia, the Phillies quickly put Bedrosian back in the bullpen, where he appeared in 68 games and nailed down 29 saves in 1986. The following year, Bedrosian struggled early, but by the end of July he'd saved his 30th game. At the time, it was the earliest date in the season any reliever had ever gotten to that mark. He ended the season with 40 saves in 48 opportunities. When the sportswriters' ballots were finally tallied, Bedrosian narrowly beat out the Cubs' Rick Sutcliffe for the 1987 Cy Young Award. It's hard to imagine where the Phillies would have been without Bedrosian's 40 saves in 1987. As it was, the team finished a disappointing 80-82, good for fourth place in the N.L.'s Eastern division.

Bedrosian spent the first six weeks of the 1988 season on the D.L. with a strained muscle in his side. However, he still managed to pitch in 57 games and post 28 saves. But his opportunities occurred far less frequently for a last-place Phillies team that only won 65 games.

By the middle of 1989, the Phillies were headed for a second straight last-place finish, and as a result, were in a re-building mode. So, they shipped Bedrosian to the Giants for a package of players that included pitcher Terry Mulholland and infielder Charlie Hayes. Bedrosian spent the next two years with Giants and Twins before returning to Atlanta in 1993 for three final seasons with the Braves.

Darren Daulton
Catcher, 1983; 1985 - 1997

Darren Daulton played through injuries and almost constant pain to eventually become the Phillies leader on the field and in the clubhouse. Despite being a three-sport athlete in high school in his native Kansas, Daulton wasn't chosen by the Phillies until the 25th round of the 1980 draft.

But Daulton's progress towards the major leagues was hampered by an almost constant series of injuries. Chronic shoulder problems caused him to miss half of both the 1984 and 1985 seasons. In 1986, a home plate collision in late June blew out his left knee, ending his season.

The Phillies brass grew so concerned about Daulton's health issues that they signed veteran catcher Lance Parrish in 1987 to provide some stability behind the plate. As a result, Daulton, who began the season on the Disabled List, started just 33 games. In 1988, Daulton again saw limited duty as Parrish's backup until his season was cut short in August when he(Daulton) broke his hand punching a wall in the Phillies clubhouse after striking out.

In 1989, Daulton finally managed to stay healthy for an entire season, but his anemic performance at the plate had Phillies fans questioning his contributions. The following season, Daulton finally began to realize his potential as he threw out 39% of opposing base runners and ranked near the top of N.L. backstops in several key offensive categories.

But one way or another, Daulton couldn't seem to stay healthy long. In early May of 1991, Daulton and teammate Lenny Dykstra were both seriously injured when Dykstra slammed his car into a tree after the pair had attended John Kruk's bachelor party in the Philadelphia suburbs. Daulton missed the next six weeks and his season was later ended prematurely in early September by knee surgery.

Thanks to a strenuous rehabilitation program, Daulton came back better than ever in 1992. At age 30, he led all National League catchers by playing in 141 games totaling over 1200 innings. He hit a career-best 27 home runs and his 109 RBI were tops in the league, making him only the fourth catcher to ever lead the N.L. in that category. Despite the numerous operations on both knees, and the daily grind of crouching behind the plate, Daulton's 11 steals in 1992 were the most by a Phillies catcher in 65 years.

However, the Phillies 70-92 record in 1992 resulted in another last-place finish. Thus, no one could have imagined that the very next season would be Daulton's and the Phillies finest in a decade.

Mike Schmidt
Spring Training, 1989

By 1989, Mike Schmidt was 39 and the wear and tear of 16 seasons appeared to be taking its' toll. Schmidt had struggled through an injury-plagued season in 1988. After nine straight seasons with 30 or more home runs, Schmidt hit only 12. After driving in more than 100 runs in four of the previous five seasons, he managed only 62. He played his final game of that season on August 12 and underwent shoulder surgery three weeks later.

Thus, when Schmidt arrived in Clearwater for spring training in 1989, the Phillies were unsure of what to expect. Although Schmidt opened the season by hitting a home run in the each of first two games, by the end of May he'd hit only six. Worse still, he was hitting .203. During a West Coast road trip in late May, Schmidt suddenly announced his retirement before a game in San Diego.

Schmidt's departure severed the last link to the Phillies championship teams of the 1970's and early 80's. He remains to this day, however, the Phillies career leader in almost every significant offensive category. Schmidt played in 2404 games. As of 2008, no other Phillie has ever gotten to 1800. He is the Phillies' all-time leader in hits, home runs, RBI, runs scored, walks and sacrifice flies. Schmidt also won three MVP awards, 10 Gold Gloves and was a 12-time All-Star. In addition, *The Sporting News* named him the Player of the Decade for the 1980's.

In 1990, the Phillies retired Schmidt's number 20 and he was elected to the Hall of Fame in 1995

Lenny Dykstra
Outfielder, 1989 - 1996

Lenny Dykstra's all-out style of play endeared him to Phillies fans and provided a catalyst at the top of the Phillies batting order. Dykstra had once stolen 105 bases in a single season in the minor leagues and had already won a World Series ring with the Mets in 1986 prior to being traded to Philadelphia in the middle of the 1989 season. Dykstra immediately took over as the Phillies regular centerfielder.

Dykstra's free-wheeling attitude and unkempt appearance quickly made him a blue-collar favorite of the fans and the local press. From the ever-present wad of chewing tobacco bulging from his cheek to his uniquely superstitious habits, Dykstra made a colorful sight wherever he went. He routinely discarded equipment he thought unlucky and often changed uniforms between innings in an effort to bust out of a slump, real or imagined.

But it was as the Phillies lead-off hitter that Dykstra demonstrated his real value to the team. His determination to reach base any way he could soon proved pivotal to the Phillies success. In 1990, Dykstra's 192 hits were tied for the most in the National League. His .325 average was fourth best in the N.L. and his 23-game hitting streak was the longest in the league that season. In addition, he stole 33 bases in 38 attempts and coaxed 89 walks. The sum total of all that was Dykstra leading the National League in on-base percentage.

But Dykstra also excelled in the field. In 1990, he had more putouts than any other outfielder in the league. But a car accident in 1991 and three trips to the disabled list in 1992 cost Dykstra a large portion of the next two seasons. His healthy return in 1993 would coincide with the most productive year of his career and a trip to the World Series for the Phillies.

Terry Mulholland
Pitcher, 1989 - 1993; 1996

Terry Mulholland was an extremely durable lefthander with a great pick-off move who threw a no-hitter for the Phillies in 1990. Mulholland began his big league career with the Giants before being traded to the Phillies in 1989 as part of the deal for closer Steve Bedrosian. Just two months after the trade, Mulholland beat San Francisco 1-0 on a two-hit shutout.

The following year, Mulholland improved on that performance by again dominating his former team. On August 15, Mulholland need just 2:06 to set down 27 Giants hitters for 6-0 victory at the Vet. He struck out eight and only an error by Phillies third baseman Charlie Hayes in the seventh inning kept Mulholland from throwing a perfect game. In late September, he threw another two-hitter against St. Louis, but lost 1-0 when the Phillies' 10 hits failed to produce a single run. It was also one of Mulholland's six complete games that season.

In 1991, Mulholland was 16-13 for the Phillies as his eight complete games were the third-most in the National League. His 13-11 record in 1992 included a league-best 12 complete games. He also broke the major league record for pickoffs in a single season by nailing 16 would-be base runners. In fact, Mulholland's move was so effective that there were only two successful steals against him all season.

In 1993, Mulholland was 12-9 with a pair of shutouts. In the World Series versus Toronto, he won Game 2 by pitching into the sixth inning of a 6-4 Phillies win, but left Game 6 after five innings trailing 5-1 in the final game of the Series. The following Spring, the Phillies shipped Mulholland to the Yankees.

Mulholland pitched one season for both the Yankees and the Giants before rejoining the Phillies in 1996. However his return was short-lived at the Phillies traded him again, this time to Seattle. Over the next 10 seasons, Mulholland switched teams nine times. He made 70 appearances for the Cubs in 1998 and finally retired at the age of 43 in 2006.

Ricky Jordan
First Baseman, 1988 - 1994

Ricky Jordan was a first-round pick of the Phillies whose six years with Philadelphia included only one season as an everyday player. Playing a position normally associated with big run producers, Jordan was more of a line-drive hitter who hit for average but displayed little power.

When his five-plus seasons in the Phillies farm system were finally rewarded with a mid-season call-up in 1988, Jordan got off to a torrid start. Jordan hit a home run in his second plate appearance and became the first Phillies player to ever hit three round-trippers by the end of his first week in the majors. In August, he put together an 18-game hitting streak. He finished his rookie season with a .308 average, 11 home runs and 43 RBI in 69 games.

Installed as the Phillies regular first baseman for the 1989 season, Jordan struggled with a wrist injury for much of early part of the season. He did, however, have a very productive second half of the season with 50 of his eventual 75 RBI coming after the All-Star break.

But 1990 was a step backward for Jordan as he spent three weeks on the disabled list and a month back in the minors. Halfway through that season, the Phillies moved outfielder John Kruk to first base in a bid to get more offensive production from the position. Jordan instantly became a part-time player.

In 1991, Jordan started just 67 games and was often manager Jim Fregosi's first option off the bench as a pinch-hitter. But nine home runs and 49 RBI in 301 at-bats was not going to get Jordan back in the everyday lineup.

Jordan's final three seasons with the Phillies produced a total of 17 home runs and 89 RBI. In 1995, he signed with the Angels as a free agent, but never played a single game for them. Jordan was later sold to Seattle, where he started seven games in 1996 before being released.

John Kruk
Outfielder/First Baseman, 1989 - 1994

John Kruk was a gifted hitter who excelled at getting on base and helped lead the Phillies back to World Series for the first time in a decade. Kruk began his time in the major leagues with San Diego in 1986. In only his second season in the big leagues, Kruk hit .313 with 20 home runs and 91 RBI. But injuries limited his playing time in 1988 and Kruk's offensive numbers dropped off. When he struggled at the plate again 1989, batting just .189 by early June, the Padres traded him to the Phillies.

In Philadelphia, Kruk quickly regained his earlier form and hit .331 over the remainder of the season despite missing nearly all of July recovering from knee surgery. In 1991, Kruk hit .294 with a career-high 21 home runs for the Phillies and drove in 92 runs to lead the team in all three categories. In 1992, Kruk hit .323 and ranked second in the National League in on-base percentage.

But it was more than his play on the field that endeared Kruk to the fans and the press. When the Phillies captured their first divisional crown in 10 years in 1993, Kruk's off-beat demeanor in the clubhouse helped pave the way. For it was Kruk, along with Darren Daulton, Lenny Dykstra and Dave Hollins who made up a veteran core of players who bonded together to impose on their teammates a "whatever it takes" attitude towards winning. In fact, Kruk's ability to keep the mood light with his constant one-liners was pointed to by many of the players as a key ingredient in the team's success.

But Kruk's credibility as a team leader was grounded in his ability to back it up between the lines. In 1993, he hit .316 and drove in 85 runs as he was selected to his third straight All-Star team. He also collected 111 walks and again finished second in the N.L. in on-base percentage. In the playoffs against Atlanta, Kruk had two doubles, a triple, a home run and five RBI. In the World Series, he hit .348 with seven walks.

But knee injuries limited Kruk to just 67 starts in 1994 and he left the Phillies to sign with the White Sox as a free agent. However, he played just 42 games for Chicago and he retired later that same season at age 34. In 2004, Kruk joined ESPN as an analyst.

Tommy Greene
Pitcher, 1990 - 1995

Tommy Greene was a big, strong right-hander who threw a no-hitter for the Phillies in 1991 before arm problems cut short his big league career. Greene was traded to the Phillies in 1990 after making just six starts for the Atlanta Braves.

The following May, in just his second start of the 1991 season, Greene struck out ten Expos and held Montreal hitless at Olympic Stadium. Just five days later, Greene threw a second complete-game shutout against Montreal by limiting the Expos to three hits. His scoreless innings streak eventually reached 29 innings as he reeled off five straight victories. Greene threw more than 200 innings and ended the season with a 13-7 record.

But shoulder problems cost Greene almost the entire 1992 season and he ended the year with 3-3 record.

Greene rebounded to have his finest season the following year. He was 8-0 in his first 10 starts and, in mid-May, Greene began a stretch of five straight complete-game victories. He thus became the first Phillies pitcher since Steve Carlton in 1972 to produce such a run. By the All-Star break, Greene's record stood at 11-2. He twice struck out 10 or more batters and even managed to hit a pair of home runs. Best of all, the Phillies were 23-7 in his 30 starts.

In light of Greene's success, no one could have predicted that his career was all but over. However, between 1994 and 1996, Greene made a total of 13 starts and threw less than 70 innings for the Phillies as repeated shoulder problems constantly interrupted his seasons. In 1997, he signed with Houston, but threw just nine innings before betting shipped to the minors. Greene finally retired in 1998 at age 31.

Dave Hollins
Third Baseman, 1990 - 1995; 2002

Dave Hollins spent just two seasons as the Phillies everyday third baseman, but twice drove in more than 90 runs and was an integral part of the team's championship run in 1993. Hollins was a hard-nosed player known for his intensity both on the field and in the clubhouse. Hollins had played football in high school and approached games with a demeanor and focus that scared even his teammates. Curt Schilling later observed, "Dave Hollins is the only guy I've ever seen who is actually capable of killing somebody on a baseball field."

Hollins replaced Charlie Hayes as the Phillies regular third baseman in 1992. As a switch hitter, Hollins insisted on crowding the plate and set a new club record by being hit by a pitch 19 times that season. When combined with his 76 walks, Hollins scored the second most runs(104) in the National League that year. He also batted .270 with 27 home runs and 93 RBI.

In 1993, Hollins had nearly an identical season at the plate. He drove in 93 runs and scored 104 for the second straight season. Hollins thus became the first Phillie since Juan Samuel in 1984-85 to have consecutive 100 run seasons. He was also chosen to the All-Star team and had two home runs and four RBI in the playoffs against the Braves.

But Hollins missed all but the first six weeks of the 1994 season with a pair of broken bones in his left hand. When Charlie Hayes returned to the Phillies in 1995, the club moved Hollins to first base, but he wasn't there long as he was dealt to the Red Sox in late July. From that point on, Hollins needed to keep his bags packed as he was constantly on the move. Over the next six seasons, Hollins played for five major and five minor league teams before rejoining the Phillies in 2002. But after hitting just .118 and starting only five games, he called it quits at age 36.

Jim Fregosi
Manager, 1991 - 1996

Jim Fregosi's five-plus seasons as Phillies manager produced the team's first National League pennant in a decade. As a player, Fregosi had enjoyed a long and productive career as an infielder, primarily with the Angels and Mets, before turning to managing. Fregosi managed both the Angels and the White Sox for a total of seven seasons before taking over the Phillies from Nick Leyva just two weeks into the 1991 season.

Fregosi inherited a Phillies team that hadn't produced a winning record in four years. Fregosi's first two years at the helm soon proved that he didn't have a magic wand as the Phillies struggled through another two consecutive sub-.500 seasons. In fact, the team's last place finish in 1992 did little to convince most observers that better days were right around the corner.

But the 1993 Phillies were a different bunch in many ways. They got off to a torrid start, winning nine of their first 12 games and by the end of April they were 17-5 and boasted the best record in the majors. It was also the team's best start in franchise history.

The Phillies spectacular turnaround was a result of both talent and timing. After several years of battling injuries, Lenny Dykstra and Darren Daulton remained healthy for the entire season. The additions of veterans like Danny Jackson, Pete Incaviglia, Jim Eisenreich and David West provided much needed depth. Pitchers Tommy Greene and Curt Schilling both won 16 games and Fregosi kept his bench players fresh by platooning at several key positions. The team's penchant for late-inning heroics captivated the city of Philadelphia and the fans responded by turning out in record numbers at the Vet.

For his part, Fregosi soon recognized the unique grouping of talent that had been assembled. He later remarked, "Those '93 guys didn't care about personal stats. They were the most unselfish group I ever coached. These guys did those unselfish things, because if they didn't do them, they'd hear about it from every other guy in that clubhouse. That clubhouse atmosphere was critical to the club's success. When they came off that field, they had fun, and I never stopped them from having fun. My rules were simple. You come here every day to bust your butt to win."

But for all the Phillies' success in 1993, the magic soon proved short lived. Fregosi and his players was unable to replicate that season and quickly returned to their losing ways. After another three straight sub-.500 seasons, Fregosi was let go after the 1996 season. He later became a scout for the Braves.

Mitch "Wild Thing" Williams
Pitcher, 1991 - 1993

Mitch Williams's brief tenure with the Phillies provided a lifetime of highs and lows. Williams made his major-league debut with the Texas Rangers in 1989 at the age of 21. In his first two seasons there, Williams appeared in 80 and 85 games respectively. When he was traded to the Cubs in 1989, he posted 36 saves and his 76 outings that season again led the league. But Williams's penchant for getting in and out of late-inning jams wasn't for the faint of heart. His tendency to average nearly a walk per inning got him nicknamed "Wild Thing" and often had fans on the edge of their seats.

In 1990, Williams had an off year for the Cubs. He recorded just 16 saves, had 1-8 record and missed a month in the middle of season with knee surgery. The Phillies decided he was worth taking a chance on and acquired Williams in a trade the day before the season opener in 1991. Williams responded to his new surroundings with a career-best 2.34 ERA, made 60 appearances and posted 30 saves for the Phils.

In 1992, Williams saved 29 games out of 36 opportunities. Despite his unorthodox approach, Williams grudgingly earned the respect of his teammates. Darren Daulton recalled, "He was a big kid. He wanted the ball all the time, and he'd throw a fit if he didn't get the ball. A lot of guys get timid. If they don't have their best stuff, they want to sit out. Not Mitch. He didn't do it pretty, but he was there pitching his heart out whenever you called."

In 1993, Williams's ability to close out games was never more crucial to the Phillies success. His 43 saves that season would remain the most in franchise history until 2002 and his work in the playoffs against Atlanta guaranteed the Phillies a return trip to the World Series. Unfortunately, Williams's legacy would ultimately come to rest on the final pitch of his Phillies career. Joe Carter's dramatic ninth-inning home run for the Blue Jays in Game 6 of the World Series would immediately overshadow all of Williams's other accomplishments.

The fans' reaction to the loss made it impossible for Williams to remain in Philadelphia and he was traded to Houston that off-season. Williams pitched for parts of another three seasons with the Astros, Angels and Royals, before retiring in 1997. Williams eventually returned to Philadelphia and worked as a studio host on Phillies broadcasts.

Mickey Morandini
Second Baseman, 1990 - 1997; 2000

Mickey Morandini was a sure-handed fielder whose five full seasons in the Phillies infield included an unassisted triple play. Morandini had a brief trial with the Phillies in 1990 before spending most of the 1991 season as the team's everyday second baseman. He stole 13 bases in 15 attempts and hit .249.

In 1992, Morandini led the Phillies with eight triples and committed the fewest errors of any second baseman in the National League. During a September game in Pittsburgh, Morandini turned an unassisted triple play in the sixth inning of a tie game by spearing a line drive off the bat of the Pirates' Jeff King and doubling up base runners Andy Van Slyke and Barry Bonds. When the Phillies won their first divisional title in a decade in 1993, Morandini had a 66-game errorless streak and finished second in fielding percentage among all N.L. second baseman.

The following season, Morandini started slowly and saw his playing time reduced as he shared second base duties with veteran Mariano Duncan. But in 1995, Morandini led the Phillies in triples for the fourth straight season and was selected to his first All-Star team. 1996 saw Morandini steal 26 bases in 31 attempts and his 40 doubles in 1997 were tops on the Phillies.

The Phillies traded Morandini to the Cubs following the 1997 season. His first year in Chicago turned out to be the best of his major league career. Morandini hit .296 with a career-high eight home runs and 53 RBI. He also led all N.L. second baseman in fielding percentage, committing only five errors all season.

After a second productive season for the Cubs in 1999, Morandini signed with the Expos as a free agent. But he was quickly sold back to the Phillies that same Spring and put in four months of work in Philadelphia before being traded to Toronto. There he played 35 games over the final two months of the season and promptly retired.

Jim Eisenreich
Outfielder, 1993 - 1996

Jim Eisenreich was a gifted defensive outfielder who hit better than .300 during all four of his seasons with the Phillies. Eisenreich had made his debut with the Minnesota Twins in 1982 before a neurological disorder, later diagnosed as Tourette Syndrome, caused him to leave the game in 1984. In 1987, Eisenreich signed a minor league deal with Kansas City and by 1989, he'd begun a four-year run as one of the Royals regular outfielders.

The Phillies signed Eisenreich as a free agent in 1993 to provide a veteran bat off the bench. What they got was a pure hitter who gradually played his way into the everyday lineup and rarely made a miscue in the field. Eisenreich hit .318 in 1993 and put together a 13-game hitting streak. When the Phillies got to the World Series, he started all six games and produced seven RBI.

In the field, Eisenreich proved to be exceptionally sure handed. Between 1993 and 1995, he committed a total of three errors while appearing in 341 games in the Phillies outfield. In 1995 he played the entire season without a single error.

At the plate, he became manager Jim Fregosi's first choice as a pinch hitter in key situations. Beginning in 1994, Eisenreich hit .301, .316 and an eye-popping .361 in consecutive seasons. In 1995 he hit a career-high 10 home runs.

Following the 1996 season, Eisenreich signed as a free agent with the Florida Marlins, where he helped win a World Series in his first season. But just a month into the 1998 season, the Marlins sent Eisenreich to the Dodgers as part of the multi-player deal for catcher Mike Piazza. He finished out the year in Los Angeles and promptly retired at age 39.

Pete Incaviglia
Outfielder, 1993 - 1994; 1996

Slugger Pete Incaviglia's short stay with the Phillies produced some tape-measure home runs and helped the Phillies return to the World Series. Incaviglia joined the Texas Rangers in 1986 without ever playing a single day in the minor leagues. As a rookie, he hit 30 home runs and drove in 88 runs, but also led the A.L. with 185 strikeouts. His first five years in Texas produced a total of 124 home runs. In 1991, Incaviglia was released by Texas, but quickly signed with Detroit. However, injuries limited his playing time and the following season he played for the Houston Astros.

In 1993, the Phillies signed him to strengthen their bench. On a team loaded with veteran players, Incaviglia thrived and walloped 24 home runs for the 1993 Phillies. Although he split playing time in left field with Milt Thompson, his 89 RBI and .274 average were both career highs. Incaviglia had 10 games with three or more RBI that season and in July he hit a ball into the upper deck in left field at the Vet. By seasons' end, he led the Phillies in slugging percentage.

In 1994, Incaviglia's playing time decreased as his batting average dropped to .230. But he continued hitting for distance. In early May, he hit a ball measured at 481 feet in Atlanta off the Braves' Steve Bedrosian. It was the longest home run in the National League that season and the sixth grand slam of Incaviglia's career. Although he did homer in four straight games in late May, his 32 RBI were the fewest of his nine full seasons in the majors. That off-season, Incaviglia signed to play in Japan. After an injury-plagued season, he returned to the States and rejoined the Phillies.

But it proved to be short stay. Despite hitting 16 home runs in only 269 at-bats, the Phillies traded Incaviglia to the Orioles in late August. He played parts of another two seasons with four different clubs before hanging it up after the 1998 season.

Curt Schilling
Pitcher, 1992 - 2000

When Curt Schilling joined the Phillies in 1992, there was little to indicate how dominating a front-line starter he would become. A second round pick of the Red Sox in 1986, Schilling had blazed his way through the minor leagues but struggled to find his place in the majors. When the deal was made to send Schilling to the Phillies it was the third time he'd been traded in four years. In fact, during parts of four seasons with Baltimore and Houston, Schilling had made just four major-league starts, thrown a total of less than 150 innings, and spent most of his time pitching out of the bullpen.

Initially, the Phillies continued using Schilling as a reliever, but when starter Tommy Greene went down in mid-May with shoulder problems, Schilling was forced into the rotation. He won his first start, against the Astros, and three weeks later threw a complete game three-hit shutout against the Pirates at the Vet. In late July, he shut out the Padres and Mets in consecutive starts as part of a stretch of 29 consecutive scoreless innings. In early September, he produced a one-hitter against New York. By season's end, Schilling had posted a 14-11 record, thrown 10 complete games and four shutouts, and his ERA of 2.35 was the fourth lowest in the National League.

In 1993, Schilling picked up right where he left off, losing just once in his first 14 starts. His 16-7 record included a pair of shutouts over the Cubs and Dodgers in April and his 186 strikeouts ranked fourth in the N.L. In the playoffs against Atlanta, Schilling went eight innings in both Game 1 and Game 5, allowing two runs each time, but got a pair of no-decisions when the Phillies won both games late by identical scores of 4-3. For his efforts, Schilling was named series MVP. In the World Series versus Toronto, Schilling lost Game 1, but came back to blank the Blue Jays 2-0 in Game 5.

But injuries limited Schilling's effectiveness over the next two years. Elbow and knee surgery in 1994 were followed by shoulder surgery in 1995 as Schilling struggled through consecutive 2-8 and 7-5 seasons. In 1996, Schilling didn't make his first start until mid-May and, while he did rack up eight games with 10 or more strikeouts and threw eight complete games to lead the league, his 9-10 record was little help to a team that lost 95 games.

In 1997, Schilling proved he was finally healthy by setting a new franchise strikeout record. His 319 strikeouts were the most in the National League that season and eclipsed the old mark of 310 set by Steve Carlton in 1972. Schilling made 35 starts and had 17 games with at least 10 punch outs. On September 1, he struck out 16 Yankees. He was selected to his first All-Star team and finished the season with a 17-11 record for the Phillies.

As dominating as Schilling's 1997 season was, his best days were still ahead of him.

Lenny Dykstra
World Series, 1993

When the Phillies came up short against Toronto in the 1993 World Series, it wasn't for any lack of effort on Lenny Dykstra's part. Dykstra's regular season in 1993 had been his most productive ever. He batted .305 and became the first National League player to ever lead the league in both hits and walks in the same season. In addition, his 143 runs scored were the most in the N.L since 1932. Dykstra also stole 37 bases and his 44 doubles were the second most in the N.L. When the season ended, he was second in the MVP balloting to the Giants' Barry Bonds.

In the playoffs against the Braves, it was Dykstra's second home run of the series in the 10th inning of Game 5 that gave the Phillies the lead three games to two. But Dykstra relished playing in the spotlight and he saved his best for the game's biggest stage.

Facing Toronto in the World Series, Dykstra was a one-man wrecking crew. His home run late in Game 2 helped insure a 6-4 Phillies win. In Game 4 he had a double and two home runs to drive in four runs in a wild slugfest that ended with a 15-14 win for Toronto. In Game 6, Dykstra's three-run homer off Dave Stewart helped the Phillies rally to take a 6-5 lead into the ninth inning. Although the Phillies came up short in the World Series, Dykstra finished the postseason with six home runs, 10 RBI and four stolen bases.

Lenny Dykstra and Darren Daulton
Spring Training, 1995

By the time the Phillies reported to Clearwater for spring training in 1995, the team's success in 1993 must have seemed like a distant memory. After getting back to the World Series for the first time in 10 years, the 1994 season had been a massive letdown for both the players and the fans.

The Phillies started 1994 off poorly, losing 20 of their first 32 games, and by mid-May they were nine games out of first place. When the season was cut short by a strike in August, the Phillies were in fourth place, more than 20 games out, and their record stood at 54-61.

By 1995, several of the team's nucleus of veteran players were missing. John Kruk, Terry Mulholland and Mitch Williams were long gone and Dave Hollins would be traded that July. Despite that, the Phillies got off to a great start in 1995 and were in sole possession of first place as late as July 3. But as the season wore on, injuries to several key players started to mount. Staff ace

Curt Schilling ended up missing most of the second half of the season with shoulder surgery. Lenny Dykstra's back and knee problems limited him to just 62 games and Darren Daulton missed the final six weeks of the season with yet another round of knee surgery. As a result, the Phillies collapsed in the second half and finished the year at 69-75 and 21 games behind the eventual-champion Atlanta Braves.

Spinal surgery would limit Lenny Dykstra to just 34 starts as the Phillies centerfielder in 1996 and he would be forced to retire at age 36.

Darren Daulton moved to left field in 1996 to ease the strain on his aching knees, made five starts, and was forced to miss the remainder of the season. In 1997, he made 70 starts in right field for the Phillies before being traded to the Marlins, with whom he won a World Series that season, before retiring at age 35.

Mike Lieberthal
Catcher, 1994 - 2006

Mike Lieberthal was an excellent defensive catcher who spent nearly a decade behind the plate as the Phillies' everyday backstop. Selected by the Phillies with the third-overall pick in the 1990 draft, Lieberthal had two brief trials in Philadelphia before he spent 1996 backing up veteran catcher Darren Daulton. By 1997, the everyday catching job was finally Leiberthal's as Daulton's age and injuries got him moved to the outfield.

In 1999, Lieberthal had the best season of his career, hitting .300 with 31 home runs and 96 RBI. His 31 homers established a new Phillies record for the most round-trippers by a catcher. In addition, Lieberthal became the first Phillie since Mike Schmidt in 1981 to hit at least .300 and have 30 or more home runs in the same season. Lieberthal was selected to the National League's All-Star team and he also became just the second Phillies catcher to ever win a Gold Glove award.

But a series of injuries cost sidelined Lieberthal for a good portion of the next two seasons. Elbow and ankle problems cost him a third of the 2000 season and in 2001, he played in just 34 games before a knee injury ended his season in mid-May. In 2002, he hit three home runs in a game against the Dodgers. A consistent run producer, Lieberthal hit .313 with 81 RBI in 2003. The following year he had his fourth season with at least 30 doubles and strung together a team-high 14 game hitting streak.

But by 2006, Lieberthal was 34 and the injuries and all those innings behind the plate were taking their toll. He started just 56 games for the Phillies that season and his offensive production dropped off sharply. That off-season, Leiberthal signed a free agent deal with the Dodgers, but he played sparingly in 2007 and was released at season's end.

Scott Rolen
Third Baseman, 1996 - 2002

Scott Rolen's booming bat and spectacular defense made him the 1997 National League Rookie of the Year, but his stay in Philadelphia was cut short by a contract dispute. Rolen initially joined the Phillies for the final two months of the 1996 season after moving quickly through the Phillies' minor league system.

In his first full season in the majors, Rolen hit .283 and his 21 home runs and 92 RBI made him the first Phillies rookie to lead the team in both categories since Greg Luzinski in 1972. Those stats were also enough to make Rolen the Phillies' first Rookie of the Year since Richie Allen in 1964.

In 1998, Rolen had his best year as a Phillie. He hit 31 home runs, 45 doubles, produced 110 RBI and scored 120 runs. He also established himself as one of the league's top defensive players. At age 23, he won his first Gold Glove award, making him the first Phillie since Mike Schmidt in 1986 to be selected. His quick reactions and strong throwing arm dazzled the fans and quickly became an almost nightly feature of the highlight reels.

Although back problems limited Rolen to 112 games in 1999, he continued piling up the extra-base hits. In 2000, he led the Phillies in RBI for the third time in four seasons and in 2001 his 107 RBI ranked second to Bobby Abreau's 110. That same season, Rolen also won his third Gold Glove award.

But by the start of the 2001 season, the Phillies had produced five straight losing seasons and Rolen began to resent being the target of the fans' frustrations. He signed a one-year contract for 2002 and made his first All-Star squad, but when he turned down the Phillies' offer of a long-term deal, Rolen was traded to St. Louis that August.

In St. Louis, Rolen helped power the Cardinals to three postseason appearances in five years and he finally won a World Series ring in 2006. But Rolen and Cardinals manager Tony LaRussa began publicly squabbling in the press and 2007 was Rolen's final year in St. Louis.

He was traded to Toronto for the 2008 season.

Terry Francona
Manager, 1997 - 2000

Manager Terry Francona's four years as Phillies skipper failed to produce a single winning season. As a player, Francona had been a first round draft pick of the Expos and spent the decade of the 1980's mostly as a reserve with five different teams. In 1992, he began managing in the minors for the White Sox organization. After four seasons of riding buses in the minors, he spent 1996 as a coach with the Tigers.

Francona took over a Phillies team that had produced three consecutive losing seasons. A quick glance at the National League rankings revealed a Phillies team that didn't produce enough offense and a pitching staff that ranked near the bottom. In 1997, only one of the 15 other N.L. teams scored less runs than the Phillies and the team gave up more runs than all but two other clubs. It was a combination that led to a 68-94 record and another losing season.

In 1998, things got only slightly better. Despite big years from Curt Schilling, Scott Rolen and Rico Brogna, the Phillies still managed to go 75-87. The team's lack of depth and faulty starting pitching produced a club that was 12 games out of first by late May.

1999 began as an improvement over the previous season when the Phillies managed to play better than .500 ball until early August. But they collapsed in the second half, at one point losing 17 out of 18, to finish 77-85. When the Phillies went 65-97 in 2000, Francona's fate was sealed. He was replaced by Larry Bowa for the 2001 season.

Francona resurfaced as a manager with the Red Sox in 2004 and promptly guided Boston to their first World Series win in 86 years. Francona's Red Sox repeated as champions in 2007.

Rico Brogna
First Baseman, 1997 - 2000

Rico Brogna's four seasons with the Phillies included three years with at least 20 home runs and two seasons with 100-plus RBI. Brogna was originally a first round pick of the Tigers, but his progress towards the majors was slowed by injuries and he was traded twice before joining the Phillies in 1997.

The Phillies had been without a dependable first baseman since the departure of John Kruk. Brogna gave them both a slick fielder and improved offensive production. In 1997, Brogna hit 20 home runs and knocked in 81 runs, both the second highest marks on the club. In addition, he ran off a 14-game hitting streak and had seven three-hit games.

Brogna's 1998 season included another 20 home runs and his 104 RBI were the most by a Phillies first baseman since Don Hurst in 1932. He had four two-homer games and in late July he drove in a run in eight straight contests. It was also his second straight year with 36 doubles. In the field, Brogna committed just five errors all season and ranked third in fielding percentage.

1999 was more of the same for Brogna as he swatted 24 home runs and drove in 102 runs. It made him the only Phillies first baseman in the 20th Century to ever have back-to-back 100 RBI seasons. That August he had two home runs and seven RBI in a game against the Padres.

But in 2000, it all came to a sudden end. Brogna started slowly with just one home run and 12 RBI in the first six weeks of the season. Then, a broken left arm sidelined him for more than two months. When he returned in late July, Brogna started just three games for the Phillies, going 4 for 15 at the plate, before the Phillies put him on waivers.

Claimed by the Red Sox, Brogna finished out the season with Boston before signing with Atlanta for 2001. But his power was clearly gone as he hit just three home runs in 206 at-bats for the Braves and was released in mid-season. At age 31, his career in the majors was over.

Curt Schilling
Wrigley Field, 1998

In 1998, Curt Schilling became just the fifth pitcher in major league history to record consecutive 300 strikeout seasons. At age 31, Schilling proved his durability by simply overpowering opposing hitters. He set the tone right from Opening day, when he threw eight scoreless innings against the Mets in a game the Phillies eventually lost 1-0 in 14 innings. In his second start, he struck out 15 Braves to beat Greg Maddux and Atlanta 1-0. In his third start, he blanked Maddux and Atlanta again, 1-0, on a complete game two-hitter. By the time he was chosen for the All-Star team that year, Schilling already had 180 strikeouts. By season's end, his 268 innings and 15 complete games were both the most in the majors.

In 1999, Schilling was 15-6 despite missing most of the final two months of the season with shoulder problems. In fact, off-season shoulder surgery would cost Schilling the first month of the 2000 season. It would also prove to be

Schilling's final year in Philadelphia as he struggled to a 6-6 record before being dealt to Arizona in late July for four players.

But his next two seasons with the Diamondbacks would produce consecutive 20-win seasons and a World Series championship in 2001. An injury shortened season in 2003 had Schilling on the move again, this time to the Red Sox. There, he won 21 games in 2004 and helped pitch Boston to their first World Series title since 1918. When the Red Sox won a second title in 2007, Schilling came within a single out of a no-hitter in June versus Oakland. But Schilling began 2008 on the disabled list, leaving his future, at age 41, in doubt.

Back in Philadelphia, Schilling's 319 strikeouts remain the Phillies all-time single season record.

Kevin Jordan
Infielder, 1995 - 2001

Kevin Jordan's entire major league career was spent with the Phillies, but he played sparingly and was mostly used off the bench as the team's primary pinch-hitter. Jordan could play every infield position but shortstop and he was frequently inserted into the lineup late in the game for defensive purposes.

After a brief trial with the Phillies late in 1995, Jordan made the club out of spring training in 1996 and took over at first base for the injured Gregg Jeffries. But in mid-May, Jordan tore up his left knee chasing a pop foul, ending his season.

In 1997, Jordan played in 84 games, but started just 29. His best stretch came in August when he had a nine-game hit streak and produced an RBI in five straight games. His 13 pinch hits led the team. That fact was that, despite hitting .293 in his 45 starts in 1998, Jordan just wasn't going to dislodge the likes of Scott Rolen, Rico Brogna or Marlon Anderson from their regular spots in the Phillies infield. His 15 pinch hits that season were the third best in the National League.

Jordan's playing time increased temporarily in 1999 when he took over at third for Rolen, who went down with a back injury in August. Jordan responded to the opportunity by hitting .285 and driving in a career-high 51 runs. But Jordan's batting average dropped to .220 in 2000 and he started just 30 games in 2001 before being released prior to the start of the 2002 season.

Doug Glanville
Outfielder, 1998 - 2002; 2004

Speedy Doug Glanville spent four seasons running down fly balls and stealing bases for the Phillies. Glanville was a first-round draft pick of the Cubs who played one full season in Chicago before being dealt to the Phillies in 1997 for Mickey Morandini. Inserted as the Phillies' lead-off hitter, Glanville led the National League in plate appearances in his first season in Philadelphia. He also stole 23 bases and scored 106 runs.

In 1999, Glanville had the best year of his career. He racked up 204 hits, batted .325 and drove in a career-high 73 runs. His 204 hits made Glanville the first Phillie since Pete Rose in 1979 to top 200 hits. For good measure, he kept up his larceny on the base paths, stealing 34 bases in 36 attempts. When Glanville scored 101 runs that season, he also became the first Phillies outfielder to have consecutive years with 100 runs scored since Richie Ashburn in 1953-54.

Glanville also provided the Phillies with first-rate play in the outfield. In 1998 he played more innings than any other centerfielder in the National League and in 1999 his 14 outfield assists led all N.L. centerfielders. His speed allowed him to cover a lot of ground and in 2001 he ranked second among all N.L. outfielders in total chances and putouts.

In 2002, Glanville's batting average dropped for the third straight season as he began sharing time in centerfield. That off-season, at age 32, Glanville signed with the Texas Rangers as a free agent, but his stay there proved short. He played in just 52 games before being traded to the Cubs.

Glanville returned to the Phillies for the 2004 season, but he played sparingly, hit .210 and was released at season's end. It was his final season in the majors.

Bobby Abreu
Outfielder, 1998 - 2006

Bobby Abreu's rare combination of power and speed gave the Phillies one of their most potent all-around threats in franchise history. Abreu had played briefly with Houston before being taken by Tampa Bay in the 1998 expansion draft. But the Phillies pulled off one of the great heists of all time by sending infielder Kevin Stocker to Tampa Bay for Abreu. The Phillies immediately made the 24 year-old Abreu their starting right fielder.

In 1998, Abreu hit .312 to lead the Phillies in batting. He also put opposing base runners on notice by chalking up 17 outfield assists. For an encore, Abreu hit .335, third highest in the N.L., with 20 home runs and 109 walks in 1999. His 11 triples that same season led the National League.

At the plate, Abreu was an exceptionally patient hitter. He routinely went deep in the count and had seven straight seasons for the Phillies with at least 100 walks. It was a mark of Abreu's ability to get on base regularly that, beginning in 1999, he scored more than 100 runs six times in seven seasons. The string was broken just once, in 2003, when he scored 99.

Abreu's most productive season came in 2001, when he hit 31 home runs and drove in 110 runs. In 2002, his 50 doubles led the N.L. and were the most two-baggers by a Phillie since Chuck Klein in 1932. But Abreu was one of those rare players who hit for average as well as power. When he hit .301 in 2004, it was the sixth time in seven years Abreu had finished at or above .300.

In 2005, Abreu collected an RBI in 10 straight games, tying the franchise record set by Pinky Whitney in 1931. When he finished the season with 102 RBI, it marked the fourth time in five seasons that Abreu knocked in more than 100 runs. In addition, his 24 home runs and 31 stolen bases made Abreu only the third player in major league history with seven consecutive seasons of at least 20 home runs and 20 stolen bases. The only other players to go 20/20 for seven straight years were the father and son duo of Bobby and Barry Bonds.

But all that production came at a cost, and Abreu's hefty paycheck eventually became too much for the Phillies front office. The arrival of outfielder Aaron Rowand in 2006 and the development of Shane Victorino soon provided the Phillies with less costly alternatives, and thus, Abreu was dealt to the Yankees at the trading deadline in 2006.

In New York, Abreu continued putting up big offensive numbers. He finished the remainder of the 2006 season by hitting .330 for the Yankees and ended the year with 41 doubles, 107 RBI, 30 stolen bases and 124 walks. In 2007, he once again drove in more than 100 runs. But, at age 33, Abreu's home run production fell off and he finished the season with less than 20 home runs for the second straight year.

Pat Burrell
Outfielder, 2000 -

Pat Burrell's performance during three seasons at the University of Miami got him chosen by the Phillies with the first overall pick in the 1998 draft. In 1996, Burrell was the first college freshman to ever win an NCAA batting title and in 1998 he was chosen as the winner of the Golden Spikes Award, given annually to the nation's top amateur player.

Burrell joined the Phillies seven weeks into the 2000 season and although he played in just 111 games, he led all National League rookies in home runs(18), doubles(27) and RBI(79). Despite those numbers, he somehow finished fourth in the Rookie of the Year balloting. In 2001, Burrell excelled at the plate and in the field. His 18 outfield assists led the National League, he hit 27 home runs and put together an 18-game hitting streak.

Burrell's breakout season came in 2002, when he hit 37 home runs and drove in 116 runs. It was the most home runs by a Phillie since Mike Schmidt in 1986 and Burrell finished the year ranked third in the N.L. in RBI. Those numbers convinced the Phillies front office to lock up Burrell with a six-year contract extension.

But all those extra zeros on his paycheck came with the vastly increased expectations of Phillies fans. When Burrell proceeded to have a poor year at the plate in 2003, he became the target of their displeasure. A .209 batting average and just 64 RBI were viewed as a poor return on the team's investment. In 2004, Burrell got off to a hot start with 11 RBI in his first 10 games. By the end of May he was hitting .313. But an injured left wrist in August cost him playing time and he finished the season with 24 home runs and 84 RBI.

Burrell answered his critics by putting up another huge year in 2005. He drove in 21 runs in April, one short of the club record, and was twice named N.L. Player of the Week. His 117 RBI were tied for second best in the N.L. and his 32 home runs were tops on the Phillies.

Over the following two seasons, Burrell worked to cut down his strikeout totals, but he failed to raise his batting average above .260 in either 2006 or 2007. However, his 30 home runs in 2007 gave him seven straight years with 20 or more round-trippers.

In 2008, Burrell came out of gate swinging a hot bat. He batted .326 for the first month of the season and drove in 24 runs in the season's first 27 games. All that production in the final year of his contract soon had fans speculating about his future with the Phillies.

Randy Wolf
Pitcher, 1999 - 2006

Randy Wolf won 16 games for the Phillies in 2003 during a career beset by arm problems. Wolf was a second round pick of the Phillies in 1997. Desperate for quality starts wherever they could find them, the Phillies rushed Wolf to the majors at age 23 after only 280 innings of work in the minor leagues. Although he averaged nearly a strikeout per inning, Wolf made it past the seventh inning only four times in 21 starts and ended up with a 6-9 record and an ERA of 5.55.

In 2000, the trade of Curt Schilling in late July suddenly left Wolf as the ace of the Phillies starting staff. He finished the year with a staff-high 11 wins, threw 206 innings and made 32 starts. In 2001, Wolf struggled to a 10-11 record, despite throwing two shutouts in the final month of the season including a one-hitter against the Reds.

Wolf led the Phillies in starts, innings pitched and wins in 2002 but got the second poorest run support of any National League pitcher, limiting him to an 11-9 record. He deserved a much better fate as he struck out 10 or more batters four times that year and ran off a string of 27 consecutive scoreless innings beginning in August.

In 2003, Wolf threw 200-plus innings for the second consecutive year and went 16-10. He had a pair of shutouts against the Astros and the Cubs and was selected to his first All-Star team. Always a good hitter, Wolf had 11 RBI that season and in 2004 he hit three home runs, including two in one game against the Rockies.

But elbow surgery cost Wolf the second half of the 2005 season and the first half of 2006. He didn't make his first start that year until late July and, although Wolf was 4-0 in 12 starts, he made it past the fifth inning only twice. The Phillies decided Wolf's injury history made him too risky to re-sign.

That off-season, Wolf signed a free agent contract with the Dodgers. His 18 starts prior to the All-Star break produced a 9-6 record, but he missed the entire second half of the 2007 season with shoulder problems. In 2008, Wolf signed with the San Diego Padres, where he was 6-9 in his first 20 starts before being traded to the Houston Astros in late July.

Jimmy Rollins
Spring Training, 2000

The arrival of shortstop Jimmy Rollins gave the Phillies an offensive catalyst at the top of their batting order and a five-tool player to rebuild their infield around. Rollins was chosen by the Phillies right out of high school in the second round of the 1996 draft. During his first three full seasons in the minor leagues, Rollins averaged more than a hit per game. Called up by the Phillies for the final two weeks of the 2000 season, Rollins bashed a triple in his first at-bat in the big leagues and ended up with a.321 average.

In his first full season in the majors in 2001, Rollins swiped 35 consecutive bases before being thrown out. By season's end, he'd stolen 46 in 54 attempts. Rollins was also the first rookie to lead either league in triples and stolen bases in the same year since Minnie Minoso in 1951.

In 2002, Rollins became the first shortstop in major league history to make the All-Star team in his first two seasons. In 2003, his 42 doubles made Rollins just the second Phillies shortstop to ever hit at least 40 in a single season. In the field, Rollins' strong arm and extensive range were quickly earning him a reputation as one of the league's premier defensive players.

At the plate, Rollins' more disciplined approach produced a dramatic increase in his offensive numbers in 2004. By cutting down on his strikeouts, Rollins saw his batting average rise to .289 as he scored more than 100 runs and had 190 hits for the first time. Additionally, his 73 RBI were the most by a Phillies shortstop in more than 50 years.

In 2005, Rollins made his third All-Star team as he had 21 games with three or more hits and led all N.L. shortstops in hits, doubles and runs scored. He finished the 2005 season with a 36-game hitting streak which eventually reached 38 before ending the following season. It remains the longest such streak by a Phillies player in franchise history.

Rollins hit 25 home runs in 2006 to set a new Phillies single season mark for shortstops. In an August game against the Reds, he hit a home run from both sides of the plate making him only the third player in Phillies history to ever accomplish such a feat. That same season, at age 27, Rollins also notched the 1,000th hit of his career.

For a player who had already set so many new offensive marks for the Phillies franchise, Rollins' best days were still ahead of him.

Larry Bowa
Manager, 2001 - 2004

When the Phillies lost 97 games and finished last in 2000, the Phillies front office decided a change was in order. Larry Bowa was hired to replace manager Terry Francona and the local press immediately began taking bets on how soon the volatile Bowa would lose his cool.

Bowa had managed San Diego for parts of two seasons in 1987-88 before the team's poor play got him fired. Since the championship year of 1993, the Phillies had run off seven straight losing seasons and the fiery Bowa was seen as the antidote for the club's lackadaisical play. At first, the new approach seemed to pay off.

In 2001, the Phillies got off to a great start and found themselves in first place at the All-Star break. Although they eventually finished the season two games behind the Atlanta Braves, the Phillies' 86-76 record was a huge improvement. For his efforts, Bowa was voted the National League's Manager of the Year.

But over the next three seasons, the Phillies failed to improve their place in the standings. Although Bowa guided the Phillies to 86-win seasons in both 2003 and 2004, their failure to overtake Atlanta and win a divisional title became increasingly frustrating for the fans and the front office.

As a result, Bowa was let go in the final days of the 2004 season. After working as a broadcaster in 2005, Bowa returned to coach with the Yankees beginning in 2006.

Placido Polanco
Infielder, 2002 - 2005

Versatile Placido Polanco came to the Phillies from the Cardinals in the Scott Rolen trade and spent three seasons catching anything that was hit his way. Initially, Polanco replaced Rolen at third base, before moving to second the following season. At the plate, he excelled at making contact and was among the league's most difficult hitters to strike out. In 2003, he had 14 home runs, 30 doubles and stole 14 bases in 16 chances. An exceptionally gifted fielder, Polanco led all National League second baseman in fielding percentage in 2004.

However, the development of Chase Utley made Polanco expendable and he was traded to Detroit during the 2005 season, where he hit .338 over the second half of the season. In the 2006 divisional playoffs against the Yankees, Polanco hit .412 and was named series MVP.

In 2007, he batted .341, racked up 200 hits, scored 100 runs and drove in a career-best 67 runs. Defensively, Polanco started 138 games at second base in 2007 and didn't make a single error all season.

Jim Thome
First Baseman, 2003 - 2005

Jim Thome's short stay in Philadelphia produced consecutive 40 home run seasons for just the second time in franchise history. Following the 2002 season, the Phillies went looking to upgrade their offense, which had ranked eighth in the N.L. in runs scored. In inking Jim Thome to a six-year deal, the Phillies signed one of the game's most productive sluggers.

Thome's first nine full seasons in the majors with Cleveland had produced 324 home runs and six years with more than 100 RBI. Unlike many power hitters, Thome also had a keen eye at the plate and led the A.L. in walks three times.

In his debut season in Philadelphia, Thome lived up to his reputation by hitting 47 home runs to lead the National League. For good measure, his 131 RBI ranked third in the N.L. and were the most by a Phillies player in 71 years. In August, Thome hit a home run in four straight games and in September he produced an RBI in eight straight games. By season's end, despite striking out a league-high 182 times, Thome had notched his fifth straight season with 100 walks, 100 runs and 100 RBI.

In 2004, Thome hit 42 home runs and drove in 105 runs. He, thus, became the first Phillies player since Chuck Klein in 1929-30 to have back-to-back seasons with at least 40 home runs.

But Thome's 2005 season was cut short by a back problem in May and elbow tendonitis July, limiting him to just 57 games. Thome's absence opened the door for rookie Ryan Howard, who proceeded to hit .288 with 22 home runs and 63 RBI in limited duty. That off-season, the Phillies decided their future lay with Howard and shipped Thome to the White Sox for outfielder Aaron Rowand and two minor league pitchers.

In Chicago, Thome returned to form and clouted 42 home runs to go with 102 RBI in his first season with the White Sox. In 2007, Thome's power numbers decreased slightly but he did hit his 500th career home run late in the season.

Kevin Millwood
Pitcher, 2003 - 2004

Kevin Millwood's two seasons with Philadelphia were highlighted by a no-hitter against the Giants in 2003. Millwood had twice won 18 games for the Atlanta Braves before coming to the Phillies in exchange for catching prospect Johnny Estrada. Millwood was a big, strong right-hander who always seemed poised to etch his name in the record books. In the 1999 divisional playoffs, while still pitching for the Braves, Millwood tossed a complete-game one-hitter against the Astros in Game 2 of the series.

In Philadelphia, Millwood got off to great start. On April 27, in his sixth outing of the season, Millwood gave up three walks and struck out 10 Giants at Veterans Stadium to win 1-0. A Ricky Ledee home run in the bottom of the first inning provided the game's only tally. It was just the third 1-0 no-hitter ever thrown in the majors. Millwood would also later throw a pair of three-hit shutouts against the Expos and Padres that same season. Despite winning 10 games by the All-Star break, Millwood finished the season with a 14-12 record as his 222 inning pitched were the third most in the National League.

In 2004, Millwood struggled to stay in games. For a pitcher who had thrown five complete games in 2003, Millwood didn't make it past the seventh inning in any of his 25 starts in 2004. Additionally, he spent a month on the D.L. with elbow problems and made only three starts after July. Worse yet, he lasted only two innings in each of them.

That off-season, Millwood signed with Cleveland, where he was 9-11 in 2005 despite leading the American League with a 2.86 ERA. In 2006, he moved on to the Texas Rangers where he led the A.L. in starts and won 16 games. But Millwood was 10-14 in 2007 and just 6-5 in his first 18 starts of 2008.

Billy Wagner
Pitcher, 2004 -2005

Billy Wagner's track record of closing out games while with the Houston Astros led to two seasons at the back of the Phillies bullpen. Following the 2003 season, the Phillies front office decided they needed a replacement for veteran closer Jose Mesa, who'd saved 42 and 45 games in back-to-back seasons before performing poorly in 2003. With five seasons with 30 or more saves already under his belt, Wagner was a proven entity, coming off the best season of his career. In 2003, Wagner had saved 44 games, posted an ERA of 1.78 and struck out 105 batters in only 86 innings of work.

The Phillies traded three young pitchers to Houston for Wagner, who at age 33 was in the prime of his career. But Wagner's first season in Philadelphia was interrupted by injuries as he missed two months with groin and shoulder problems. As a result, he was limited to just 48 innings of work and earned a save in 21 out of 25 opportunities.

In 2005, Wagner appeared in 75 games and picked up 38 saves as his ERA of 1.51 was the lowest of his career. But it was not quite enough. Despite winning 88 games, the Phillies came up short, finishing two games behind Atlanta. That off-season, Wagner signed a free agent deal with the New York Mets.

Brett Myers
Pitcher, 2002 -

Brett Myers was a first-round pick of the Phillies whose strong right arm propelled him to the major leagues by age 21. The Phillies drafted Myers right out of high school with the 12th overall pick in the 1999 draft. Myers joined the Phillies midway through the 2002 season and immediately showcased his talent by holding the Chicago Cubs to just two hits over eight innings in winning his major league debut. Three weeks later, he threw a complete game to beat Milwaukee 4-1.

Myers was 14-9 in 2003 as he struck out 11 Pirate hitters in his first start of the season. That June, Myers shut out Boston on three hits. Myers struggled through an up and down year in 2004 and finished up 11-11. But in 2005, Myers was 13-8 and struck out 208 batters in 215 innings of work. At the plate, Myers aided his own cause with 10 hits and five RBI that

season. Myers' 12-6 record in 2006 made him the Phillies' leader in wins as he averaged nearly a strikeout an inning.

But early in 2007, the Phillies decided to move Myers to the closer's role. Despite missing two months in the middle of the season, Myers pitched effectively, saving 21 of 24 chances, and was on the mound when the Phillies clinched their first divisional title in 15 years. The acquisition of closer Brad Lidge prior to the 2008 season got Myers put back in the Phillies rotation.

However, Myers got off to a very rocky start in 2008, winning just three of his first 17 starts. In late June he was sent down to Triple A in an effort to regain his form.

Chase Utley
Second Baseman, 2003 -

That Chase Utley's first major league hit was a grand slam home run should come as no surprise for a player that seems intent on re-writing the record books. Utley was a first round-pick of the Phillies in 2000 after starring at UCLA. Three years in the minors got Utley a brief trial with the Phillies in 2003, when he was the final batter at Veterans Stadium.

In 2004, Utley began the season at Scranton, but got called up in early May to sub for the injured Placido Polanco. In his first 10 starts, all at second base, Utley produced a total of 16 RBI, including a home run in three straight games. In July, he hit a dramatic ninth inning home run off Braves closer John Smoltz to tie a game the Phillies eventually won in 10 innings. He finished the year with 13 home runs and 57 RBI in only 267 at-bats.

Finally, given the chance to play on an everyday basis in 2005, Utley had a breakout season. He batted .291 with 28 round-trippers and 105 RBI. It was the most runs ever driven in by a Phillies second baseman. His 39 doubles led the team and Utley also produced five multi-home run games. For good measure, he stole 16 bases in 19 tries.

In 2006, Utley would serve notice that he belonged among the game's elite offensive performers.

Charlie Manuel
Manager, 2005 -

Charlie Manuel is the first Phillies manager to preside over three straight winning seasons in almost 30 years. Not since the days of Danny Ozark in the late 1970's had the Phillies produced three consecutive winning records for the same skipper.

As a player, Manuel had a brief career as a part-time player with both the Twins and Dodgers, before spending six years in Japan, where he played on three pennant-winning teams and was the first American ever named league MVP. Manuel's 48 home runs in 1980 led the league and were the most in Japanese baseball ever hit by an American up to that time.

When he was finally done playing, Manuel returned to the States and began managing in the minor leagues. In 1994, he joined the Cleveland Indians as their hitting coach and, six years later, he took over as manager for Mike Hargrove. Manuel's Indians won 90 or more games for two straight seasons and won a divisional title in 2001 before losing to Seattle in the postseason. When Cleveland got off to a 39-47 start in 2002, Manuel was fired at the All-Star break.

The next season, Manuel joined the Phillies front office as an assistant to General Manger Ed Wade. When Larry Bowa was let go in 2004, Manuel was named his replacement for the 2005 season.

In 2007, the Phillies won 89 games and their first divisional title in 15 years.

Ryan Howard
First Baseman, 2004 -

That they were 139 other players taken before Ryan Howard in the 2001 draft says all you need to know about the difficulty of evaluating young talent. Howard was selected by the Phillies in the fifth round after playing his college ball at Southwest Missouri State.

But Howard's prodigious talents were on display long before he made it to the major leagues. In his second full season in the minors, Howard was named the MVP of the Florida State League when his .304 average and 23 home runs led the league. Promoted to AA Reading in 2004, Howard smashed 37 home runs and drove in 102 runs in exactly 102 games to be named MVP of the Eastern League.

He was quickly moved up to Triple A Scranton, where he knocked in 29 runs in 29 games and earned a call-up to the Phillies for the final month of the 2004 season. Despite hitting .282 in 19 games in September, the Phillies shipped Howard back to Triple A for the 2005 season principally because there was no place for him in the Phillies' line-up. Veteran Jim Thome was a fixture at first base and entering the third year of a six year deal.

Back in the minors, Howard continued to force the Phillies' hand by hitting .371 for Scranton during the first half of the season. But only when Thome went on the D.L. on July 1, and missed the remainder of the year with elbow problems, did Howard finally get his chance. Over the final half of the 2005 season, he made the most of it by hitting .288 with 22 home runs and 63 RBI. His 10 round-trippers in September were the most ever by a rookie during that month and he even hit a pair of grand slams against the Dodgers and the Braves.

For his efforts, Howard was named the National League's Rookie of the Year. The Phillies were finally convinced and, that off-season, they traded Thome to the White Sox to make room for their young slugger at first base. In 2006, Howard would reward the Phillies decision with one of the greatest offensive seasons in team history.

Jon Lieber
Pitcher, 2005 - 2007

Veteran Jon Lieber had already spent a decade in the major leagues and won 20 games for the Cubs in 2001 before joining the Phillies in 2005. Lieber was just two years removed from reconstructive elbow surgery when the Phillies inked him to three-year deal. When healthy, Lieber was an "innings eater", having thrown more than 200 innings three straight seasons for the Cubs and leading the N.L. in starts and innings pitched in 2000.

Lieber's first year with the Phillies turned out to be his best. He made 35 starts, threw 218 innings and his 17 victories were the most by a Phillies pitcher in eight years. He won his first four starts and four of his last five but in between, Lieber suffered from poor run support as the Phillies were shut out in five of his starts. His best outing was eight scoreless innings against the Braves in late September.

In 2006, Lieber was 9-11 as he missed five weeks of the season. The highlight came in mid-May with Lieber retiring the first 20 Reds batters he faced before settling for a 2-0 victory in which he allowed just three hits. He also managed to throw a pair of complete games versus the Mets in August, the second a 3-0 shutout.

But Lieber's 2007 season was limited to 12 starts and a 3-6 record as arm problems ended his season in late June. The lone bright spot came on June 9 when Lieber threw a complete-game three hit shutout at Kansas City.

That off-season, Lieber re-signed with the Cubs for 2008, where he began the season working out of the bullpen.

Tom "Flash" Gordon
Pitcher, 2006 -

Tom Gordon's first seven years in the major leagues were spent as a starter with Kansas City before he was eventually moved to the bullpen, where he reinvented himself as late-inning specialist. In his rookie season of 1989, Gordon was 17-9 for the Royals. But during his next six seasons, Gordon never won more than 12 games for Kansas City in any of them. After two additional seasons as a starter with Boston, Gordon was shifted to the bullpen. There he immediately led the American League with 46 saves for the Boston Red Sox in 1998.

But elbow surgery cost Gordon the entire 2000 season and he bounced around between the Cubs, Astros and Yankees before signing as a free agent with the Phillies at age 38. In 2006, Gordon posted 34 saves for Philadelphia despite missing almost three weeks with shoulder problems.

Gordon began 2007 as the Phillies closer, but a trip to the D.L. in early May forced the club to move Brett Myers to the bullpen and when Gordon returned two months later, he worked the remainder of the year as a set-up man.

Cole Hamels
Pitcher, 2006 -

Cole Hamels' talented left arm got him selected by the Phillies in the first round of the 2002 draft and earned him 15 wins in his first full season in the majors. But his path to the major leagues was not without some bumps. While working his way through the Phillies minor league system, Hamels missed a large chunk of both the 2004 and 2005 seasons with various injuries.

In 2006, Hamels began the season at Class A Clearwater, but was in the majors by May 12 after making just seven starts in the minors. For a pitcher with less than 200 innings of professional experience, Hamels seemed unfazed facing big league hitters. In his debut against the Reds in Cincinnati, Hamels threw five scoreless innings, allowing just one hit and striking out seven. By the time Hamels gave up a run in the major leagues, he'd thrown 10 scoreless innings. Although he finished the season with a 9-8 record, Hamels struck out 145 batters in 132 innings of work, including pair of games with 12 punch outs.

Hamels' 2007 season included several memorable outings. He threw seven scoreless innings on Opening Day against Atlanta. In his fourth start, Hamels struck out 15 Reds and allowed a single run to post his first complete game in the majors. He was selected to the All-Star team and finished the year with a 15-5 record. In his final outing of the regular season, Hamels struck out 13 Washington hitters and threw eight scoreless innings. More importantly, the victory put the Phillies in first place, one game ahead of the Mets with just two to play, for the first time all season.

In 2008, Hamels picked up right where he left off, winning five of his first eight starts. On May 15, he blanked Atlanta 5-0 to earn his first career shutout, and three weeks later, he shut out the Reds 2-0 on three hits. By the time he was selected to the N.L. All-Star team, Hamels had posted a record of 9-6 in his first 20 starts.

Shane Victorino
Outfielder, 2005 -

Shane Victorino's speed got him nicknamed the "flyin Hawaiian", but his real value to the Phillies came from his performance near the top of the Phillies batting order. The switch-hitting duo of Jimmy Rollins and Victorino at the top of the lineup set the table for the run producers like Chase Utley, Ryan Howard and Pat Burrell while wreaking havoc on the base paths.

Victorino began 2006 as the Phillies fourth outfielder. But the trade of Bobby Abreu in late July immediately opened the door to more playing time. Given a chance to play everyday, Victorino excelled at the plate and in the field. He reached base in 23 straight games, played the entire second half of the season without making a single error and led the team in outfield assists. In the final week of the season, he had five hits in a game against the Marlins.

In 2007, Victorino hit .281 and that June he posted a 14-game hitting streak. He also stole 37 bases, including a stretch of 26 straight at one point. Although he missed two weeks early in the 2008 season with a twisted ankle, Victorino quickly returned to form, hitting .322 in May and scoring 29 runs in 29 games.

Jamie Moyer
Pitcher, 2006 -

Jamie Moyer's long and productive career is proof positive that pitching is about more than throwing hard. In fact, Moyer's ability to still get major league hitters out in his mid-40's is a testament to the power of deception and ability to change speeds. Moyer was traded to the Phillies by Seattle, for whom he had twice won 20 games, during the final third of the 2006 season. Proving himself remarkably durable, Moyer had thrown more than 200 innings seven times during his nine full seasons with the Mariners.

With the Phillies, Moyer went 5-2 in his eight starts during the final six weeks of the 2006 season. Impressed by what they saw from the 43 year-old, the Phillies signed Moyer to a two year contract extension. In 2007, he gave them their money's worth. He led the club in starts, innings pitched and his 14 victories were second only to Cole Hamel's 15. When the Phillies won their first divisional title in 15 years, Moyer got the ball for Game 3 of the playoffs versus Colorado. He pitched six innings of one-run ball at Coors Field in a game the Phillies eventually lost 2-1.

Chase Utley
2007

In 2006, Chase Utley etched his name in the Phillies record books with one of the most productive seasons in team history. When he banged out 203 hits and finished the year batting .309, with 32 home runs, 40 doubles and 102 RBI, he became just the second Phillies player to ever hit all those benchmarks in a single season. Not since Chuck Klein in 1932 had another Phillie posted those figures while also scoring at least 130 runs.

Additionally, when Utley drove in more than 100 runs for the second straight season, he became the first Phillies second baseman to ever have multiple 100-RBI seasons. In late June he began a 35-game hit streak, tying him for the longest such run by a second-sacker in major league history. As a result, Utley was chosen as the starting second baseman on the N.L. All-Star team.

In 2007, Utley's appeared well on his way to a second straight record-setting season By late July, Utley had already produced 134 hits, 17 home runs and 82 RBI in his first 100 games when a broken right hand sidelined him for a month. He finished the season with a .322 average, 103 RBI and his 48 doubles were the most ever by a Phillies second baseman. However, Phillies fans were left to speculate what Utley's final tallies might have been had he played in another 30 games.

To say Utley got off to a torrid start in 2008 might be an understatement. He batted .352 in April and by the first week of June, Utley already had 21 home runs and 51 RBI.

Aaron Rowand
Outfielder, 2006 - 2007

Aaron Rowand's all-out style of play made him a fan favorite during his two seasons with the Phillies. Rowand came to the Phillies in the trade that sent Jim Thome to the White Sox. Rowand immediately took over in centerfield for the Phillies and was hitting .310 by early May when his spectacular running catch of a fly ball in deep right centerfield became one of the season's most replayed highlights. Despite slamming face first into the outfield wall and suffering a broken nose, Rowand held on to the ball. He also needed surgery and missed the next two weeks. In late August, he had his season ended prematurely when he collided with Chase Utley on a fly ball at Wrigley Field, breaking his ankle. That second injury limited Rowand to 109 games in 2006.

In 2007, Rowand hit .309 with 27 home runs while scoring 105 runs. He was at his best during a two-week stretch in July. In the span of ten days, Rowand had three doubles in a game three times. Less than a week later, he was 5 for 6 in a game against the Dodgers. In all, Rowand rapped out 189 hits including 45 doubles.

But the Phillies allowed Rowand to leave that off-season when he signed a free-agent deal with the Giants.

Kyle Kendrick
Pitcher, 2007 -

Rookie Kyle Kendrick was pushed into emergency duty as a starter in 2007 after injuries to the Phillies pitching staff left the team short-handed. At 22, Kendrick was a seventh-round pick of the Phillies with four nondescript seasons in the minors under his belt. But when Freddy Garcia went down in early June, the Phillies promoted Kendrick from Double A Reading to take his place. In his debut, Kendrick got a no-decision by allowing three runs in six innings against the White Sox. He won his next outing versus Cleveland and was 4-0 in his first six starts.

Kendrick ended up making 20 starts for the Phillies in 2007 and ate up 120 innings at a time when the club's starting staff was stretched thin. Better yet, his 10-4 record produced the most wins by a rookie pitcher for the Phillies since 1990. Chosen to start Game 2 of the playoffs against Colorado, Kendrick failed to make it past the fourth inning in a 10-5 loss.

In 2008, Kendrick was 8-3 at the All-Star break.

Greg Dobbs
Infielder, 2007 -

Greg Dobbs' ability to play several positions and his success at the plate make him a valuable addition to the Phillies. Dobbs had gone un-drafted despite hitting .438 as a senior at the University of Oklahoma. Signed by Seattle, he had three brief trials with the Mariners before being claimed off waivers by the Phillies early in 2007.

Although he played the majority of his games at third base for the Phillies in 2007, Dobbs also subbed for Ryan Howard at first and started an additional 22 games in the outfield. The result was a .272 average with 20 doubles, 10 home runs and 55 RBI in only 324 at-bats. His 18 pinch-hit RBI were the most in the majors. Dobbs also had a pair of four-hit games and a grand slam against the Mets in September that turned a 6-5 Phillies lead into an eventual 10-6 win.

Two months into the 2008 season, Dobbs was clearly manager Charlie Manuel's first choice off the bench as he was 26 for 72 for a .356 average.

Jayson Werth
Outfielder, 2007 -

Outfielder Jayson Werth was first-round pick of the Orioles whose career was often interrupted by injuries prior to his arrival in Philadelphia. His first four years in the Orioles system were followed up by a trade to Toronto, with whom he made his major league debut late in 2002. Two years later, he was shipped to the Dodgers. But Werth missed the first month of the 2005, and the entire 2006 season with wrist surgery. The Phillies signed him as a free agent that off-season.

Finally healthy, Werth saw extended playing time in the Phillies outfield in 2007. As the weather heated up, so did his bat. In an August series against the Padres, Werth knocked out a hit in nine straight at-bats, one short of the franchise record. As the season wound down and the Phillies closed in on the Mets, Werth had two triples and a pair of stolen bases in a 14-inning win over St. Louis.

In 2008, Werth's playing time increased when Shane Victorino went out for two weeks in April. Werth responded by going on a tear at the plate. On May 16, he hit three home runs and drove in eight runs against Toronto.

Ryan Howard
2007

Ryan Howard's first full season in the major leagues produced a new Phillies single-season home run mark and a Most Valuable Player award. In 2006, Howard simply overpowered opposing pitchers by slamming 58 round-trippers and driving in 149 runs to led the N.L. in both categories. He also hit .313 and scored 104 runs. In early September, he hit three home runs off Atlanta's Tim Hudson in an 8-7 win over the Braves. It was just one of seven multi-homer games that season for Howard. When he was voted the National League MVP, Howard became only the second player in major league history to win the Rookie of the Year award and MVP award in back-to-back seasons.

In 2007, Howard continued to swing the most potent bat in the Phillies lineup. His 47 home runs and 136 RBI again led the club and made him just the fourth Phillies player ever to have consecutive 40 home run seasons. Despite striking out a league-leading 199 times, Howard was at his best in the final, crucial week of the season as the Phillies chased down the struggling Mets. Over the season's last six games, Howard hit five home runs and drove in 11 runs against the Braves and Nationals to help power the Phillies to their first divisional crown in 15 years.

But Howard struggled at the plate early in 2008, striking out 84 times in his first 219 at-bats and frequently chasing bad pitches out of the strike zone. Yet, in spite of hitting just .234, Howard's 28 home runs and 84 RBI were both tops in the National League at the All-Star break.

Jimmy Rollins
2007

Prior to the start of the 2007 season, Jimmy Rollins told reporters that the Phillies were the team to beat in the N.L. East. Despite the fact that the Phillies had finished 12 games behind the Mets in 2006, Rollins put the rest of the league on notice that he and his Phillies teammates were planning on winning their first divisional title in 15 years. In making such a bold predication, Rollins opened himself up to the critics and second-guessers. Then he went out and backed up his words with an MVP-caliber season.

In 2007, Rollins led by example and had his greatest season to date. He played in all 162 games and his 212 hits were the most by a Phillies player in more than 30 years. His 20 triples led the National League and set a new Phillies single-season record. His 30 home runs and 94 RBI were both career highs.

Rollins began the season on a tear, going deep six times in the first 11 games. He racked up 63 multi-hit games, tops in the majors while scoring a league-high 139 runs. By the end of the season, Rollins had become the fourth player in major league history with at least 20 doubles, triples, home runs and stolen bases in the same year. His combination of power and speed made Rollins just the second Phillie ever to have at least 30 home runs and 30 stolen base in the same season. In addition to his MVP award, Rollins also took home a Gold Glove award and a Silver Slugger bat, given to the league's best hitting player at each position.

In 2008, Rollins began the season with a home run on opening day for the second straight year.

Geoff Jenkins
Outfielder, 2008 -

Geoff Jenkins was brought in by the Phillies to provide additional outfield help and a veteran bat off the bench. When the Phillies allowed outfielder Aaron Rowand to depart via free agency, they went looking for a replacement. After shifting Shane Victorino to centerfield, they settled on Jenkins to add depth in right field.

During his previous nine-plus seasons with the Milwaukee Brewers, Jenkins had proven to be a solid run producer with seven years of 20 or more home runs and three years with at least 90 RBI. His best offensive season in Milwaukee had come in 2000, when Jenkins hit 34 home runs, drove in 94, batted .303 and scored 100 runs. In 2001, he had a home run in five straight games.

Jenkins began the 2008 season platooning with Jayson Werth in right field for the Phillies.

Pedro Feliz
Third Baseman, 2008 -

Pedro Feliz, like Geoff Jenkins, was another veteran player brought in to shore up the Phillies lineup for the 2008 season. The Phillies had struggled to find a reliable option at third base ever since the departure of Scott Rolen in 2002. The ensuing five seasons had forced Phillies fans to endure a series of players who couldn't handle the rigors of one of the game's most demanding positions.

Over his first seven seasons in the major leagues, all with the Giants, Feliz had slowly developed into a steady run producer with four straight years of 20 or more home runs. His 35 doubles and 98 RBI in 2006 were both career highs and in 2007, he led all National League third baseman in fielding percentage.

In 2008, Feliz solved the Phillies need for more offense at third base by putting up another solid year at the plate. In late May, he was 4 for 6 with four RBI in a game at Colorado.

Photograph Index

Photograph Credits

Brace, George:
111(top), 117, 120(bottom), 121(top), 123, 126(bottom)

Chicago Historical Society:
(*Chicago Daily News* negatives collection)
9 (sdn-2390)
10 (sdn-1518)
12 (sdn-1539)
13 (sdn-1519)

Cincinnati Post, The:
77, 122, 162

Getty Images:
114, 177, 188, 189, 190, 191, 192, 194, 195(bottom), 196, 202, 207

Goldstein, Dennis:
18, 20, 24, 27, 28, 29, 33, 34, 36, 38, 42, 44(bottom), 45, 46(bottom), 50, 53, 54, 57, 58(bottom), 67, 68(top), 70, 90, 91(bottom)

**Library of Congress
Prints and Photographs Division:**
11 (LC-DIG-ggbain-09155)
15 (LC-DIG-ggbain-07981)
19 (LC-DIG-ggbain-12274)
21 (LC-DIG-ggbain-09136)
32 (LC-USZ62-132539)
37 (LC-DIG-ggbain-12276)
39 (LC-DIG-ggbain-24543)

McWilliams, Doug:
125, 126(top), 129, 130, 131, 132, 133, 134, 135, 136, 137, 138, 140

Mumby, Mike:
14, 17, 23, 26, 35, 51, 61, 78, 101

National Baseball Hall of Fame Library:
Cooperstown, NY
16, 22, 25, 30, 36, 40, 41, 43, 44(top), 46(top), 48, 49, 52(top), 56, 58(top), 62, 63(bottom), 64, 65, 66, 68(bottom), 69, 72(bottom), 74, 75, 83, 84, 86, 87, 91(top), 92, 95, 97, 98, 100, 102, 103, 104, 105, 106, 108(bottom), 109, 110(bottom), 111(bottom), 112, 113, 115, 118, 128, 139(bottom), 157

Stang, Mark:
52(bottom), 63(top), 88, 159, 163(top), 166, 193, 197(top), 199 (top), 200, 203

The Sporting News:
8, 76(top), 120(top)

The Urban Archives; Temple University:
Philadelphia, Pennsylvania
frontispiece, 31, 47, 55, 59, 60, 71, 72(top), 73, 76(bottom), 79, 80, 81, 82, 85, 89, 93, 94, 96, 99, 107, 108(top), 110(top), 116, 119, 121(bottom), 124, 127, 139(top), 141, 142, 143, 144(top), 145(bottom), 147, 148, 149, 151, 154

Trombetti, Skip:
195(top), 197(bottom), 198, 199(bottom), 201

Wallin, Jack:
144(bottom), 145(top), 146, 150, 152, 153, 155, 156, 158, 160, 161, 163(bottom), 164, 165, 167, 168, 169, 170, 171, 172, 173, 174, 175, 176, 178, 179, 180, 181, 182, 183, 184, 185, 186, 187

The Phillie Phanatic
Citizens Bank Ballpark, 2007

For better than 30 years, Phillies fans have been treated to the antics of the game's greatest mascot. After making his debut early in the 1978 season, the Phanatic has endeared itself to three generations of fans with its' wild antics on the field and in the stands.

To order additional copies of *Phillies Photos*, or for information about other titles currently available from Orange Frazer Press, please call **1–800–852–9332**, or visit our website at **orangefrazer.com**. Address inquiries to:
Orange Frazer Press
P.O. Box 214
37½ West Main Street
Wilmington, OH 45177.